LUXURY HOUSES

HOLIDAY ESCAPES

edited by fusion publishing

teNeues

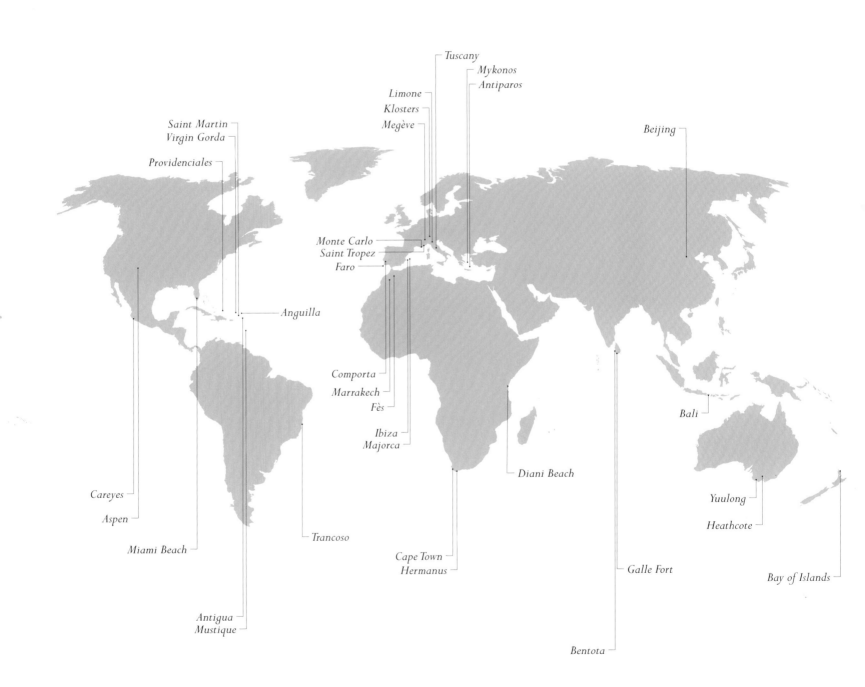

Tuscany
Mykonos
Antiparos
Limone
Klosters
Megève
Saint Martin
Virgin Gorda
Beijing
Providenciales
Monte Carlo
Saint Tropez
Faro
Anguilla
Comporta
Marrakech
Fès
Bali
Ibiza
Majorca
Careyes
Yuulong
Aspen
Heathcote
Diani Beach
Miami Beach
Trancoso
Cape Town
Hermanus
Galle Fort
Bay of Islands
Antigua
Mustique
Bentota

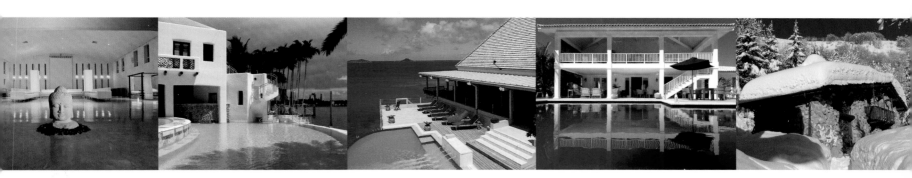

Luxury Hotels

HOLIDAY ESCAPES

Vacation Dream Houses

"Bless me with luxury. Necessities I can do without," Oscar Wilde once declared. With this criterion, the dandy, writer and playwright would have felt right at home at the resorts presented here. Not that they lack necessities in any way. Instead, they offer perfect and, above all, creative luxury in terms of architecture, interior design and features. These resorts fulfill your wishes before you even know you have them. And this is what true comfort ultimately is about.

Esthetic perfection also means that the villas harmoniously blend into the landscape, that they place as little burden on sensitive ecosystems as possible and that they either accentuate the beauty of their surroundings—or that they merge with them so that they literally appear to evolve from the dense tropical vegetation, like the Villa Dewata on Bali. The Island of the Gods requires a special architectural feel that, rather than disrupting that beautiful landscape, which has been characterized by a traditional life-style throughout the centuries, gives prominence to its characteristics.

When it comes to the aforementioned Villa Dewata, whose structure and architecture are based on Balinese traditions, architects have done themselves proud. So cleverly do the villa's pavilions, built of glass and natural materials, blend in with its environment of water-lily ponds and rice fields, so imperceptible is the design of the transition between its large, seemingly or actually open spaces and the nature around it that the estate actually seems to rise organically from its garden.

The Amanyara villas on the west coast of the Caribbean island of Providenciales are another remarkable example of architecture perfectly merging with the surrounding landscape. Their large swimming pools are surrounded by black lava rock from Indonesia—creating a visually perfect counterpart to the lakes in the area. The architecture of the pavilions making up each residence reflects components of the surrounding landscape through its use of natural colors and materials. Heavy use of glass also creates an impression of transparency and flowing transitions between the interior and exterior of the places—and, needless to say, the décor inside always remains state-of-the-art.

For a bucolic chalet in the Alps to be based on the building techniques of old is almost imperative, because Mother Nature has a way of showing her harsh side around these latitudes and the chalet clearly has to reflect its original purpose as shelter from the various climates. In fact, the landscape and climate around these parts leave virtually no options save for heavy wooden beams and a cozy but bucolic interior. And even in the age of floor heating and hot, bubbling Jacuzzis out in the snow, the sight of a fireplace never fails to warm the human psyche. While boasting all these amenities, the Chalet Anna in the French ski resort of Megève simultaneously lends a new, fresh touch to this warm and cozy ambience with its bright-red furniture and surprising perspectives.

Other structures are clearly designed to be sophisticated works of art and demonstrate architecture as one of the greatest accomplishments of civilization. One of these is the Villa Karl, the former residence of fashion creator Karl Lagerfeld, which dominates a promontory in Monaco like a sparkling jewel. Its cream-colored façade, vast terrace, classic garden and exquisite interior are as remote from nature as Monte Carlo itself—which is exactly why its grandeur fits so perfectly into an environment where upscale lifestyles have always flourished.

The fact that this concept can also work conversely in an environment of relative wilderness is manifested by the Villa Rahimoana in northern New Zealand. While the exterior of this avant-garde structure seems to consist primarily of glass, clear lines and modern works of art characterize its interior. Yet, sitting on its cliff above the Bay of Islands, it doesn't seem out of place at all, especially when you're inside the building. Its enormous glass fronts can make you feel like you're outside looking down on the whitecap of the South Pacific. That notwithstanding, the exterior of the cool and flat architecture of the building, never rising beyond the height of the nearest palm tree, fits into its subtropical surroundings with amazing harmony.

Every villa presented here is as unique as the landscape in which it was built. However, here's what they have in common: maximum standards of esthetics and convenience. Each one is a work of art in its own right that responds to its surroundings by neatly integrating itself and by quoting elements from it. Leafing through these pages is bound to kick your imagination into high gear and leave you with one thought: These are the palaces of the modern age.

Stefanie Bisping

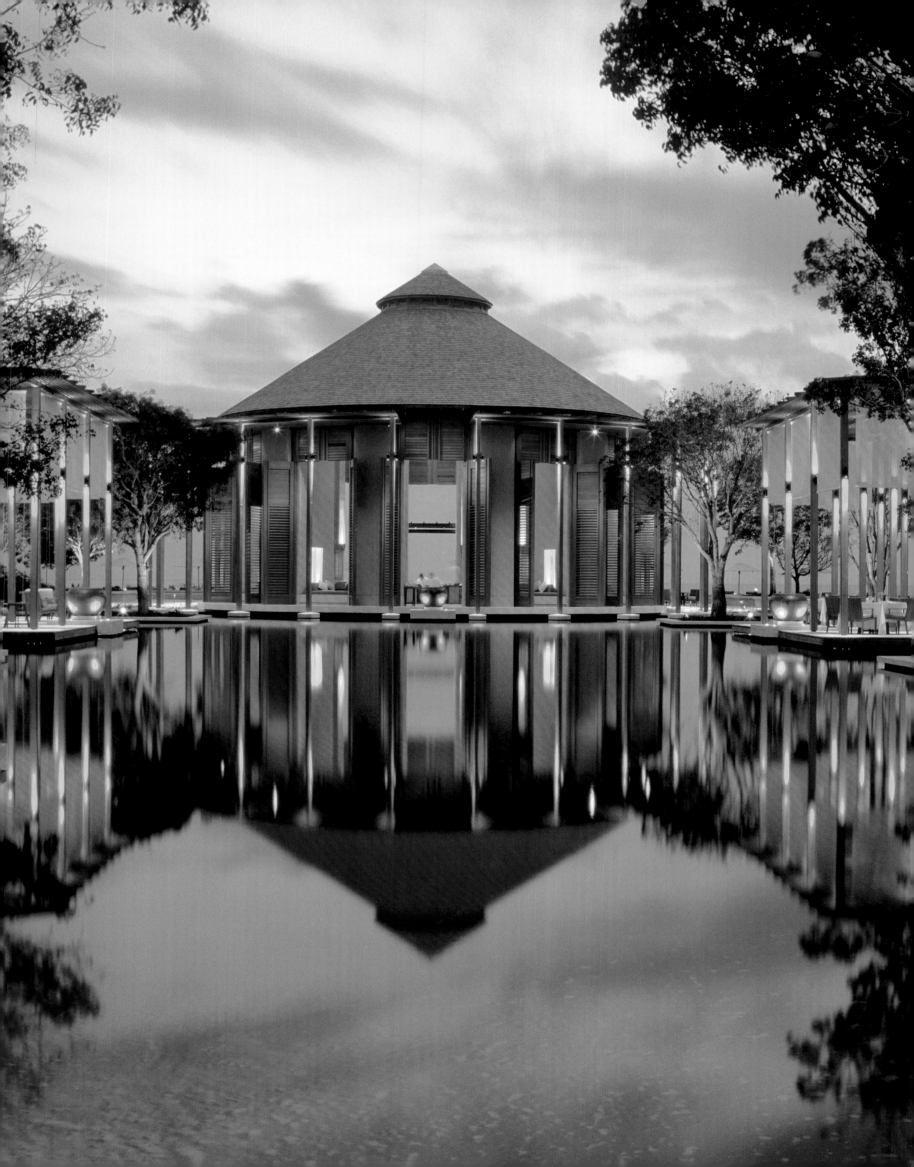

Traumhäuser auf Zeit

„Man umgebe mich mit Luxus. Auf alles Notwendige kann ich verzichten", erklärte einst Oscar Wilde. Gemessen an diesem Maßstab hätte sich der Dandy, Dichter und Dramatiker in den hier vorgesellten Domizilen wohlgefühlt. Nicht, dass es ihnen am Notwendigen fehlt. Vielmehr bieten sie in Architektur, Interieur und Ausstattung perfekten und vor allem kreativen Luxus. Diese Häuser erfüllen Wünsche, bevor man merkt, dass man sie verspürt. Und das macht schließlich wahren Komfort aus.

Ästhetische Perfektion bedeutet auch, dass die Villen sich harmonisch in die Landschaft einfügen, sensible Ökosysteme so wenig wie möglich belasten und die Schönheit ihrer Umgebung entweder akzentuieren – oder so mit ihr verschmelzen, dass sie buchstäblich aus dichter tropischer Vegetation zu wachsen scheinen, wie dies bei der Villa Dewata auf Bali der Fall ist. Die Insel der Götter erfordert ein besonderes architektonisches Fingerspitzengefühl, damit ihre wunderschöne, über Jahrhunderte durch eine traditionelle Lebensweise geprägte Landschaft nicht gestört, sondern in ihren Eigenheiten betont wird.

Bei der schon genannten Villa Dewata, die in ihrer Struktur und Bauweise auf balinesischen Traditionen fußt, ist das gelungen. So geschickt sind die aus Glas und Naturmaterialien erbauten Pavillons in die Umgebung aus Seerosenteichen und Reisfeldern eingefügt, so unmerklich sind die Übergänge zwischen den großen, offen erscheinenden oder tatsächlich offenen Räumen und der Natur ringsum gestaltet, dass sich das Anwesen geradezu organisch aus dem Garten zu entwickeln scheint.

Auch die Amanyara-Villen an der Westküste der Karibikinsel Providenciales sind ein eindrucksvolles Beispiel für perfekt mit der umliegenden Landschaft verschmelzende Architektur. Die großen Swimmingpools sind mit schwarzem Lavagestein aus Indonesien gefasst – und bilden so optisch perfekte Gegenstücke zu den Seen auf dem Areal. Die Architektur der Pavillons, aus denen jede Residenz besteht, nehmen mit natürlichen Farben und Materialien Komponenten der Landschaft auf. Viel Glas schafft auch hier einen Eindruck von Transparenz und fließenden Übergängen zwischen Innen- und Außenbereich – wiewohl sich die Ausstattung innen selbstverständlich auf dem neuesten Stand der Technik befindet.

Dass ein uriges Chalet in den Alpen sich an traditioneller Bauweise orientiert ist fast zwingend, weil sich die Natur in diesen Breiten von ihrer harschen Seite zeigen kann und das Haus seine ursprüngliche Bestimmung als Schutz vor den verschiedenen Witterungen klar spiegeln muss. Somit scheinen Landschaft und Klima geradezu nach schweren Holzbalken und einem kuscheligen, aber rustikalen Interieur zu verlangen. Und psychologisch wärmt der Anblick eines Kamins auch in Zeiten von Fußbodenheizung und warm blubberndem Jacuzzi im Schnee. Das Chalet Anna im französischen Wintersportort Megève erfüllt diesen Anspruch, verleiht aber dem warmen und heimeligen Ambiente zugleich durch knallrote Möbel und überraschende Perspektiven eine neue, frische Note.

Andere Häuser sind sichtbar als raffinierte Kunstwerke konzipiert und weisen die Baukunst als eine der höchsten Errungenschaften der Zivilisation aus. Dazu gehört etwa die Villa Karl, einstmals Residenz des Modeschöpfers Karl Lagerfeld, die auf einer Landzunge in Monaco ruht wie ein funkelndes Juwel. Die cremefarbene Fassade, die riesige Terrasse, der klassische Garten und das erlesene Interieur stehen der Natur so fern wie Monte Carlo selbst – und fügen sich mit ihrer Grandezza gerade deshalb perfekt in eine Umgebung ein, in der seit jeher die gehobene Lebensart gepflegt wird.

Dass dieses Konzept umgekehrt auch in relativer Wildnis funktionieren kann, beweist die Villa Rahimoana im Norden Neuseelands. Außen scheint sie hauptsächlich aus Glas zu bestehen, innen prägen den avantgardistischen Bau klare Linien und moderne Kunstwerke. Dennoch wirkt er auf seiner Klippe über der Bay of Islands nicht wie ein Fremdkörper, am wenigsten, wenn man sich im Gebäude befindet. Vermitteln die gewaltigen Glasfronten doch den Eindruck, man stünde im Freien und blicke von dort auf die Wellen des Südpazifiks. Aber auch von außen verbindet sich die kühle und flache Architektur, die über die Höhe der nächsten Palme nicht hinausragt, überraschend harmonisch mit der subtropischen Umgebung.

So unterschiedlich wie die Landschaften, in denen sie erbaut wurden, sind auch die Villen selbst. Eines haben die hier vorgestellten Häuser jedoch gemeinsam: höchste Ansprüche an Ästhetik und Komfort. Jedes für sich ist ein Kunstwerk, das auf seine Umgebung reagiert, indem es sich geschickt einfügt und Elemente aus ihr zitiert. Beim Blättern gerät man ins Träumen und ein Gedanke drängt sich auf: Dies sind die Paläste der Moderne.

Stefanie Bisping

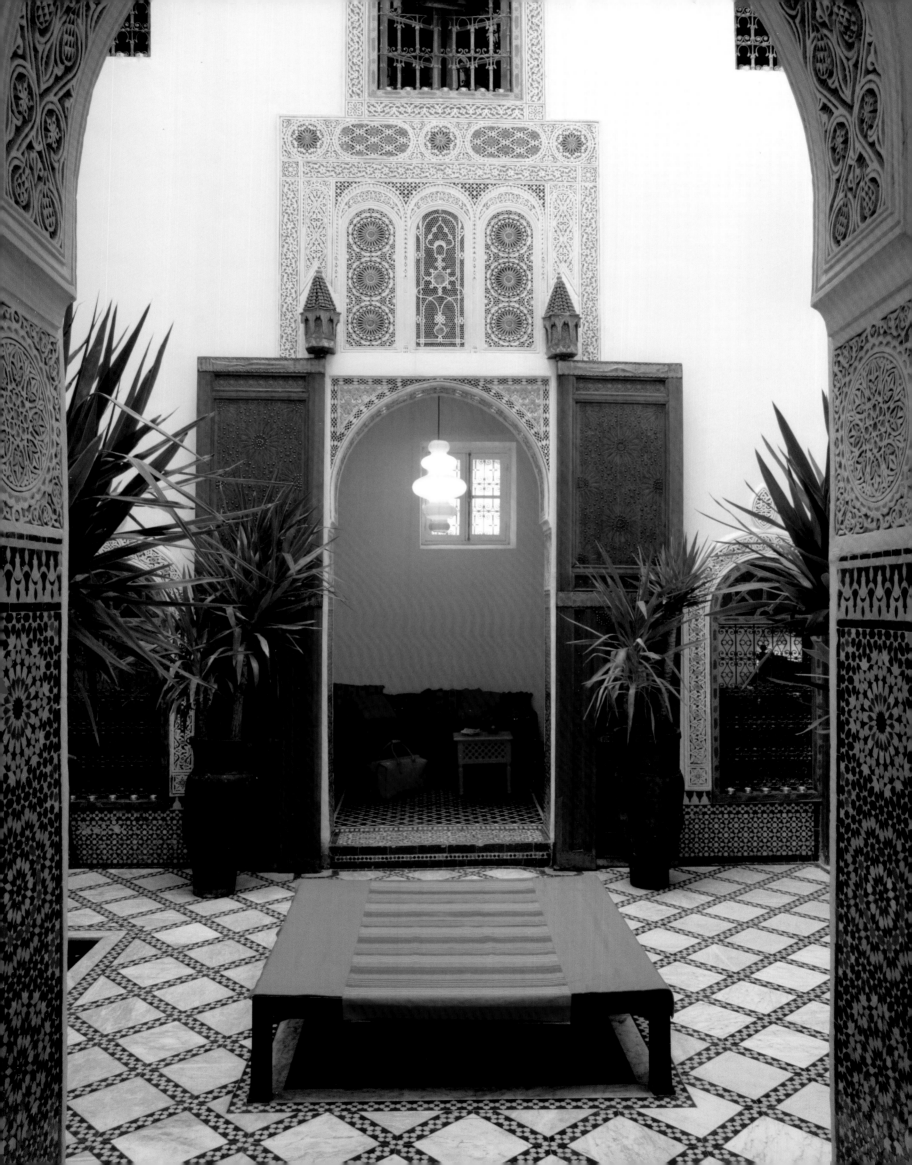

Un moment
dans une maison de rêve

« Offrez-moi du luxe, je peux me passer du nécessaire », déclara un jour Oscar Wilde. Selon ces critères, le dandy, écrivain et dramaturge se serait senti chez lui dans les résidences présentées ici. Non qu'elles manquent du nécessaire. Elles offrent même un luxe parfait et surtout très créatif dans leur architecture, leur intérieur et leur mobilier. Ces maisons comblent tous vos désirs avant même que vous réalisiez que vous les avez. Et c'est au fond ce qui caractérise le vrai confort.

La perfection esthétique suppose aussi que les villas s'intègrent harmonieusement dans le paysage et qu'elles nuisent le moins possibles aux écosystèmes sensibles ; ou bien elles accentuent la beauté de leur environnement – ou bien elles se fondent si intimement avec lui qu'elles ont l'air de pousser littéralement dans la luxuriante végétation tropicale, comme la Villa Dewata à Bali. L'Ile des Dieux exige un tact architectural particulier pour ne pas perturber ses merveilleux paysages, marqués par un mode de vie multiséculaire, mais au contraire en mettre en valeur les spécificités.

C'est ce qui a été réalisé avec la Villa Dewata, dont la structure et l'architecture sont basées sur les traditions balinaises. Les pavillons faits de verre et de matériaux naturels sont si artistiquement fondus dans le paysage, avec ses étangs à nénuphars et ses rizières, que la propriété semble quasiment pousser organiquement dans le jardin. Il en va de même avec les transitions au design discret entre les grandes pièces, apparemment ou véritablement ouvertes, et le monde naturel qui les entoure.

Les villas Amanyara, sur la côte occidentale de l'île caribéenne de Providenciales, sont également un exemple impressionnant d'architecture se mêlant parfaitement au paysage alentour. Les vastes piscines sont bordées de roche volcanique noire importée d'Indonésie – créant le contrepoint visuel parfait des lacs de la région. L'architecture des pavillons, qui constituent chaque résidence, reflète les composantes du paysage à travers des couleurs et matériaux naturels. Les nombreux vitrages créent également une impression de transparence et de fluidité dans la transition entre les espaces intérieurs et extérieurs – quant à l'aménagement intérieur, il est évidemment du dernier cri.

Un chalet rustique dans les Alpes doit presque impérativement être conçu selon le style architectural traditionnel, car Dame Nature peut se montrer rigoureuse sous ces latitudes. La maison doit clairement refléter son rôle originel de protection contre les diverses conditions météorologiques. Le paysage et le climat semblent littéralement exiger de lourdes poutres de bois et un intérieur cosy mais rustique. Et même à l'ère du chauffage par le sol et des jacuzzis bouillonnants dans la neige, la vue d'une cheminée fait toujours chaud au cœur. Le Chalet Anna, dans la station de ski française de Megève, répond à cette exigence, tout en apportant à cette ambiance confortable et chaleureuse une note de fraîcheur et de nouveauté, grâce à un mobilier rouge vif et des perspectives surprenantes.

Les autres maisons sont visiblement conçues comme des œuvres d'art sophistiquées, démontrant que l'architecture est l'une des plus grandes réussites de la civilisation. L'une d'entre elles est la Villa Karl, ancienne résidence du créateur de mode Karl Lagerfeld. Elle repose sur un promontoire à Monaco, comme un joyau étincelant dans son écrin. Sa façade couleur crème, son immense terrasse, son jardin classique et son intérieur sélect sont aussi éloignés de la nature que Monte-Carlo même – et c'est en cela que cette magnificence s'intègre parfaitement dans un cadre où l'on a toujours cultivé un style de vie haut de gamme.

La Villa Rahimoana, au nord de la Nouvelle-Zélande, prouve que ce concept peut aussi fonctionner à l'inverse dans un environnement relativement sauvage. De l'extérieur, elle semble être constituée principalement de verre, alors qu'à l'intérieur, sa structure avant-gardiste se distingue par des lignes claires et des œuvres d'art modernes. Cependant, posée sur sa falaise au-dessus de la Bay of Islands, elle ne donne pas l'impression d'être un corps étranger. Quand on se tient à l'intérieur du bâtiment, les gigantesques façades de verre donnent l'impression qu'on est en plein air à contempler les vagues du Pacifique sud en contrebas. De l'extérieur, l'architecture froide et plate qui ne dépasse pas la hauteur du palmier le plus proche, s'harmonise étonnamment bien avec l'environnement subtropical.

Ces villas sont aussi différentes les unes des autres que les paysages où elles ont été construites. Cependant, les maisons présentées ici ont une chose en commun : les plus hauts standards en matière d'esthétique et de confort. Chacune d'entre elles est une œuvre d'art à part entière, en interaction avec son environnement dans lequel elle s'intègre astucieusement et dont elle cite certains éléments. En feuilletant ces pages, vous vous prendrez à rêver et une pensée vous viendra à l'esprit : voilà les palais de la modernité.

Stefanie Bisping

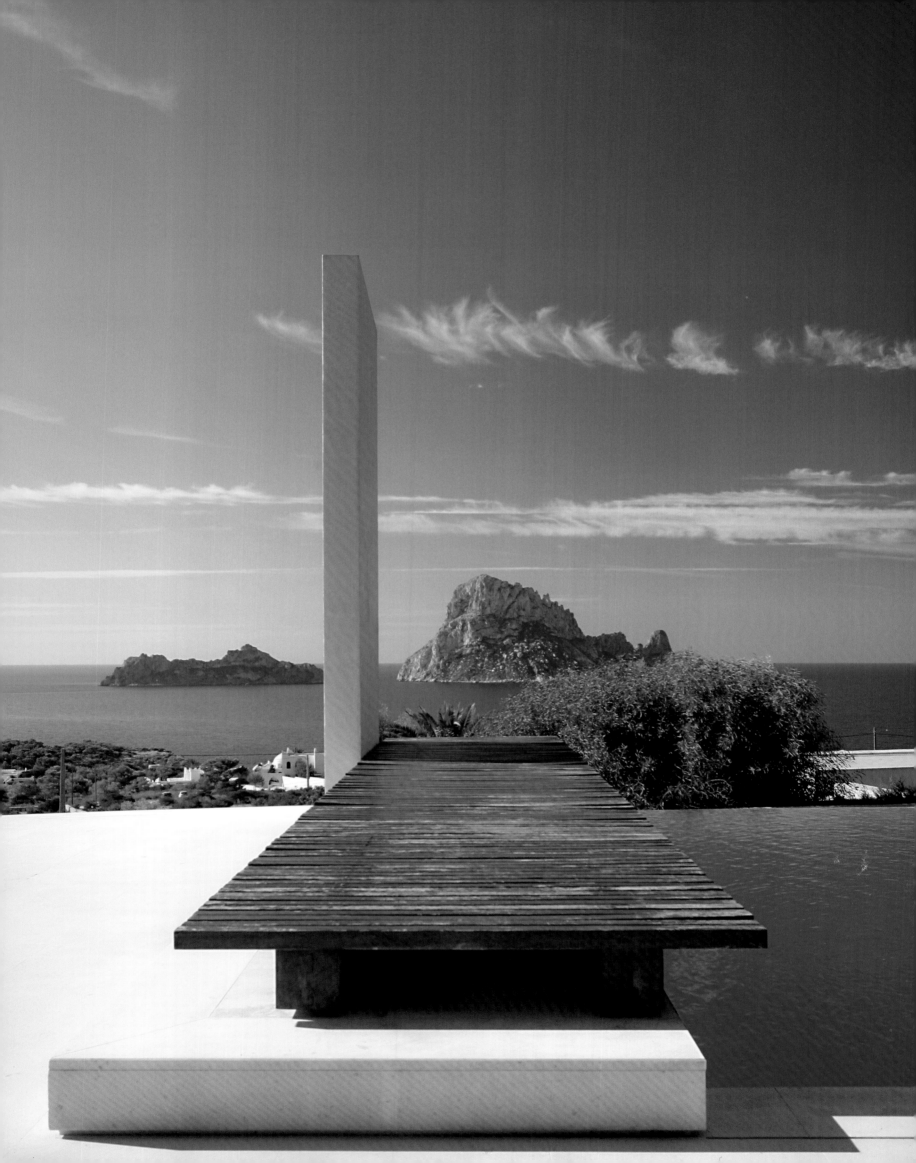

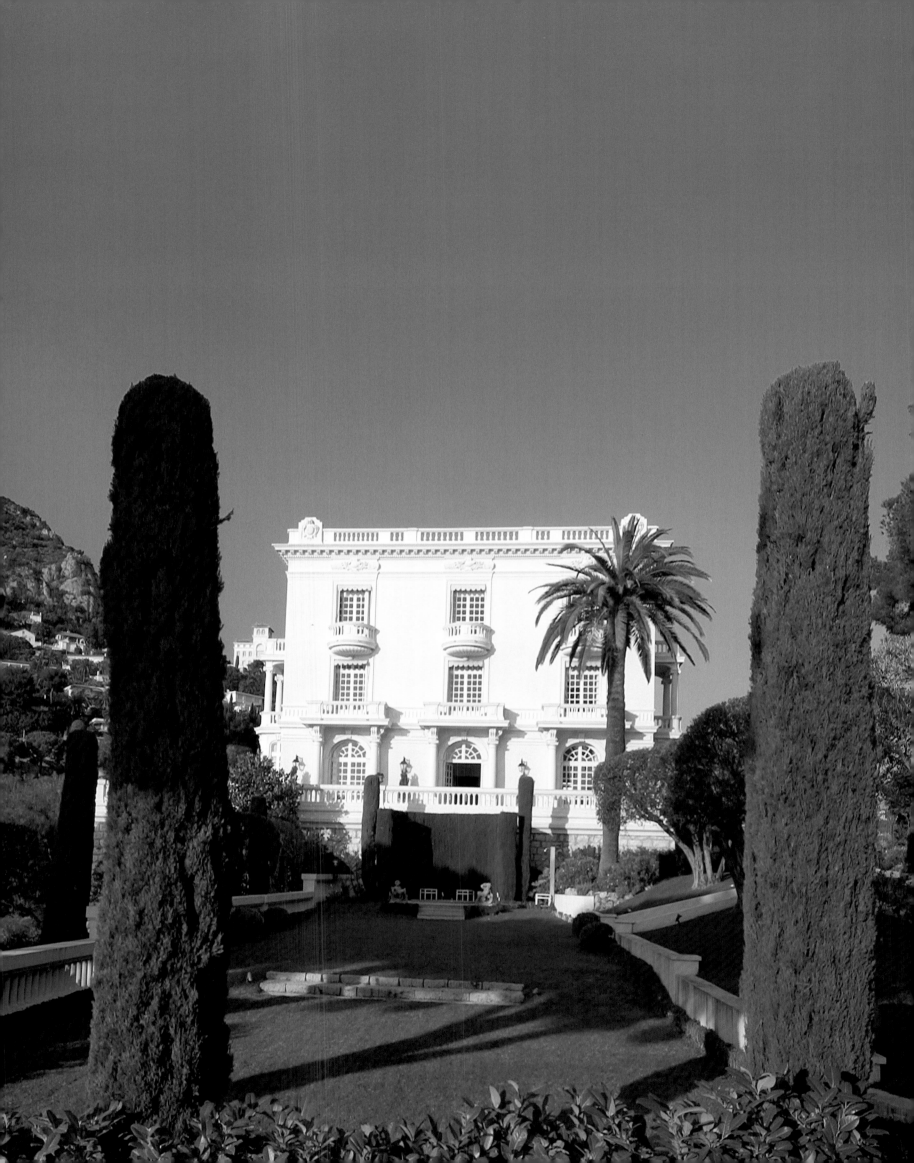

Una temporada en una casa de ensueño

"Dadme los lujos de la vida que de las necesidades puedo prescindir", proclamó en una ocasión Oscar Wilde. De acuerdo con esa visión seguro que el *dandy*, poeta y dramaturgo se hubiera sentido muy a gusto en cualquiera de las residencias que muestra la obra. Y no porque prescindan de necesidades, sino más bien por la perfección y creatividad de su lujosa arquitectura, interiorismo y decoración. Estas casas satisfacen ya todo deseo antes de que se manifieste. Y en definitiva, en eso consiste el verdadero confort.

La perfección estética de estas edificaciones implica además la capacidad de integrarse de forma armónica en el paisaje, de repercutir en los ecosistemas en la menor medida posible y de resaltar la belleza del entorno, o fundirse con él hasta llegar literalmente a formar parte de la espesura de su vegetación tropical, como es el caso de Villa Dewata en la isla de Bali. En la Isla de los Dioses el diseño arquitectónico exige un especial tacto para que su maravilloso paisaje, marcado por una forma de vida centenaria, no se vea afectado, si no al contrario, que sea la arquitectura la que destaque su belleza.

Esto se ha logrado con éxito en el caso de Villa Dewata, cuya estructura se fundamenta en las tradiciones balinesas. Sus pabellones, de cristal y materiales naturales, se funden con un paisaje de estanques de nenúfares y campos de arroz; apenas existen barreras entre los amplios espacios, a veces abiertos, y la naturaleza circundante, que parece sumergir al edificio de manera orgánica en el propio jardín.

Las casas Amanyara, en la costa occidental de la isla caribeña de Providenciales, son otro impresionante ejemplo de una arquitectura perfectamente integrada en el paisaje. Negras rocas volcánicas de Indonesia circundan las enormes piscinas, y se complementan a la perfección con los lagos de la zona. La arquitectura de los pabellones que conforman todas las viviendas, incorpora elementos del paisaje a través de colores y materiales naturales. La abundancia de cristal alimenta la sensación de transparencia y de fusión entre el interior y el exterior; a ello se une, por supuesto, un equipamiento interior de auténtica vanguardia.

El uso de técnicas tradicionales de construcción para una antigua casa de campo en los Alpes casi se da por hecho, teniendo en cuenta que, en este entorno, la naturaleza puede mostrar su cara más despiadada y la vivienda debe reflejar ante todo su originaria función de refugio frente a las inclemencias del tiempo. De ahí que parezca que el paisaje y las condiciones climáticas determinen un interior confortable pero rústico, con pesadas vigas de madera. En tiempos de suelos calefactados y burbujeantes jacuzzis, la sola presencia de la chimenea hace entrar en calor psicológicamente. El chalé Anna, en la francesa estación de invierno de Megève, cumple con todas esas exigencias, dando a la vez un toque de frescura a la cálida y hogareña atmósfera, a través de sus muebles de color rojo vivo y sorprendentes vistas.

Otras construcciones se conciben como refinadas obras de arte, y constituyen así claros ejemplos de que la arquitectura es uno de los mayores logros de la civilización. Entre ellas figura Villa Karl; la que en su día fue residencia del diseñador Karl Lagerfeld se levanta como una resplandeciente joya sobre una lengua de tierra de Mónaco. La fachada en tonos crema, la espaciosa terraza, el jardín de corte clásico y el exclusivo interior están tan alejados de la naturaleza como el propio Montecarlo, pero precisamente por esa grandeza se integran a la perfección en un entorno en el que desde siempre se ha sabido vivir a lo grande.

Villa Rahimoana, en el norte de Nueva Zelanda, muestra que tal concepto también funciona a la inversa en un entorno relativamente salvaje. Desde el exterior parece estar construida básicamente de cristal; el interior de este vanguardista edificio está marcado por líneas claras y modernas obras de arte. Sin embargo, se levanta sobre el risco que domina la Bay of Islands sin desentonar lo más mínimo. Menos aún, una vez en el interior; ante los frontales de cristal se tiene la sensación de elevarse en el aire y divisar desde allí las olas del Pacífico. Pero también su exterior de arquitectura, fría y plana, que no llega a sobrepasar las copas de las palmeras, se funde con el entorno subtropical de manera armónica.

Todas estas viviendas son tan diversas como los paisajes que las rodean. Y todas ellas tienen no obstante algo en común: las máximas exigencias en estética y confort. Cada una es por sí misma una obra de arte que interacciona con su entorno, se funde con él habilidosamente y toma prestados algunos de sus elementos. Al hojear este libro se sentirá un mundo de sueños, cuyos protagonistas son estos palacios del mundo moderno.

Stefanie Bisping

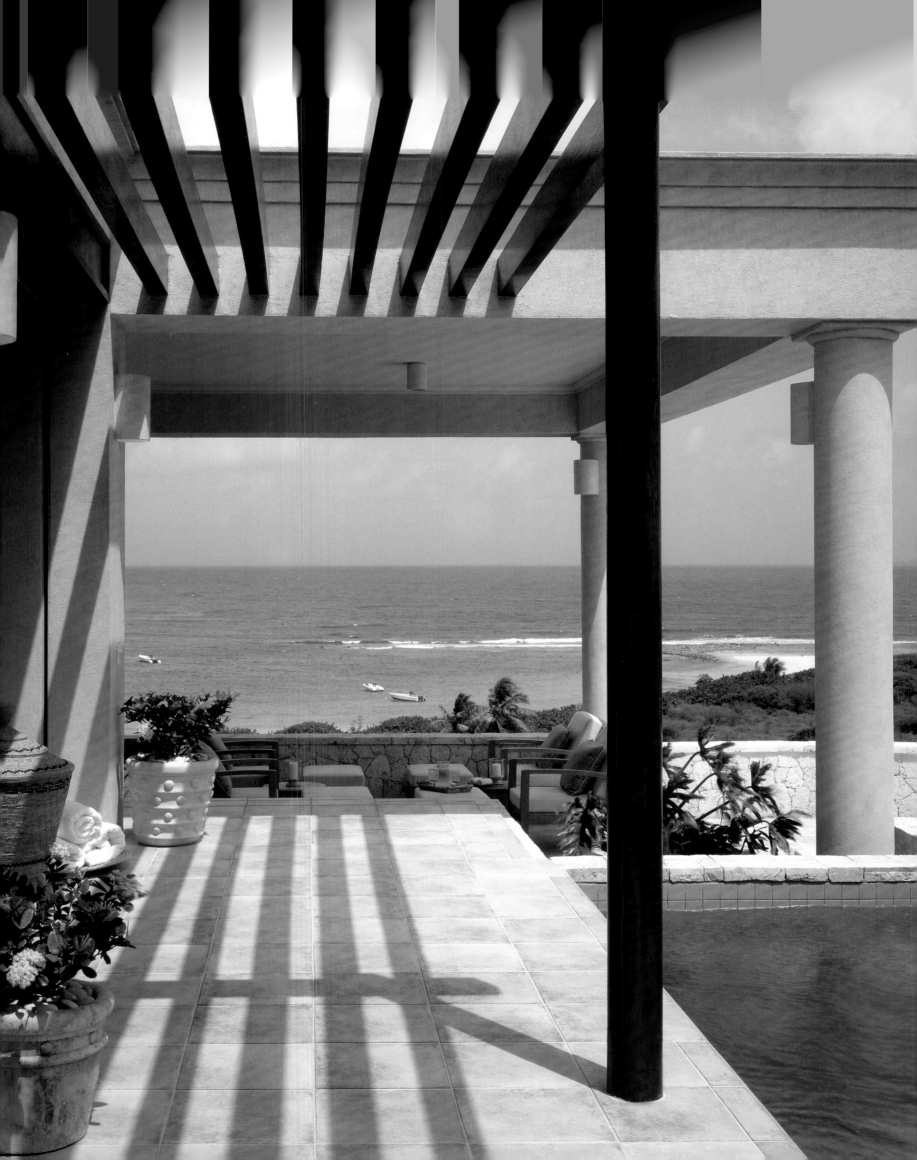

Un momento
in una casa da sogno

"Circondatemi di lusso. A tutto il necessario posso rinunciare", disse una volta Oscar Wilde. Se prendiamo come riferimento questo metro di misura, il celebre dandy, poeta e drammaturgo si sarebbe sentito a proprio agio nelle dimore qui presentate. Non che manchi loro il necessario. Anzi, offrono lusso perfetto dal punto di vista architettonico, degli interni e dell'arredamento, e soprattutto lusso creativo. Queste case esaudiscono i desideri prima che ci si renda conto di averli. Ed è questo, in fondo, che fa il vero comfort.

La perfezione estetica significa anche ville che si inseriscono armonicamente nel paesaggio, che gravano il meno possibile sull'ecosistema e che accentuano la bellezza dei dintorni, oppure si fondono talmente con essa che sembrano letteralmente spuntare dalla fitta vegetazione tropicale, come è il caso di Villa Dewata a Bali. L'isola degli dei richiede una particolare sensibilità architettonica per non disturbare il suo straordinario paesaggio, segnato da secoli di vita tradizionale, ma, al contrario, per esaltarne le caratteristiche.

L'intento è riuscito con la già citata Villa Dewata, che nella sua struttura e nella modalità di costruzione si poggia sulle tradizioni di Bali. I padiglioni costruiti in vetro e materiali naturali sono inseriti così abilmente nell'ambiente di laghetti di ninfee e campi di riso, il passaggio tra i grandi spazi, fittizi o realmente aperti, e la natura intorno è così impercettibile, che la tenuta sembra addirittura svilupparsi organicamente dal giardino.

Anche le ville Amanyara, sulla costa occidentale dell'isola caraibica Providenciales, sono uno straordinario esempio di architettura perfettamente fusa con il paesaggio circostante. Le grandi piscine sono fatte di pietra lavica nera proveniente dall'Indonesia, e creano un contrasto otticamente perfetto con i laghi sull'areale. L'architettura dei padiglioni che compongno ogni residenza imita, con colori e materiali naturali, le componenti del paesaggio. L'abbondanza di vetro crea anche qui l'impressione della trasparenza e di passaggi continui tra l'ambiente interno ed esterno, sebbene gli interni siano ovviamente arredati con la tecnica di ultima generazione.

Che un tipico chalet delle Alpi si orienti ad uno stile di costruzione tradizionale è quasi d'obbligo, perché la natura da queste parti si può mostrare dal suo lato più ostile e la casa deve rispecchiare chiaramente il suo scopo originario di protezione dalle intemperie. Per questo motivo, il paesaggio e il clima richiedono pesanti travi di legno ed interni avvolgenti ma rustici. Psicologicamente, inoltre, la vista di un camino dà una sensazione di calore anche in tempi in cui ci sono riscaldamenti a pannelli radianti nei pavimenti e Jacuzzi che ribollono nella neve. Lo chalet Anna, situato nella francese Megève, meta di sport invernali, soddisfa questa richiesta, ma al contempo dona all'ambiente caldo e familiare una nota nuova e fresca, grazie a mobili rosso fuoco e a prospettive sorprendenti.

Altre case sono state chiaramente concepite come opere d'arte raffinate e provano che l'architettura è una delle conquiste più alte della civilizzazione. Di queste fa parte Villa Karl, un tempo residenza del creatore di moda Karl Lagerfeld, che si appoggia come un gioiello scintillante su una lingua di terra del Principato di Monaco. La facciata color crema, l'enorme terrazzo, il giardino classico e gli interni raffinati sono lontani dalla natura come Monte Carlo stesso e, proprio per questo, si inseriscono perfettamente, con la loro sontuosità, in un ambiente nel quale da sempre viene coltivato un modus vivendi ricercato.

Che questo concetto possa funzionare anche in una regione relativamente selvaggia, è dimostrato da Villa Rahimoana nel nord della Nuova Zelanda. All'esterno essa sembra essere fatta principalmente di vetro, all'interno questa costruzione d'avanguardia è caratterizzata da linee chiare e opere d'arte moderne. Ciononostante, non appare come un corpo estraneo sulla scogliera sopra la Bay of Islands. Ancora meno, quando ci si trova all'interno dell'edificio, si ha l'impressione, data dalle enormi facciate di vetro, di stare all'aria aperta e di guardare da lì le onde del Pacifico meridionale. Ma anche dall'esterno l'architettura fredda e piatta, che non supera l'altezza di una palma, si lega in modo sorprendentemente armonico con l'ambiente subtropicale circostante.

Le ville sono così differenti l'una dall'altra come i paesaggi nei quali sono state costruite. Ma le case qui presentate hanno una cosa in comune: soddisfare le massime esigenze di estetica e di comfort. Ognuna per sé è un'opera d'arte che reagisce all'ambiente circostante inserendovisi armonicamente e riprendendone gli elementi. Sfogliando le pagine di questo libro si sogna ad occhi aperti e un pensiero si fa insistente: questi sono i palazzi dell'era moderna.

Stefanie Bisping

Villa Bear's Creek

Aspen, Colorado

Heavy wooden beams under a high ceiling, a crackling fire in the fireplace and deep armchairs: The Great Hall of Bear's Creek in Aspen hasn't just borrowed its name, but also its ambience from the world of English aristocratic estates. Large window fronts, an open dining room and the wide terrace combine the elegance of Old Europe with the spatial generosity of America. The open-air Jacuzzi offers a view of the starry skies and the snowfields. You might just have to force yourself to even go on a ski run.

Schwere Holzbalken unter einer hohen Decke, knisterndes Feuer im Kamin, tiefe Sessel: Die Große Halle von Bear's Creek in Aspen hat nicht nur den Namen, sondern auch das Ambiente aus der Welt englischer Adelssitze entliehen. Große Fensterfronten, ein offenes Esszimmer und die weite Terrasse verbinden die Eleganz des Alten Europa mit der räumlichen Großzügigkeit Amerikas. Aus dem im Freien gelgenen Jacuzzi bietet sich der Blick auf den Sternenhimmel und die Schneefelder. Da muss man sich geradezu aufraffen, überhaupt noch auf die Piste zu gehen.

De lourdes poutres de bois sous un haut plafond, un feu crépitant dans la cheminée et de profonds fauteuils : le grand hall du Bear's Creek à Aspen a emprunté non seulement son nom, mais aussi son ambiance au monde des propriétés anglaises aristocratiques. De grandes façades de verre, une salle à manger ouverte et une vaste terrasse marient l'élégance de la Vieille Europe aux grands espaces de l'Amérique. Le jacuzzi en plein air offre une vue sur les cieux étoilés et les champs enneigés. Il faudra sans doute faire un effort pour quitter ce lieu et rejoindre les pistes de ski.

Pesadas vigas de madera soportando techos altos, fuego crepitando en la chimenea y mullidos sillones: el gran salón de Bear's Creek en Aspen no sólo comparte el nombre, sino también la atmósfera de las residencias de la nobleza inglesa. Grandes ventanales frontales, un comedor abierto y una amplia terraza fusionan la elegancia de la vieja Europa con la generosidad de espacio de América. Desde el jacuzzi al aire libre se disfruta del firmamento y las lomas de nieve. En tal ambiente de relax cuesta ponerse en pie e ir a la pista.

Pesanti travi di legno sotto un soffitto alto, un fuoco scoppiettante nel camino e soffici poltrone: la grande sala di Bear's Creek, ad Aspen, non ha preso in prestito solo il nome dalle residenze nobili inglesi, ma anche l'ambiente. Grandi vetrate, una sala da pranzo aperta e l'ampio terrazzo uniscono l'eleganza della vecchia Europa ai vasti spazi americani. Dalla Jacuzzi situata all'aria aperta si vede il panorama del cielo stellato e dei campi innevati. Bisogna proprio farsi forza per riuscire ad andare sulle piste.

Bear's Creek combines country-house charm with contemporary comfort on 4,000 sq. ft. of living space. Each of the four bedrooms includes a marble bath.

Auf 370 m² Wohnfläche vereint Bear's Creek Landhauscharme mit zeitgemäßem Komfort. Jedes der vier Schlafzimmer besitzt ein Marmorbad.

Bear's Creek mêle charme campagnard et confort contemporain sur 370 m² de surface habitable. Chacune des quatre chambres dispose d'une salle de bains en marbre.

Los 370 m² de Bear's Creek aúnan el encanto de las casas de campo y las comodidades modernas. Cada uno de los cuatro dormitorios cuenta con un baño de mármol.

Su una superficie abitativa di 370 m², Bear's Creek unisce il fascino di una casa di campagna e il comfort conforme ai tempi. Ognuna delle quattro camere da letto ha un bagno di marmo.

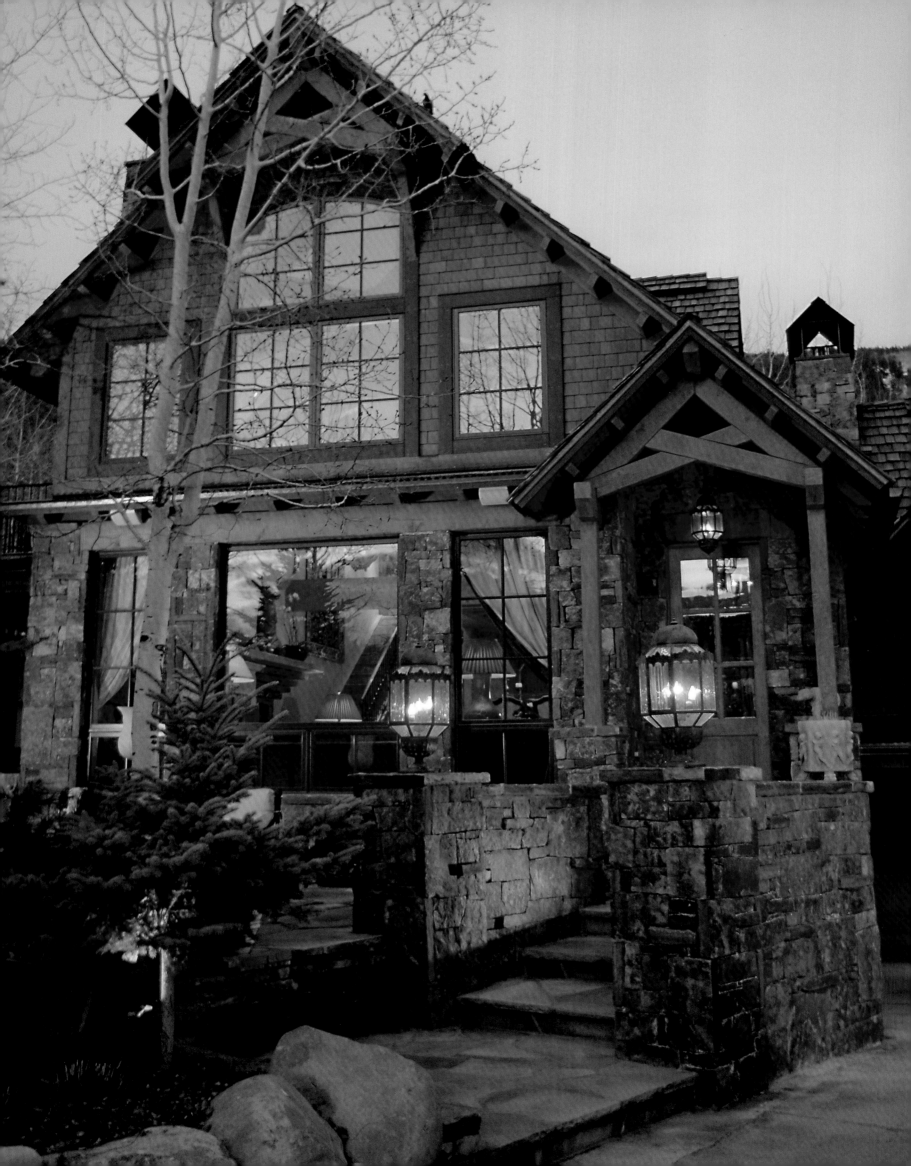

Meeting place for well-being: Windows with glazing bars, stone walls and a large fireplace give the Great Hall its bucolic ambience.

Treffpunkt zum Wohlfühlen: *Sprossenfenster, steinerne Mauern und ein großer Kamin verleihen der Großen Halle rustikales Ambiente.*

Un lieu de rencontre et de bien-être : *les fenêtres à carreaux, les murs de pierre et la large cheminée confèrent une atmosphère rustique au grand hall.*

Un lugar de reunión para sentirse bien: *las ventanas con barrotillos, muros de piedra y una gran chimenea visten el gran salón de un ambiente rústico.*

Appuntamento con il benessere: *finestre a riquadri, muri di pietra e un grande camino rendono rustica la grande sala.*

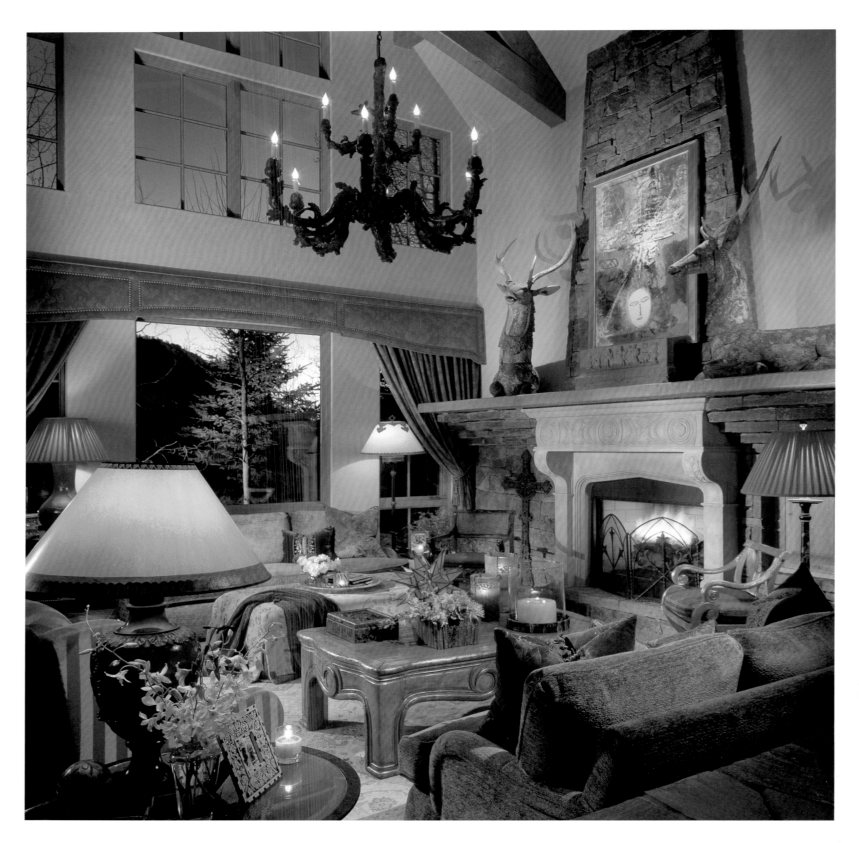

Fine curtains keep out bad dreams in the master bedroom.

Im Master Bedroom sperren feine Vorhänge schlechte Träume aus.

De fins rideaux éloignent les mauvais rêves de la chambre.

En el dormitorio principal, los finos cortinajes no dejan pasar malos sueños.

Nella camera da letto le raffinate tende tengono lontani i brutti sogni.

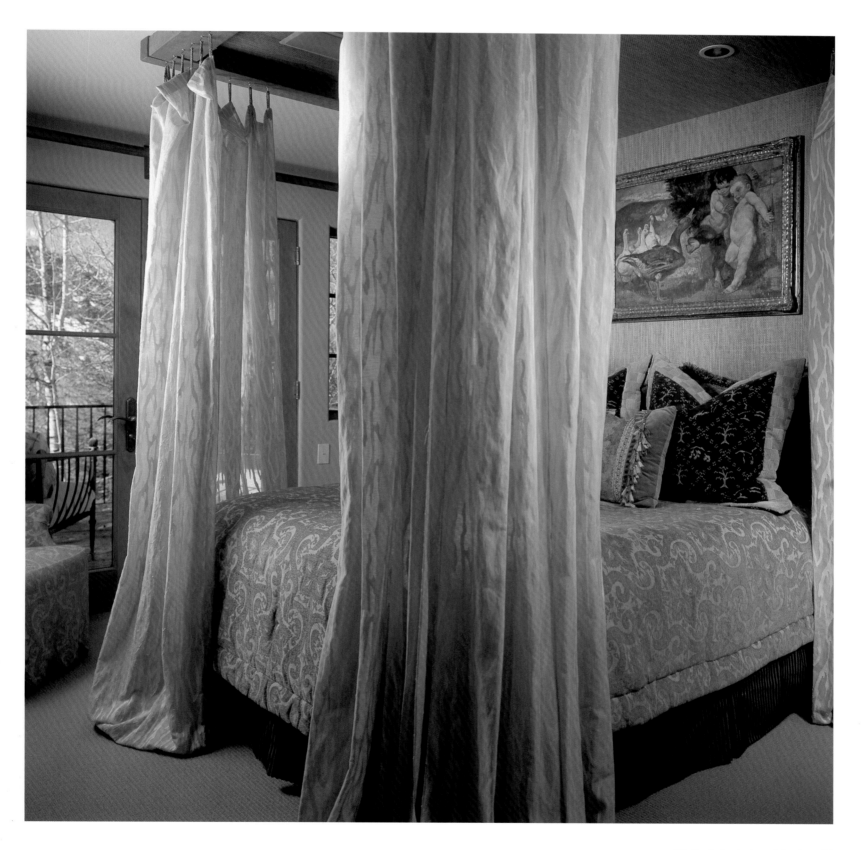

Villa Athena

Hibiscus Island, South Miami Beach, Florida

A touch of the Mediterranean right outside Miami Beach: The main house, guesthouse and boathouse of Villa Athena radiate in white under the deep-blue sky with a pool kept cool by Greek-style windmill sails. Round stone arches and open patios make the estate into a miniature Aegean village. The inside is dominated by white leather and dark wood while the outside displays the colors of Hibiscus Island: palm-tree green and ocean turquoise. This is a universe that can do without the rest of the world. A gym and a home theater make this dream complete.

Ein Hauch von Mittelmeer vor Miami Beach: Weiß leuchten Haupt-, Gäste und Bootshaus der Villa Athena unter tiefblauem Himmel, den Pool beschirmen die Segel einer Windmühle in griechischem Stil. Steinerne Rundbögen und offene Patios machen das Anwesen zur Miniatur eines ägäischen Dorfs. Innen dominieren weißes Leder und dunkles Holz, außen die Farben von Hibiscus Island: das Grün der Palmen und das Türkis des Meeres. Es ist ein Universum, das den Rest der Welt nicht braucht. Ein Fitness-Saal und ein Kino ergänzen diesen Traum.

Une touche méditerranéenne à l'extérieur de Miami Beach : la maison principale, la maison d'hôtes et le hangar à bateaux de la Villa Athena sont d'un blanc éclatant sous le ciel d'un bleu profond, et la piscine est protégée par des voiles de moulin à vent dans le style grec. Des arches rondes de pierre et des patios ouverts font de la propriété un véritable village égéen miniature. L'intérieur est dominé par le cuir blanc et le bois foncé. L'extérieur affiche les couleurs de l'île Hibiscus : vert palmier et bleu turquoise. C'est un univers qui n'a pas besoin du reste du monde. Une salle de fitness et un cinéma viennent compléter ce rêve.

Un toque mediterráneo en Miami Beach: el blanco de la vivienda principal, la de huéspedes y del garaje para barcos reluce bajo el cielo de azul intenso. Las aspas de un molino de viento al gusto griego protegen la piscina. Arcos de piedra y patios convierten este lugar en una aldea egea en miniatura. El interior está dominado por el cuero blanco y la madera oscura; en el exterior rigen los colores de la Hibiscus Island: el verde de las palmeras y el turquesa del mar. Un universo que puede prescindir del resto del mundo. El gimnasio y el cine completan este lugar de ensueño.

Aria di Mediterraneo davanti a Miami Beach: la casa principale, quella degli ospiti e la rimessa delle barche di Villa Athena si illuminano di bianco sotto un cielo di un blu profondo, mentre la piscina è protetta dalle vele di un mulino a vento in stile greco. Archi in pietra e patii aperti trasformano la tenuta nella miniatura di un villaggio egeo. All'interno dominano pelle bianca e legno scuro, all'esterno i colori di Hibiscus Island: il verde delle palme e il turchese del mare. È un universo che non ha bisogno del resto del mondo. Una palestra e un cinema completano questo sogno.

 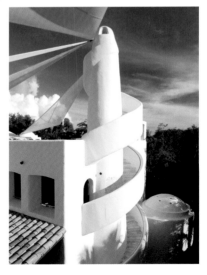

Ceiling fans keep the bedroom cool while windmill sails do the same outside. The inviting pool offers a pleasant way to refresh.

Im Schlafzimmer spenden Ventilatoren Kühlung, im Freien die Segel der Windmühle. Angenehme Erfrischung bietet der einladende Pool.

Les ventilateurs au plafond tempèrent la chambre, tout comme les voiles de moulin à vent à l'extérieur. La piscine très tentante permet de se rafraîchir agréablement.

En los dormitorios refrescan el ambiente los ventiladores, mientras, fuera se encarga el velamen del molino. La piscina invita a refrescarse.

Nella camera da letto i ventilatori diffondono il fresco, all'aperto le vele del mulino a vento. L'invitante piscina offre un piacevole refrigerio.

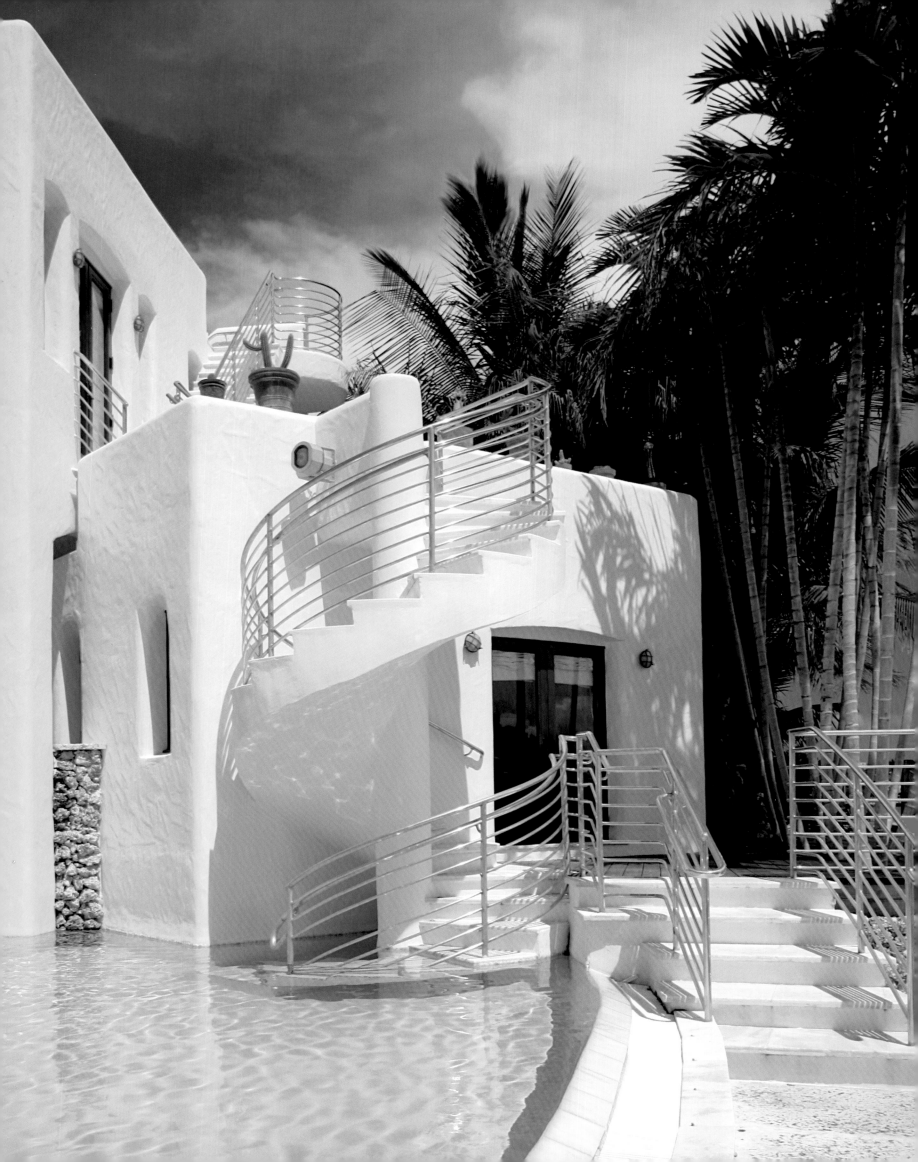

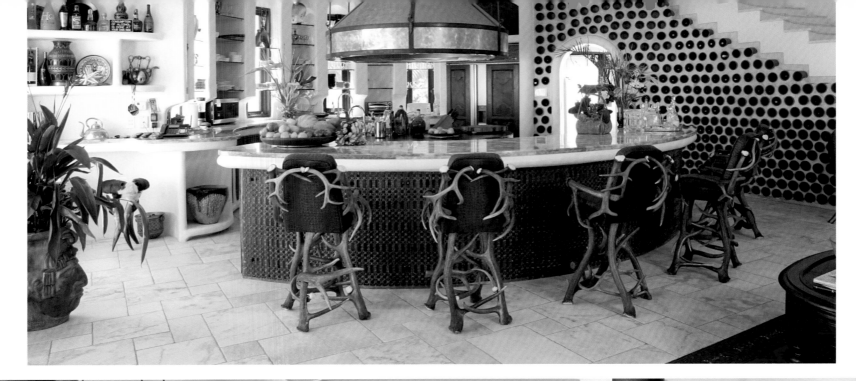

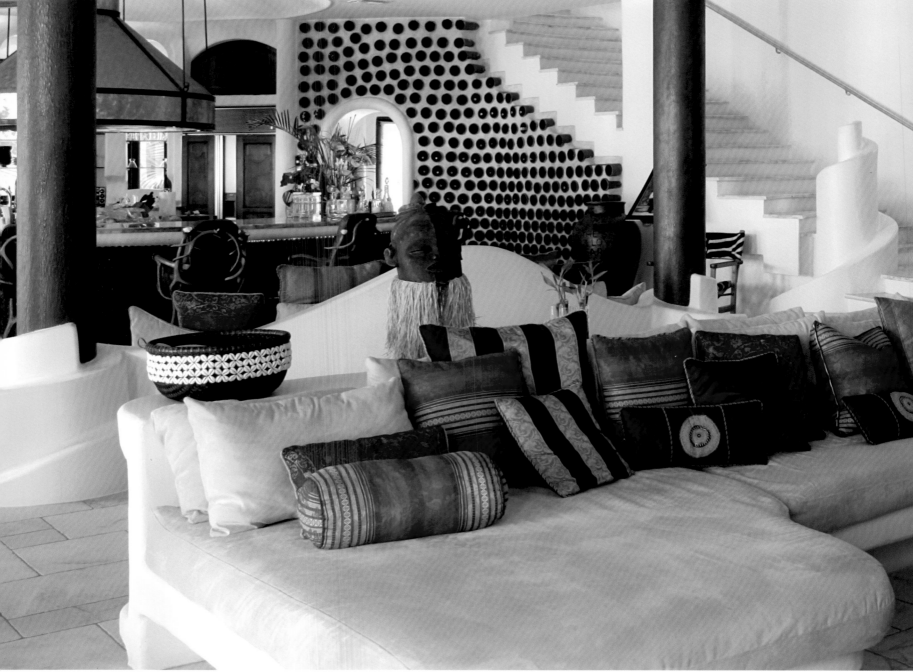

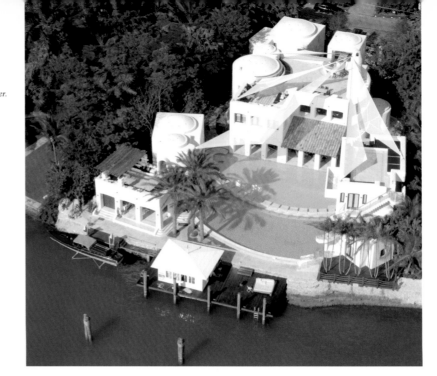

Several lounge areas and seven bedrooms are loosely grouped around the central pool of the villa.

Um den zentralen Pool der Villa gruppieren sich locker mehrere Lounge-Bereiche und sieben Schlafzimmer.

Plusieurs salons et sept chambres sont regroupés autour de la piscine centrale de la villa.

En torno a la piscina central se agrupan con amplitud varias áreas lounge y siete dormitorios.

Intorno alla piscina centrale della villa sono sparse numerose aree lounge e sette camere da letto.

Villa Grandioso

South Miami Beach, Florida

The name says it all. 16,146 sq. ft. of living space, a lounge with a 33 ft. ceiling, room for 50 guests and the gigantic terrace surrounded by palms prove that modesty is not necessarily a virtue. The largest estate in South Beach is also one of the most spectacular. Lots of light, lots of white, minimalist but effectively arranged furniture—this art-deco building from the 1930s was renovated in 2005 and presents a vision of ultra-cool living in the third millennium. Amenities such as a poolroom and a home cinema are a given.

Der Name ist Programm. 1.500 m² Wohnfläche, eine 10 m hohe Lounge mit Raum für 50 Gäste und die gigantische mit Palmen bestandene Terrasse beweisen, dass Bescheidenheit nicht unbedingt eine Zier ist. Das größte Anwesen in South Beach ist auch eines der spektakulärsten. Viel Licht, viel Weiß, minimalistische, aber effektvoll platzierte Möbel – das in den 30er-Jahren des vorigen Jahrhunderts erbaute und 2005 neu gestaltete Art déco-Gebäude ist eine Vision ultracoolen Wohnens im dritten Jahrtausend. Annehmlichkeiten wie ein Billardzimmer und ein eigenes Heimkino besitzt es natürlich auch.

Tout est dans le nom : les 1.500 m² d'espace habitable, le salon avec une hauteur de 10 m sous plafond et de l'espace pour 50 invités, et l'immense terrasse entourée de palmiers prouvent que la modestie n'est pas forcément une vertu. La plus grande propriété de South Beach est aussi l'une des plus spectaculaires. Beaucoup de lumière, beaucoup de blanc, un mobilier minimaliste mais bien agencé – le bâtiment Art-Déco construit dans les années 30 a été rénové en 2005 et offre un aperçu de la vie ultra-cool du troisième millénaire. Il comporte bien évidemment des installations telles qu'une salle de billard et un cinéma privé.

Su nombre lo dice todo: una superficie de 1.500 m², un lounge con techos a 10 m de altura y capacidad para 50 invitados y la gigantesca terraza con palmeras constatan que la modestia no es siempre la mejor forma de ornamento. Esta gran propiedad en South Beach es también una de las más espectaculares. Todo un derroche de luz y blancura, y un mobiliario, aunque minimalista, perfectamente dispuesto para crear efecto. El edificio Art-Decó erigido en los años 30 del pasado siglo, ha sido rediseñado en 2005, convirtiéndose en una imagen del estilo de vivir ultra moderno del tercer milenio. Dispone, claro está, de comodidades tales como sala de billar y su cine casero.

Il nome è tutto un programma. I 1.500 m² di superficie abitabile, la lounge alta 10 m con posto per 50 ospiti e il magnifico terrazzo ornato di palme dimostrano che la modestia non è un vanto ad ogni costo. La più grande tenuta di South Beach è anche una delle più spettacolari. Tanta luce, tanto bianco, mobili minimalistici ma collocati ad effetto – l'edificio Art déco costruito negli anni '30 del secolo scorso e rinnovato nel 2005 è una visione eccezionale del modo di abitare nel terzo millennio. Naturalmente, esistono anche comodità come una sala di biliardo e un home cinema.

 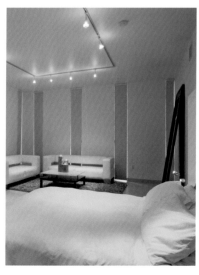

A Buddha statue at the center of the huge lounge exudes a peaceful atmosphere. You can spend the night in one of the five bedrooms and the day on the sundeck.

Ein Buddha in der Mitte der riesigen Lounge verströmt eine friedliche Atmosphäre. Nachts ruht man in einem der fünf Schlafzimmer, tags auf dem Sonnendeck.

Un bouddha au centre de l'immense salon dégage une atmosphère sereine. Vous pouvez vous reposer dans l'une des cinq chambres pendant la nuit et sur la terrasse pendant la journée.

La imagen de un Buda en el centro del enorme lounge irradia una atmósfera de paz. De noche se descansa en uno de los cinco dormitorios, y de día tomando el sol en la terraza.

Un Buddha nel mezzo dell'enorme lounge emana un'atmosfera di pace. Di notte ci si riposa in una delle cinque camere da letto, di giorno sul ponte passeggiata.

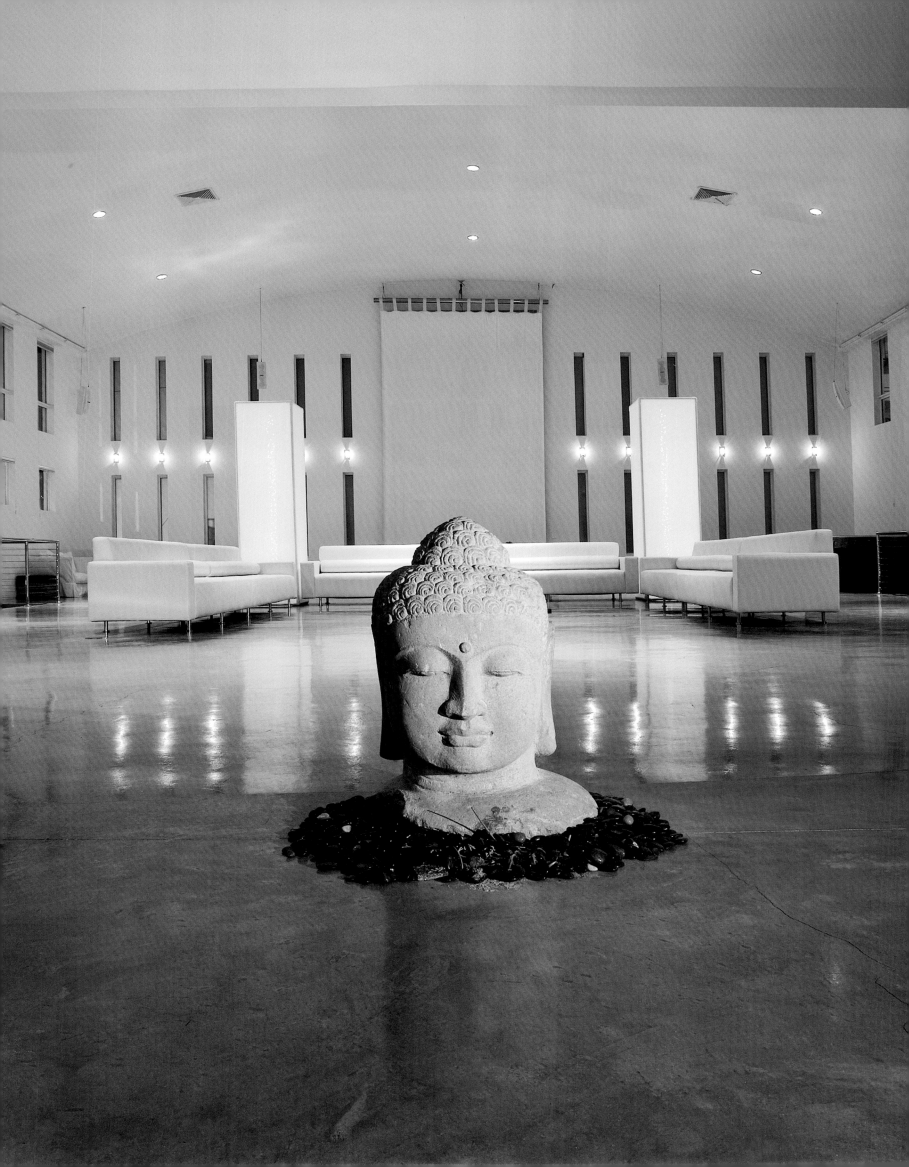

The gallery of the lounge is gigantic too. The dark wooden floor adds warmth.

Gigantisch ist auch die Galerie der Lounge. Der dunkle Holzboden verleiht ihr Wärme.

La galerie du salon aussi est immense. Le parquet de bois sombre la rend plus chaleureuse.

La galería del área lounge es gigantesca. El parqué en tonos oscuros le surte de calor.

Magnifica è anche la galleria della lounge. Il pavimento di legno scuro le dona calore.

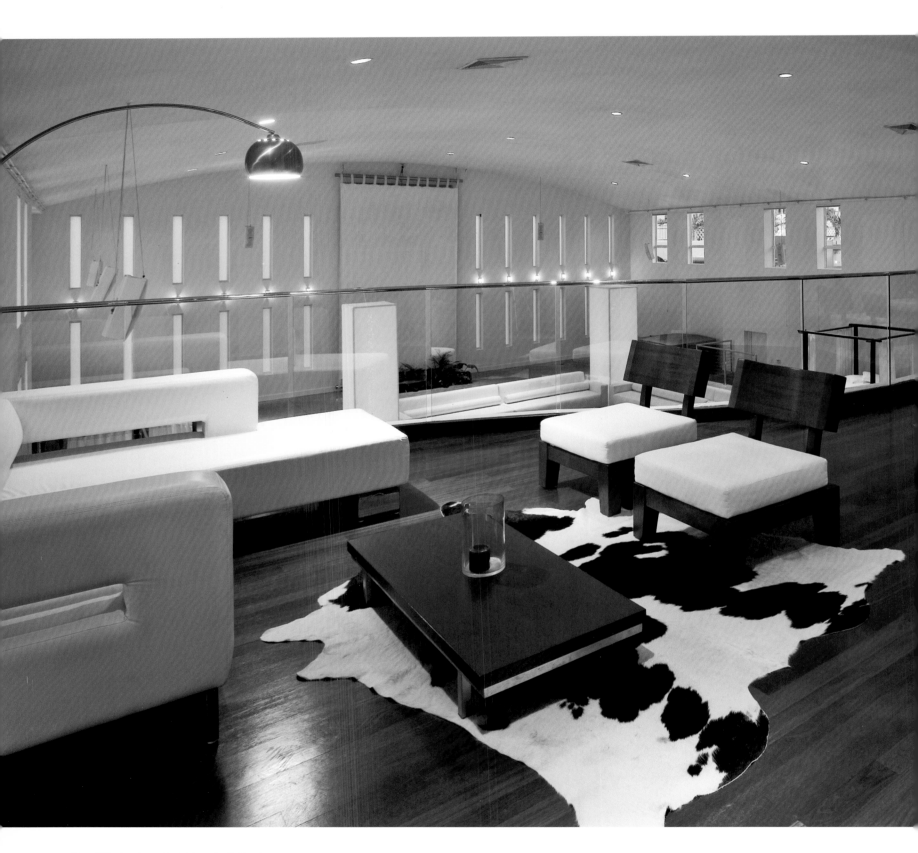

The 1200 sq. ft. kitchen-living room of the grand villa is perfectly suited for dining in a group.

In der 110 m² großenWohnküche der grandiosenVilla lässt es sich hervorragend mit mehreren Leuten tafeln.

La cuisine salle-à-manger de 110 m² de cette grande villa convient merveilleusement aux dîners de groupe.

La espaciosa cocina comedor de 110 m² de esta enorme mansión es ideal para compartir mesa con cantidad de invitados.

Nella cucina abitabile di 110 m² della grandiosa villa ci si può sedere comodamente a tavola con molte persone.

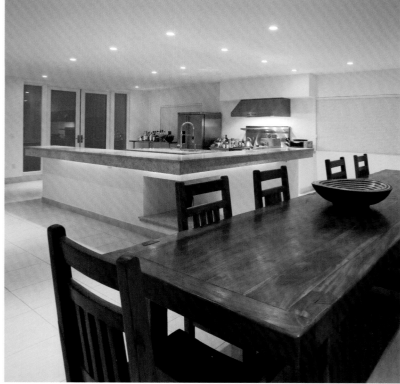

Villa Grandioso *South Miami Beach, Florida* 25

Bajacu

Providenciales, Turks and Caicos Islands, Caribbean

This dream home is embedded in a tropical forest with a wonderful ocean view on three sides from its hillside location on the southern coast of Providenciales, which is part of the Turks and Caicos Islands in the Caribbean. Its garden is a kaleidoscope of bougainvillea. Terraces and shady seats competing for the loveliest view. The heart of this dream home is its "palapa," an open lounge decorated with African and Asian furniture. At the foot of the estate lies one of the fabulous beaches for which these Caribbean islands are famous.

Von einem Hügel an der Südküste der zu den Turks und Caicos gehörenden Insel Providenciales aus bietet dieses in den tropischen Wald gebettete Traumhaus auf drei Seiten einen herrlichen Blick auf das Meer. Der Garten ist ein Farbenrausch aus Bougainvillea. Terrassen und schattige Sitzplätze konkurrieren um die schönste Aussicht. Herzstück des Hauses ist die „Palapa", eine mit Möbeln aus Afrika und Asien dekorierte offene Lounge. Am Fuß des Anwesens liegt einer der Traumstrände, für die diese Karibikinsel berühmt ist.

Cette maison de rêve nichée dans une forêt tropicale offre une magnifique vue sur l'océan sur trois côtés depuis les collines de la côte sud de Providenciales, une île appartenant aux Turks-et-Caïcos. Le jardin est un kaléidoscope de bougainvillées ; les terrasses et les chaises longues rivalisent pour la plus belle vue. Le cœur de la maison est le « Palapa », un salon ouvert décoré de meubles asiatiques et africains. Une des fabuleuses plages qui font la réputation de ces îles caribéennes est juste au pied du domaine.

Sobre una colina en la costa meridional de Providenciales, perteneciente a las Turcas y Caicos, esta casa de ensueño insertada en la selva tropical goza de magníficas vistas al mar desde tres de sus costados. El jardín es una explosión de color de buganvillas. Las terrazas y los asientos a la sombra se disputan las mejores vistas. El centro está constituido por la "Palapa", un área lounge abierta decorada con mobiliario africano y asiático. A los pies de la casa se encuentra una de las playas paradisíacas que han dado la fama a esta isla caribeña.

Da una collina sulla costa meridionale dell'isola di Providenciales, che fa parte delle Turks e Caicos, questa casa da sogno situata nella foresta tropicale offre su tre lati una vista magnifica sul mare. Il giardino è un'esaltazione di colori fatto di bougainville, le terrazze e i posti per sedere all'ombra fanno concorrenza tra loro per la vista più bella. Il cuore della casa è la "Palapa", una lounge all'aperto decorata con mobili provenienti dall'Africa e dall'Asia. Ai piedi della tenuta si trova una delle spiagge da sogno per le quali è famosa quest'isola caraibica.

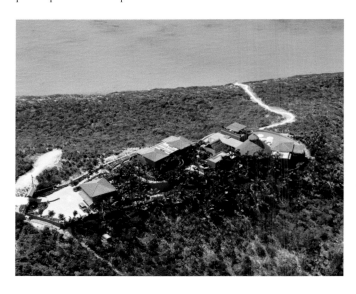

Bajacu means "rising sun" in the language of the Caribbean. Mexican architect Marco Aldaco has made sure that the villa also unfolds its magic after dawn.

Bajacu bedeutet in der Sprache der Kariben „aufgehende Sonne". Der mexikanische Architekt Marco Aldaco hat dafür gesorgt, dass die Villa ihre Magie auch nach der Morgenröte entfaltet.

Bajacu signifie « lever de soleil » en langue caribéenne. L'architecte mexicain Marco Aldaco s'est assuré que la villa déploie toute sa magie après l'aube.

En lengua caribeña, Bajacu significa "sol naciente". El arquitecto mexicano Marco Aldaco se ha encargado de que la mansión despliegue toda su magia también tras la aurora.

Bajacu nella lingua dei caribi significa "il sole che sorge". L'architetto messicano Marco Aldaco ha fatto sì che la villa risplenda nella sua magia anche dopo l'alba.

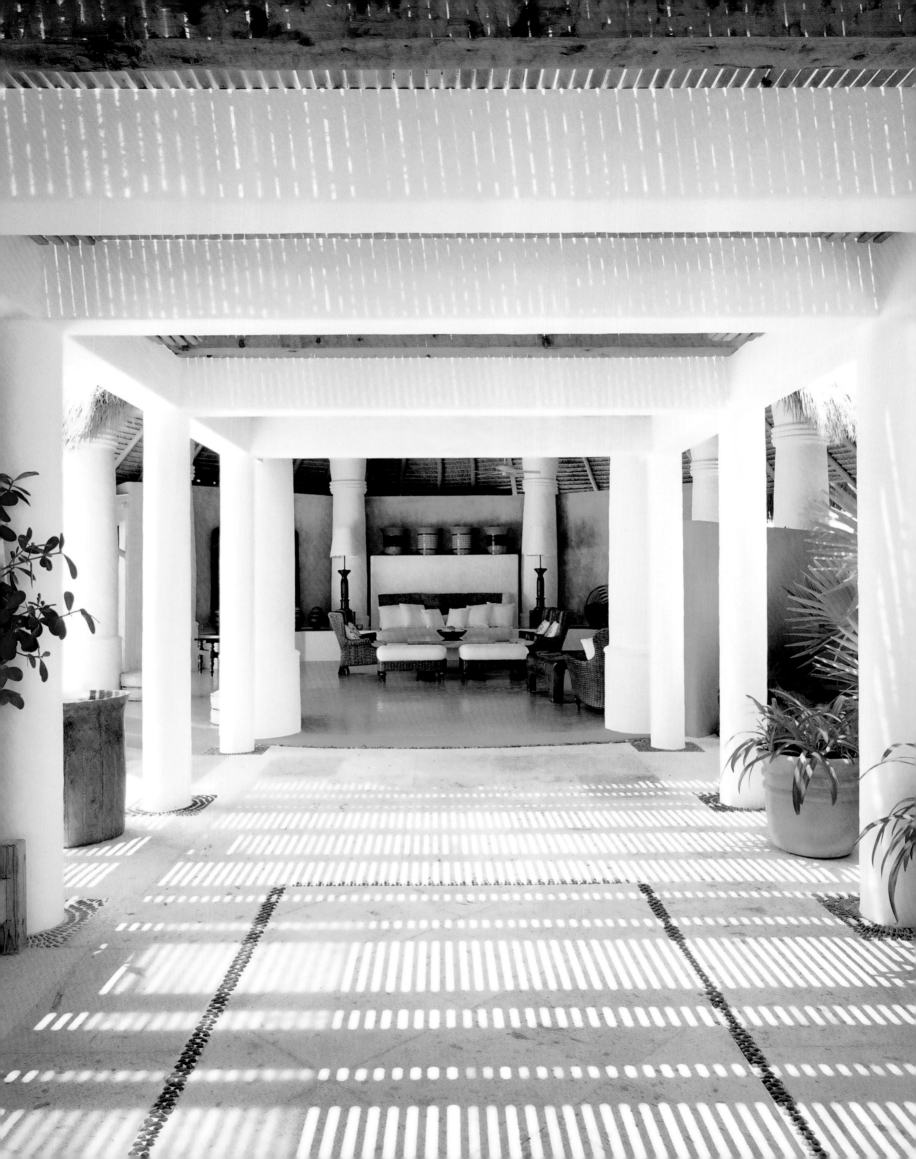

Each of the villa's rooms offers a view of the ocean and its luxuriantly blooming gardens.

Die Villa bietet von allen Räumen einen Blick auf das Meer und die üppig blühenden Gärten.

Chacune des pièces de la villa offre une vue sur l'océan et le jardin luxuriant.

Todas las estancias gozan de vistas al mar y al exuberante jardín.

La villa offre da tutte le stanze la vista sul mare e sui giardini fioriti.

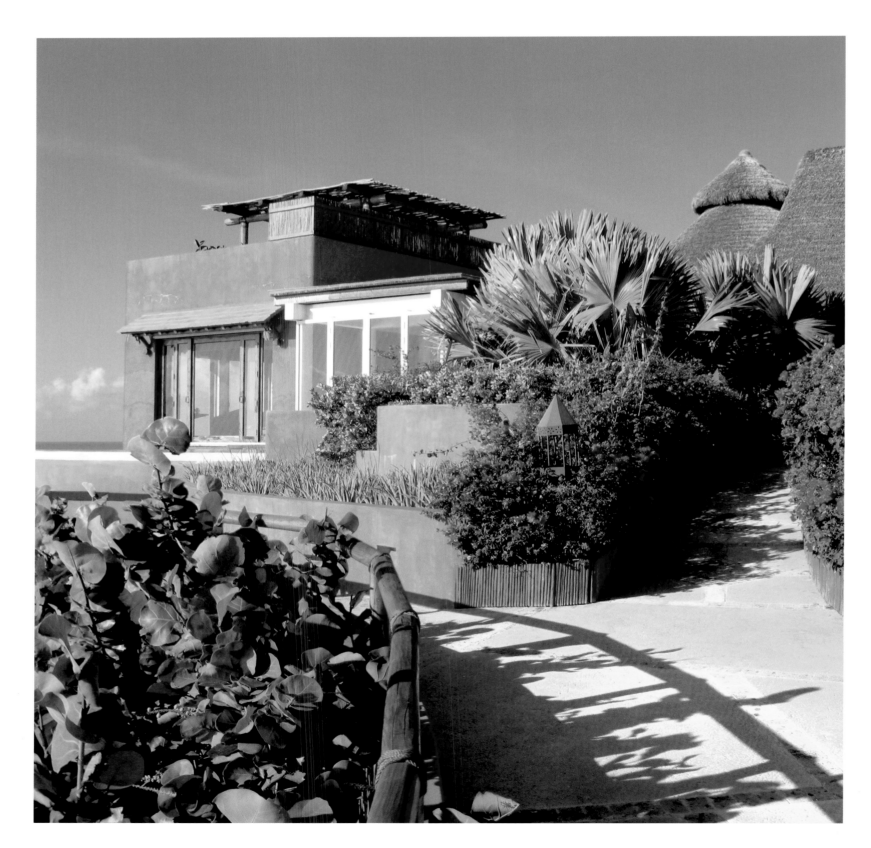

The pool curves around the sun terrace and the estate. Warm hues, lots of fresh air and exquisite furniture distinguish the "palapa," the center of the villa.

Der Pool beschreibt einen Bogen um die Sonnenterrasse und das Haus. Warme Farben, viel Luft und erlesene Möbel prägen die „Palapa", das Zentrum der Villa.

La piscine courbe entoure la terrasse et la maison. Des couleurs chaudes, beaucoup d'air frais et un mobilier raffiné caractérisent le « Palapa », le centre de la villa.

La piscina describe un arco alrededor de la terraza y la casa. Los colores cálidos, la abundancia de corrientes de aire y un mobiliario selecto caracterizan la "Palapa", el centro de la mansión.

La piscina descrive una curva intorno alla terrazza e alla casa. I colori caldi, gli spazi ariosi e i mobili pregiati caratterizzano la "Palapa", il centro della villa.

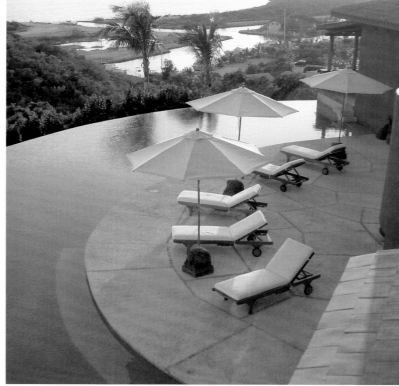

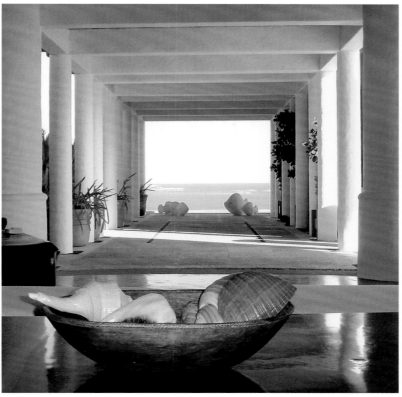

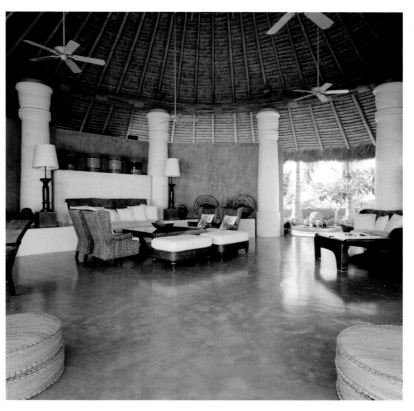

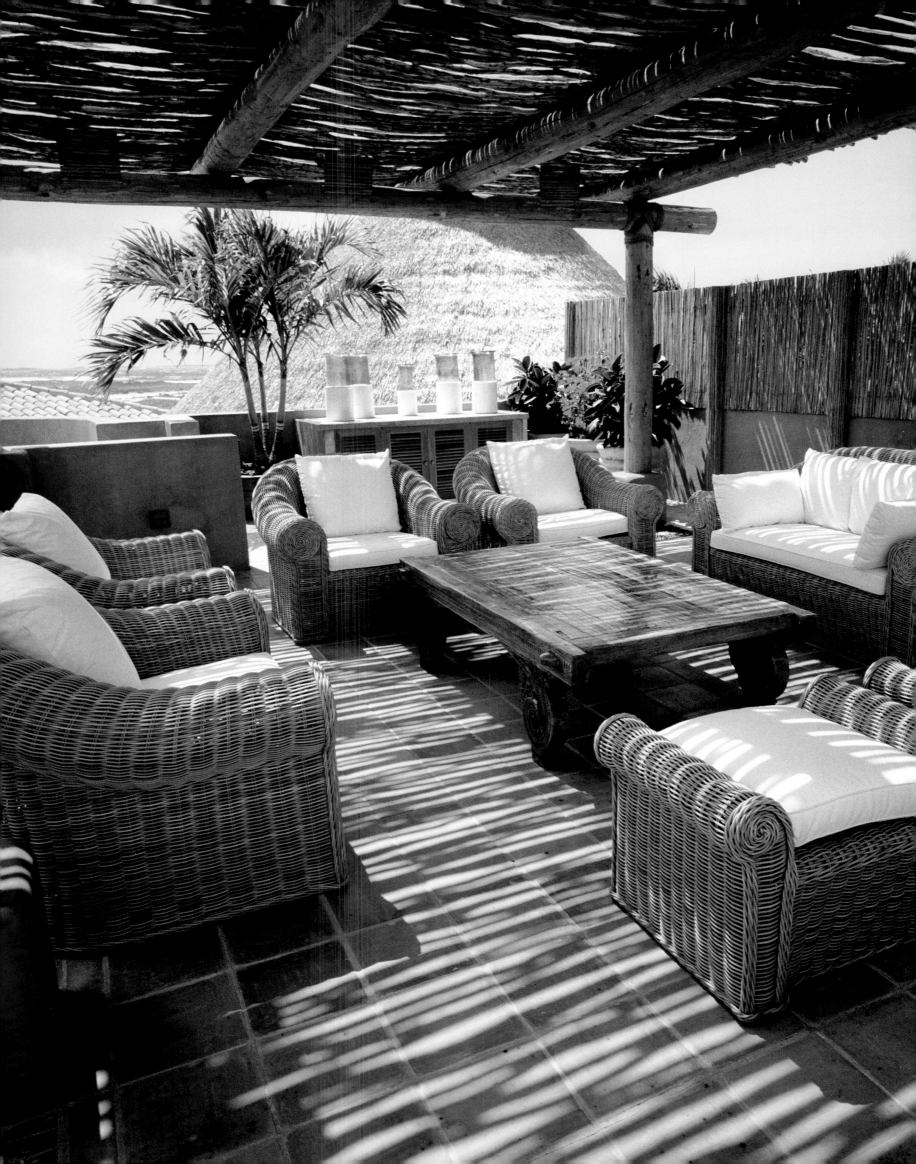

Go ahead and sink into a deep armchair in the afternoon and look forward to the sundowner. The design of the five bedrooms and seven bathrooms is deliberately simple with intriguing details.

Am Nachmittag sinkt man in einen tiefen Sessel. Vorfreude auf den Sundowner ist erlaubt. Das Design der fünf Schlafzimmer und sieben Bäder ist bewusst schlicht, aber mit interessanten Details gestaltet.

L'après-midi, vous pouvez vous enfoncer dans un fauteuil profond, pour attendre le coucher du soleil. Le design des cinq chambres et des sept salles de bains est délibérément simple mais comprend des détails intéressants.

Al atardecer, postrado en un mullido sillón, apetece disfrutar del relax. El diseño de los cinco dormitorios y los siete baños se ha mantenido sobrio, pero dotado de interesantes detalles.

Nel pomeriggio ci si lascia cadere in una comoda poltrona e ci si concede l'attesa di una passeggiata al tramonto. Il design delle cinque camere da letto e dei sette bagni è strutturato in modo volutamente semplice, ma con dettagli interessanti.

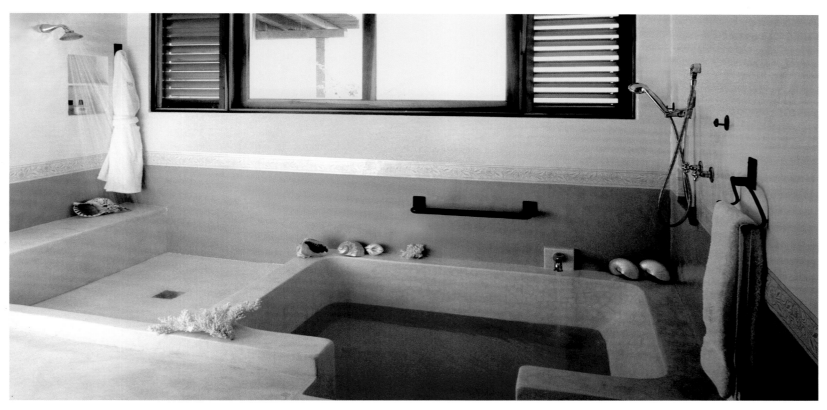

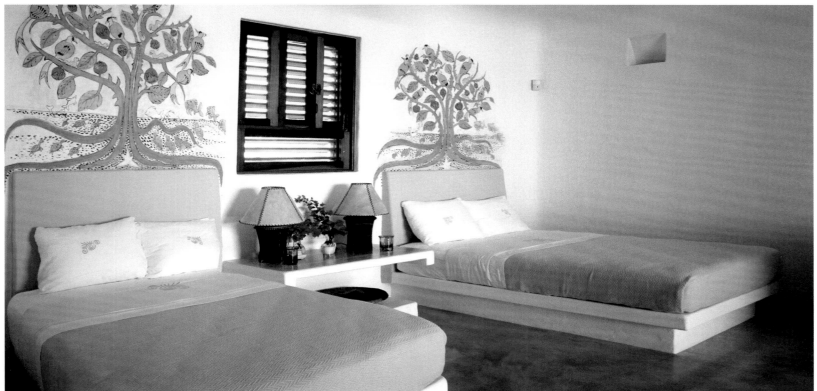

Amanyara
Providenciales, Turks and Caicos Islands, Caribbean

Admist secluded beaches and rocky sea inlets, the Amanyara villas are situated on Providenciales, a Caribbean island whose northwestern coast is less exposed to tourism. Northwest Point Marine National Park, a world-famous hotspot for divers, begins almost right at the doorsteps of the 33 villas. Each of the residences has its own pool and consists of five pavilions covering 8,610 sq. ft. to create a living area of about 8,070 sq. ft., so there is space aplenty for privacy and complete relaxation. Simple elegance and ceiling-high window fronts distinguish the architecture and interior.

Gesäumt von einsamen Stränden und Felsbuchten liegt das Amanyara an der touristisch weniger erschlossenen Nordwestküste der Karibikinsel Providenciales. Der Northwest Point Marine National Park, ein weltbekannter Hotspot für Taucher, beginnt quasi vor den Türen der 33 Villen. Mit jeweils 800 m² Grundstück und knapp 750 m² Wohnfläche bieten die aus je fünf Pavillons und einem Pool bestehenden Residenzen viel Platz und die nötige Privatsphäre für vollkommene Erholung. Schlichte Eleganz und raumhohe Fensterfronten prägen Architektur und Interieur.

Bordée de plages solitaires et de criques rocheuses, Amanyara se trouve sur la côte nord-ouest de Providenciales, dans la partie la moins touristique de l'île caribéenne. Le Parc National de Northwest Point Marine, un site bien connu des plongeurs du monde entier, commence littéralement à la porte des 33 villas. Comprenant cinq pavillons de 800 m² et un espace séjour de 750 m², ainsi qu'une piscine, les résidences offrent espace et intimité pour une relaxation totale. Une élégance simple et de grandes baies vitrées caractérisent l'architecture et l'intérieur.

Amanyara se encuentra en el emplazamiento poco explotado por el turismo de la costa noroccidental de la isla caribeña de Providenciales, enmarcada por playas desiertas y calas rocosas. El Northwest Point Marine National Park, famoso entre los buceadores del mundo entero, queda a las puertas de las 33 viviendas. Los 750 m² habitables y 800 m² de terreno de estas residencias dotadas de piscina y cinco pabellones, proporcionan espacio de sobra y la privacidad necesaria para disfrutar de un descanso absoluto. Su discreta elegancia y los ventanales frontales caracterizan tanto a la arquitectura como al interior.

Circondata da spiagge isolate e baie rocciose, Amanyara è situata sulla costa nordoccidentale dell'isola caraibica meno dotata di strutture turistiche, Providenciales. Il Northwest Point Marine National Park, un'area di grande interesse per i sommozzatori, conosciuta in tutto il mondo, inizia praticamente davanti alle porte delle 33 ville. Ognuna con 800 m² di terreno e circa 750 m² di superficie abitativa, le residenze, composte ognuna da cinque padiglioni e una piscina, offrono molto spazio e la necessaria sfera privata per un completo riposo. L'architettura e gli interni sono caratterizzati da semplice eleganza e vetrate a tutta parete.

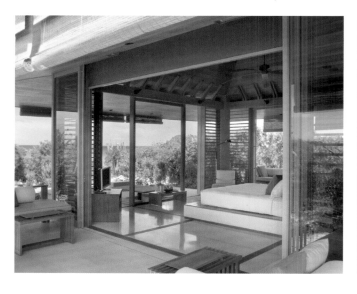
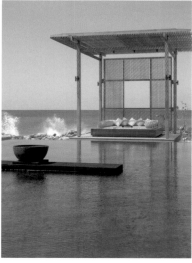

The pavilions adjoining each villa are grouped around gigantic swimming pools with borders of black Indonesian volcanic stone that appear to blend into the ocean. Ceiling-high glass fronts and natural materials create an atmosphere of discreet exclusivity.

Die Pavillons jeder Villa gruppieren sich um riesige, in schwarzen Vulkanstein aus Indonesien gefasste Swimmingpools, die ins Meer überzugehen scheinen. Raumhohe Glasfronten und natürliche Materialien wie Stein und Holz schaffen eine Atmosphäre dezenter Exklusivität.

Les pavillons de chaque villa sont groupés autour de gigantesques piscines bordées de pierre volcanique noire importée d'Indonésie et qui semblent se jeter dans l'océan. Les baies vitrées et les matériaux naturels créent une atmosphère de luxe discret.

Los pabellones de cada residencia se agrupan en torno a inmensas piscinas de negra piedra volcánica indonesa que parecen adentrarse en el mar. Los ventanales de cuerpo entero y materiales naturales configuran un ambiente de delicada exclusividad.

I padiglioni di ogni villa si raggruppano intorno a piscine gigantesche, fatte di roccia vulcanica nera proveniente dall'Indonesia, che sembrano riversarsi in mare. Vetrate a tutta parete e materiali naturali creano un'atmosfera di discreta esclusività.

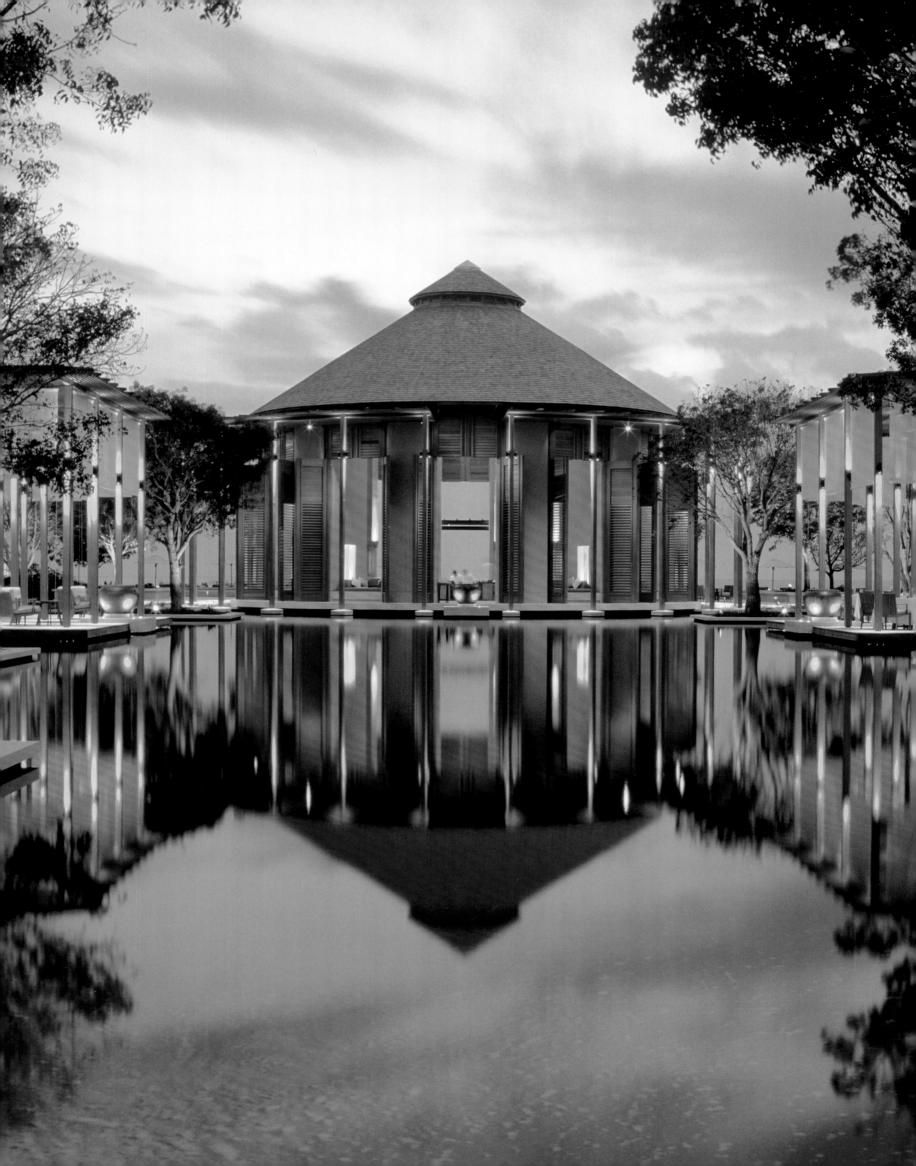

Each bedroom is housed in a separate pavilion. Some feature a direct access to the pool—ideal for a nighttime swim in the moonlight.

Jedes Schlafzimmer ist in einem separaten Pavillon untergebracht. Einige bieten einen direkten Zugang zum Pool. Ideal für ein nächtliches Bad im Mondschein.

Chaque chambre est abritée dans un pavillon séparé et quelques-unes disposent d'un accès direct à la piscine, ce qui est idéal pour un bain de minuit sous la lune.

Cada dormitorio ocupa uno de los pabellones, algunos con acceso directo a la piscina resulta ideal para darse un baño nocturno a la luz de la luna.

Ogni camera da letto è situata in un padiglione separato, alcune delle quali con accesso diretto alla piscina. Ideale per una nuotata notturna al chiaro di luna.

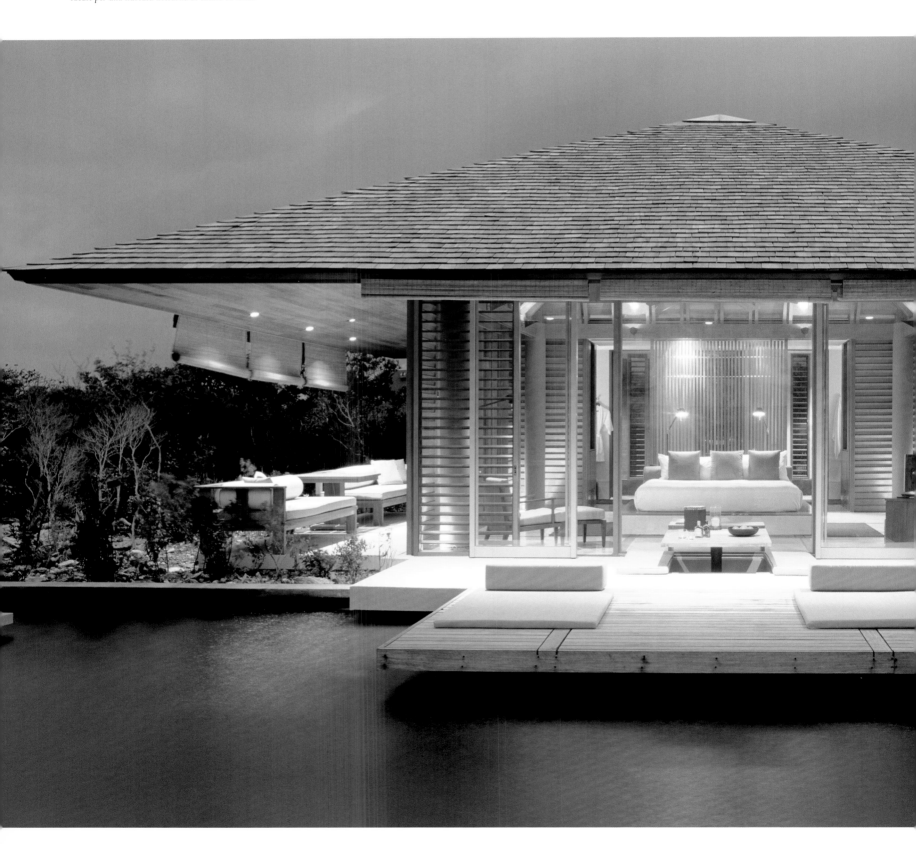

A few exclusive materials merge into surprising impressions—whether it's the ceiling of a pavilion or the furnishings in the dining room and lounges. The rule of thumb is: Symmetry is calming to the eye.

Wenige, erlesene Materialien fügen sich zu überraschenden Impressionen zusammen — sei es die Decke eines Pavillons oder die Einrichtung von Speise- und Gesellschaftsräumen, die Faustregel lautet: Symmetrie beruhigt das Auge.

Quelques matériaux choisis s'unissent pour créer des effets surprenants. Aussi bien pour le plafond du pavillon que pour les meubles de la salle à manger et des salons, le principe est simple : la symétrie calme le regard.

La fusión de unos pocos y selectos materiales crea efectos sorprendentes; tanto en el techo de los pabellones como en la decoración de comedores y salones se ha seguido una divisa: la simetría descansa la vista.

Pochi, pregiati materiali si uniscono a formare impressioni sorprendenti — non importa se si tratti del soffitto di un padiglione o dell'arredamento di sale da pranzo e salotti, la regola d'oro è: la simmetria fa riposare l'occhio.

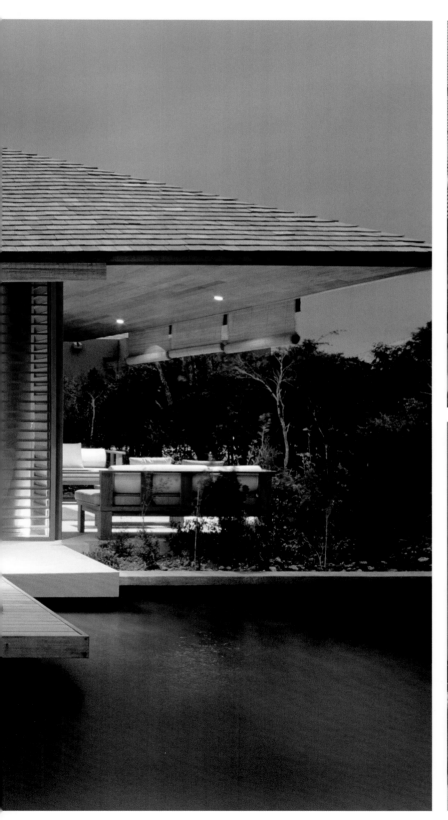

Amanyara Providenciales, Turks and Caicos Islands, Caribbean 35

Katitche Point Greathouse

Virgin Gorda, British Virgin Islands, Caribbean

The Greathouse rises in the shape of a pyramid as the center of a small paradise on Virgin Gorda. Five suites are grouped around the main structure like satellites, each of them revealing fascinating views of Mahoe Bay. Inside views extend all the way to the beams of the 36 ft. ceilings. The ground floor contains a professional kitchen, a teak dining table and chairs, and deep sofas. The gallery contains a library. Ventilators provide a constant breeze. And you'll feel like you can touch the sky from the hammock in the "Crow's Nest" as you look into the starry Caribbean skies.

Pyramidenförmig erhebt sich das Greathouse als Mittelpunkt eines kleinen Paradieses auf Virgin Gorda. Wie Satelliten gruppieren sich fünf Suiten um das Haupthaus, jede eröffnet reizvolle Blicke auf die Mahoe Bay. Innen reicht die Sicht bis zum Gebälk der 11 m hohen Decke. Im Parterre befinden sich eine Profiküche, eine Essgruppe aus Teakholz und tiefe Sofas, während auf der Galerie eine Bibliothek untergebracht ist. Ventilatoren sorgen für eine stete Brise. Dem Himmel ganz nah ist man in der Hängematte im „Crow's Nest", von wo man in den karibischen Sternenhimmel schaut.

Greathouse forme une pyramide, centre d'un petit paradis sur Virgin Gorda, une des Îles Vierges. Les cinq suites sont regroupées comme des satellites autour de la maison principale, chacune d'entre elles révélant les panoramas fascinants de la baie de Mahoe. Les vues intérieures vont jusqu'aux poutres du plafond, à 11 m de haut. Le rez-de-chaussée comprend une cuisine professionnelle, une table et des chaises en teck et de profonds canapés. La galerie dispose d'une bibliothèque. Des ventilateurs assurent une brise continue. Etendu dans le hamac du « Crow's Nest » à contempler le ciel caribéen étoilé, vous vous sentirez littéralement proche des cieux.

Con su forma piramidal, la mansión constituye el centro de este pequeño paraíso en Virgin Gorda. Cinco suites, todas con unas vistas extraordinarias a la Mahoe Bay, se agrupan a modo de satélites en torno a la casa principal. En su interior, la vista alcanza hasta la viguería del techo a 11 m de altura. En la planta baja se ubican una cocina, una mesa de comedor de teka y unos mullidos sofás; en la galería se encuentra la biblioteca. Los ventiladores proporcionan una brisa constante. En la hamaca de la "Crow's Nest" parece alcanzarse el estrellado cielo del Caribe.

Il Greathouse si eleva a forma di piramide come centro di un piccolo paradiso sulla Virgin Gorda. Cinque suite si raggruppano come satelliti intorno alla casa principale: ognuna si apre a una vista splendida sulla Mahoe Bay. All'interno la vista si inoltra fino alle travi del soffitto alto 11 m. Al piano terra si trovano una cucina professionale, un tavolo da pranzo con sedie in teak e larghi divani, mentre nella galleria si trova una biblioteca. Sei ventilatori creano una costante brezza. Nell'amaca collocata in una specie di "Crow's Nest", dalla quale si può guardare il cielo stellato dei Caraibi, ci si ritrova vicinissimi al cielo.

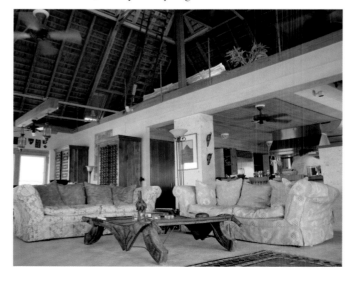

Katitche Point Greathouse is one of the most beautiful estates of the British Virgin Islands. Authentic works of art define its interior.

Katitche Point Greathouse ist eines der schönsten Anwesen der British Virgin Islands. Authentische Kunstobjekte bestimmen ihr Interieur.

Katitche Point Greathouse est une des plus belles propriétés des Îles Vierges britanniques. Son intérieur est caractérisé par d'authentiques objets d'art.

Katitche Point Greathouse es uno de los enclaves más hermosos de las Islas Vírgenes Británicas. Auténticas obras de arte imprimen carácter a su interior.

Katitche Point Greathouse è una delle tenute più belle delle Isole Vergini britanniche. Veri e propri oggetti d'arte definiscono gli interni.

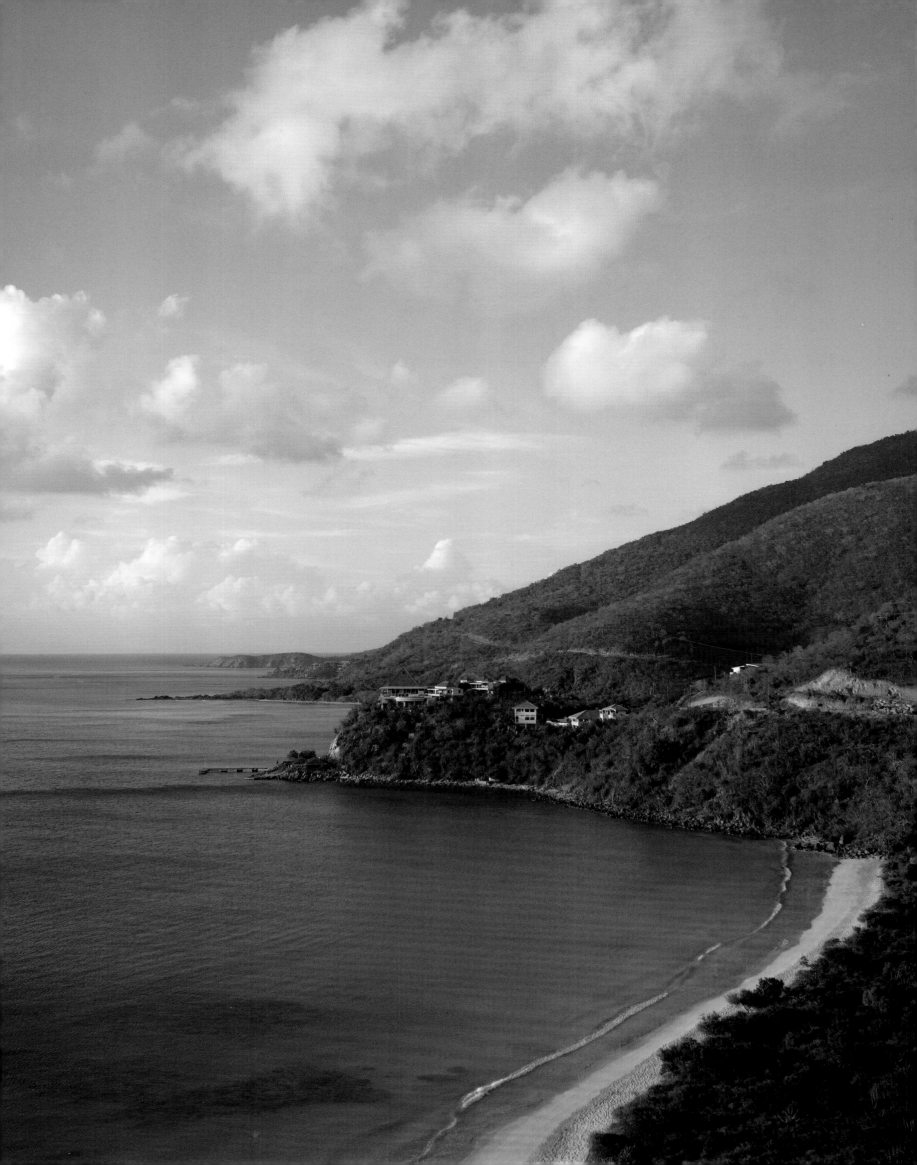

Each view is spectacular. The pool deck reveals a view of Tortola and neighboring Dog Islands.

Jede Aussicht ist spektakulär. Vom Pooldeck öffnet sich der Blick auf Tortola und die benachbarten Dog Islands.

Chaque panorama est spectaculaire. La piscine révèle la vue sur Tortola et les Dog Islands voisines.

Cada una de las vistas es espectacular. Desde la cubierta de la piscina se divisa la isla de Tortola y las vecinas Dog Islands.

Ogni vista è spettacolare. Dal ponte della piscina si apre la vista su Tortola e le vicine Dog Islands.

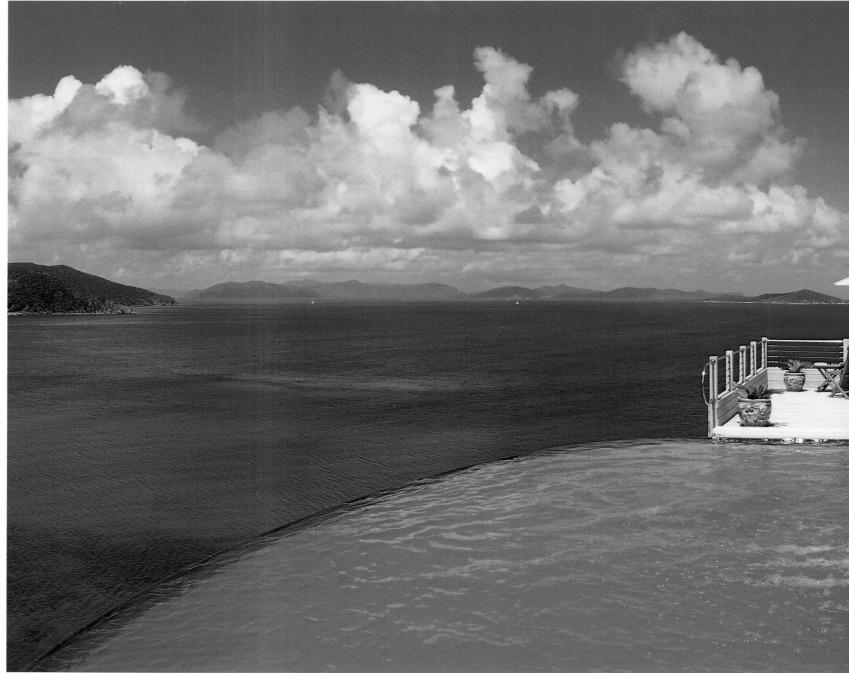

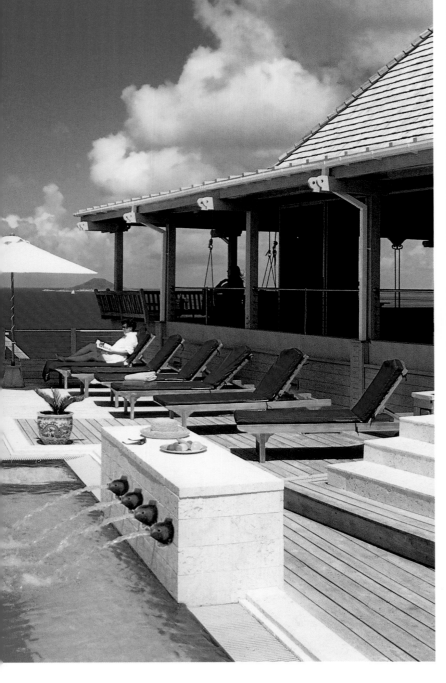

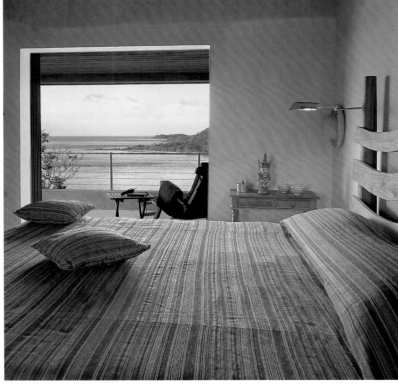

Katitche Point Greathouse *Virgin Gorda, British Virgin Islands, Caribbean* 39

Villa Indigo
Anguilla, British West Indies, Caribbean

A reef with the beautiful name of Cinnamon Reef shelters the bay of Little Harbour on Anguilla. Above the bay, you'll find Villa Indigo in a tropical garden. With its seven bedrooms and bathrooms, three kitchens, a pavilion for romantic dinners by candlelight, two pools and a private beach with a beach island, this estate is a sanctuary that leaves virtually nothing to be desired. Patios and terraces offer fabulous views of the Caribbean and, in the evening, the chef invites everyone to a barbecue on the beach beneath the stars.

Ein Riff mit dem schönen Namen Cinnamon Reef schützt die Bucht von Little Harbour auf Anguilla. Über ihr liegt die Villa Indigo in einem tropischen Garten. Mit sieben Schlafzimmern und Bädern, drei Küchen, einem Pavillon für romantische Dinners bei Kerzenschein, zwei Pools und einem Privatstrand mit Badeinsel ist dieses Anwesen ein Refugium, das kaum einen Wunsch offen lässt. Patios und Terrassen bieten traumhafte Aussichten auf die karibische See, an deren Strand der Küchenchef abends zum Barbecue unter Sternen bittet.

Un récif portant le joli nom de Cinnamon Reef protège la baie de Little Harbour à Anguilla. La Villa Indigo est située au-dessus, dans un jardin tropical. Cette propriété est un sanctuaire qui exauce quasiment tous les souhaits avec ses sept chambres et salles de bains, ses trois cuisines, son pavillon pour des dîners romantiques aux chandelles, ses deux piscines et sa plage privée avec une île pour se baigner. Les patios et les terrasses offrent une vue fabuleuse sur les Caraïbes, et le soir sur la plage le chef cuisinier vous invite à un barbecue sous les étoiles.

Un arrecife con el bonito nombre de Cinnamon Reef protege la bahía de Little Harbour en Anguilla. Sobre ella se levanta Villa Indigo, en medio de un jardín tropical. Con sus siete dormitorios y baños, tres cocinas, un pabellón para las cenas románticas a la luz de las velas, dos piscinas y una playa privada con isla, la propiedad se convierte en el refugio que satisface todos los deseos. Los patios y las terrazas brindan vistas de ensueño al Caribe. Por la noche, el chef de cocina prepara barbacoa en la playa, a la luz de las estrellas.

Una scogliera con lo splendido nome Cinnamon Reef protegge la baia di Little Harbour ad Anguilla. Al di sopra si trova Villa Indigo, situata in un giardino tropicale. Con sette camere da letto e bagni, tre cucine, un padiglione per cene romantiche a lume di candela, due piscine e una spiaggia privata con isola per il bagno, questa tenuta è un rifugio che esaudisce ogni desiderio. I patii e i terrazzi offrono una vista favolosa sul mare dei Caraibi, sulle cui spiagge, la sera, lo chef de cuisine invita a un barbecue sotto le stelle.

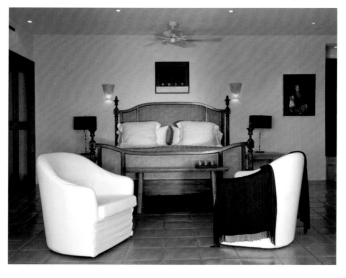 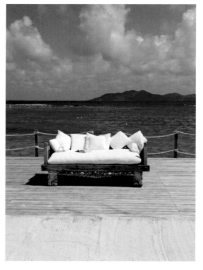

Perfect seclusion: *Situated in a tropical garden, Villa Indigo offers the maximum in luxury and exclusiveness.*

Perfekte Abgeschiedenheit: *In einem tropischen Garten gelegen, bietet die Villa Indigo ein Maximum an Luxus und Exklusivität.*

Solitude parfaite : *située dans un jardin tropical, la Villa Indigo offre le plus haut degré de luxe et d'exclusivité.*

El retiro perfecto *en un jardín tropical ofrece el máximo lujo y exclusividad.*

Isolamento perfetto: *situata in un giardino tropicale, Villa Indigo offre il massimo del lusso e dell'esclusività.*

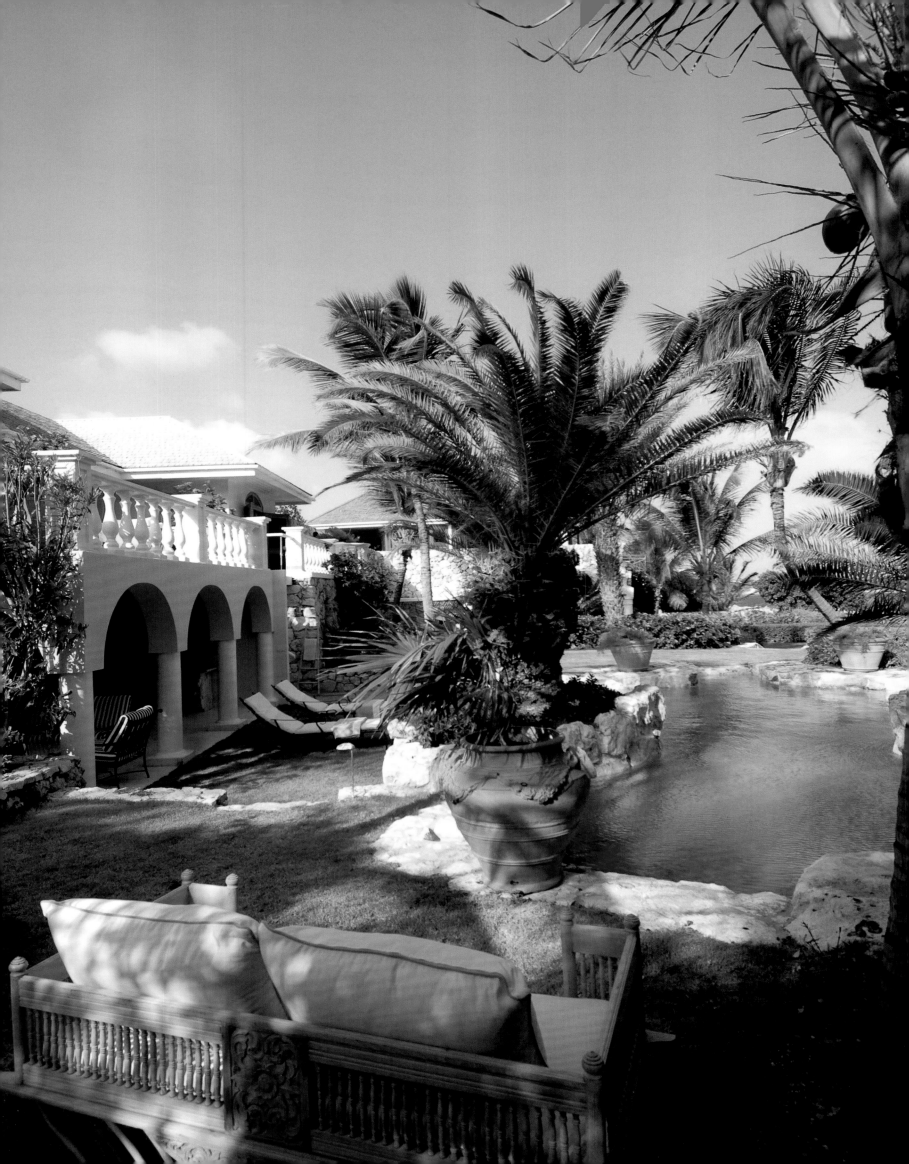

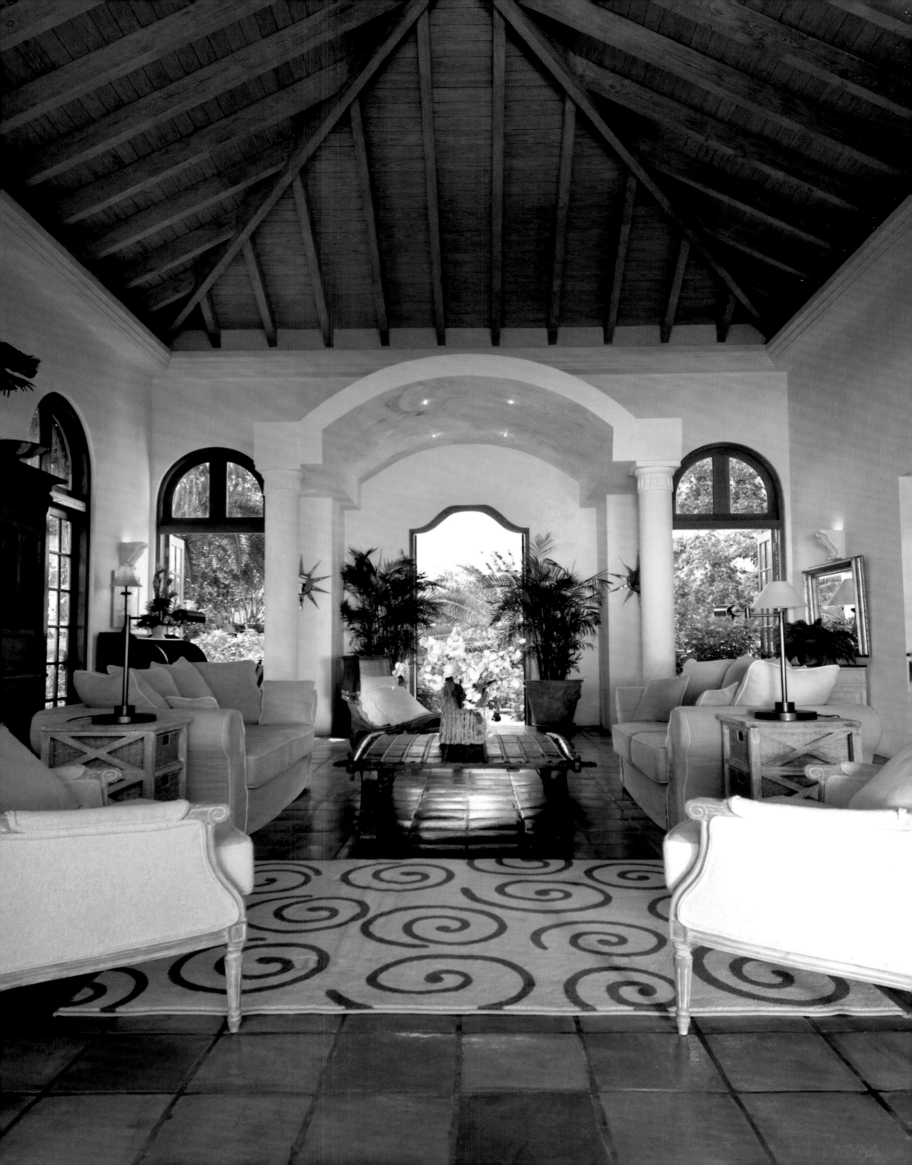

Wood, natural stone and tiles create a tropical ambience with a colonial note.

Holz, Naturstein und Fliesen schaffen ein tropisches Ambiente mit kolonialer Note.

Le bois, la pierre naturelle et les tuiles créent une ambiance tropicale avec une note coloniale.

La madera, la piedra natural y las baldosas crean un ambiente tropical con toques coloniales.

Il legno, la pietra naturale e le piastrelle creano un ambiente tropicale con una nota coloniale.

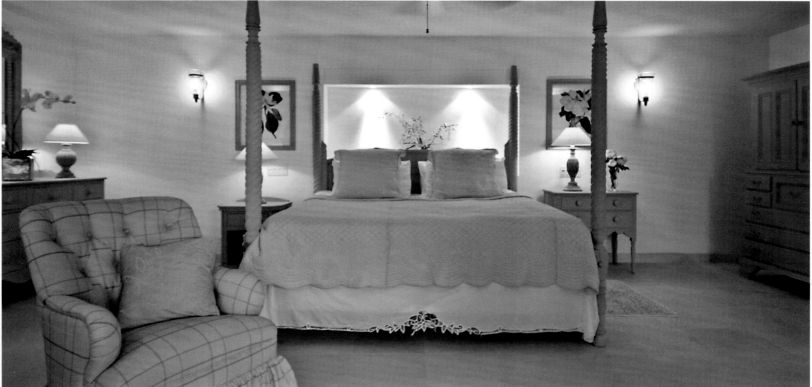

Each of the seven bedrooms displays an individual design. Each one also has its own terrace with a beautiful view of the garden and the ocean.

Jedes der sieben Schlafzimmer ist individuell gestaltet. Allen gemein ist eine eigene Terrasse und der schöne Blick in den Garten und das Meer.

Chacune des sept chambres a un design particulier. Elles possèdent toutes leur propre terrasse avec une magnifique vue sur le jardin et l'océan.

Cada uno de los siete dormitorios se ha diseñado de forma individual. Todos cuentan con su propia terraza y fantásticas vistas al jardín y al mar.

Ognuna delle sette camere da letto è arredata in modo individuale. Tutte hanno un terrazzo proprio e una splendida vista sul giardino e sul mare.

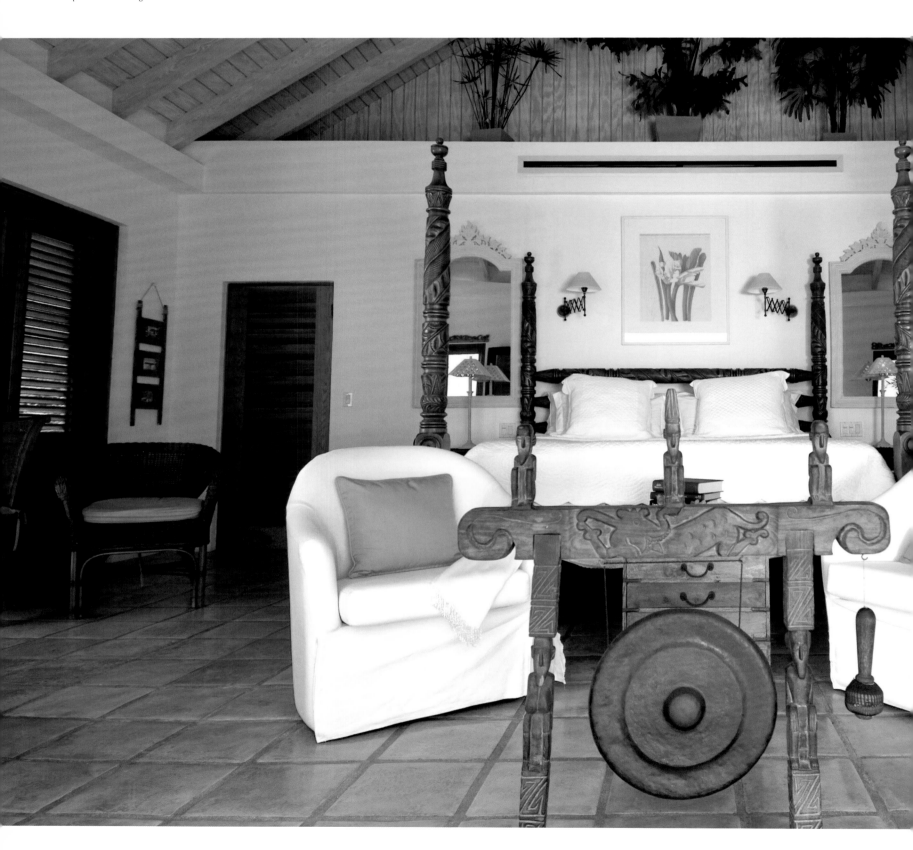

Villa Indigo *Anguilla, British West Indies, Caribbean* 45

Bird of Paradise

Anguilla, British West Indies, Caribbean

Located above the heavenly beach of Sandy Hill Bay on Anguilla in the British West Indies, this estate offers a view of the ocean and of the neighboring islands of Saint Barth and Saint Martin. It consists of four buildings, a plunge pool and a main pool, made to look like a lagoon. Here, everything fits right down to the detail—from the fans under tropical wood ceilings to the coffee bars in the bathrooms. Its entire terrace front can be opened to extend the living area to the outside. Furniture imported from Bali and art objects from Africa and the Pacific add a special charm to its interior.

Über dem Traumstrand der Sandy Hill Bay auf Anguilla liegt dieses aus vier Häusern, einem Plunge-Pool und dem einer Lagune nachempfundenen großen Pool bestehende Anwesen mit Blick auf das Meer und die Nachbarinseln Saint-Barth und Saint-Martin. Hier stimmt jedes Detail, von den Ventilatoren unter den Decken aus Tropenhölzern bis zur Kaffee-Bar im Bad. Die ganze Terrassenfront lässt sich öffnen, sodass der Wohnraum bis ins Freie reicht. Möbel aus Bali und Kunstobjekte aus Afrika und der Südsee verleihen dem Interieur seinen besonderen Reiz.

Cette propriété comptant quatre maisons, un bain à bulles et une grande piscine qui ressemble à un lagon s'étend sur la plage paradisiaque de Sandy Hill Bay à Anguilla. Elle offre une vue sur l'océan et les îles voisines de Saint-Bart et Saint-Martin. Chaque détail, des ventilateurs sous les plafonds de bois tropical, au comptoir couleur café dans la salle de bains, est tout simplement juste. Toute la façade donnant sur la terrasse peut s'ouvrir pour que l'espace de vie s'étende à l'air libre. Le mobilier importé de Bali et les objets d'art d'Afrique et des Mers du Sud confèrent un charme particulier à l'intérieur.

Esta urbanización, compuesta por cuatro casas, una piscina con trampolín y otra mayor semejante a una laguna, se sitúa ante una playa de ensueño en la Sandy Hill Bay de Anguila, ante las vistas al mar y a las islas vecinas de Saint Barth y Saint Martin. Cada uno de los detalles encaja a la perfección: desde los ventiladores de techo en maderas tropicales hasta el café-bar del baño. La terraza abierta prolonga el salón hasta el exterior. Mobiliario balinés y obras de arte de África y Oceanía visten el interior de un encanto especial.

Questa tenuta, con vista sul mare e sulle vicine isole di Saint-Barth e Saint-Martin, si trova sulla spiaggia da sogno della Sandy Hill Bay, ad Anguilla, ed è composta da quattro case, una piscina relax non riscaldata e una piscina che ricrea una laguna. Qui ogni dettaglio è al posto giusto, dai ventilatori sotto i soffitti di legno tropicale fino al bar per il caffè in bagno. Tutta la parte frontale del terrazzo può essere aperta per estendere la zona abitativa fino all'esterno. I mobili di Bali e gli oggetti d'arte provenienti dall'Africa e dai mari del Sud donano agli interni un fascino particolare.

 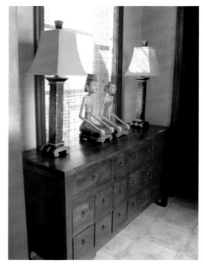

*The **Bird of Paradise** offers peace of mind, both visually and spiritually. Its décor and accessories bear witness to the global journeys of its owners.*

*Das **Bird of Paradise** bietet Platz zum Durchatmen und Entspannung für Auge und Geist. Seine Einrichtung und die Accessoires erzählen von den Weltreisen der Besitzer.*

***Bird of Paradise** offre de l'espace pour respirer et détendre à la fois les yeux et l'esprit. Son mobilier et ses accessoires racontent les voyages autour du monde de son propriétaire.*

*El **Bird of Paradise** es el lugar ideal para respirar a fondo y relajarse en cuerpo y alma. Su decoración y accesorios relatan los viajes por el mundo de sus propietarios.*

*Il **Bird of Paradise** offre spazio all'occhio e allo spirito per respirare profondamente e rilassarsi. Il suo arredamento e gli accessori raccontano dei viaggi intorno al mondo fatti dai proprietari.*

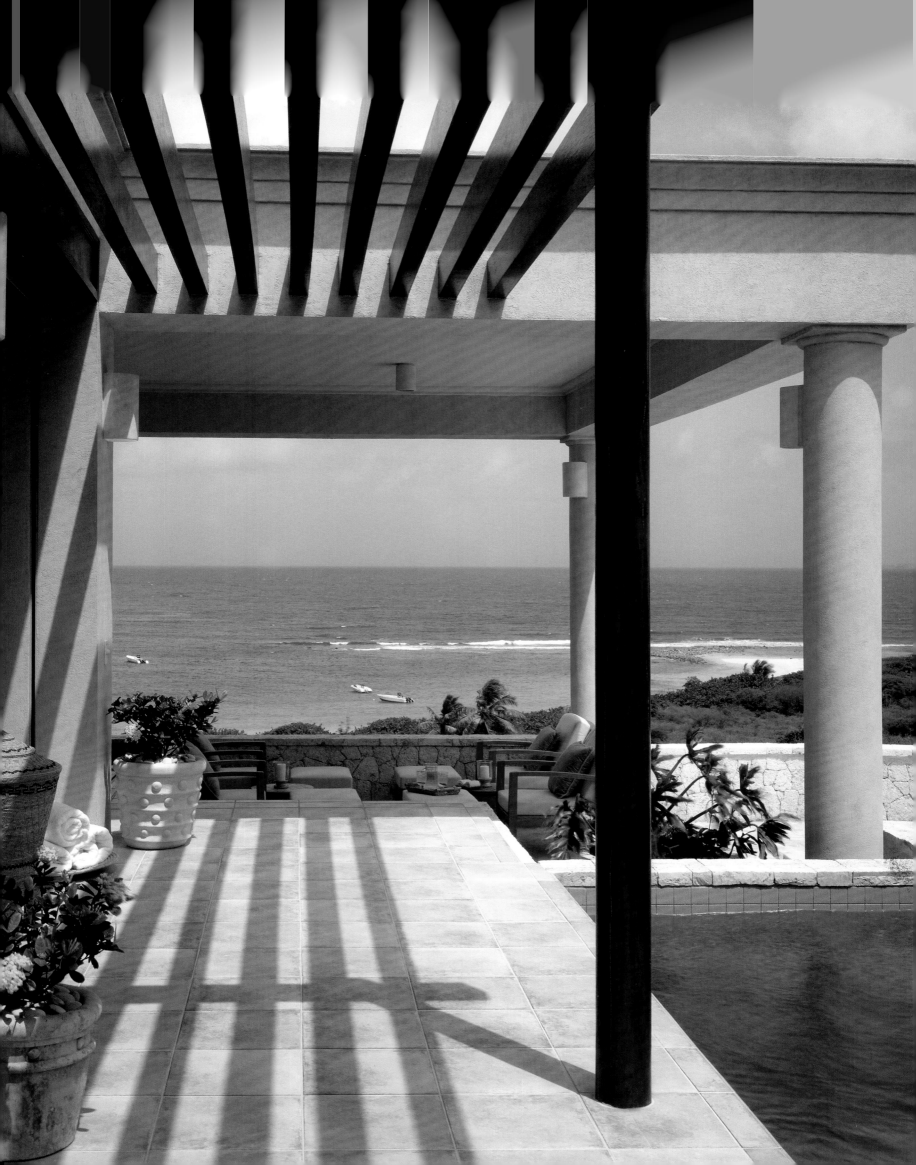

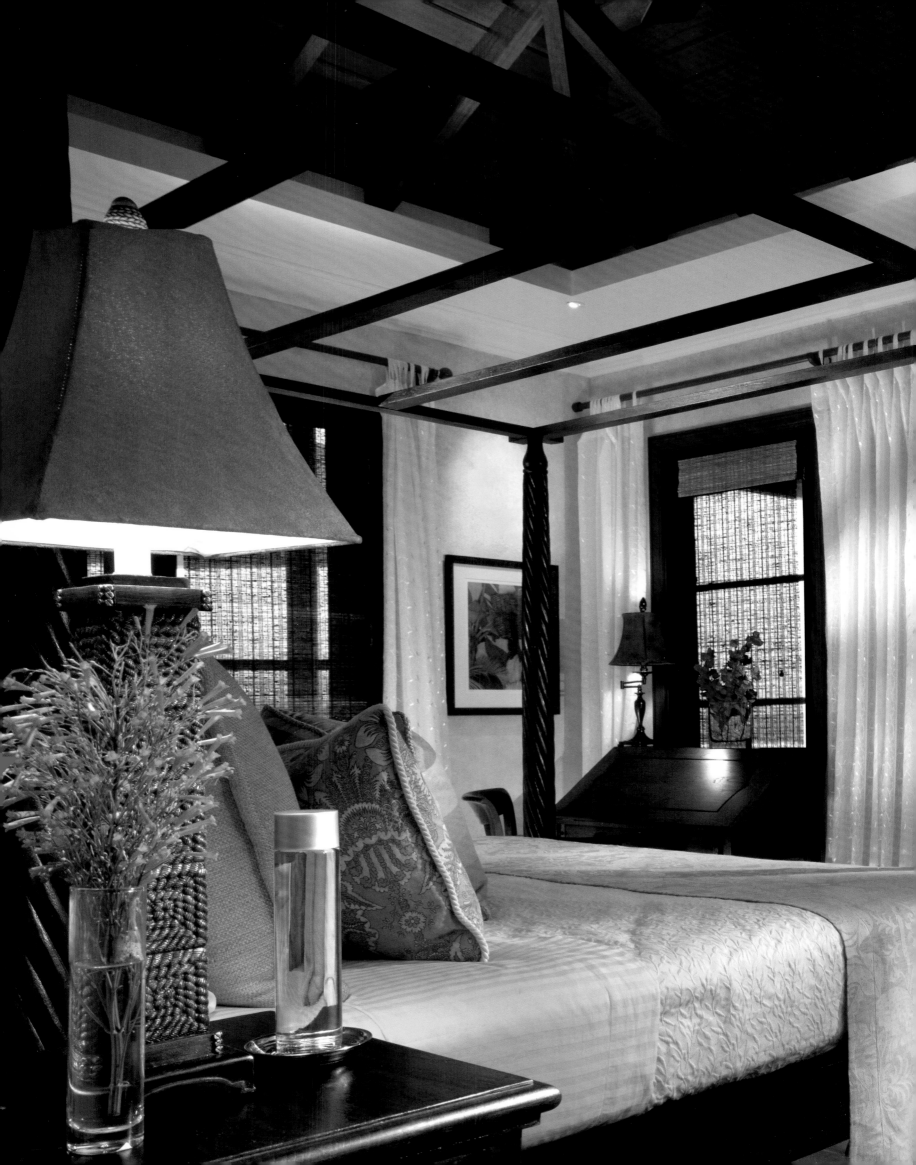

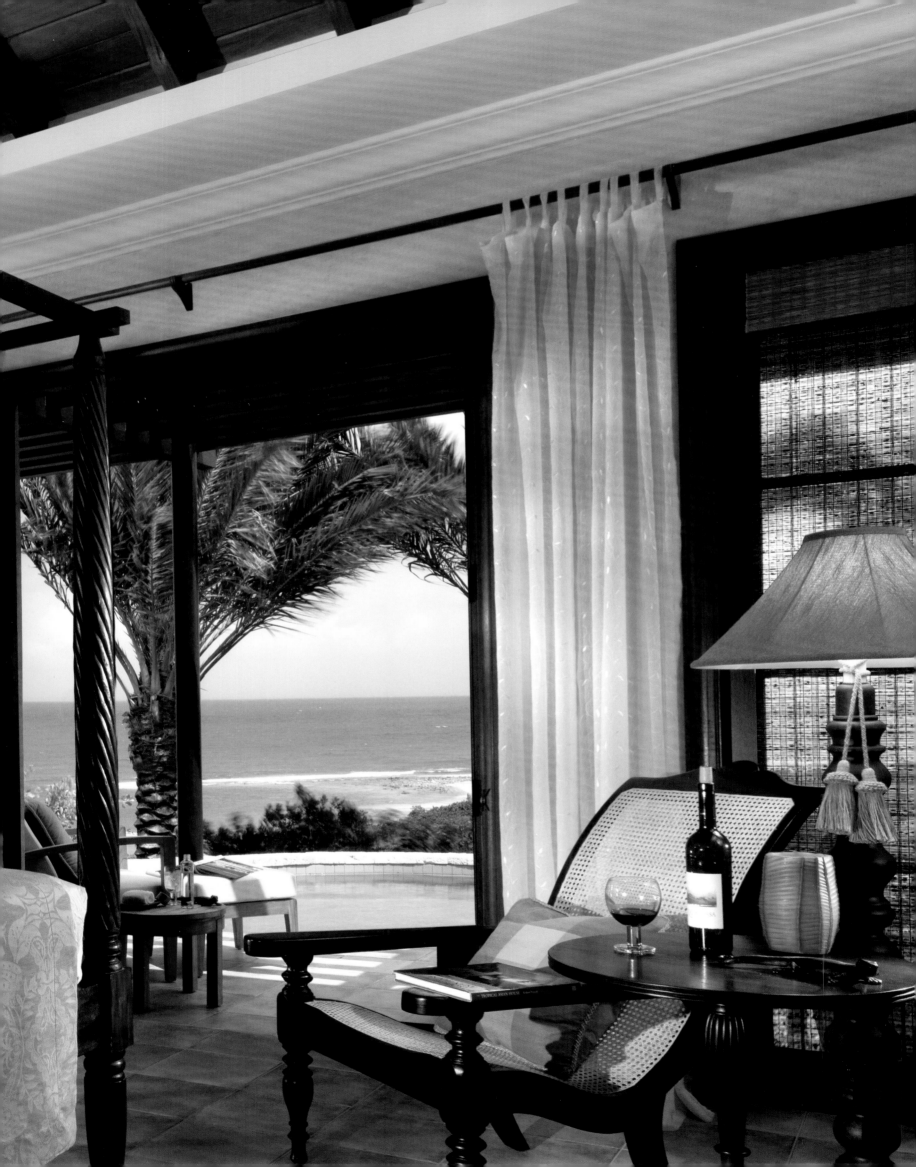

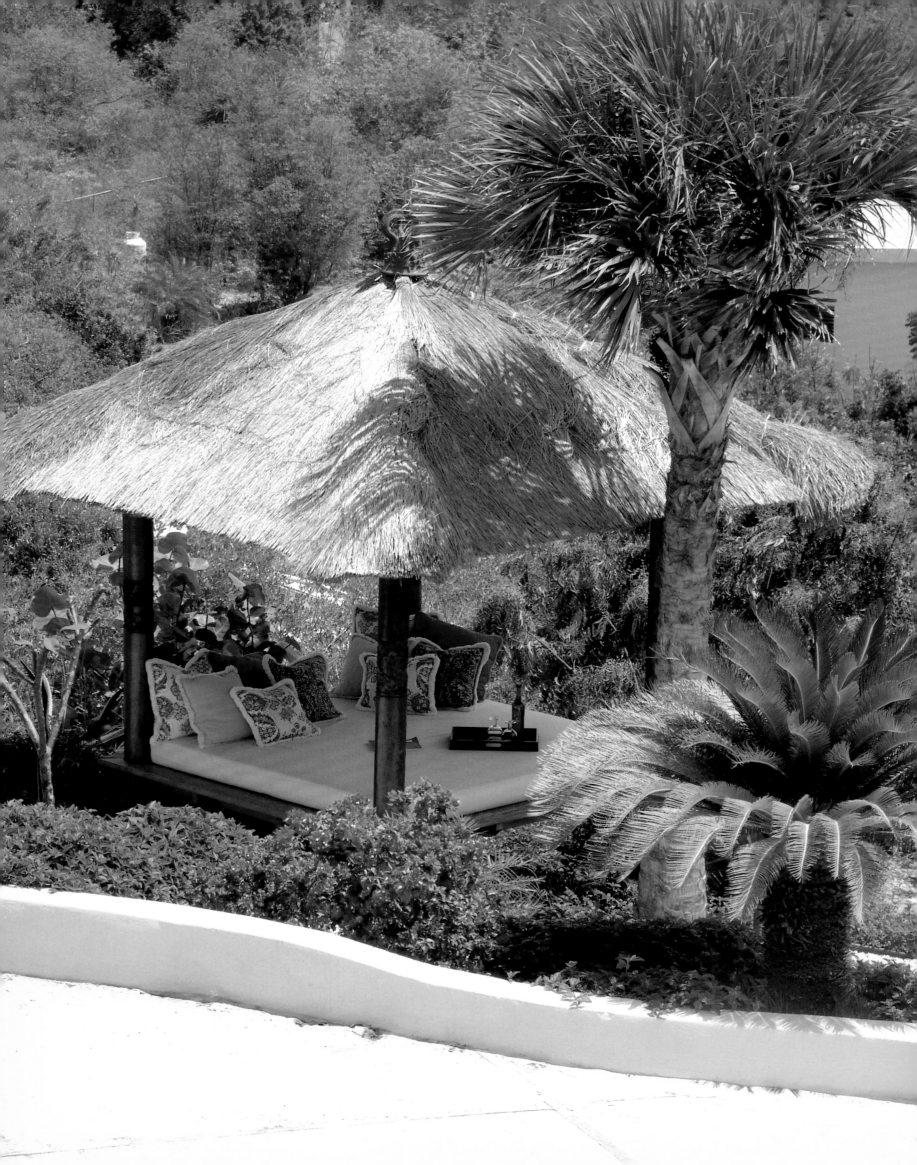

The daybed in the garden really does feel like paradise.

Auf dem Ruhebett im Garten fühlt man sich tatsächlich wie im Paradies.

On se sent réellement au paradis sur le divan au jardin.

En el diván del jardín se descansa verdaderamente como en el paraíso.

Sul divano in giardino ci si sente veramente come in paradiso.

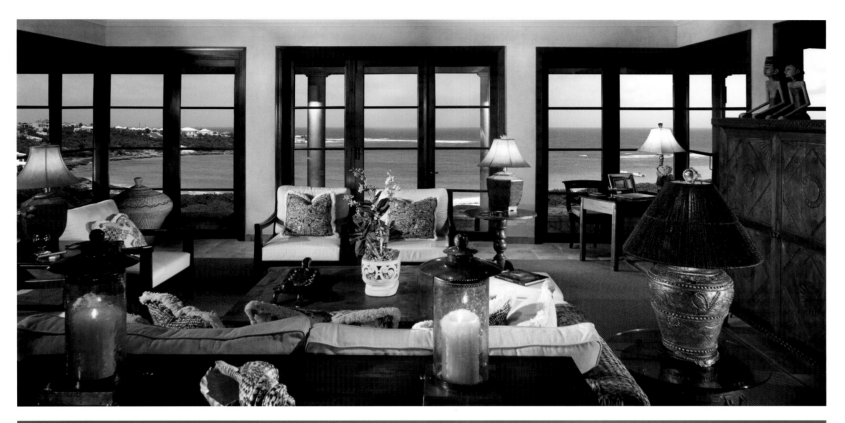

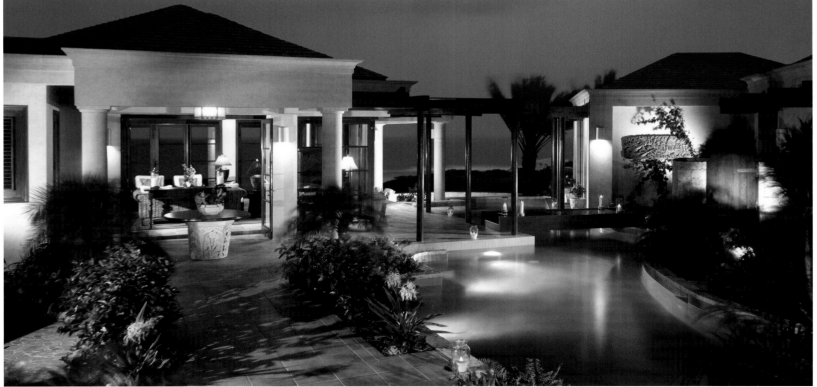

Antigua Wild Dog Villa
Antigua, British West Indies, Caribbean

Located on a hill on Antigua's northeastern coast and consisting of multiple buildings, this villa offers an unobstructed view of the ocean from three sides. Nothing about the minimalist décor of its living area distracts from what really matters: that view of the ocean just beyond the villa's spacious terrace. So look forward every day to the spectacle of Caribbean sunsets—whether you're indoors or outdoors. The décor of the other rooms in the main building and guest pavilion is humble and elegant as well, imparting an atmosphere of vast, open space.

Auf einem Hügel an der Nordostküste Antiguas gelegen und aus mehreren Gebäuden bestehend, bietet diese Villa auf drei Seiten einen unverstellten Meerblick. Im minimalistisch eingerichteten Wohnbereich lenkt nichts vom Wesentlichen ab: der Aussicht auf das Meer jenseits der großzügigen Terrasse. Man kann sich daher täglich sowohl im Inneren wie im Freien am Schauspiel des karibischen Sonnenuntergangs erfreuen. Auch die übrigen Räume von Haupthaus und Gästepavillon sind sparsam, aber stilvoll eingerichtet und vermitteln eine Atmosphäre von Raum und Weite.

Cette villa comprenant plusieurs bâtiments offre sur trois côtés une vue dégagée sur l'océan depuis une colline de la côte septentrionale d'Antigua. Dans la salle de séjour meublée de manière minimaliste, rien ne distrait l'œil de l'essentiel : la vue sur l'océan juste de l'autre côté de la vaste terrasse. Vous pouvez donc profiter chaque jour du spectacle du coucher de soleil caribéen, à l'extérieur ou à l'intérieur. Les autres pièces de la maison principale et des pavillons des invités sont décorées avec sobriété et élégance, et dégagent une atmosphère d'espace et de liberté.

Esta residencia compuesta por varios edificios se ubica en una colina de la costa nororiental de Antigua y ofrece formidables vistas al mar por tres de sus costados. El salón, de decoración minimalista, no distrae la atención de lo verdaderamente importante: la panorámica al mar, más allá de la amplia terraza. El fabuloso espectáculo de un atardecer caribeño se disfruta a diario tanto fuera como dentro. Las demás estancias de la casa principal y de invitados están también dotadas de una decoración sobria y con estilo, que proporciona una sensación de espacio y amplitud.

Situata su una collina sulla costa nordorientale di Antigua e composta da diversi edifici, questa villa offre, su tre lati, una spettacolare vista sul mare. Nella zona abitativa, arredata in modo minimalistico, nulla distrae dall'essenziale: la vista sul mare al di là dell'ampio terrazzo. Grazie a ciò, si può godere dello spettacolo del calar del sole caraibico sia dall'interno che all'aria aperta. Anche gli altri locali della casa principale e del padiglione per gli ospiti sono arredati in modo semplice ma elegante, e trasmettono un'atmosfera di spazio e ampiezza.

Nothing in this villa distracts from what really matters—the ocean. Accordingly, everything in it has been carefully selected and positioned.

In dieser Villa soll nichts vom Wesentlichen – dem Meer – ablenken. Deshalb ist jedes Stück mit Bedacht ausgewählt und platziert.

Rien dans cette villa ne devrait distraire de l'essentiel : l'océan. Chaque objet a donc été soigneusement sélectionné et positionné.

En esta mansión nada ha de distraer la atención al océano. De ahí que cada elemento haya sido seleccionado y emplazado cuidadosamente.

In questa villa nulla deve distrarre dall'essenziale: l'oceano. Per questo ogni pezzo è stato scelto e collocato con attenzione.

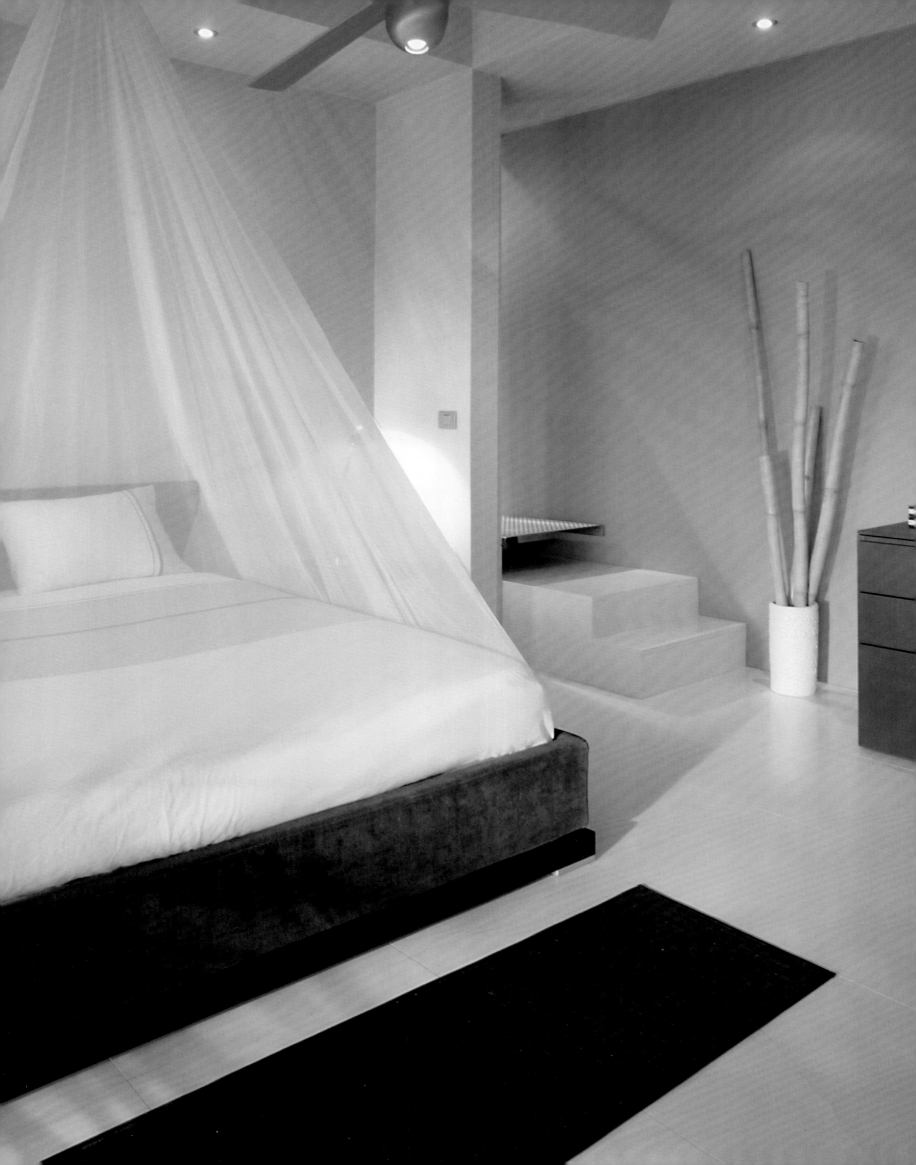

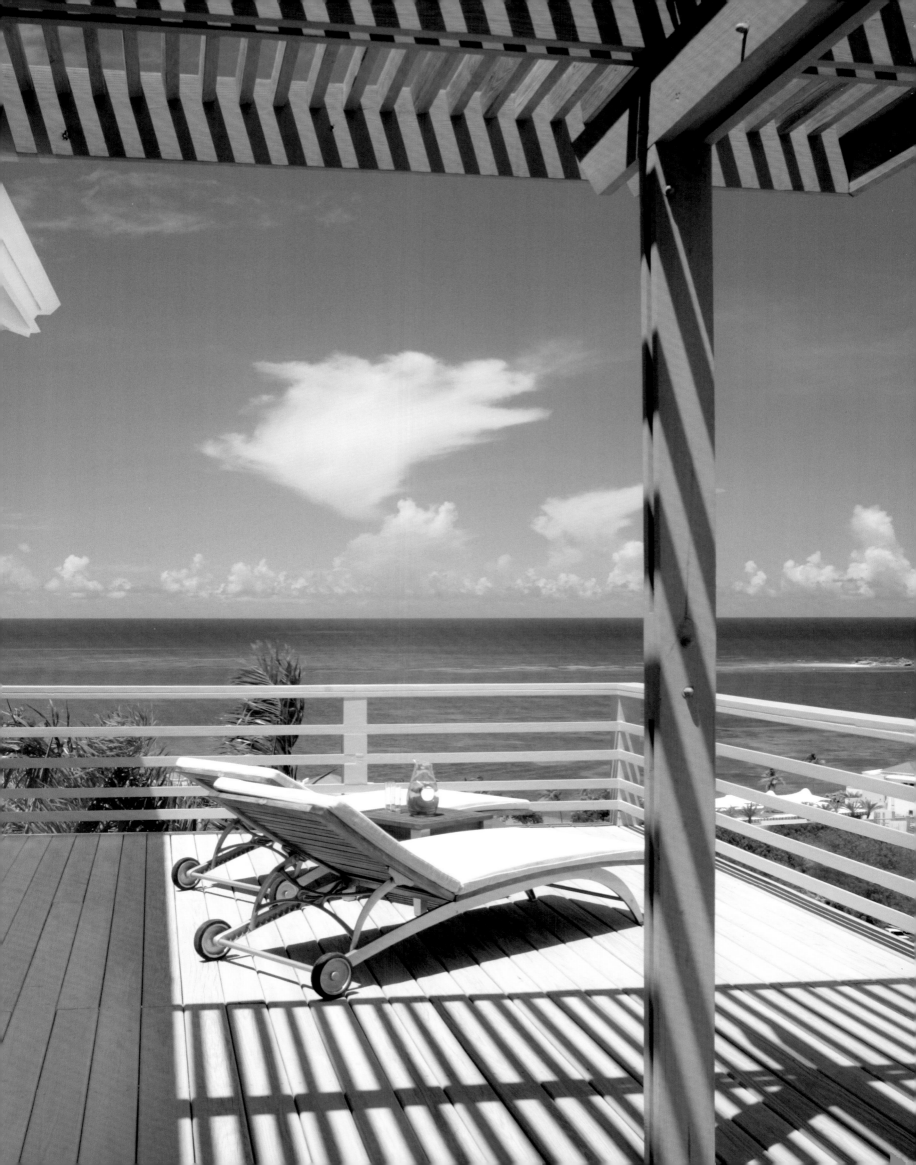

While guests are lulled into their dreams by the soft murmur of the waves, chef Zoe performs true miracles in the professional kitchen.

Während die Gäste sich von dem leisen Murmeln der Wellen in ihre Träume wiegen lassen, vollbringt Chefin Zoe in der Profiküche wahre Wunder.

Tandis que les invités s'abandonnent à leurs rêves dans le doux murmure des vagues, le chef cuisinier Zoe fait de vrais miracles dans la cuisine professionnelle.

Mientras el leve murmullo de las olas mece los sueños de los invitados, Zoe, la jefe de cocina, hace verdaderas maravillas en la cocina profesional.

Mentre gli ospiti si lasciano cullare dal mormorio leggero delle onde, la chef de cuisine Zoe crea dei veri e propri miracoli nella cucina professionale.

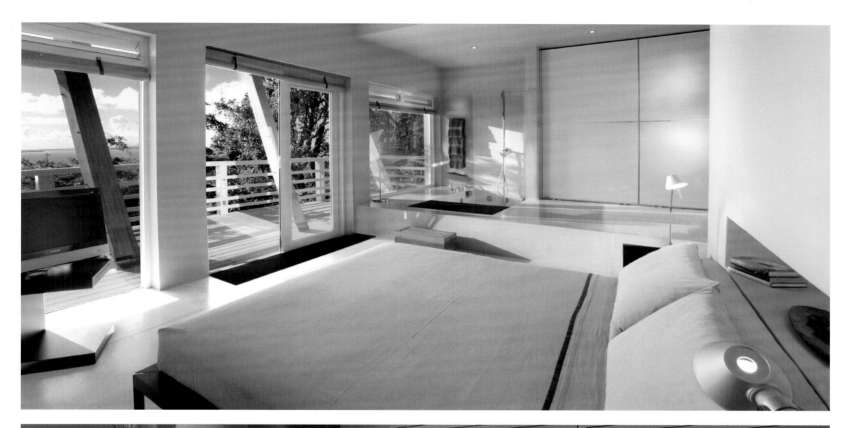

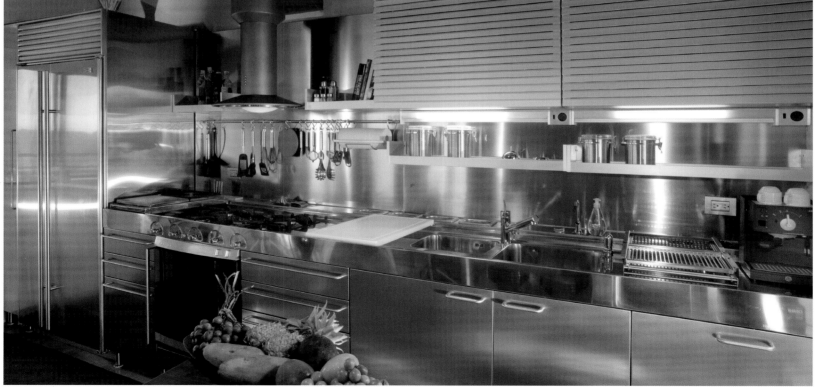

Mes Amis

Saint Martin, Caribbean

The giant terrace of this estate consisting of two villas on the French Caribbean island of Saint Martin with a view of Anguilla could equal the sundeck of an ocean liner. Two heated pools, a Jacuzzi and a bar are some of the other amenities of the outside area. The interior of Mes Amis is decorated in Caribbean colors. Its eleven bedrooms are individually decorated—for example, pink paneling with curtains and carpets in the same color. The estate's own top chef is in charge of the professional kitchen.

Die riesige Terrasse dieses aus zwei Villen bestehenden Anwesens auf der französischen Karibikinsel Saint-Martin mit Blick auf Anguilla würde dem Sonnendeck eines Ozeandampfers zur Ehre gereichen. Zwei beheizte Pools, ein Jacuzzi und eine Bar zählen zu den weiteren Annehmlichkeiten des Außenbereichs. Das Interieur ist in karibischen Farben gestaltet. Die elf Schlafzimmer sind individuell eingerichtet – etwa mit pinkfarbener Täfelung und Vorhängen und Teppichen in den gleichen Farben. In der Profiküche wirkt der hauseigene Spitzenkoch.

Cette propriété comprend deux villas sur l'île de Saint-Martin, dans les caraïbes françaises et possède une terrasse gigantesque avec vue sur Anguilla qui pourrait être comparée au pont supérieur d'un paquebot de croisière. Deux piscines chauffées, un jacuzzi et un bar sont quelques uns des équipements de l'espace extérieur. L'intérieur est décoré aux couleurs caribéennes. Les onze chambres sont meublées individuellement – par exemple, avec des panneaux roses et des rideaux et tapis de la même couleur. Le grand chef cuisinier de la propriété est à l'œuvre dans la cuisine professionnelle.

La gigantesca terraza de esta propiedad caribeña en la isla francesa de Saint Martin, formada por dos villas con vistas a Anguila es un tributo a la cubierta de un trasatlántico. Entre las comodidades de la parte exterior se cuentan dos piscinas climatizadas, un jacuzzi y un bar. En el interior predominan los colores caribeños. El diseño y la decoración de las once habitaciones se han individualizado, por ejemplo, con revestimientos y cortinas en rosa y alfombras en el mismo color. La cocina profesional cuenta con su propio cocinero de elite.

L'enorme terrazzo di questa tenuta composta da due ville sull'isola caraibica francese Saint-Martin, con vista su Anguilla, sarebbe l'orgoglio del ponte passeggiata di un transatlantico. Due piscine riscaldate, una Jacuzzi e un bar fanno parte delle ulteriori comodità dell'area esterna. L'interno è allestito con colori caraibici. Le undici camere da letto sono arredate in modo individuale, per esempio con pannelli rosa e tende e tappeti nello stesso colore. Nella cucina professionale lavora un cuoco di fama proprio della casa.

The courage to contrast: Strong colors make for a feel good mood.

Mut zum Kontrast: Starke Farben machen gute Laune.

Le courage des contrastes : les couleurs vives vous mettent de bonne humeur.

Atreviéndose con los contrastes: los colores vivos alegran el ánimo.

Il coraggio dei contrasti: i colori forti stimolano il buon umore.

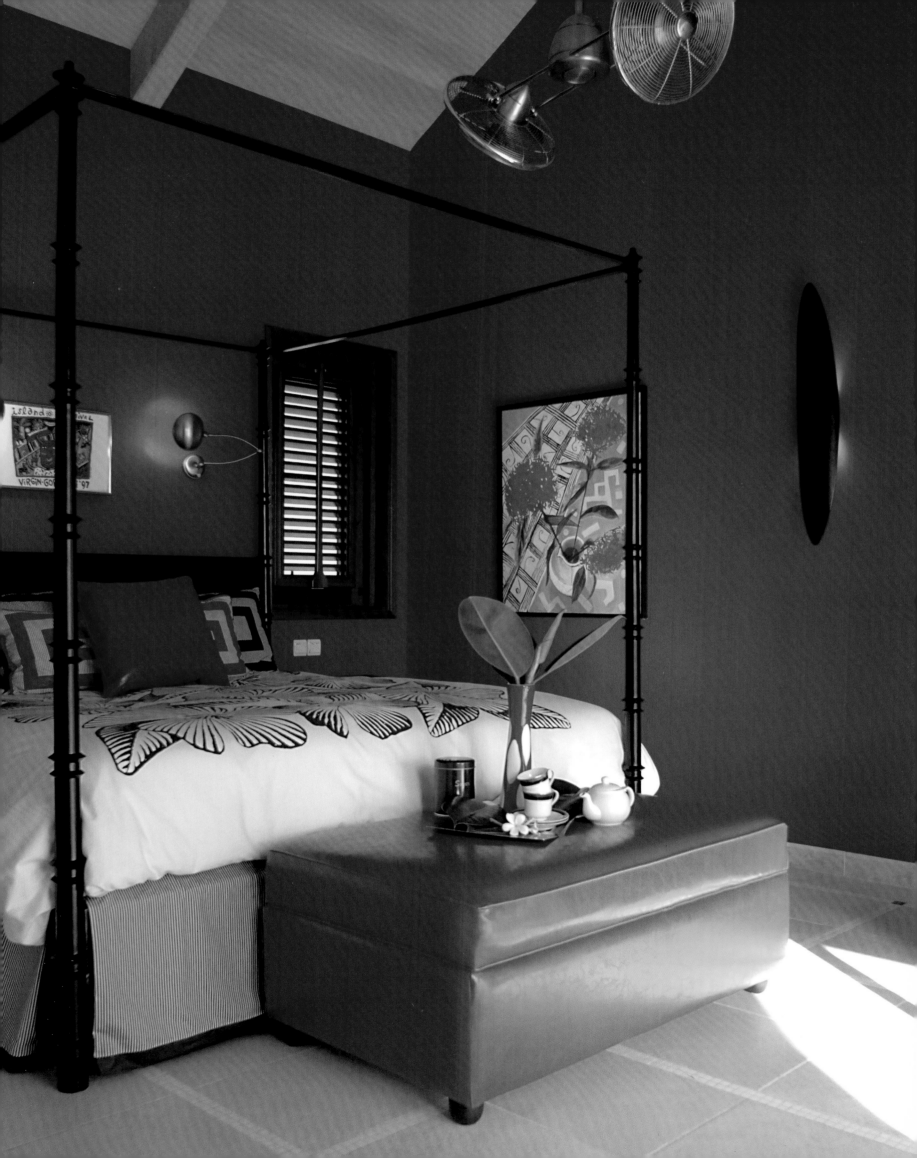

Sailing on the high seas: The sun terrace of the estate.

Als wäre man auf hoher See: Die Sonnenterrasse des Anwesens.

Comme si vous étiez en haute mer : la terrasse de la propriété.

Como estar en alta mar. La terraza de la residencia.

Come se si stesse in alto mare: il ponte passeggiata della tenuta.

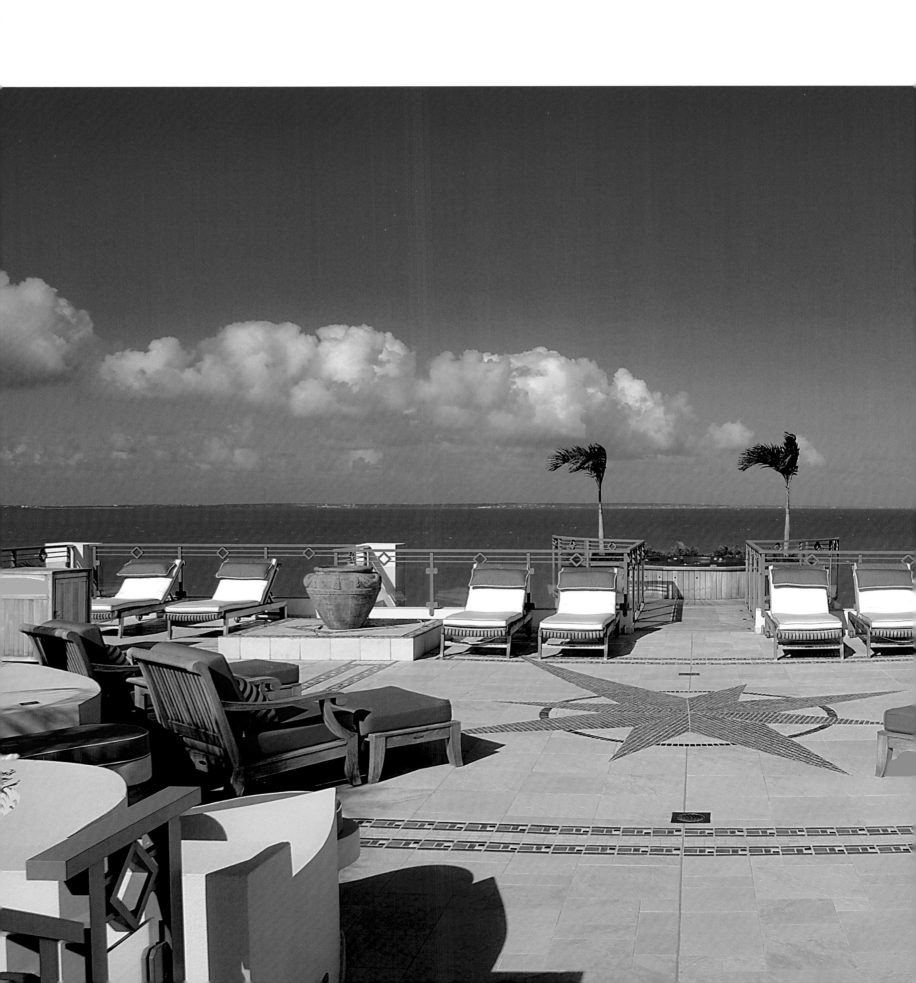

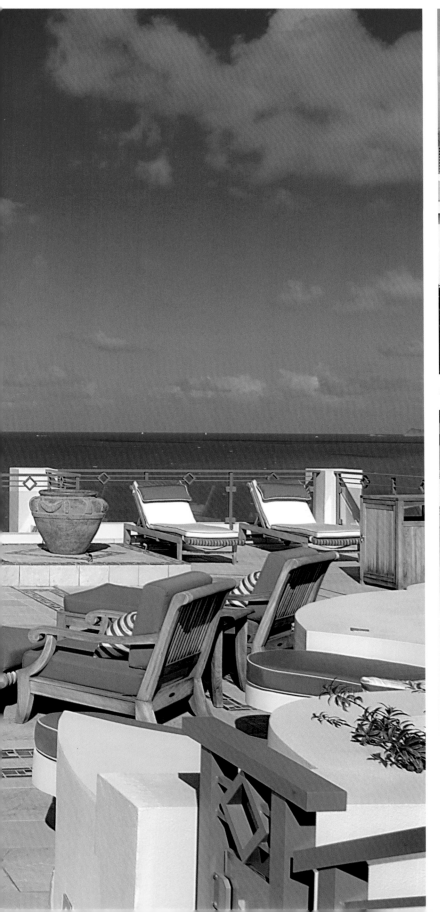

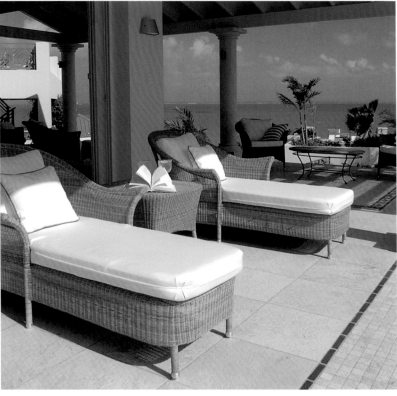

No Limit

Saint Martin, Caribbean

Situated in the hills of Terre-Basse, a peninsula separated from Saint Martin by a salt lagoon, this postmodern villa offers a view of the ocean and the neighboring island of Saba. An open-air lounge and the spacious, partially covered wooden deck of the infinity pool make the hustle and bustle of this Caribbean celebrity island seem far away and the elegant, minimalist design of the three bedrooms has a calming effect. A professional kitchen, spa and air-conditioned gym turn the estate into an inviting refuge that pampers its guests in every way.

In den Hügeln von Terre-Basse, einer durch eine Salzlagune von Saint-Martin getrennten Halbinsel, liegt diese postmoderne Villa mit Blick auf das Meer und die Nachbarinsel Saba. Eine Open-Air-Lounge und das großzügige, teils überdachte Holzdeck des Infinity-Pools lassen den Trubel der karibischen Prominenten-Insel in weite Ferne rücken, und das elegante, reduzierte Design der drei Schlafzimmer wirkt beruhigend. Eine Profiküche, ein Spa und ein klimatisierter Fitnessraum machen das Anwesen zu einem einladenden Refugium, das seine Gäste rundum perfekt verwöhnt.

Cette villa postmoderne avec vue sur l'océan et l'île voisine de Saba est située dans les collines de Terre-Basse, une péninsule séparée de Saint-Martin par un lagon d'eau salée. Le salon à ciel ouvert et la terrasse de bois spacieuse, partiellement couverte, au bord de la piscine à débordement vous transportent loin de l'agitation de l'île caribéenne préférée des célébrités. Le design élégant et minimaliste des trois chambres a un effet reposant. Une cuisine professionnelle, un spa et une salle de fitness climatisée transforment la propriété en un refuge accueillant qui choie parfaitement ses hôtes.

La posmoderna villa con vistas al mar y a la vecina isla de Saba está levantada sobre las colinas de Terre-Basse, una península separada de Saint Martin por una laguna de agua salada. Un lounge al aire libre y la tarima semicubierta de la piscina de desborde infinito permiten dejar atrás el ajetreo de esta isla caribeña frecuentada por famosos. El diseño elegante y minimalista de sus tres dormitorios crea un efecto relajante. La cocina profesional, spa y gimnasio climatizado le convierten en un atractivo refugio, que sabe mimar a sus huéspedes a la perfección.

Tra le colline di Terre-Basse, una penisola separata da Saint-Martin mediante una salina, si trova questa villa post-moderna con vista sul mare e sulla vicina isola di Saba. Una lounge all'aria aperta e il terrazzo di legno parzialmente coperto dell'infinity pool fanno apparire lontano il trambusto dell'isola caraibica dei VIP, mentre il design elegante e sobrio delle tre camere da letto ha un effetto rilassante. Una cucina professionale, una spa e una palestra climatizzata rendono la tenuta un rifugio invitante che vizia i suoi ospiti in tutti i modi possibili.

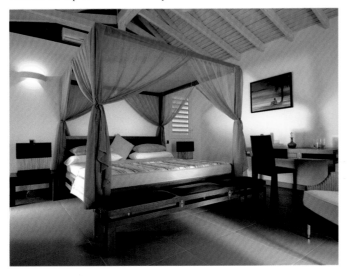

The light, friendly colors of the bedrooms are as fresh as a breeze.

Wie von einer Brise durchweht wirken die drei in lichten freundlichen Farben gehaltenen Schlafzimmer.

Les couleurs claires et agréables des chambres sont fraîches comme une brise.

La brisa parece acariciar a los tres dormitorios envueltos de agradables tonos claros.

Le tre camere da letto dai colori chiari e luminosi sembrano pervase dalla brezza.

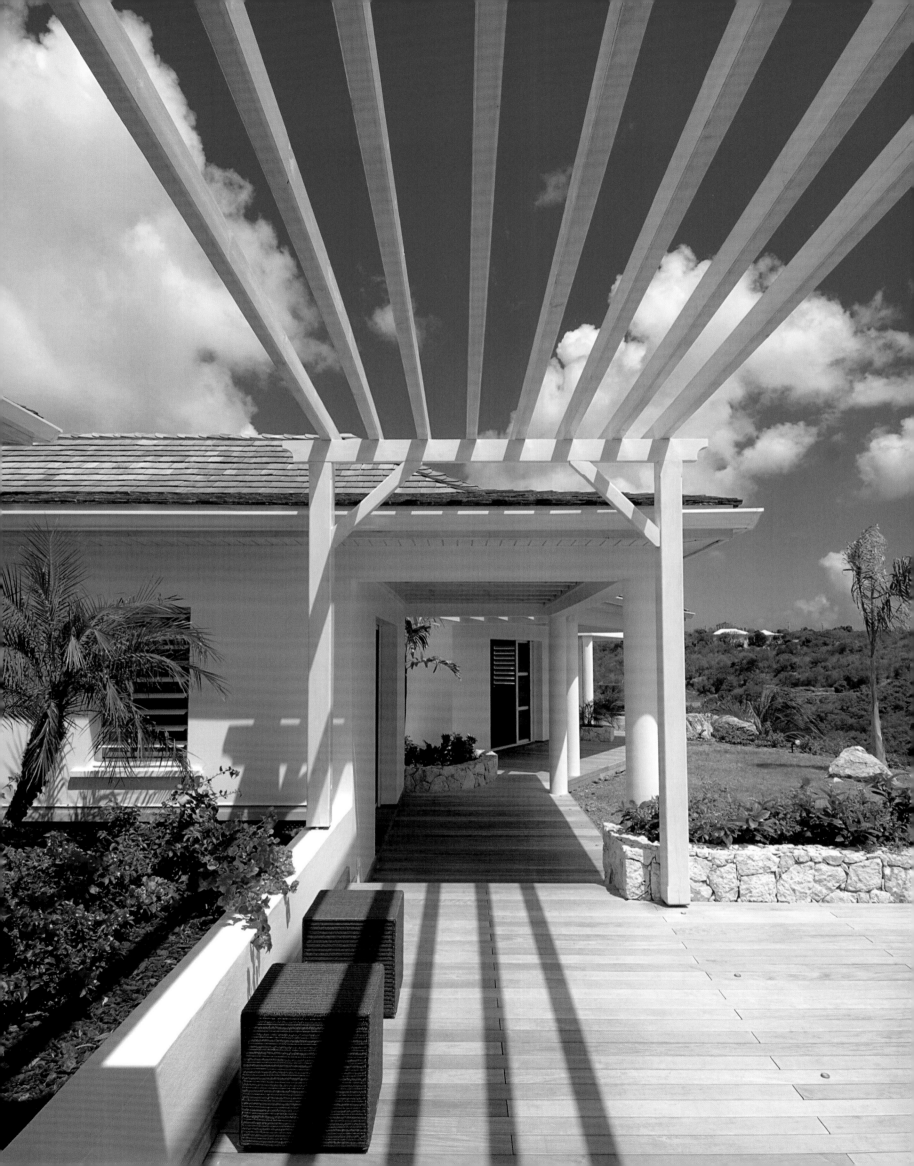

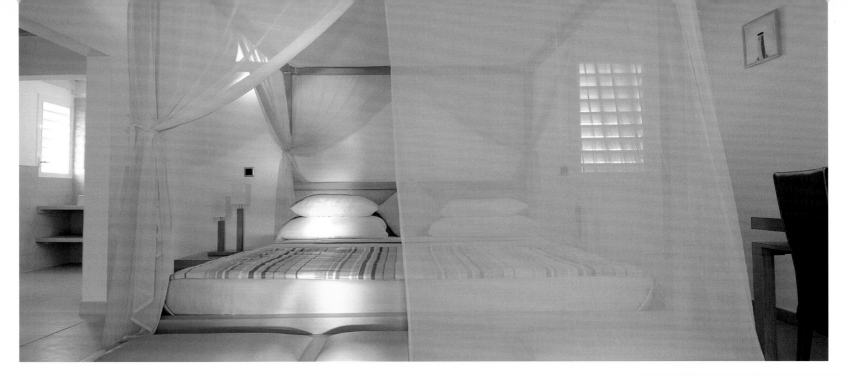

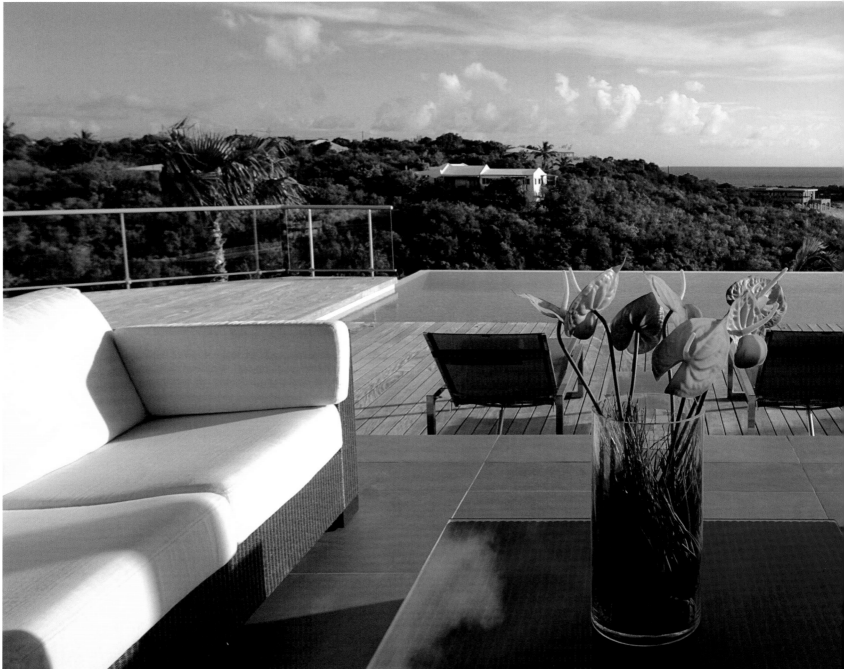

Caribbean spirit mixes with stylish functionality into contemporary elegance.

Karibisches Lebensgefühl verbindet sich mit stilvoller Funktionalität zu zeitgemäßer Eleganz.

L'art de vivre à la caribéenne, conjugué avec une fonctionnalité chic, aboutit à une élégance contemporaine.

El sentir caribeño se funde con una funcionalidad llena de estilo para derivar en elegancia contemporánea.

La gioia di vivere dei Caraibi si unisce ad una funzionalità piena di stile e diventa eleganza conforme ai tempi.

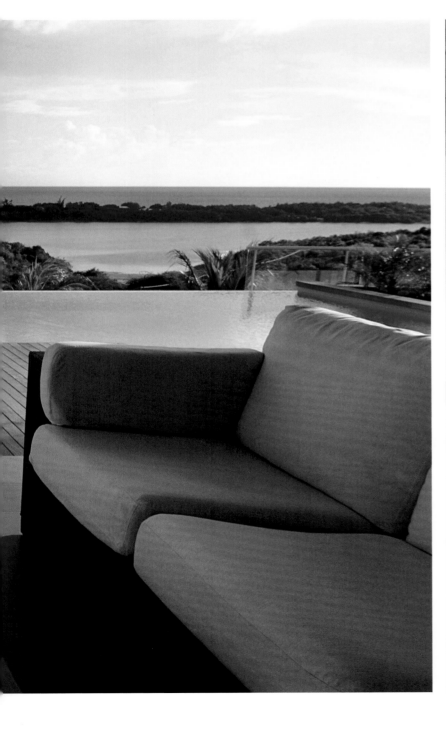

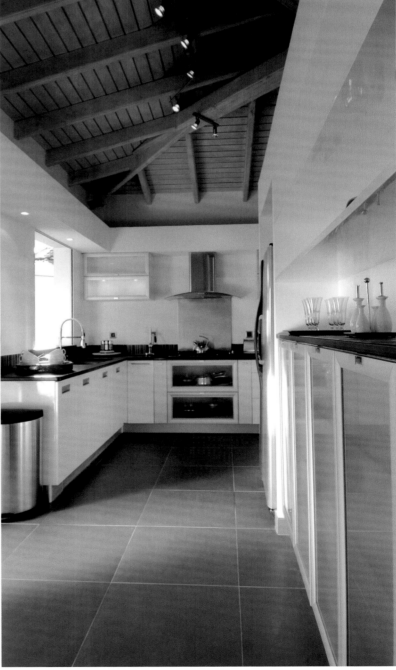

Wyler House

Mustique, Saint Vincent and the Grenadines, Caribbean

Wyler House is one of just 100 residences on the private island of Mustique to the north of Grenadine. Contemporary elegance defines its interior. A 100 ft. pool spanned by a bridge, multiple terraces with views of the surrounding tropical vegetation, a patio, three suites, along with a gaming room and gym, offer ample space to enjoy the peace and seclusion of the exclusive island. And if you're in the mood for a little action, take a stroll to the nearby yacht harbor.

Wyler House ist eine von nur 100 Residenzen auf der im Norden der Grenadinen liegenden Privatinsel Mustique. Zeitgenössische Eleganz prägt ihr Interieur. Ein 30 m langer, von einer Brücke überspannter Pool, mehrere Terrassen mit Aussicht auf die umgebende tropische Vegetation, ein Patio, drei Suiten sowie ein Spielzimmer und ein Fitnessraum bieten jede Menge Platz, um die Ruhe und Abgeschiedenheit der exklusiven Insel zu genießen. Steht einem der Sinn nach ein wenig Trubel kann man zu dem in der Nähe liegenden Yachthafen spazieren.

Wyler House est l'une des 100 résidences que compte l'île privée de Moustique, au nord des Grenadines. Une élégance contemporaine définit son intérieur. Une piscine de 30 m de long, enjambée par un pont, plusieurs terrasses avec vue sur la végétation tropicale environnante, un patio, trois suites, ainsi qu'une salle de jeux et une salle de fitness offrent un vaste espace pour profiter de la paix et de l'isolement de cette île élitiste. Si vous avez envie d'un peu plus d'activité, allez vous promener dans le port de plaisance voisin.

Wyler House es una de las aproximadamente 100 residencias de la isla privada de Mustique, en el norte de las Granadinas. La elegancia contemporánea domina el interior. Una piscina de 30 m de longitud salvada por un puente, varias terrazas con vistas a la vegetación tropical circundante, patio, tres suites, sala de juegos y gimnasio ofrecen un inmenso espacio para disfrutar de la calma y la privacidad de esta exclusiva isla. Si se busca un poco de ajetreo, siempre se puede dar un paseo por el puerto deportivo cercano.

Wyler House è una delle appena 100 residenze situate sull'isola privata di Mustique, nel nord delle Grenadine. Eleganza contemporanea caratterizza gli interni. Una piscina lunga 30 m, attraversata da un ponte, diversi terrazzi con vista sulla vegetazione tropicale circostante, un patio, tre suite, una stanza dei giochi e una palestra, offrono tutto lo spazio necessario per assaporare la tranquillità e la solitudine di quest'isola esclusiva. Se si ha voglia di un po' di trambusto, si può passeggiare verso il porto per gli yacht situato nelle vicinanze.

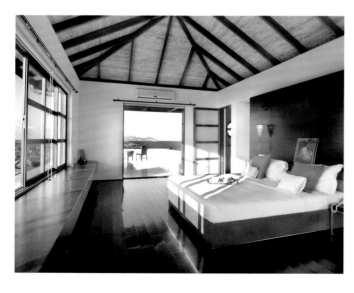

Spacious suites with fantastic views characterize the villa designed by Italian architect Paolo Piva.

Großzügige Suiten mit fantastischen Ausblicken prägen die Villa, die der italienische Architekt Paolo Piva entworfen hat.

La villa conçue par l'architecte italien Paolo Piva se distingue par des suites spacieuses offrant une vue fantastique.

Las amplias suites con fantásticas vistas caracterizan a la mansión diseñada por el arquitecto italiano Paolo Piva.

Spaziose suite con una vista fantastica caratterizzano questa villa progettata dall'architetto italiano Paolo Piva.

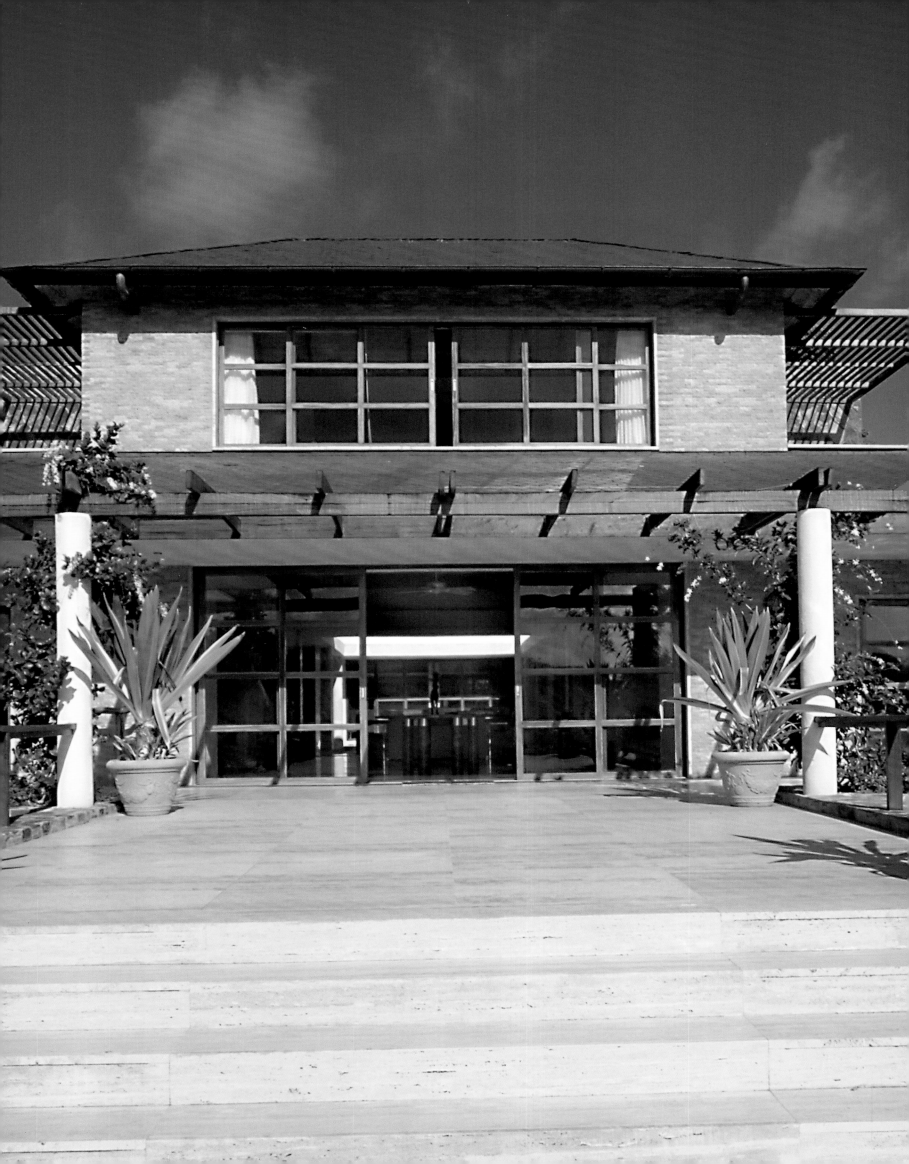

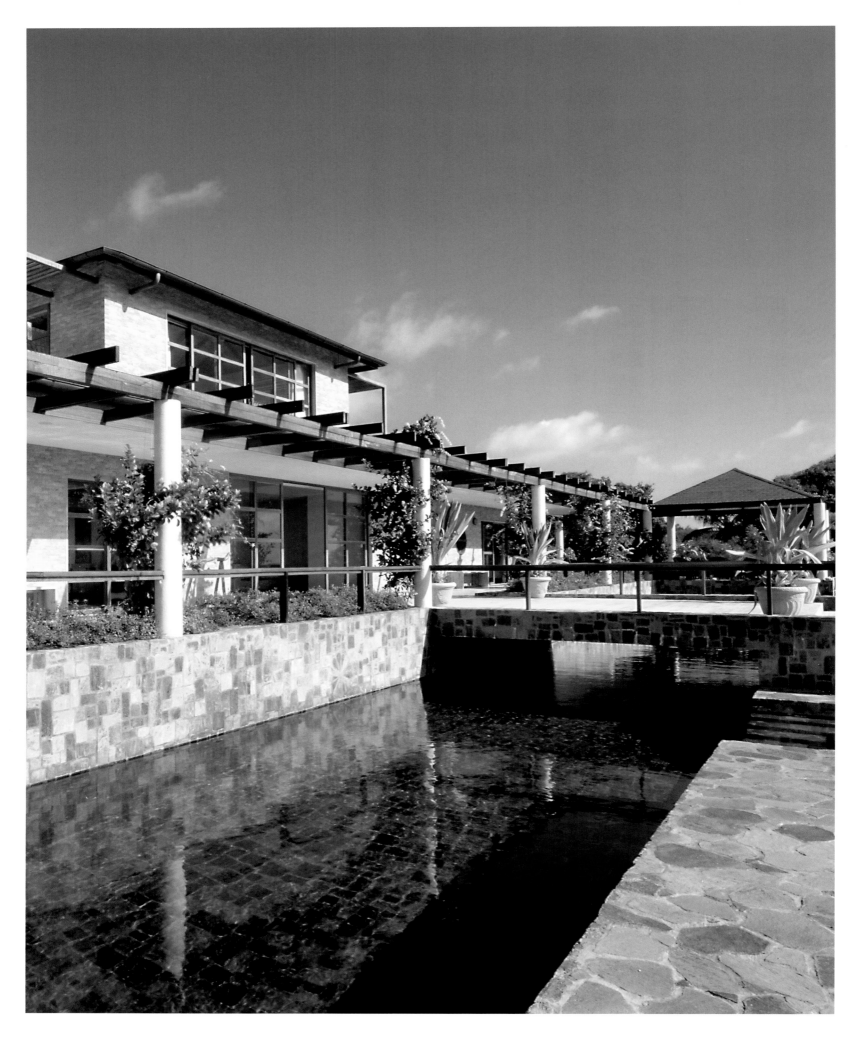

The only difficult decision to make here is choosing your favorite spot.

Schwer fällt hier nur die Entscheidung, welcher Ort zum Lieblingsplatz wird.

Choisir votre endroit préféré est la seule décision difficile que vous aurez à prendre ici.

En semejante vivienda es difícil escoger un rincón predilecto.

Qui è solo difficile scegliere quale luogo è il preferito.

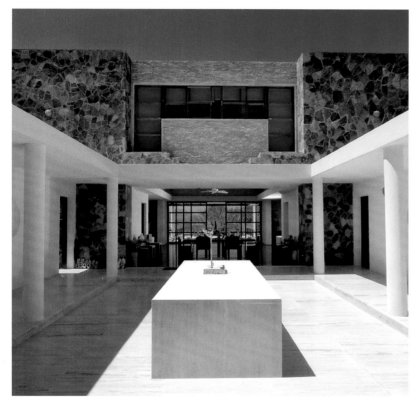

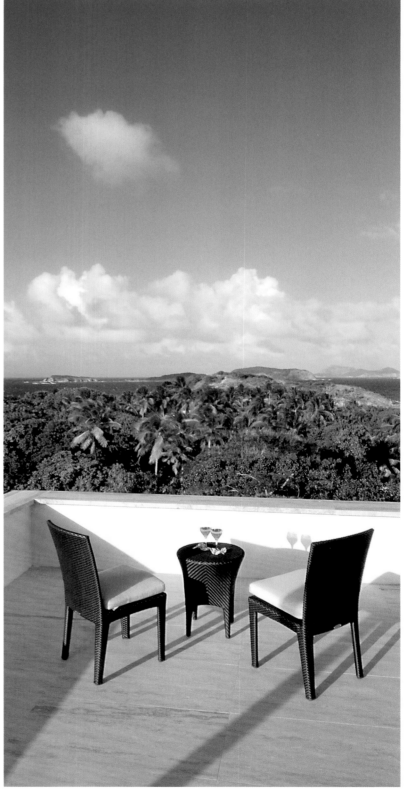

Cuixmala

Careyes, Mexico

Located in a dense tropical forest, this Moorish fairytale castle towers above 2 miles of untouched sand beach in Cuixmala on the Costalegre in Mexico. Situated in a nature reserve covering 24,000 acres, this estate was erected for billionaire Sir James Goldsmith, who spent the last ten years of his life there. The financial tycoon created his own idyllic universe: In addition to sea turtles, jaguars and hundreds of species of birds, exotic animals like zebras and antelopes make this area their habitat.

In Cuixmala an der mexikanischen Costalegre thront dieses maurische Märchenschloss in dichtem tropischen Wald über einem 3 km langen, menschenleeren Sandstrand. Das in einem 10.000 ha großen Naturschutzgebiet gelegene Anwesen wurde für den Milliardär Sir James Goldsmith erbaut, der hier die letzten zehn Jahre seines Lebens verbrachte. Der Finanzmagnat schuf sich sein eigenes, idyllisches Universum: Außer Meeresschildkröten, Jaguaren und Hunderten von Vogelarten leben hier Exoten wie Zebras und Antilopen.

Ce château de conte de fée de style maure se dresse fièrement à 3 km au-dessus d'une plage de sable déserte, dans une forêt tropicale dense, à Cuixmala sur la Costa Alegre au Mexique. La propriété située dans une réserve naturelle de plus de 10.000 ha a été construite pour le milliardaire Sir James Goldsmith, qui a passé ici les dix dernières années de sa vie. Le magnat de la finance y a créé son propre univers idyllique : outre des tortues de mer, des jaguars et des centaines d'espèces d'oiseaux, vivent ici des animaux exotiques comme des zèbres et des antilopes.

En Cuixmala, en la Costa Alegre mexicana, se levanta imponente este castillo morisco de fábula, entre la tupida selva tropical y ante una desierta playa de 3 km. La propiedad ubicada en un paraje natural de 10.000 ha, fue erigida por el multimillonario Sir James Goldsmith, que pasó aquí los últimos diez años de su vida. El magnate de las finanzas creo su propio universo idílico: además de tortugas marinas, jaguares y cientos de aves, en este lugar conviven animales aún más exóticos como cebras o antílopes.

A Cuixmala, sulla Costa Alegre messicana, troneggia questo castello moresco del mondo delle fiabe, nella fitta foresta tropicale su una spiaggia di sabbia assolutamente deserta, lunga 3 km. La tenuta, situata su un'area di 10.000 ettari posta sotto tutela ambientale, è stata costruita dal miliardario Sir James Goldsmith, che ha trascorso qui gli ultimi dieci anni della sua vita. Il magnate delle finanze creò qui il proprio universo idilliaco: oltre alle testuggini, ai giaguari e a centinaia di varietà di uccelli, vi vivono specie esotiche come zebre e antilopi.

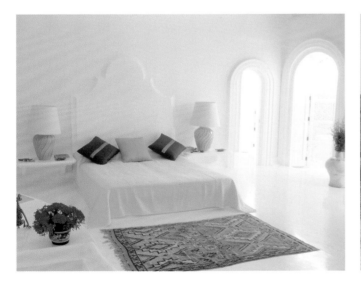

Luxury meets ecology: The Cuixmala Ecological Foundation protects the local biodiversity while the zoological park adds exotic animals. Food for the residence comes from its own organic cultivation.

Luxus und Ökologie: Die Cuixmala Ecological Foundation schützt die lokale Artenvielfalt, der Tierpark ergänzt sie um Exoten. Die Lebensmittel für die Residenz stammen aus eigenem Bioanbau.

Luxe et écologie : la Fondation Ecologique de Cuixmala protège la biodiversité locale et apporte des animaux exotiques au parc zoologique. La nourriture de la résidence provient de ses propres cultures biologiques.

Lujo y ecología: La Cuixmala Ecological Foundation protege la diversidad autóctona, complementada con ejemplares exóticos. Los alimentos para la vivienda proceden de sus propios cultivos ecológicos.

Lusso ed ecologia: la Cuixmala Ecological Foundation tutela la biodiversità locale, mentre il giardino zoologico la integra di specie esotiche. I generi alimentari della residenza sono di propria produzione biologica.

Cuixmala means "resting place for the soul." La Loma, the main structure with its effectively placed furniture and brilliant color accents, offers plenty of space for any soul to relax.

Cuixmala bedeutet „Ruheplatz für die Seele". Genug Raum um die Seele baumeln zu lassen bietet das Haupthaus La Loma mit wirkungsvoll platzierten Möbeln und leuchtenden Farbakzenten.

Cuixmala signifie « lieu de repos pour l'âme ». La Loma, la maison principale, avec ses meubles disposés judicieusement et ses accents de couleur brillante, offre énormément d'espace pour savourer une pause loin des tracas quotidiens.

Cuixmala significa "el lugar de reposo para alma". La Loma, la casa principal, con un mobiliario dispuesto de forma eficaz y toques de color, ofrece espacio de sobra para ello.

Cuixmala significa "luogo di riposo per l'anima". La casa principale La Loma, con mobili e tocchi di colore piazzati a effetto, offre spazio sufficiente al relax.

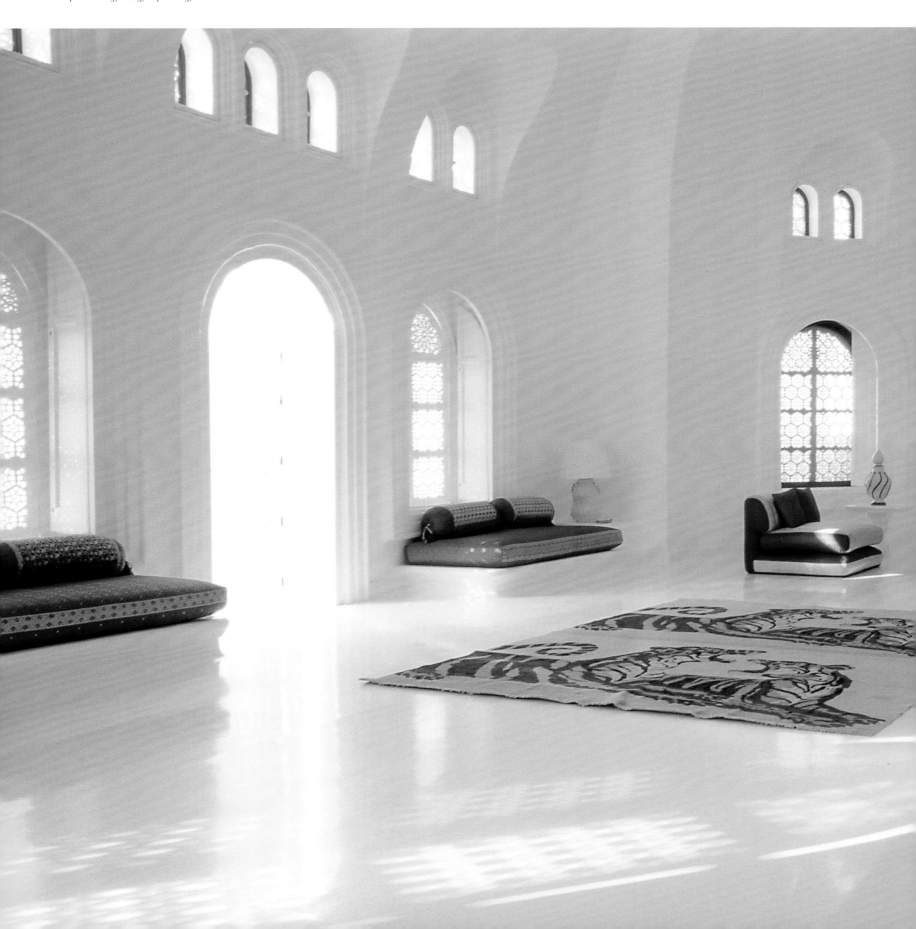

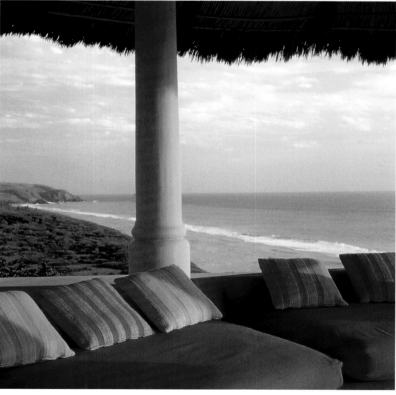

Casas de Careyes

Careyes, Mexico

Built in the traditional Mexican style, Casas de Careyes offers a magnificent view of the ocean and islands just off the coast. Six houses lie scattered across the steep cliffs on the Costa Careyes, which is part of Costa Alegre. You can choose from three to six bedrooms and spectacular terraces—the perfect place to enjoy the sunset. Although the coast here is relatively pristine, a golf course and a polo club are nearby. But it's the splendid waves of the Pacific that are every surfer's dream.

Eine herrliche Aussicht auf das Meer und die vorgelagerten Inseln eröffnet sich von den bunten, im traditionellen mexikanischen Stil erbauten Casas de Careyes. Die sechs über der Steilküste verstreuten Häuser an der zur Costa Alegre gehörenden Costa Careyes besitzen drei bis sechs Schlafzimmer und spektakuläre Terrassen – der perfekte Ort, um den Sonnenuntergang zu genießen. Obwohl die Küste relativ unberührt ist, gibt es in der Nähe einen Golfplatz und einen Poloclub. Der Traum eines jeden Surfers sind hingegen die herrlichen Wellen des Pazifiks.

La Casa Careyes, construite dans le style traditionnel mexicain, très coloré, offre une magnifique vue sur l'océan et les îles depuis la côte. Les six maisons dispersées sur les falaises de la Costa Careyes, qui fait partie de la Costa Alegre, ont de trois à six chambres et de spectaculaires terrasses – lieu idéal pour profiter du coucher de soleil. Bien que la côte soit relativement préservée, un parcours de golf et un club de polo sont situés à proximité. Les vagues splendides du Pacifique restent pourtant le rêve de tout surfeur.

Ante las Casas Careyes se abre una panorámica de fabulosas vistas al mar y a las islas. Las seis viviendas fueron construidas según el colorista estilo tradicional mexicano y diseminadas por la escarpada Costa Careyes, que forma parte de Costa Alegre. Disponen de tres a seis dormitorios y espectaculares terrazas. El sitio perfecto para disfrutar del atardecer. Si bien la costa aún permanece relativamente intacta, ya cuenta con un campo de golf y un club de polo cercanos. Aquí se cumple el sueño de todo surfista: cabalgar sobre las enormes olas del Pacífico.

Una vista magnifica sul mare e sulle isole fronteggianti si apre davanti alle colorate Casas Careyes, costruite in stile tradizionale messicano. Le sei case distribuite sulla ripida Costa Careyes, appartenente alla Costa Alegre, possiedono dalle tre alle sei camere da letto e terrazze spettacolari – il luogo perfetto per godere del tramonto. Nonostante la costa sia relativamente incontaminata, nelle vicinanze ci sono un campo da golf e un club di polo. Le magnifiche onde del Pacifico, invece, rappresentano il sogno di ogni surfista.

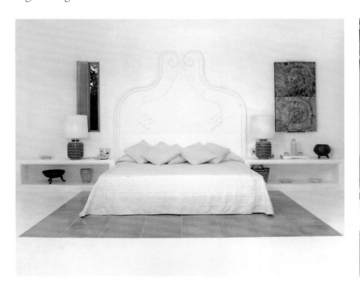

Modern Mexican art is prominently accentuated by the purist decor of the rooms. And the impression outside is hardly less opulent either.

Moderne mexikanische Kunst erhält mit den puristisch eingerichteten Zimmern einen wirkungsvollen Rahmen. Kaum weniger opulent ist der Außenbereich.

Les pièces meublées de manière puriste sont le cadre parfait pour mettre en valeur l'art mexicain moderne. L'espace extérieur est presque aussi opulent.

El arte moderno mexicano encuentra el marco perfecto en las estancias de decoración austera. Los exteriores no los son menos.

L'arte messicana moderna ottiene una cornice d'effetto con le camere arredate in modo puristico. L'area esterna non è meno ricca.

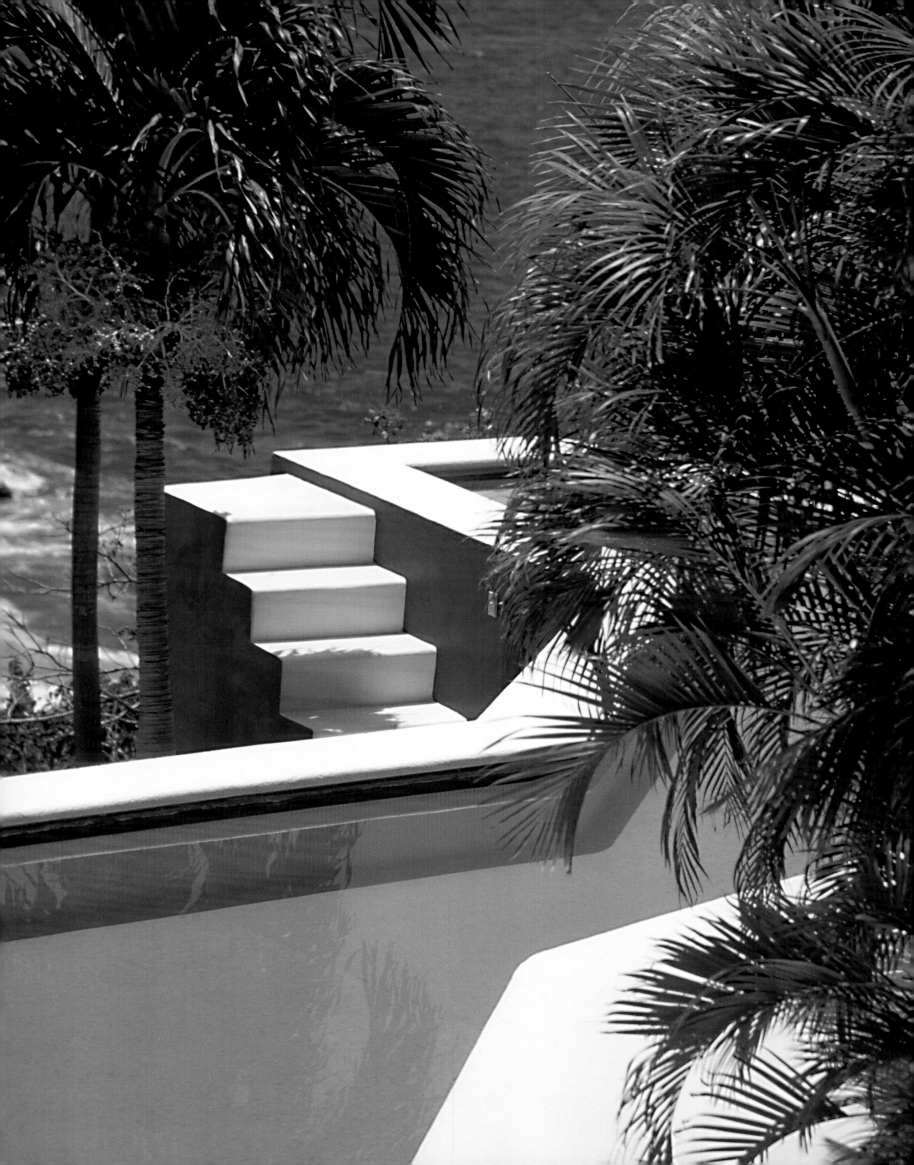

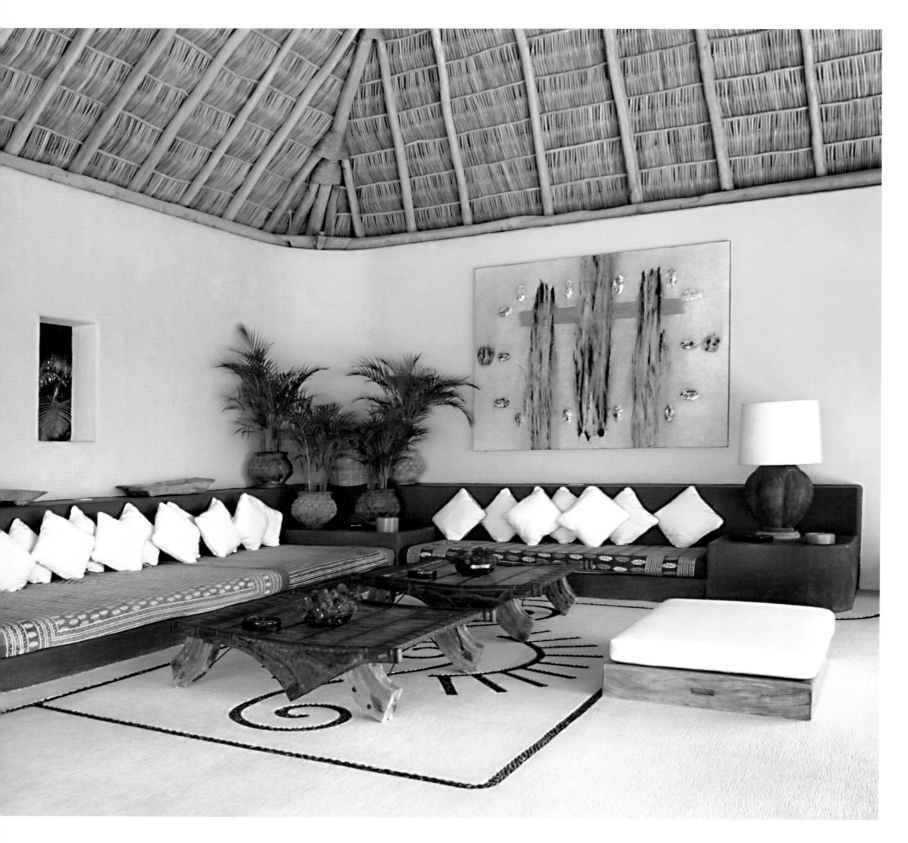

Think hacienda: *The colors of Mexico show their full beauty in a clear, minimalist ambience.*

Hacienda-Feeling: *In einem klaren, reduzierten Ambiente entfalten die Farben Mexikos ihre ganze Schönheit.*

Atmosphère d'hacienda : *les couleurs du Mexique déploient toute leur beauté dans une ambiance claire et minimaliste.*

Ambiente de hacienda: *en espacios diáfanos y reducidos, los colores de México se despliegan mostrando toda su belleza.*

Come in una hacienda: *in un ambiente nitido ed essenziale i colori del Messico si mostrano in tutta la loro bellezza.*

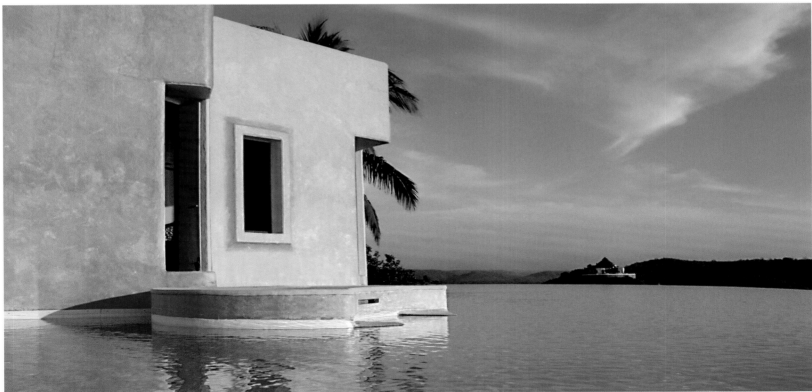

Villa Trancoso

Trancoso, Brazil

This light-flooded villa is situated in the northeastern Brazilian city of Trancoso, the most fashionable beach town in South America. The living room, kept in white, extends across the entire first floor and opens on a shady veranda. White wooden ceilings and fans radiate an optical coolness, four-post beds of dark wood and colorful rugs, pillows, and covers contrast with the brightness of the interior, while wide doors led to the wooden pool deck. The overall effect is a tropical feeling of well-being.

In Trancoso im Nordosten Brasiliens, dem angesagtesten Strandort Südamerikas, liegt diese lichtdurchflutete Villa. Das in Weiß gehaltene Wohnzimmer erstreckt sich über die ganze erste Etage und öffnet sich zu einer schattigen Veranda. Weiße Holzdecken und Ventilatoren verströmen optische Kühle, Vierpfostenbetten aus dunklem Holz und farbenfrohe Teppiche, Kissen und Decken brechen die Helligkeit des Interieurs auf, während breite Türen zum Pooldeck aus Holz führen. So entsteht eine tropische Wohlfühlatmosphäre.

Cette villa inondée de lumière se situe au nord-est du Brésil, dans la ville de Trancoso, cité balnéaire la plus tendance d'Amérique du Sud. La salle de séjour, décorée en blanc, s'étend sur tout le premier étage et s'ouvre sur une véranda ombragée. Des plafonds de bois blanc et des ventilateurs dégagent une impression de fraîcheur, les lits à colonnes en bois foncé et les tapis, oreillers et couvertures colorés contrastent avec la clarté de l'intérieur, alors que de larges portes mènent à la terrasse de bois qui entoure la piscine. L'effet général : une atmosphère de bien-être tropical.

En Trancoso, al noreste de Brasil, el enclave turístico de playa más solicitado de toda Sudamérica, se ha emplazado una mansión inundada de luz. El salón en blanco ocupa toda la primera planta y se abre a un porche bañado de sombra. Los techos de madera blancos y los ventiladores transmiten frescor a la vista. Camas con dosel de madera oscura, alfombras, cojines y techos llenos de color rompen con la claridad interior. Las amplias puertas conducen a la piscina con cubierta de madera. El objetivo es crear un ambiente tropical de bienestar.

A Trancoso, nel nord-ovest del Brasile, il luogo più in voga del Sudamerica, si trova questa villa piena di luce. Il salone tinteggiato di bianco si estende su tutto il primo piano e si apre su una veranda ombreggiata. Soffitti bianchi e ventilatori trasmettono l'idea del fresco, letti di legno scuro a quattro colonne e tappeti, cuscini e coperte colorati spezzano la luminosità dell'interno, mentre ampie porte aprono la strada verso la piscina di legno. Così si viene a creare un'atmosfera tropicale di benessere.

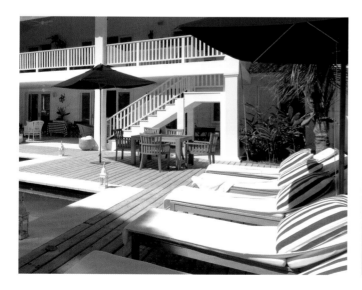
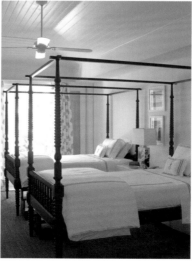

The pool makes you want to spend the whole afternoon there. Only the beds in the four colonial-style bedrooms are more comfortable than the sun loungers.

Am Pool möchte man manchen Nachmittag verstreichen lassen. Komfortabler als die dortigen Liegen sind nur noch die Betten der vier in Kolonialstil gehaltenen Schlafzimmer.

La piscine vous invite à vous détendre tout l'après-midi. Seuls les lits des quatre chambres de style colonial offrent plus de confort que les chaises longues.

En las tumbonas de la piscina no surje otro deseo que hacer infinita la tarde. Aún más cómodas aún son las camas de los cuatro dormitorios decorados al estilo colonial.

A bordo piscina viene voglia di trascorrere più di un pomeriggio. Più confortevoli delle sdraio disponibili sono solo i letti che si trovano nelle quattro camere da letto in stile coloniale.

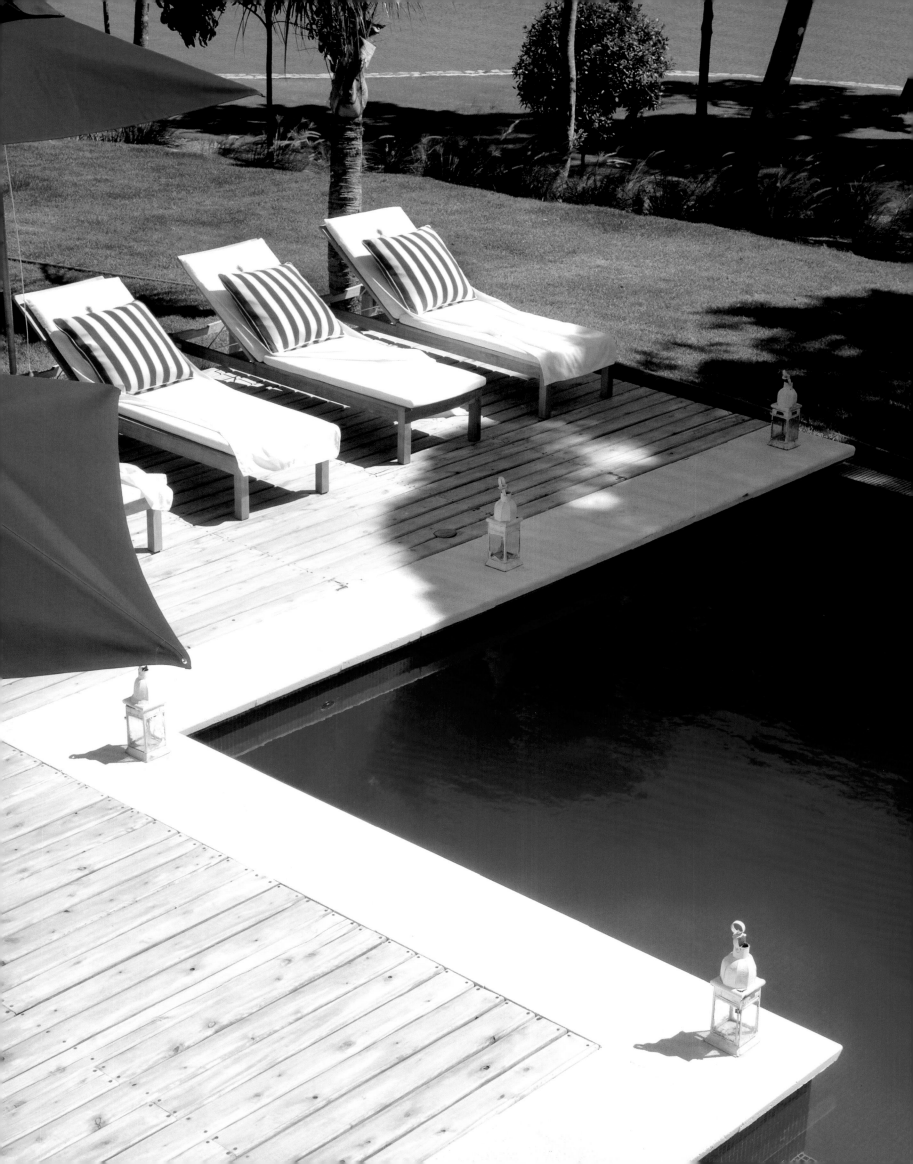

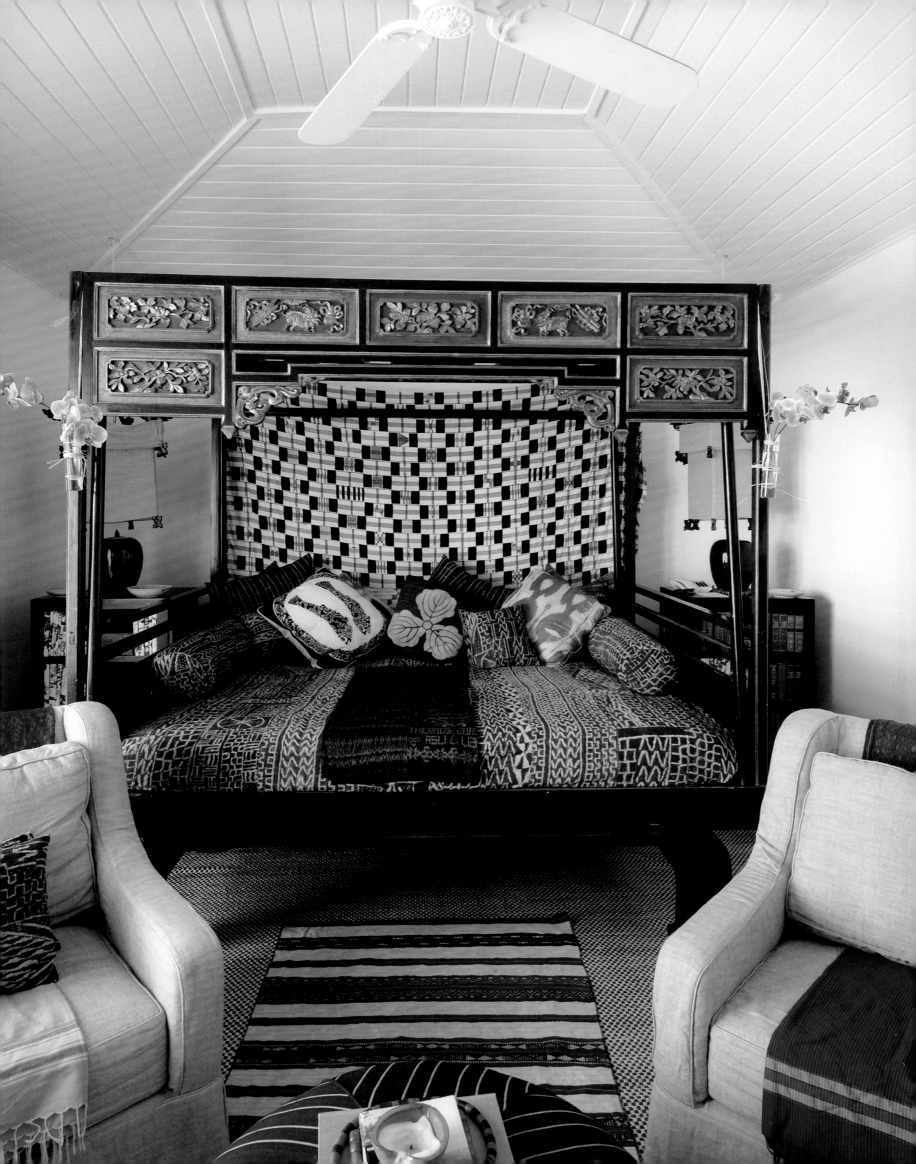

A blaze of colors *against the white floors, ceilings, and walls: The bedroom and lounge are a feast for the eyes.*

Farbenpracht vor *weißen Böden, Decken und Wänden: Schlafzimmer und Lounge sind ein Fest für die Augen.*

Une explosion de couleurs *sur les sols, plafonds et murs blancs : les chambres et le salon sont un régal pour les yeux.*

Frente al blanco reluciente *de los suelos, el techo y las paredes, el derroche de color de los dormitorios y la sala de estar son una fiesta para la vista.*

Un arcobaleno di colori *in contrasto con pavimenti, soffitti e pareti bianchi: la camera da letto e la lounge sono una festa per gli occhi.*

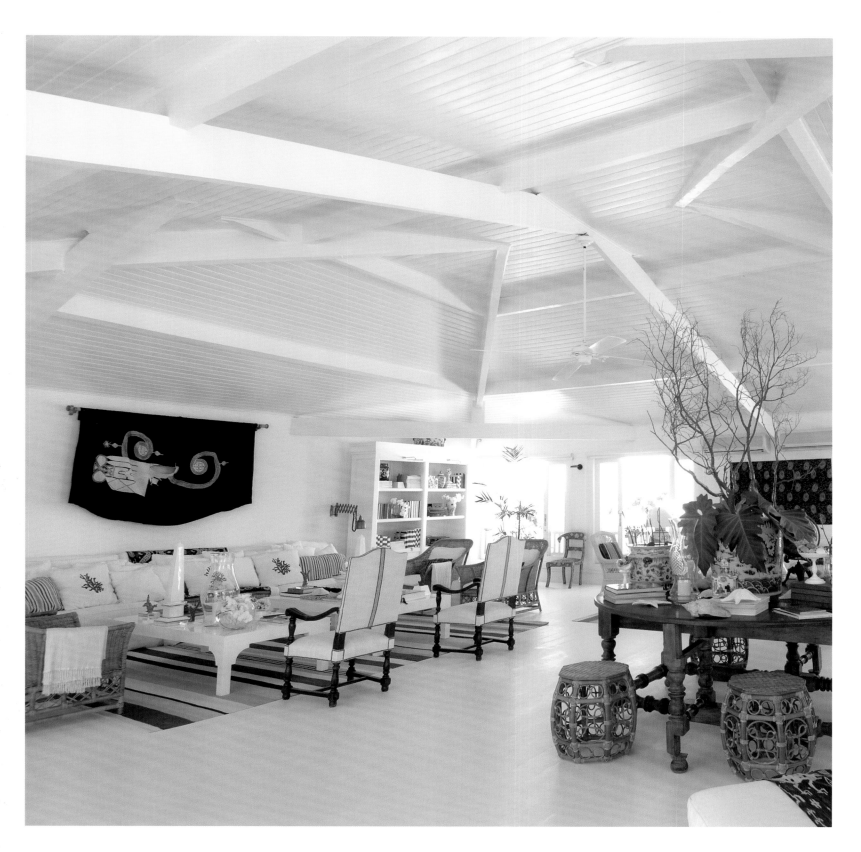

Villa Trancoso combines the structures of Brazilian colonial architecture with contemporary design and creates an overwhelming ambience as a result.

Die Villa Trancoso *verbindet die Strukturen brasilianischer Kolonialarchitektur mit zeitgenössischem Design und schafft so eine überwältigendes Ambiente.*

La Villa Trancoso *marie les structures de l'architecture coloniale brésilienne et le design contemporain pour créer une ambiance irrésistible.*

Villa Trancoso *aúna las estructuras de la arquitectura colonial brasileña con el diseño contemporáneo, ob-teniendo como resultado un magnífico ambiente.*

Villa Trancoso *unisce le strutture dell'architettura coloniale brasiliana con il design contemporaneo, creando un ambiente straordinario.*

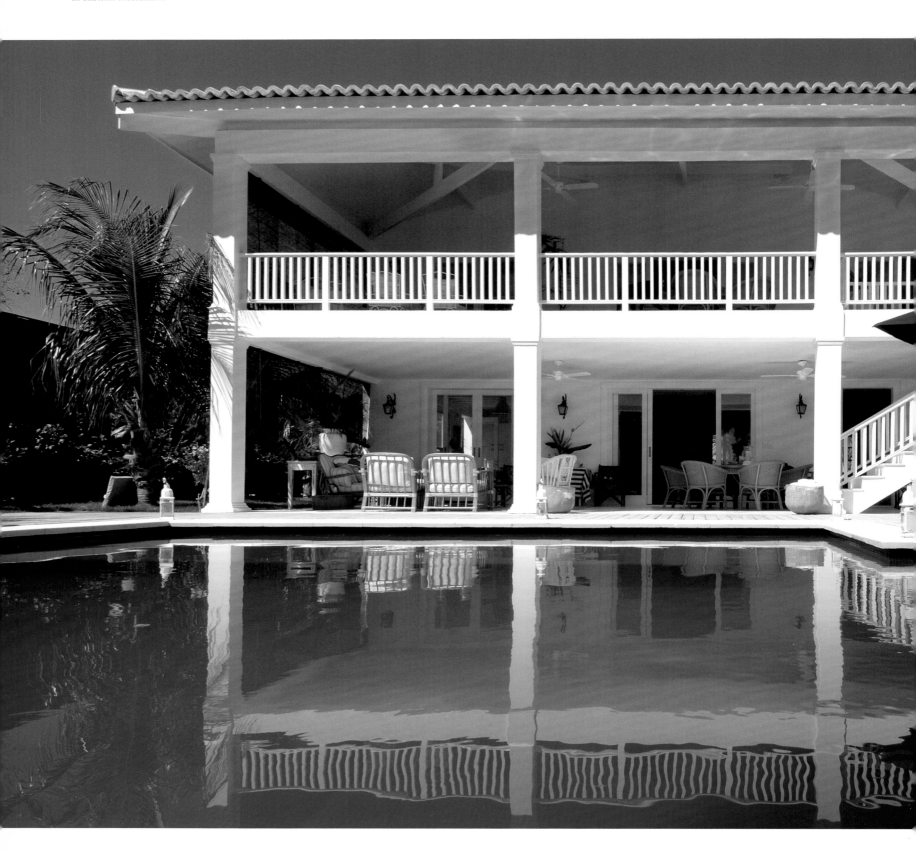

Chalet Eugenia
Klosters, Switzerland

The chalet of a well-known industrialist family from Germany in the posh Swiss ski resort of Klosters boasts eight cozy bedrooms—two of them with their own fireplace—and eight bathrooms. Add to that a study, a wine cellar and a spacious living area. Beams, carpets and a fireplace in the middle lend a warm atmosphere to this center of the chalet. Even though the chalet is just a ten-minute walk away from the village, its location within a large garden at the end of a private road offers absolute privacy.

Das Chalet einer bekannten deutschen Industriellenfamilie im Schweizer Nobelskiort Klosters verfügt über acht kuschelige Schlafzimmer – zwei davon mit einem eigenem Kamin – und acht Bäder sowie ein Arbeitszimmer, einen Weinkeller und einen weitläufigen Wohnraum. Diesem Zentrum des Hauses verleihen Balken, Teppiche und ein in der Mitte platzierter Kamin eine warme Atmosphäre. Obwohl die Ortschaft nur einen zehnminütigen Spaziergang entfernt liegt, bietet die Lage in einem großen Garten am Ende eines Privatwegs absolute Abgeschiedenheit.

Le chalet d'une célèbre famille d'industriels allemands, dans la station de sports d'hiver cossue de Klosters, en Suisse, dispose de huit chambres confortables – dont deux avec cheminée – et de huit salles de bains. Elle comprend également un bureau, une cave à vins et une vaste salle de séjour. Les poutres, les tapis et la cheminée au centre confèrent une atmosphère chaleureuse au cœur de la maison. Bien qu'elle soit seulement à dix minutes à pied du centre ville, son emplacement au bout d'une route privée et son grand jardin offrent un isolement absolu.

El chalé propiedad de una conocida familia de industriales alemanes, está ubicado en la exclusiva estación de esquí suiza de Klosters. Cuenta con ocho acogedores dormitorios, dos de ellos con su propia chimenea, ocho baños, un despacho, una bodega y un espacioso salón, centro del hogar dotado de vigas, alfombras y una chimenea central que configuran un cálido ambiente. Aunque al pueblo se llega en un paseo de unos diez minutos, su ubicación, en un inmenso jardín al final de un camino privado, permite que quede aislado por completo.

Lo chalet di una nota famiglia di industriali tedeschi, a Klosters, la località svizzera per lo sci d'èlite, dispone di otto accoglienti camere da letto – di cui due con camino – e di otto bagni, di uno studio, di una cantina per i vini e di un soggiorno spazioso. Le travi, i tappeti e un camino posizionato al centro della stanza donano un'atmosfera calda al cuore della casa. Nonostante il paese disti solo pochi minuti a piedi, la posizione all'interno di un grande giardino, al termine di una strada privata, offre isolamento assoluto.

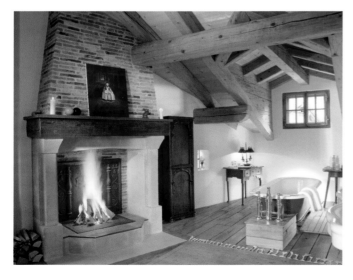

Possibly the most exclusive house in Klosters, Chalet Eugenia exudes charming Alpine coziness without getting hung up on kitsch.

Das wohl exklusivste Haus in Klosters verströmt gediegene alpenländische Behaglichkeit, ohne sich ins Kitschige zu verlieren.

Sans doute la maison la plus exclusive de Klosters, elle dégage un confort alpin élégant sans tomber dans le kitsch.

La que posiblemente sea la vivienda más exclusiva de Klosters emana una sobria sensación de bienestar alpino sin caer en lo kitsch.

La casa in assoluto più esclusiva di Klosters emana l'atmosfera piacevole e accurata delle Alpi, senza perdersi nel kitsch.

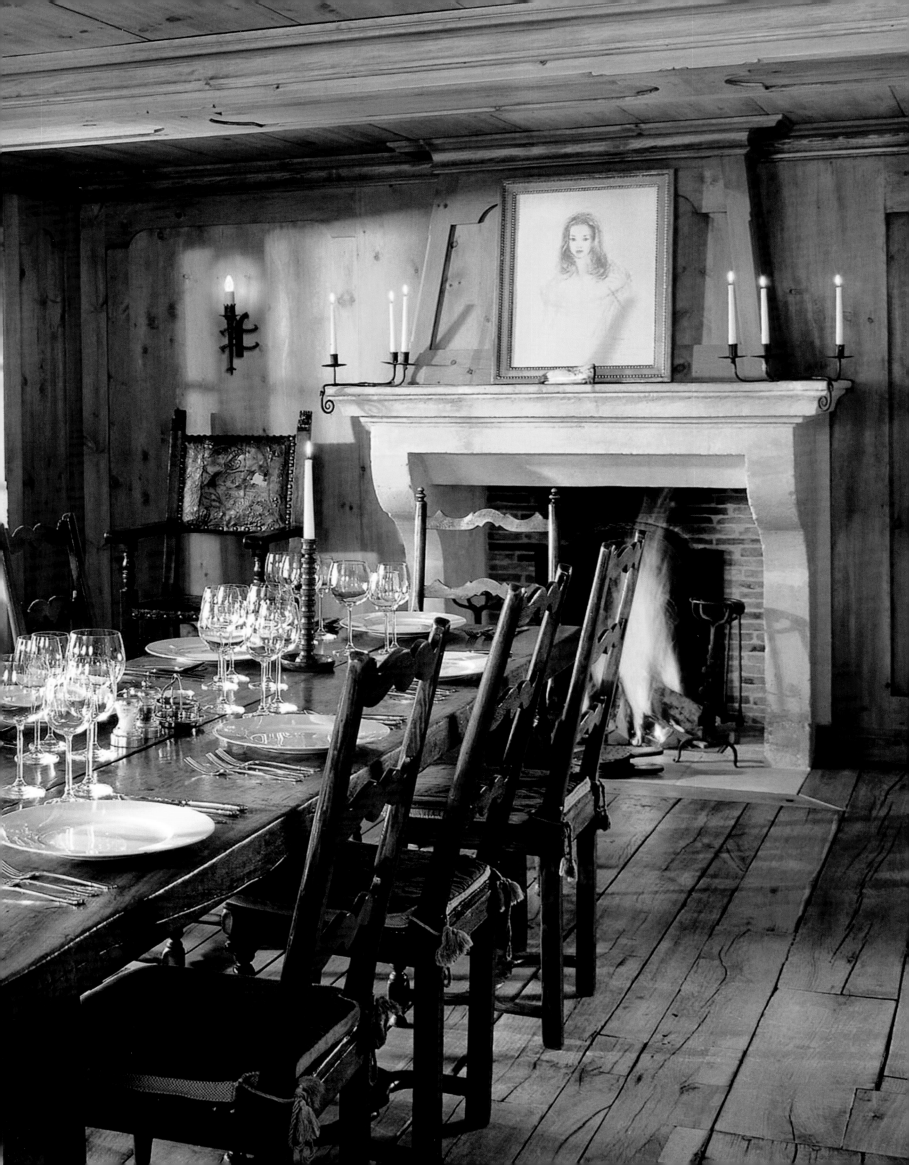

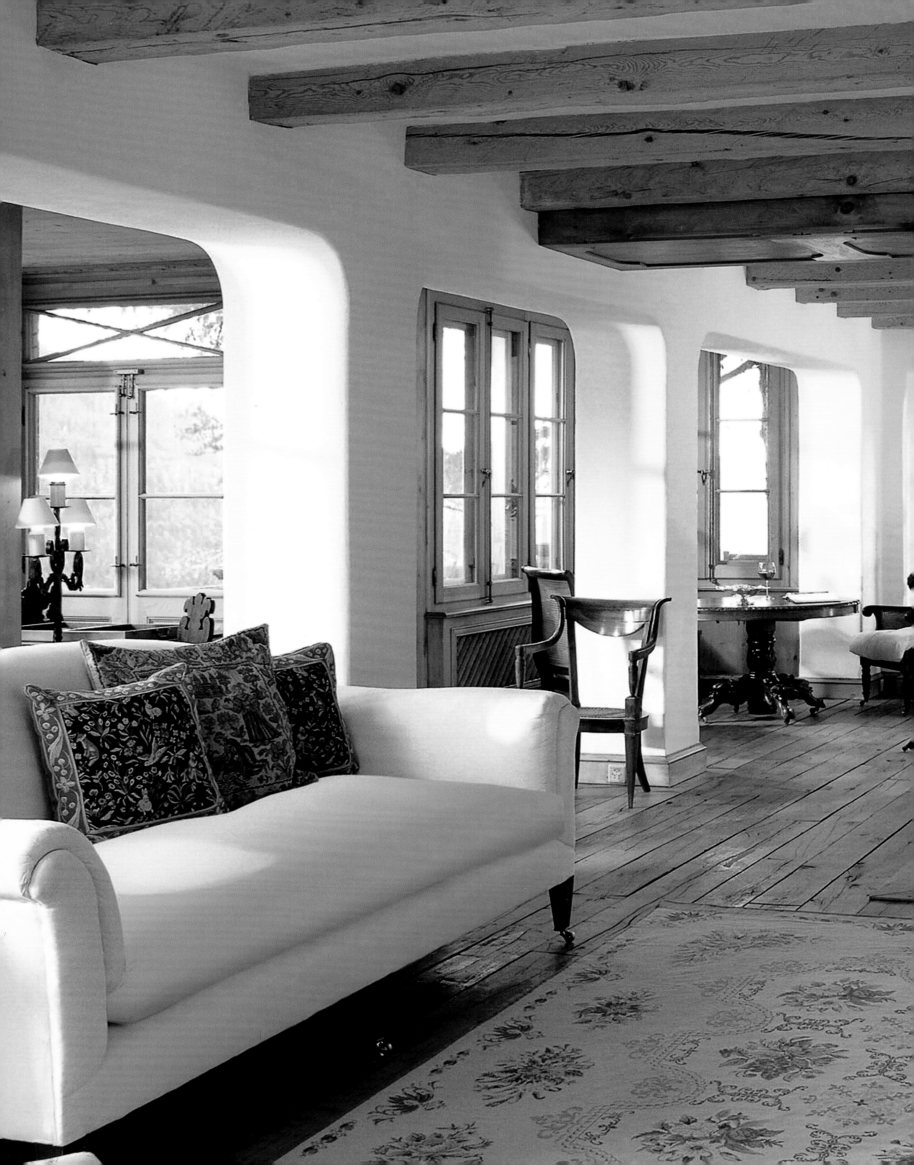

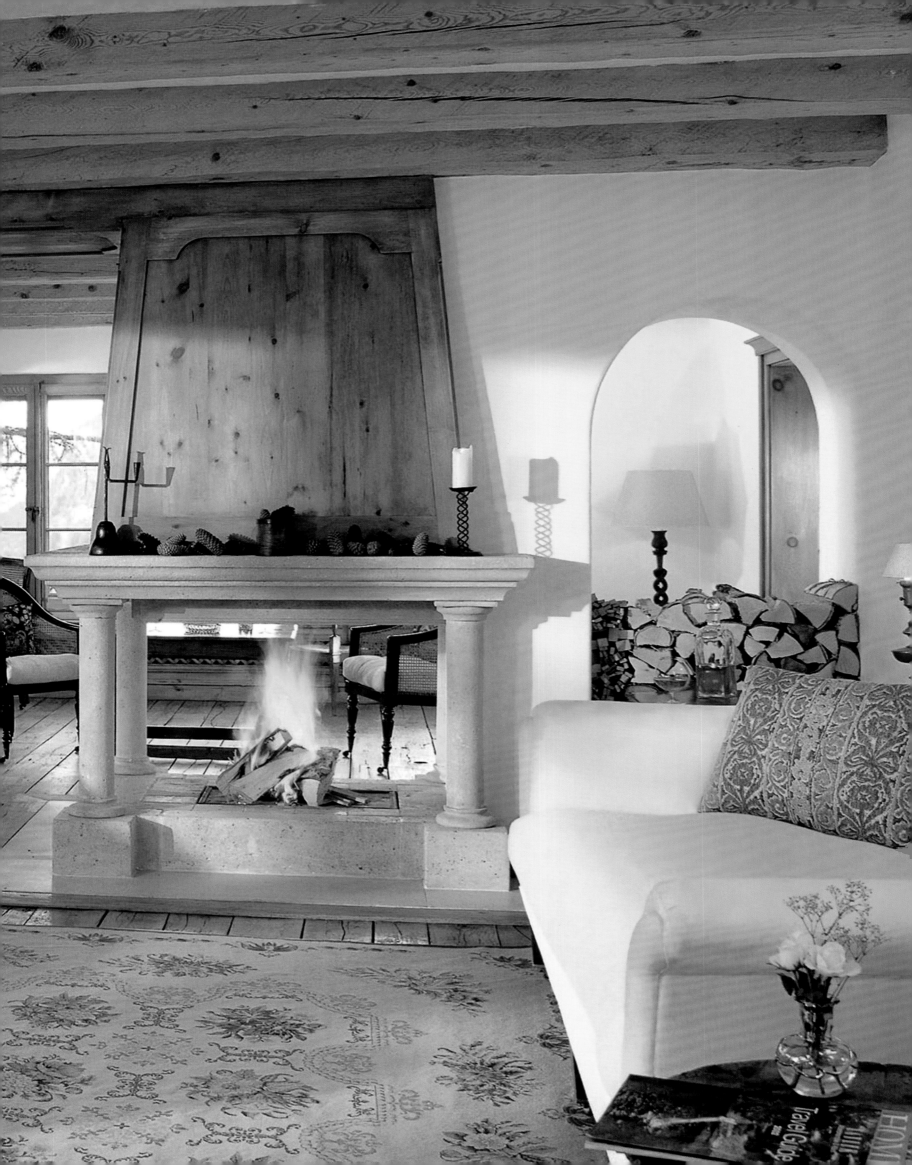

Villa Ramatuelle

Saint Tropez, France

This hill above Saint Tropez makes you feel close to the sky. Beyond the infinity pool, the Mediterranean shimmers in deep blue and fragrant pines frame a view that reveals nothing of the summertime run on the Côte d'Azur. The one-story honey-colored villa with its red tile roof and white double doors is decorated Mediterranean style with shades of white and brown. A chef, butler and chauffeur are on call. Relaxing in the thick pillows of the white ottomans on the terrace, who wouldn't want to be pampered by their services?

Auf diesem Hügel über Saint-Tropez fühlt man sich dem Himmel nahe. Jenseits des Infinity-Pools liegt tiefblau das Mittelmeer und duftende Pinien rahmen eine Aussicht, die nichts vom sommerlichen Massenansturm auf die Côte d'Azur verrät. Die einstöckige honigfarbene Villa mit rotem Ziegeldach und weißen Flügeltüren ist in mediterranem Stil in Weiß- und Brauntönen eingerichtet. Koch, Butler und Chauffeur stehen auf Abruf bereit. In den dicken Kissen der weißen Ottomane auf der Terrasse ruhend, lässt man sich gerne von ihren Diensten verwöhnen.

Vous vous sentirez proche du paradis sur cette colline surplombant Saint-Tropez. Au-delà de la piscine à débordement, le bleu profond de la Méditerranée miroite et les pins odorants encadrent la vue qui ne révèle rien de la ruée estivale sur la Côte d'Azur. La villa de plain-pied, couleur miel, avec son toit de tuiles rouges et ses doubles portes blanches, est meublée dans le style méditerranéen avec des teintes de blanc et de brun. Un chef cuisinier, un majordome et un chauffeur sont à disposition. Grâce à leurs services, vous serez choyé en vous reposant tranquillement sur la terrasse dans les épais coussins des divans.

Desde esta colina dominando Saint-Tropez parece poder tocarse el cielo. El azul intenso del Mediterráneo que prolonga la piscina de desborde infinito y el aroma de los pinos componen un cuadro en el que se pierden de vista las masificaciones estivales de la Costa Azul. La villa de una planta en color miel, tejas rojas y puertas batientes blancas se ha decorado en tonos blancos y marrones al estilo mediterráneo. La vivienda dispone de cocinero, mayordomo y chófer. Postrado sobre los cojines de los blancos divanes de la terraza, sólo resta disfrutar del servicio.

Su questa collina situata sopra Saint-Tropez ci si sente vicini al cielo. Al di là dell'infinity pool si trova il Mediterraneo di un blu profondo, e pinete profumate incorniciano un panorama che non svela nulla dell'assalto di massa alla Costa Azzurra. La villa color miele ad un piano, con il tetto di tegole rosse e le porte a battenti bianche, è arredata in stile mediterraneo nelle tonalità del bianco e del marrone. Il cuoco, il maggiordomo e l'autista sono pronti a servirvi. Sdraiati sui grandi cuscini dell'ottomana bianca sul terrazzo, è un piacere farsi viziare dai loro servigi.

Unobtrusive elegance dominates the inside, while the magic of the French Midi enchants the outside.

Innen herrscht unaufdringliche Eleganz, draußen wirkt die Magie des französischen Midi.

Une élégance discrète domine l'intérieur, tandis que la magie du Midi enchante l'extérieur.

En el interior impera una elegancia contenida, mientras, en el exterior reina la magia del Midi galo.

All'interno regna un'eleganza discreta e all'esterno si ha la magia del Midi francese.

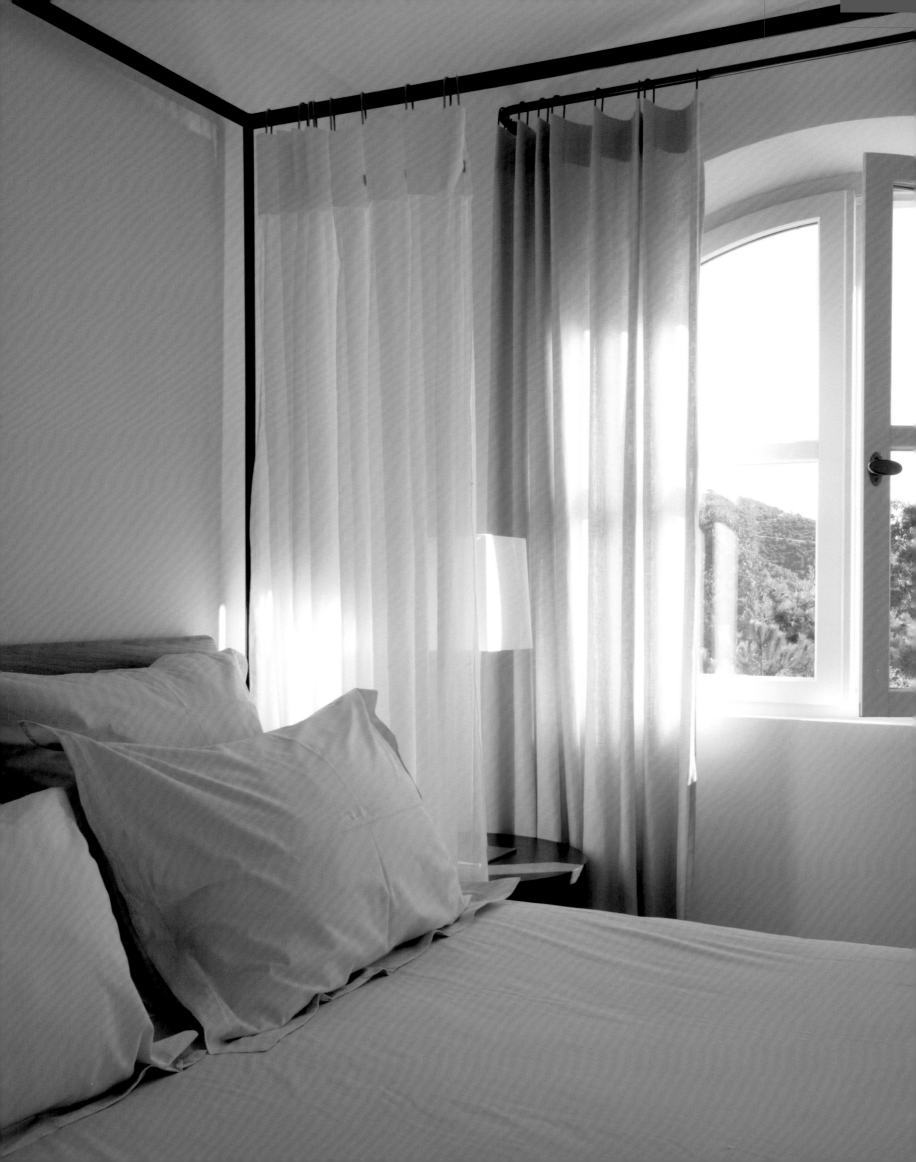

The pine fragrance and singing of the cicada have an instant calming effect. Comfortable beds and bathrooms, as beautiful as wellness oases, do the rest.

Der Duft der Pinien und der Gesang der Zikaden entspannen unmittelbar. Den Rest erledigen bequeme Betten und Bäder, so schön wie Wellness-Oasen.

Le parfum des pins et le chant des cigales vous invitent immédiatement à la détente. Des lits et des chambres confortables, aussi beaux que des oasis de bien-être, font le reste.

El aroma de los pinos y el canto de las cigarras envuelven en relax. Del resto se ocupan cómodas camas y baños dotados de la belleza de un oasis de bienestar.

Il profumo dei pini e il canto delle cicale rilassano con effetto immediato. Per il resto, sono disponibili comodi letti e bagni belli come oasi della salute.

Villa Maxime

Saint Tropez, France

Only ten minutes by boat from the famous Plage de Pampelonne, this gem is located in the Bay of Saint Tropez. The problem is it's so beautiful that you'll hardly want to leave it. Clear lines and simple elegance in shades of crème and brown dominate the interior. Lime-green pillows on dark rattan furniture stand out in the inner courtyard. If it turns too cool in the evening, you can snuggle in front of the fireplace. An infinity pool, spacious lounge and dining areas on the terrace as well as the vegetation of palm, orange and lemon trees make this Mediterranean idyll perfect.

Nur zehn Bootsminuten von der berühmten Plage de Pampelonne entfernt liegt dieses Juwel in der Bucht von Saint-Tropez. Allerdings ist es so schön, dass man es kaum verlassen will. Innen dominieren klare Linien und schlichte Eleganz in Creme- und Brauntönen, im Innenhof leuchten limettengrüne Kissen auf dunklen Rattanmöbeln. Wird es abends kühl, kuschelt man sich an den Kamin. Ein Infinity-Pool, großzügige Lounge- und Essbereiche auf der Terrasse und die Vegetation aus Palmen, Orangen- und Zitronenbäumen machen die mediterrane Idylle perfekt.

Ce joyau se dresse dans la baie de Saint-Tropez, à seulement dix minutes en bateau de la célèbre plage de Pampelonne. Cependant, sa beauté est telle que vous aurez du mal à le quitter. Des lignes claires et une élégance simple dans des tons de crème et de brun prédominent à l'intérieur. Dans la cour, des coussins vert lime sont posés sur les meubles en rotin. Quand les soirées se font plus fraîches, vous pouvez vous pelotonner devant la cheminée. Une piscine à débordement, un vaste salon et une salle à manger sur la terrasse, mais aussi la végétation de palmiers, orangers et citronniers, viennent parachever cet idyllique séjour méditerranéen.

Si bien esta joya del golfo de Saint-Tropez se encuentra a tan sólo diez minutos en barco desde la célebre playa de Pampelonne, es tan bonita que no apetece salir de ella. En su interior dominan las líneas claras y la sencilla elegancia en tonos crema y marrón. En el patio interior destacan los tapizados verde lima en muebles de mimbre oscuro. En las noches frescas apetece acurrucarse cómodamente junto a la chimenea. Una piscina de desborde infinito, el amplio espacio lounge con comedor en la terraza, ante palmeras, naranjos y limoneros hacen de éste un rincón mediterráneo idílico.

Questo gioiello situato nella baia di Saint-Tropez si trova a soli dieci minuti di barca dalla famosa Plage de Pampelonne, ed è talmente bello che non lo si vuole più lasciare. All'interno dominano linee chiare e un'eleganza sobria dai colori crema e marrone, nel cortile interno risplendono cuscini verde lime su mobili scuri in rattan. Se la sera fa freddo, ci si stringe intorno al camino. L'infinity pool, spaziose zone lounge e pranzo sulla terrazza e la vegetazione fatta di palme, aranci e limoni rendono perfetto l'idillio mediterraneo.

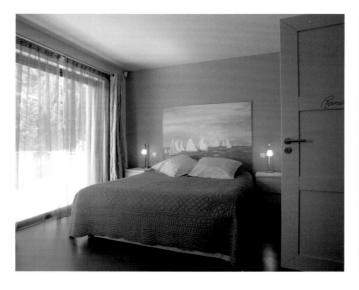
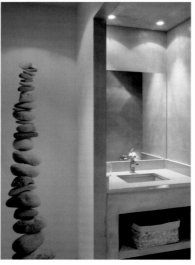

Contemporary design and perfectly harmonized warm colors create a peaceful atmosphere inside the estate.

Zeitgemäßes Design und die perfekt aufeinander abgestimmten warmen Farben verleihen dem Inneren des Hauses eine ruhige Atmosphäre.

Un design contemporain et des couleurs chaudes parfaitement assorties créent une atmosphère paisible à l'intérieur de la maison.

Diseño contemporáneo y tonos cálidos en perfecta armonía confieren a los interiores una atmósfera de placidez.

Il design conforme ai tempi e l'accostamento perfetto dei colori caldi conferiscono una tranquilla atmosfera all'interno della casa.

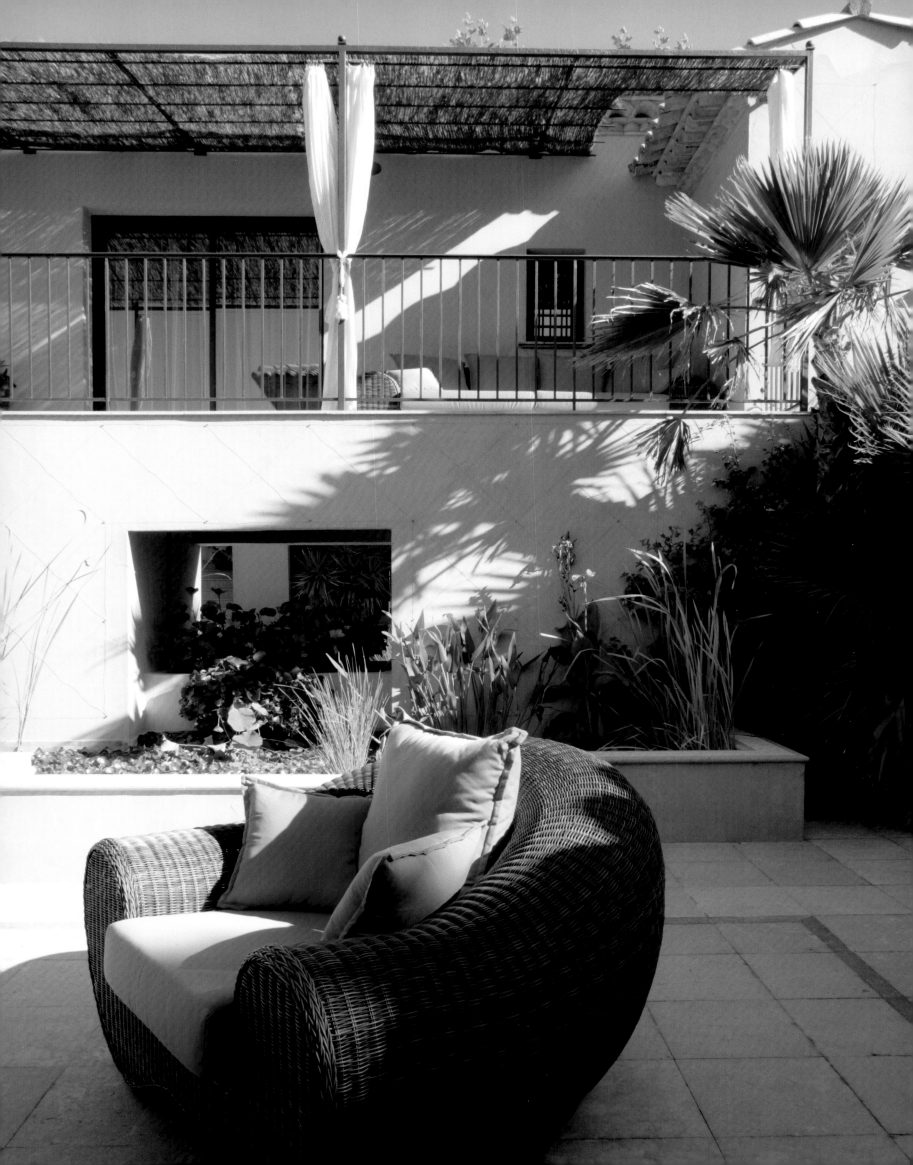

This terrace is just 300 ft. *away from the bay of what may be the world's most beautiful fishing village: Saint Tropez.*

100 m von dieser Terrasse *entfernt liegt die Bucht des vielleicht schönsten Fischerdorfs der Welt: Saint-Tropez.*

Cette terrasse est à *seulement 100 m de la baie de ce qui est peut-être le plus beau village de pêcheurs au monde : Saint-Tropez.*

A 100 m de esta terraza *se encuentra la bahía de Saint-Tropez, quizá la localidad pesquera más bella del mundo.*

A 100 m da questo terrazzo *si trova la baia del villaggio di pescatori forse più bello del mondo: Saint-Tropez.*

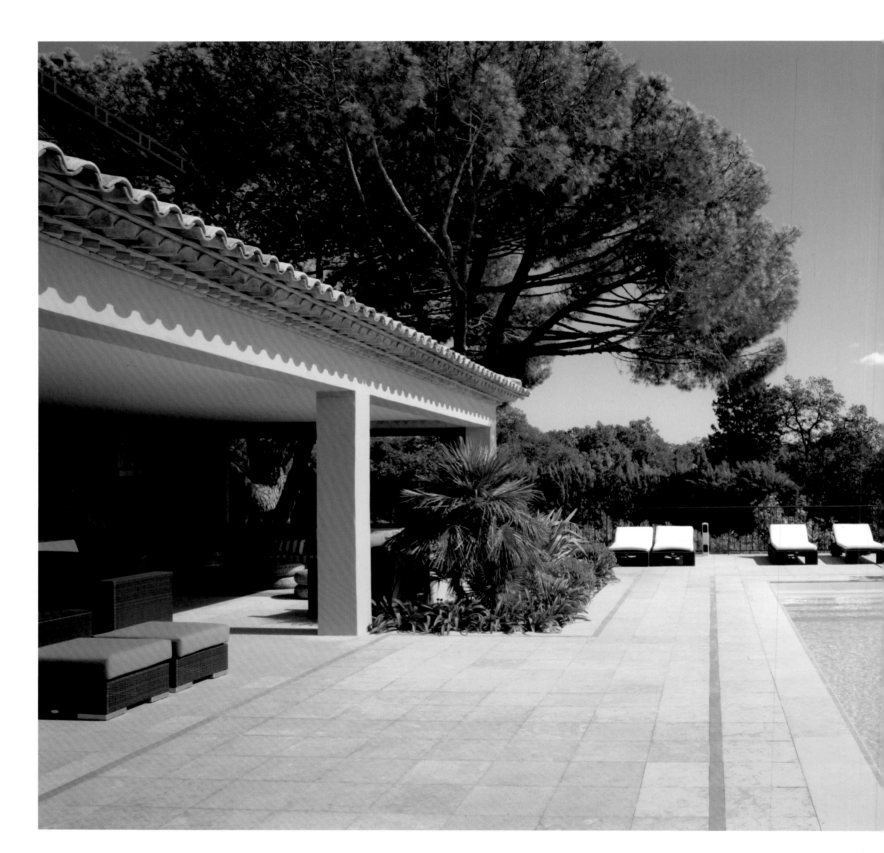

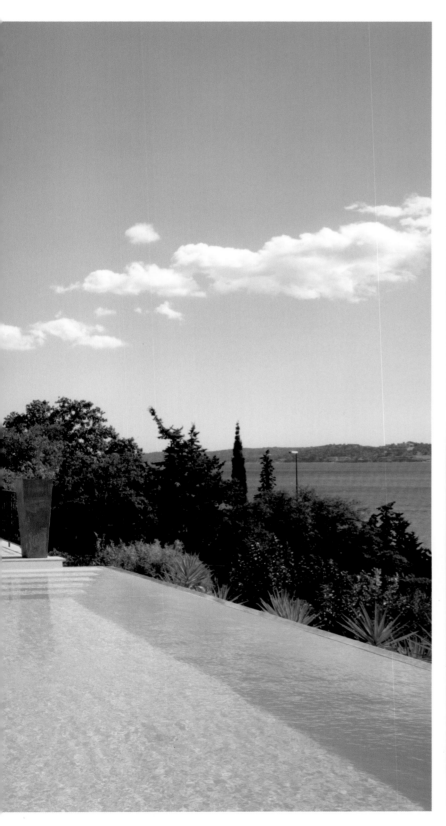

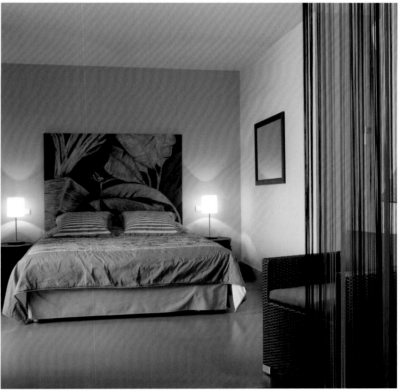

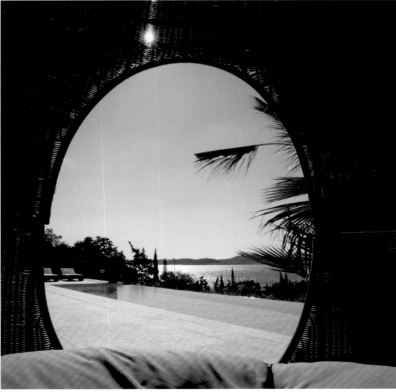

Chalet Anna

Megève, France

This cozy yet elegant wood chalet with its stone terrace is located in the French ski resort of Megève. Its interior of heavy beams and wood furniture is softened by bright red seats, bed covers and carpets, by animal-hide rugs on the floor and armchairs as well as by some architectural finesse—a bridge leads through the lobby and its 20 ft. ceiling into one of the six bedrooms. And you might as well strap your skis on right in the house: The ski slope is just 260 ft. from the front door. In the evening, you can kick back in front of a crackling fireplace in the living room.

Im französischen Skiort Megève liegt dieses urgemütliche und zugleich stilvolle Holz-Chalet mit steinerner Terrasse. Aufgelockert wird sein Interieur aus schweren Balken und Möbeln aus Holz durch knallrote Sitzmöbel, Decken und Teppiche, durch Felle auf Böden und Sesseln sowie durch architektonische Finessen – eine Brücke führt durch die 6 m hohe Lobby in eines der sechs Schlafzimmer. Die Skier schnallt man schon im Haus unter: 80 m vor der Haustür geht es auf die Piste. Am Abend kann man dann im Wohnzimmer vor einem knisterneden Kaminfeuer entspannen.

Ce chalet de **bois confortable** mais élégant avec sa terrasse de pierres est situé dans la station de ski française de Megève. Son intérieur aux lourdes poutres et meubles en bois est animé par les sièges et canapés rouge vif, les dessus de lit, les tapis et les peaux de bête déployés sur le sol et les fauteuils, ainsi que par son raffinement architectural. A travers le salon d'une hauteur de 6 m sous plafond, un pont mène à l'une des six chambres. Vous pouvez chausser vos skis dans la maison : les pistes ne sont qu'à 80 m de l'entrée. Le soir, détendez-vous devant un feu crépitant dans le salon.

La estación de esquí francesa de Megève alberga esta acogedora y elegante casa de madera con terraza de piedra. El interior de pesadas vigas y mobiliario de madera se aligera a través de asientos, techos y alfombras en rojo vivo, y pieles sobre sillones y suelos, unidos a refinados detalles arquitectónicos: un puente cruza el vestíbulo de 6 m de altura hasta una de las seis habitaciones. Los esquís se ajustan en casa ya que la pista queda a 80 m de la puerta. Por la noche se disfruta del relax en el salón junto al fuego crepitante de la chimenea.

Nella località sciistica francese di Megève si trova questo chalet di legno con un terrazzo in pietra, molto comodo e al contempo pieno di stile. Il suo interno fatto di travi pesanti e mobili di legno viene alleggerito grazie alla scelta di poltrone e divani rossi, di coperte e tappeti, di pelli sui pavimenti e di sedie, oltre a raffinatezze architettoniche: un ponte conduce attraverso la loggia alta 6 m in una delle sei camere da letto. Gli sci si possono allacciare già sotto casa: a 80 m dalla porta di casa si ha accesso alla pista. La sera ci può rilassare nel salone davanti al camino e a uno scoppiettante fuoco.

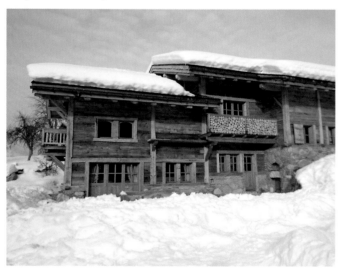

Once the snow begins to pile up in front of the door, the massive wooden structure of the Chalet Anna makes for an especially cozy atmosphere.

Wenn sich vor der Tür der Schnee türmt, verströmt der schwere Holzbau des Chalet Anna eine besonders behagliche Atmosphäre.

Quand la neige s'amoncelle devant la porte, la lourde structure en bois du Chalet Anna dégage une atmosphère particulièrement douillette.

Cuando la nieve se amontona en la puerta, la pesada estructura de madera del Chalet Anna transmite una especial sensación de bienestar.

Quando davanti alla porta si accumula la neve, la pesante struttura di legno dello chalet Anna emana un'atmosfera particolarmente gradevole.

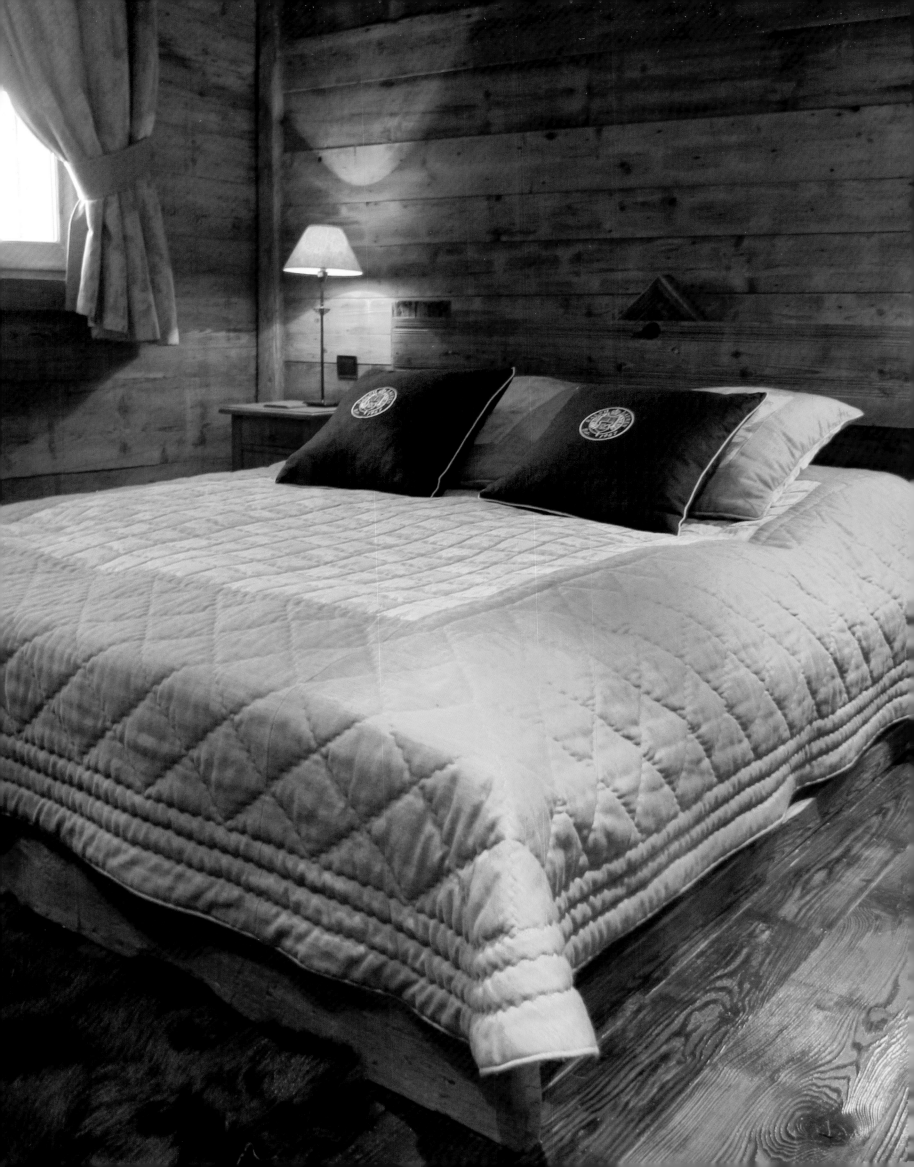

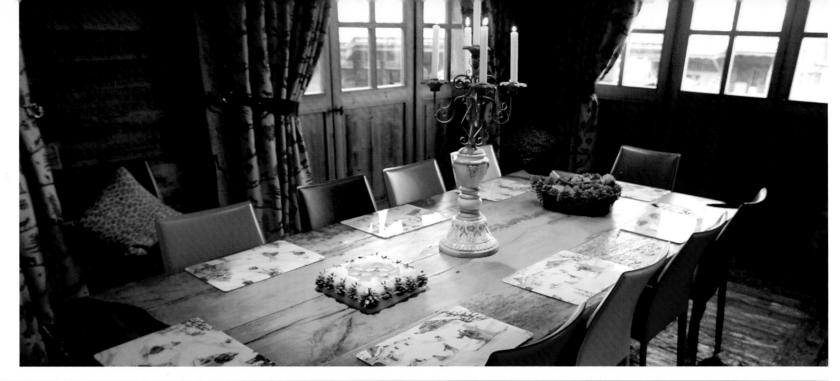

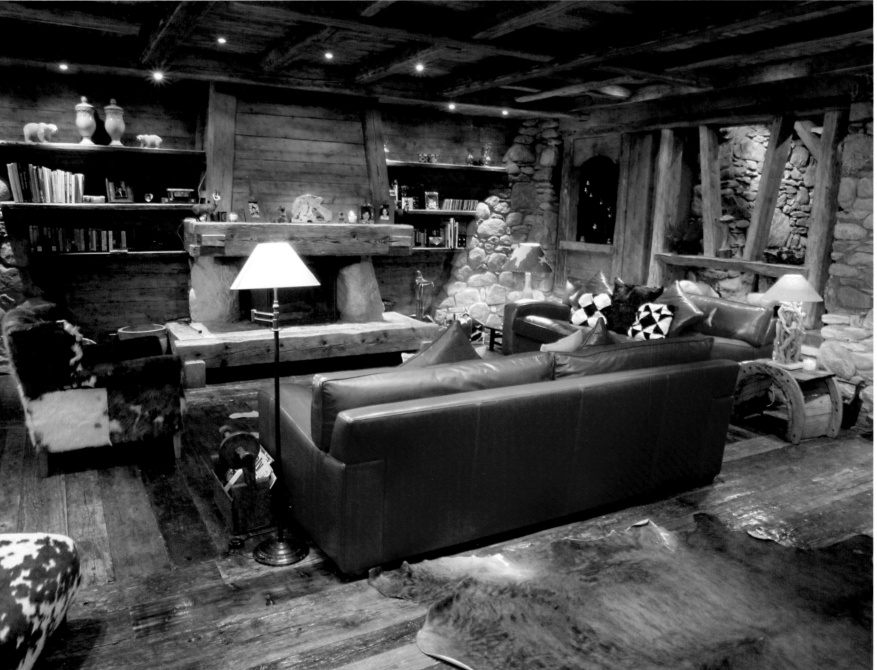

Despite its traditional architecture, the chalet is anything but conventional, thanks to original and surprising details as well as bold moments of color.

Trotz traditioneller Architektur ist das Chalet alles andere als bieder. Dafür sorgen originelle und überraschende Details sowie kühne Farbmomente.

Malgré son architecture traditionnelle, ce chalet est tout sauf conventionnel, et ce, grâce à des détails originaux et surprenants, ainsi qu'à des taches de couleur audacieuses.

A pesar de su línea arquitectónica tradicional, este chalé no resulta en absoluto anticuado. De ello se encargan los originales y sorprendentes detalles y los sutiles toques de color.

Malgrado l'architettura tradizionale, lo chalet è tutt'altro che piccolo-borghese, grazie a dettagli originali e sorprendenti e ad indovinati tocchi di colore.

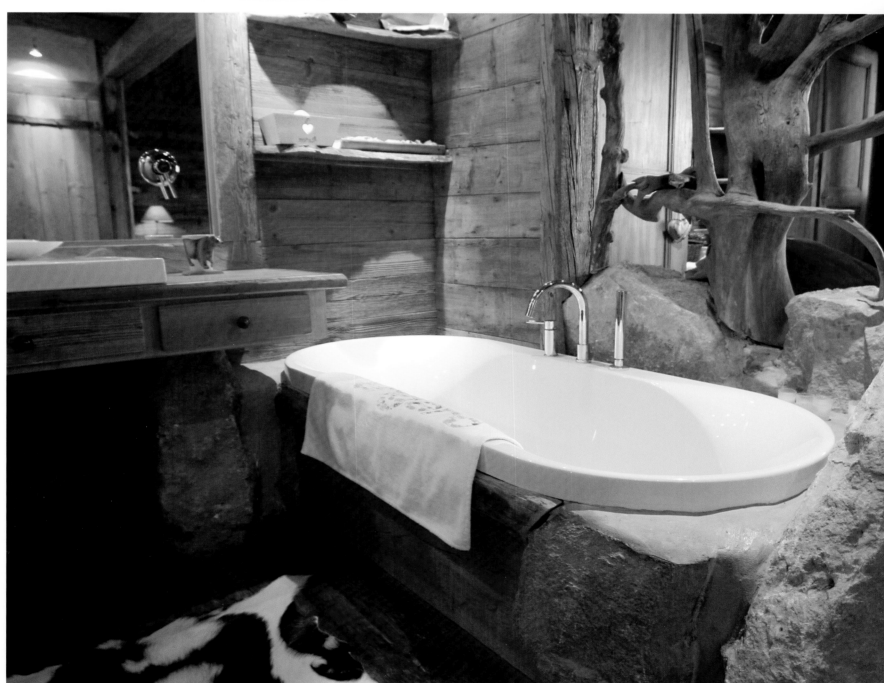

Villa Karl

Monte Carlo, Monaco

It's not just the panoramic view of the ocean, the mountains and the Bay of Roquebrune from its 780 ft. terrace that lends palatial qualities to the former domicile of Karl Lagerfeld on a promontory in Monaco. Classic elegance also characterizes its quasi-royal interior. Exquisite furniture in warm crème shades and accessories in brilliant colors reside under sparkling chandeliers. It also includes a pool, Jacuzzi, a game room with a pool table as well as a tent on the private beach of the Beach Hotel Monte Carlo.

Nicht nur der Rundblick auf das Meer, die Berge und die Bucht von Roquebrune von der 237 m² großen Terrasse verleihen dem auf einer Landzunge gelegenen ehemaligen Domizil Karl Lagerfelds in Monaco Palastqualitäten. Klassische Eleganz prägt auch das geradezu fürstliche Interieur. Erlesene Möbel in warmen Cremetönen und Accessoires in leuchtenden Farben ruhen unter funkelnden Kronleuchtern. Pool, Jacuzzi und ein Spielzimmer mit Billardtisch gehören ebenso dazu wie ein Zelt am Privatstrand des Beach Hotel Monte Carlo.

Ce n'est pas seulement la vue panoramique sur l'océan, les montagnes et la baie de Roquebrune depuis la terrasse de 237 m² qui font de l'ancienne résidence de Karl Lagerfeld un véritable palais situé sur un promontoire à Monaco. Une élégance classique caractérise également son intérieur quasiment royal. Des meubles précieux dans des tons chauds d'écru et des accessoires de couleur brillante sont disposés sous des lustres scintillants. La villa comprend également une piscine, un jacuzzi et une salle de jeux avec table de billard, ainsi qu'une tente sur la plage privée de le Beach Hotel Monte Carlo.

El carácter palaciego de la antigua residencia de Karl Lagerfeld ubicada en una lengua de terreno de Mónaco, se aprecia no sólo en las vistas panorámicas al mar, las montañas y la bahía de Roquebrune, que se disfrutan desde su terraza de 237 m². Se trata además la elegancia clásica que impregna el interior principesco. Un selecto mobiliario en tonos crema y elementos decorativos de colores luminosos reposan bajo las refulgentes arañas. La vivienda cuenta con piscina, jacuzzi y salón de juegos con mesa de billar, además de una carpa en la playa privada del Beach Hotel Monte Carlo.

Non è soltanto la vista sul mare, sulle montagne e sulla baia di Roquebrune, che si gode dal terrazzo di 237 m², a conferire le qualità di un palazzo all'ex domicilio di Karl Lagerfeld, situato su una lingua di terra nel Principato di Monaco. Un'eleganza classica caratterizza anche l'interno principesco. Squisiti mobili in caldo color crema e accessori in colori luminosi sono collocati sotto lampadari scintillanti. Una piscina, la Jacuzzi e una sala giochi con un tavolo da biliardo ne fanno parte esattamente come la tenda sulla spiaggia privata del Beach Hotel Monte Carlo.

A feudal palace from the shades of champagne on its facade to its precious furniture and exquisite decor.

Ein feudaler Palast, vom Champagnerton der Fassade bis hin zu seinen kostbaren Möbeln und seinem erlesenem Dekor.

La villa est un vrai palais féodal, depuis les teintes champagne de sa façade jusqu'à son mobilier précieux et son somptueux décor.

Un palacio feudal con una fachada en color champaña, refinado mobiliario y decoración selecta.

Un palazzo feudale, dalla tonalità champagne della facciata fino al prezioso mobilio e alle sue decorazioni pregiate.

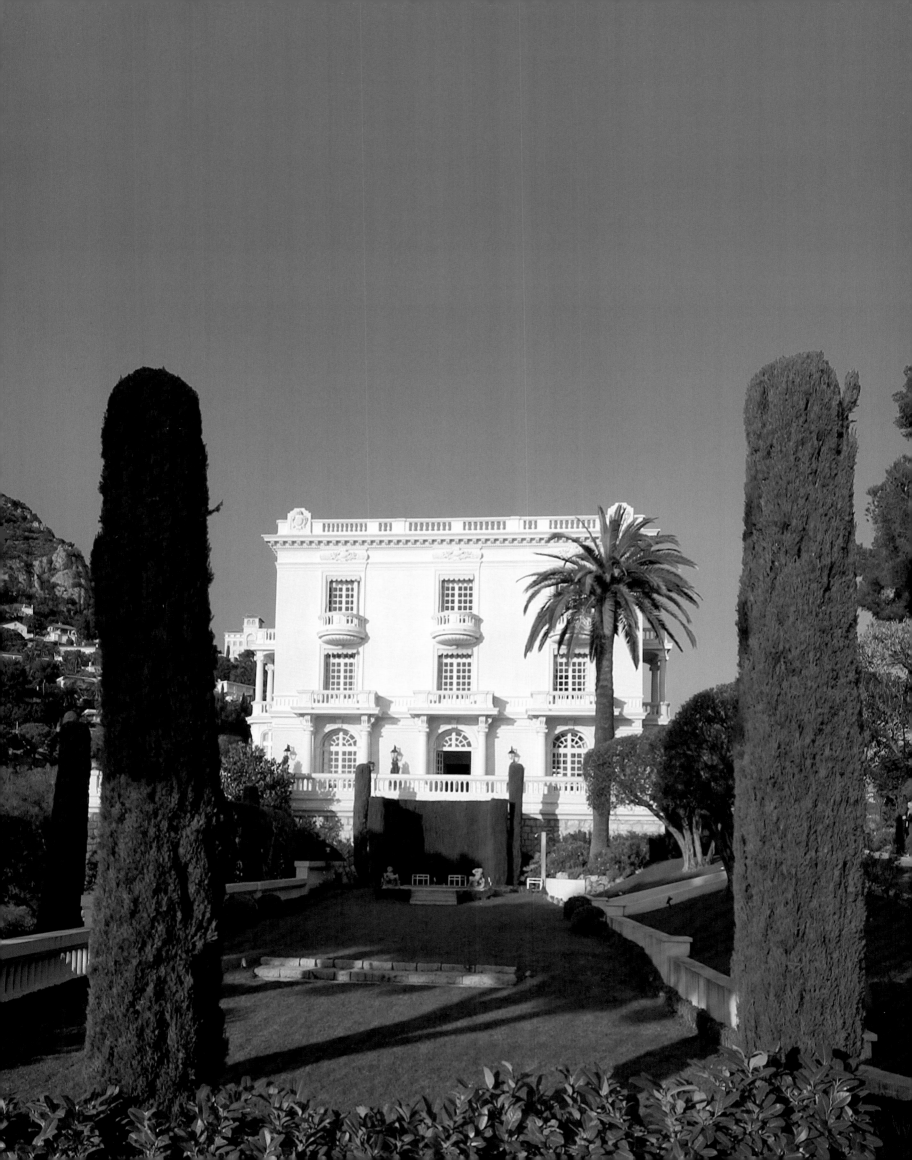

Hues of crème and brown set the tone for the exquisite interior. The kitchen is primarily the realm of the villa's own chef.

Creme- und Brauntönen bestimmen das exquisite Interieur. Die Küche ist in erster Linie das Reich des hauseigenen Kochs.

Les nuances de crème et de brun donnent le ton pour l'intérieur raffiné. La cuisine est principalement le domaine du chef cuisinier de la villa.

Los tonos crema y marrones dominan el exquisito interior. La cocina es, ante todo, el reino del cocinero de la casa.

Tonalità crema e marrone definiscono gli squisiti interni. La cucina è anzitutto il regno del cuoco della casa.

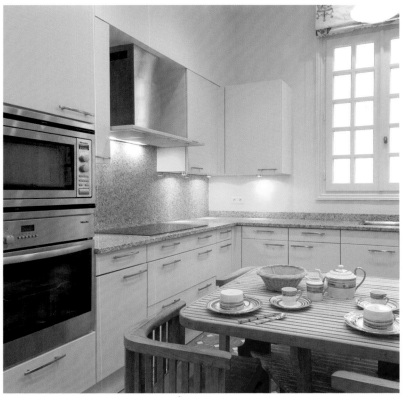

Villa Sassolini

Tuscany, Italy

A Florentine aristocratic family had this countryseat erected near Montevarchi in the Chianti mountain range in the 15ᵗʰ Century. Today, its venerable facade reveals ten rooms and suites in minimalist decor. Their interior reflects the colors of the surrounding landscape: Crème, olive, terracotta and brown are the colors of the beds, covers and lamps. Candles add atmosphere to the purist naked walls and modern washstands of the bathrooms. Rooms located at the front of the villa offer an impressive view of the Chianti hills.

Eine florentinische Adelsfamilie erbaute sich im 15. Jahrhundert diesen Landsitz bei Montevarchi im Chianti. Hinter der alten Fassade verbergen sich heute zehn minimalistisch eingerichtete Zimmer und Suiten. Ihr Interieur spiegelt das Kolorit der Landschaft: Creme, Olive, Terrakotta und Braun sind die Farben von Betten, Decken und Lampen. Den puristisch nackten Wänden und modernen Waschtischen der Bäder verleihen Kerzen Atmosphäre. Von den nach vorn gelegenen Zimmern bietet sich ein erhebender Blick auf die Hügel des Chianti.

Une famille d'aristocrates florentins s'est fait construire cette gentilhommière près de Montevarchi dans le Chianti au XVᵉᵐᵉ siècle. La vieille façade recèle maintenant dix chambres et suites meublées dans un style minimaliste. Leur intérieur reflète la gamme de couleurs du paysage : crème, olive, terracotta et brun sont les couleurs des lits, couvertures et lampes. Des bougies donnent plus d'âme aux murs nus puristes et aux lavabos modernes des salles de bains. Les chambres qui donnent sur le devant de la villa offrent une vue évocatrice sur les collines du Chianti.

En el siglo XV, una familia de la nobleza florentina mandó construir esta residencia campestre cerca de Montevarchi, Chianti. Tras la vetusta fachada se esconden hoy diez habitaciones y suites de corte minimalista. El interior refleja el colorido del paisaje: crema, verde oliva, terracota y marrón son los colores de las camas, las mantas y las lámparas. La luz de las velas dota de ambiente a las paredes desnudas y a las modernas encimeras con lavabo de los aseos. Desde las habitaciones de la parte frontal se goza de una magnífica vista a las colinas de Chianti.

Nel XV secolo una nobile famiglia fiorentina fece costruire questa tenuta di campagna presso Montevarchi nel Chianti. Dietro l'antica facciata si nascondono oggi dieci stanze e suite arredate in modo minimalistico. Il loro interno rispecchia i colori del paesaggio: crema, oliva, terracotta e marrone sono i colori dei letti, delle coperte e delle lampade. Candele donano atmosfera alle pareti puristicamente nude e ai lavabi moderni dei bagni. Dalle camere situate nella parte anteriore si gode il panorama sulle colline del Chianti.

A palette of warm crème shades lends the bedrooms and baths their special atmosphere. The terrace offers a view of one of the most beautiful landscapes in all of Europe.

Eine Palette warmer Cremetöne verleiht Schlafzimmern und Bädern Atmosphäre. Von der Terrasse blickt man auf eine der schönsten Landschaften in Europa.

Une palette de chaudes nuances crème confère une atmosphère spéciale aux chambres et aux salles de bains. De la terrasse, vous pouvez contempler l'un des plus beaux paysages d'Europe.

Una amplia gama de cálidos tonos pastel crea una embriagadora atmósfera en dormitorios y baños. Desde la terraza se divisa uno de los paisajes más bellos de toda Europa.

Una gamma di calde tonalità crema dona alle camere da letto e ai bagni un'atmosfera particolare. Dal terrazzo si gode la vista su uno dei paesaggi più belli d'Europa.

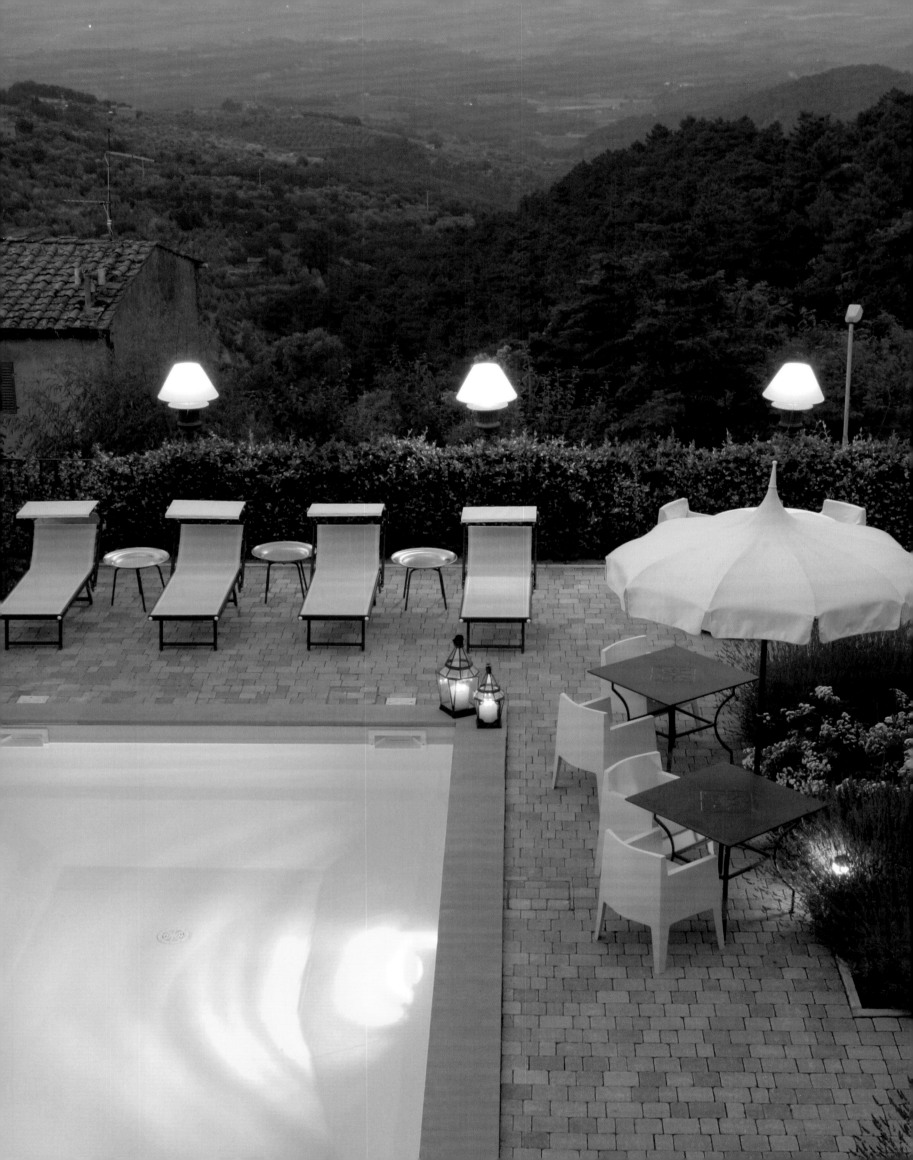

Any gaps between the historic structure of the house and the demands of a modern luxury lodging have been bridged without any sacrifice of style.

Sehr stilsicher gelingt der Brückenschlag zwischen der historischen Struktur des Hauses und den Erfordernissen einer modernen Herberge.

La transition entre la structure historique de la maison et les exigences d'une auberge moderne a été réalisée de manière très élégante.

Con estilo se ha logrado crear un paso entre la histórica estructura de la casa y las necesidades de un alojamiento moderno.

Perfettamente riuscito è il legame tra la struttura storica della casa e le esigenze di un alloggio moderno.

Villa Scannagallo

Tuscany, Italy

Villa Scannagallo near the Etruscan city of Cortona combines traditional Tuscan style with modern design and all of the amenities of the 21st Century. The red-tiled roof of the ocher-colored estate conceals five elegant bedrooms, a living room with a fireplace and an open kitchen-living room in white for banquets typical of the region with its local wines and specialties. Outside, the garden and the tanning area of the infinity pool entice you to kick back and enjoy the surrounding scenic beauty.

Traditionellen toskanischen Stil verbindet die in der Nähe der Etruskerstadt Cortona gelegene Villa Scannagallo mit modernem Design und allen Annehmlichkeiten des 21. Jahrhunderts. Im ockerfarbenen Haus verbergen sich unter rotem Ziegeldach fünf elegante Schlafzimmer, ein Wohnzimmer mit Kamin und eine offene, in Weiß gehaltene Wohnküche für landestypische Bankette mit örtlichen Weinen und Spezialitäten. Draußen verführen der Garten und die Sonnenplätze am Infinity-Pool zum beschaulichen Genuss der landschaftlichen Schönheit ringsum.

Située près de la cité étrusque de Cortona, la Villa Scannagallo allie style toscan traditionnel, design moderne et toutes les commodités du XXIème siècle. Le toit de tuiles rouges de la maison ocre cache cinq chambres élégantes, une salle de séjour avec cheminée et une cuisine ouverte sur une salle à manger décorée de blanc pour les banquets typiques de la région, à base de vins et spécialités locaux. A l'extérieur, le jardin et les miroitements de la piscine à débordement vous convaincront de profiter tranquillement de la beauté du paysage environnant.

En Villa Scannagallo, cerca de la ciudad etrusca de Cortona, el estilo toscano tradicional se fusiona con el diseño moderno y todas las comodidades del siglo XXI. Bajo una techumbre de tejas rojas, esta vivienda de tonos ocres alberga cinco elegantes habitaciones, un salón con chimenea y una cocina abierta de color blanco, en la que disfrutar de típicos banquetes con vino y especialidades del lugar. Fuera, el jardín y las tumbonas al borde de la piscina con desborde infinito inducen al placer de contemplar la belleza del paisaje circundante.

La Villa Scannagallo, situata nelle vicinanze della città etrusca di Cortona, unisce lo stile tradizionale toscano con il design moderno e tutte le comodità del XXI secolo. Nella casa color ocra, sotto un tetto di tegole rosse, si nascondono cinque camere da letto, un salone con camino e una cucina aperta bianca fatta apposta per i banchetti tipici della campagna, con vini e specialità locali. All'esterno il giardino e i posti al sole intorno all'infinity pool invitano gli ospiti a godere delle bellezze paesaggistiche circostanti.

The valley of Scannagallo provides the backdrop against this villa, which combines bucolic structures with a touch of elegance and naturalness.

Das Scannagallo-Tal bildet die Kulisse dieser Villa, die rustikale Strukturen mit einem Hauch von Eleganz und Leichtigkeit verbindet.

La Vallée de Scannagallo sert de toile de fond à cette villa qui combine des structures rustiques avec une touche d'élégance et de légèreté.

La finca enmarcada en el valle de Scannagallo asocia estructuras rústicas con un toque de elegancia y ligereza.

La valle di Scannagallo offre lo scenario per questa villa che unisce strutture rustiche ad un velo di eleganza e leggerezza.

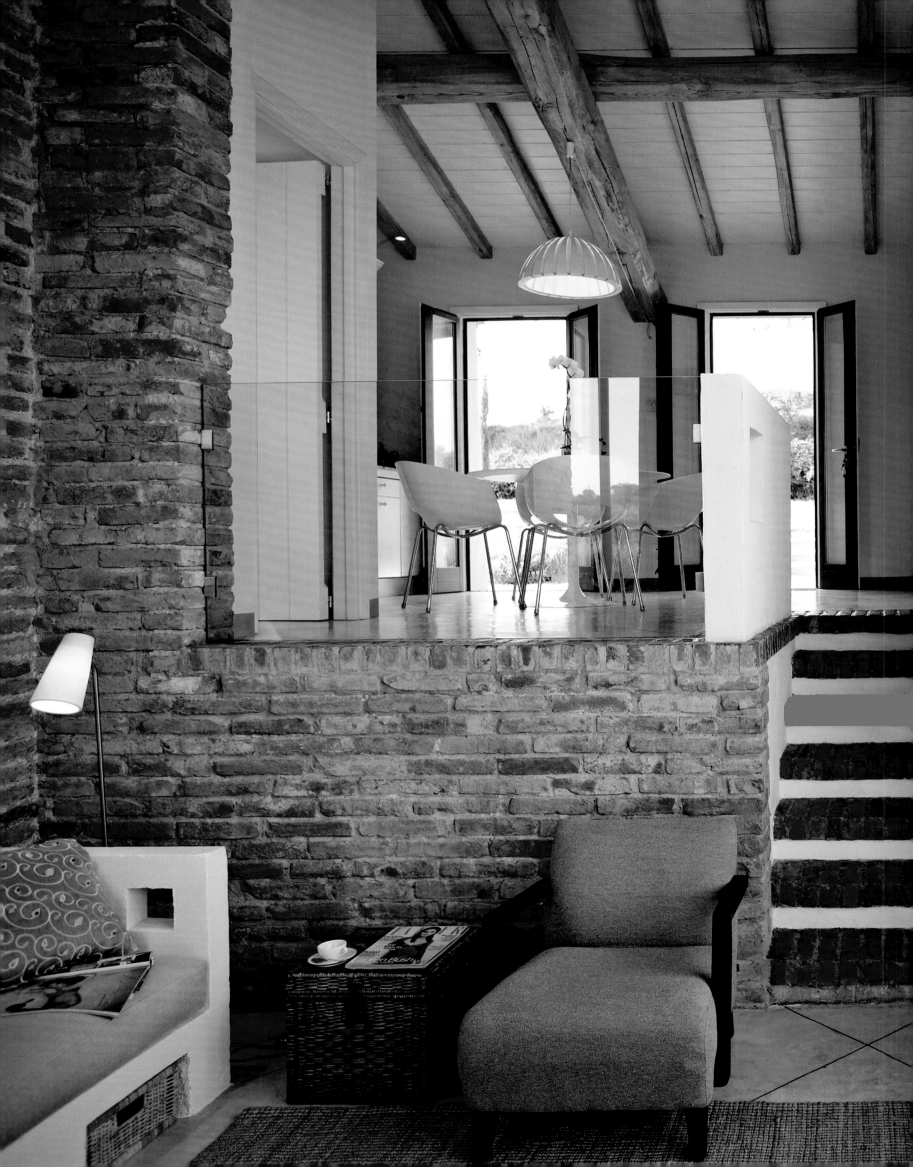

The mix of old and new elements guarantees surprising views while the bathrooms are uncompromisingly modern.

Der Mix von alten und neuen Elementen sorgt für überraschende Perspektiven. Kompromisslos modern sind dagegen die Bäder.

Le mélange d'éléments nouveaux et anciens offre des perspectives surprenantes. Par contre, les salles de bains sont résolument modernes.

El cruce de elementos antiguos y modernos genera perspectivas sorprendentes. Los baños sin embargo son claramente contemporáneos.

Elementi nuovi e antichi creano prospettive sorprendenti. I bagni invece sono moderni, senza compromessi.

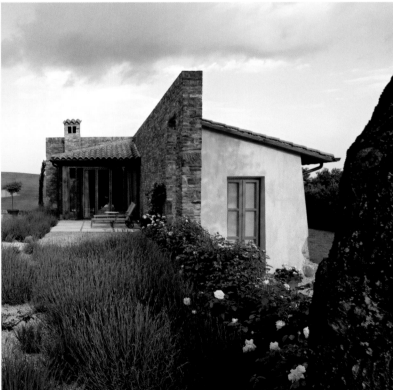

The pool is a perfect place for daydreaming Tuscan-style.

Der Pool ist ein perfekter Ort für toskanische Träumereien.

La piscine est le lieu idéal pour un rêve toscan éveillé.

La piscina es el lugar perfecto para las ensoñaciones toscanas.

La piscina è un luogo perfetto per i sogni toscani.

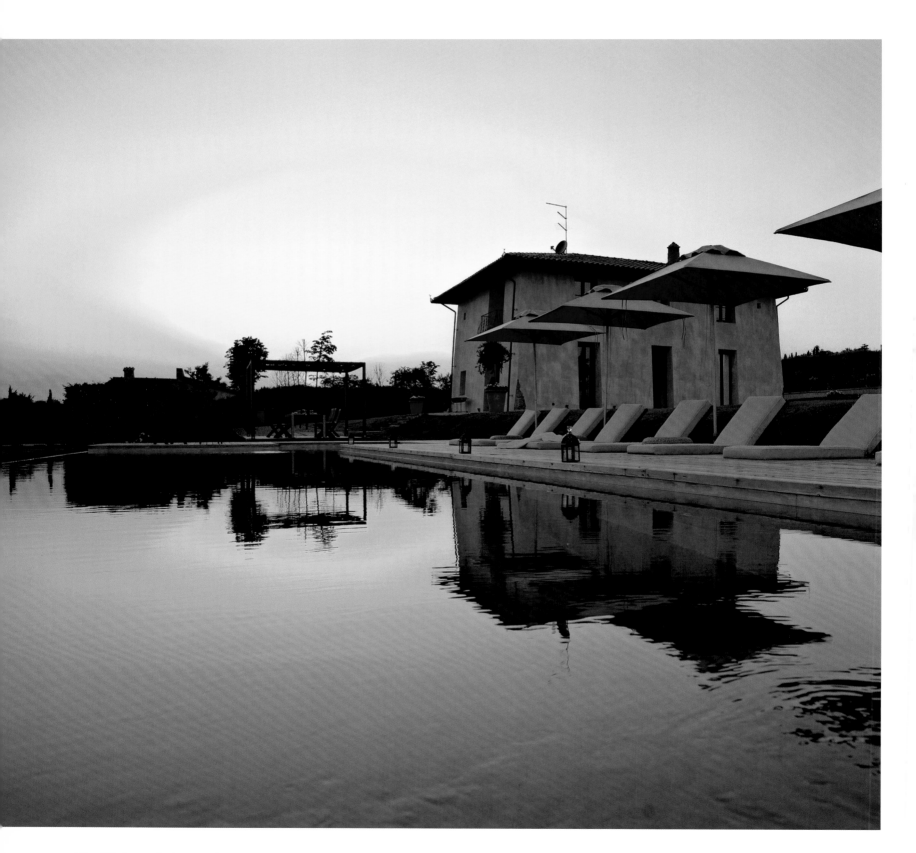

Stone and beams *create a pleasant atmosphere. The highlight and meeting place of the house is the open lounge with its brick fireplace.*

Stein und Balken *schaffen eine angenehme Atmosphäre. Highlight und Treffpunkt des Hauses ist die offene Lounge mit gemauertem Kamin.*

Les pierres et les poutres *créent une atmosphère agréable. Le joyau de la maison, et son point de rencontre, est le salon ouvert avec sa cheminée de brique.*

La piedra y viguería *crean una agradable atmósfera. El mayor atractivo y punto de encuentro de la casa es la sala lounge, abierta y con chimenea empotrada.*

Pietre e travi *creano un'atmosfera piacevole. Il culmine e il punto d'incontro della casa è la lounge aperta con il camino in muratura.*

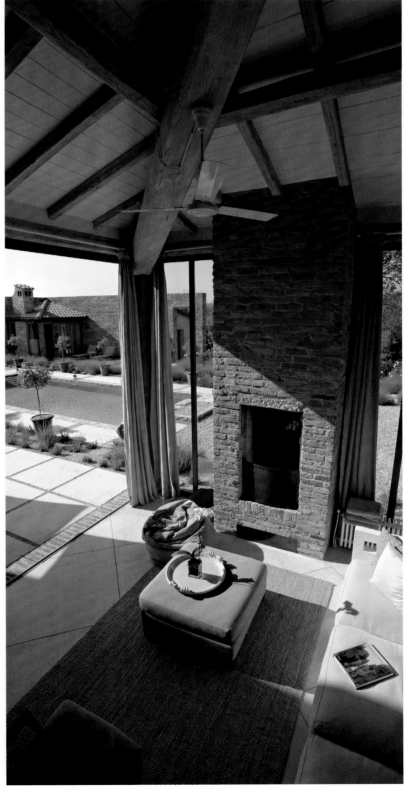

Chalet Wonderfall

Limone, Italy

With wooden beams and wooden paneling, leather armchairs, rocking chairs and fieldstone walls, Chalet Wonderfall introduces Wild West romanticism to the Ligurian Alps. Bricked-in fireplaces in all of the seven suites and in the living room, a well-stocked wine cellar and a dining table for 18 form the heart and soul of a cultivated après-ski just 300 ft. from the ski slopes of Limonetto. Thick rugs and pillows create a cozy atmosphere and a sauna and Jacuzzi provide relaxation. A waterfall rushes next to the villa.

Mit Holzbalken und -vertäfelungen, Ledersesseln, Schaukelstühlen und Mauern aus Feldstein bringt die Chalet Wonderfall Wildwestromantik in die ligurischen Alpen. Gemauerte Kamine in jeder der sieben Suiten sowie im Wohnzimmer, ein wohlgefüllter Weinkeller und eine Tafel für 18 Personen bilden den Rahmen für ein gepflegtes Après-Ski 100 m von den Pisten Limonettos entfernt. Dicke Teppiche und Kissen schaffen eine kuschelige Atmosphäre, für Entspannung sorgen Sauna und Jacuzzi. Neben dem Haus rauscht ein Wasserfall.

Avec ses poutres apparentes et ses boiseries, ses chaises en cuir, ses rocking-chairs et ses murs en pierres de champs, la Chalet Wonderfall recrée un romantisme de Far-West dans les Alpes liguriennes. Des cheminées de brique dans chacune des sept suites et la salle de séjour, une cave à vins bien remplie et une table pour 18 convives forment un cadre raffiné après le ski à seulement 100 m des pistes de Limonetto. Des tapis épais et des coussins créent une atmosphère confortable, et le sauna et le jacuzzi offrent un espace de relaxation. Une cascade ruisselle près de la maison.

Con sus vigas y revestimientos de madera, sillones de cuero, mecedoras y muros de piedra, Chalet Wonderfall transmite el romanticismo del lejano oeste en los Alpes de Liguria. Tanto las siete suites como el salón cuentan con chimenea empotrada. Una bodega repleta y una mesa para 18 personas constituyen el marco perfecto para descansar tras una jornada de esquí en las pistas de Limonetto, a 100 m de la casa. Alfombras y mullidos cojines configuran el ambiente acogedor. Para relajarse están dispuestos la sauna y el jacuzzi. Mientras, junto a la casa murmura una cascada.

Grazie alle travi e ai pannelli di legno, alle poltrone in pelle, alle sedie a dondolo e ai muri di pietra, Chalet Wonderfall porta romanticismo da western nelle Alpi liguri. I camini in muratura in ognuna delle sette suite, oltre che nel salone, una cantina di vini ben fornita e una tavola per 18 persone creano la cornice per un doposci di classe a 100 m dalle piste di Limonetto. Folti tappeti e grandi cuscini creano un'atmosfera accogliente, mentre per rilassarsi ci sono la sauna e la Jacuzzi. Accanto alla casa scroscia una cascata.

All the raging snow on Earth isn't enough for the cold to penetrate the thick walls and beams of this uniquely bucolic chalet.

So viel Schnee kann gar nicht fallen, dass Kälte durch die dicken Mauern und Balken dieses ungemein rustikalen Chalets dringt.

Il n'y aura jamais assez de neige pour que le froid puisse pénétrer les murs et les épais chevrons de ce chalet formidablement rustique.

Nunca nevará tanto como para que el frío traspase las gruesas paredes y vigas de este chalé absolutamente rústico.

Per quanto possa nevicare, il freddo non riuscirà mai a penetrare attraverso i muri spessi e le travi di questo chalet assolutamente rustico.

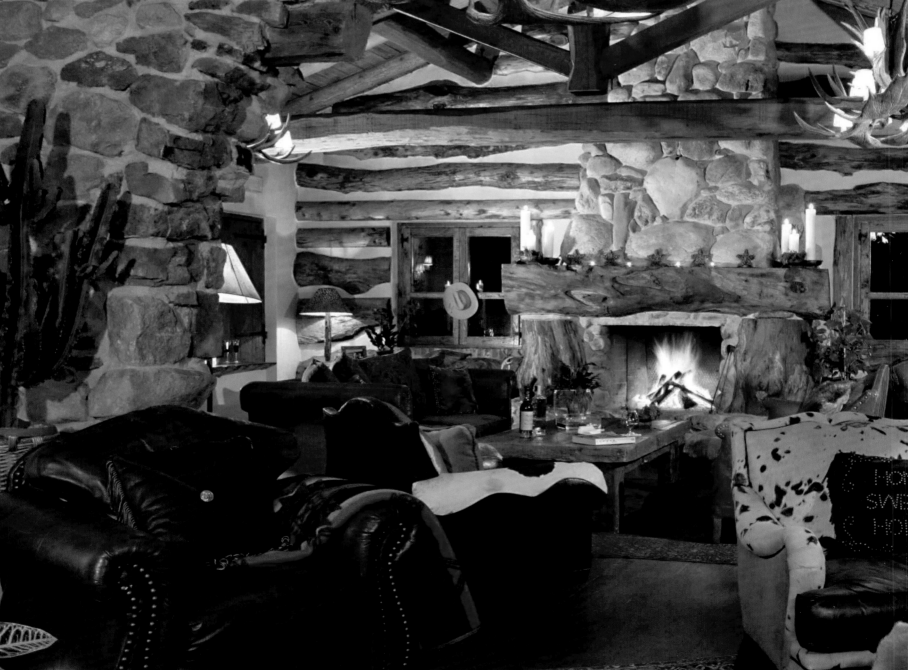

Home, sweet home: *There's a certain hint of irony when items and artifacts from the Wild West find a home at this cozy villa in northwestern Italy.*

Home, sweet home: *Nicht ohne einen Hauch von Ironie haben Accessoires und Artefakte aus dem Wilden Westen in der behaglichen Villa im italienischen Nordwesten ein Zuhause gefunden.*

Home, sweet home : *les accessoires et les meubles du Far-West ont trouvé refuge, avec une pointe d'ironie, dans cette villa confortable du nord-ouest de l'Italie.*

Home, sweet home: *no sin cierta ironía los accesorios y elementos del Lejano Oeste encuentran su hogar en esta acogedora villa del noroeste italiano.*

Home, sweet home: *con un leggero velo di ironia, gli accessori e gli artefatti del selvaggio West hanno trovato casa in un'accogliente villa del nord-ovest d'Italia.*

Chalet Wonderfall *Limone, Italy* 115

Casa Cristal

Ibiza, Spain

One of the largest private pools in Ibiza belongs to the Casa Cristal, located 12 miles from the island's capital. Inspired by the legendary Barcelona Pavilion of Bauhaus architect Mies van der Rohe, the house has two bedrooms plus bathrooms and a living area. Its design is spacious and airy on 2,600 sq. ft. Large window fronts open to the surrounding nature and—just like the terrace—offer a wonderful view of the ocean. Some of the most beautiful beaches of this Balearic island are just a few minutes away on foot.

Einen der größten Privatpools Ibizas besitzt die 20 km von der Insel-Hauptstadt gelegene Casa Cristal. Das vom legendären Barcelona-Pavillon des Bauhaus-Architekten Mies van der Rohe inspirierte Haus mit zwei Schlafzimmern nebst Bädern und Wohnraum ist auf 240 m² großzügig und luftig angelegt. Große Fensterfronten öffnen sich auf die umliegende Natur und bieten – ebenso wie die Terrasse – einen wunderbaren Blick auf das Meer. Einige der schönsten Strände der Baleareninsel liegen nur wenige Gehminuten entfernt.

Casa Cristal, située à 20 km de la capitale de l'île, possède une des plus grandes piscines privées d'Ibiza. Inspirée du mythique Pavillon de Barcelone de l'architecte du Bauhaus Mies van der Rohe, la maison qui compte deux chambres, en plus des salles de bains et de la salle de séjour, est conçue pour être spacieuse et aérée sur 240 m². De larges baies vitrées ouvrent sur la nature environnante et offrent – tout comme la terrasse – une magnifique vue sur la mer. Une des plus belles plages de l'île des Baléares est seulement à quelques minutes à pied.

Casa Cristal, a 20 km de la capital de la isla, cuenta con una de las piscinas privadas más grandes de Ibiza. La vivienda está inspirada en el legendario pabellón de la Exposición de Barcelona de Mies van der Rohe, arquitecto de la Bauhaus, y ha integrado dos dormitorios con sus baños y salón en un espacio de 240 m². Los grandes frontales de cristal se abren a la naturaleza del entorno y, al igual que la terraza, ofrecen fabulosas vistas al mar. Algunas de las playas más espléndidas de las Baleares quedan a unos pocos minutos a pie.

Casa Cristal, situata a 20 km dalla capitale dell'isola, possiede la più grande piscina privata di Ibiza. La casa, inspirata al leggendario padiglione di Barcellona dell'architetto Bauhaus Mies van der Rohe, ha due camere da letto con bagno e un soggiorno distribuiti in modo spazioso e arioso su 240 m². Le grandi vetrate si aprono sulla natura circostante e offrono, esattamente come il terrazzo, una vista meravigliosa sul mare. Alcune delle più belle spiagge dell'isola delle Baleari sono distanti solo pochi minuti a piedi.

 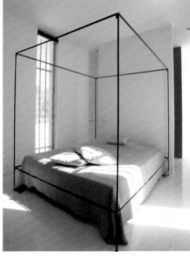

Vast views and plenty of light and white distinguish this extravagant villa.

Weite Ausblicke, viel Licht und Weiß prägen diese extravagante Villa.

Une vue panoramique, beaucoup de lumière et le blanc caractérisent cette villa extravagante.

Vastas panorámicas, un derroche de luz y el color blanco caracterizan a esta extravagante mansión.

Ampia vista, molta luce e molto bianco sono le caratteristiche di questa villa molto particolare.

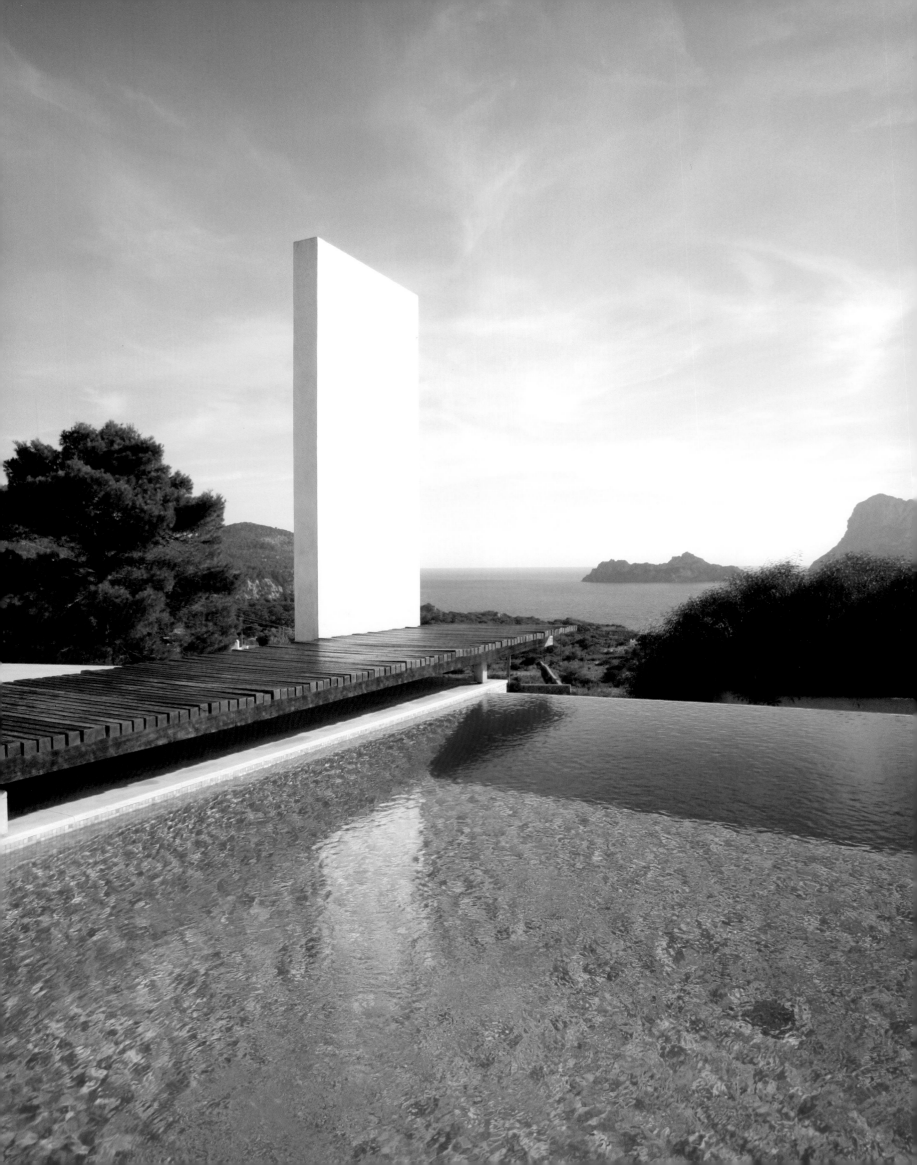

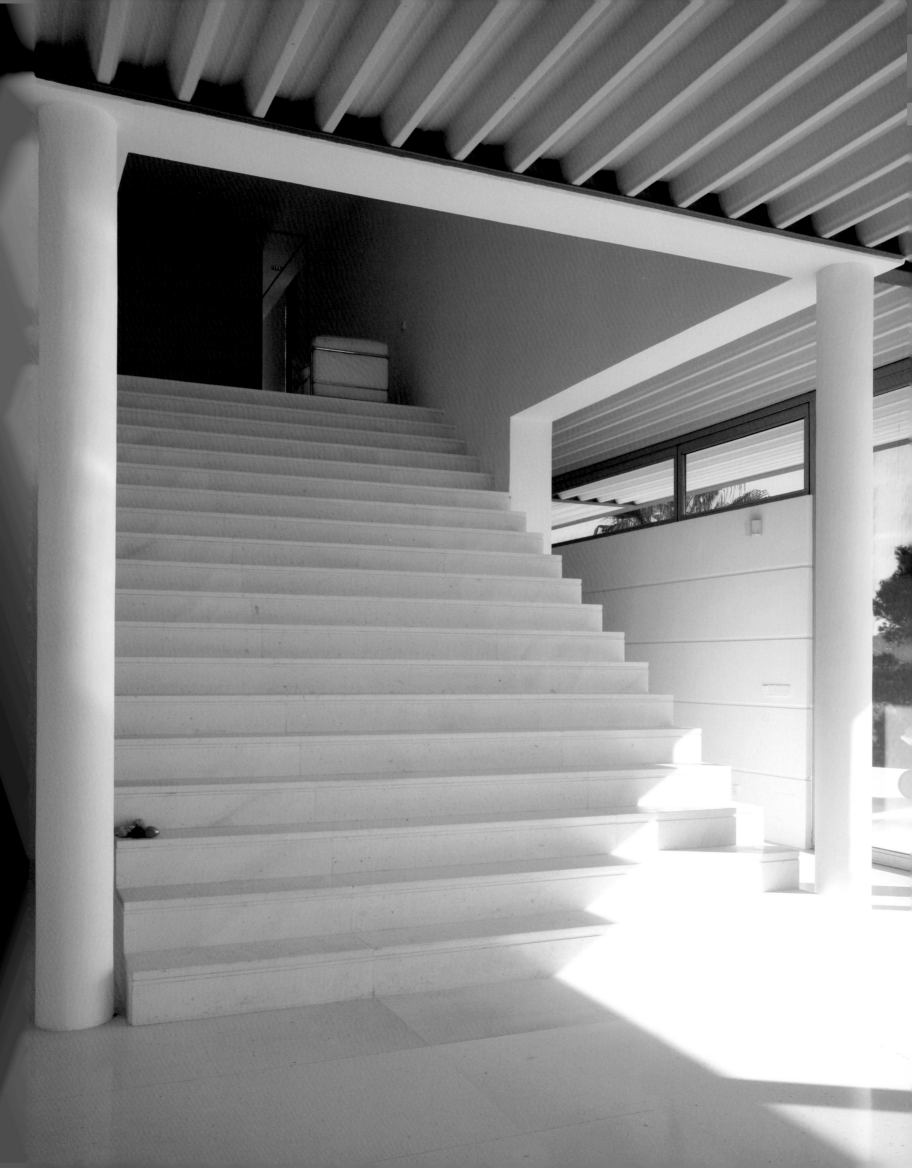

It looks like a museum for design or modern art—except that you can spend the night in it.

Fast wirkt es wie ein Museum für Design oder moderne Kunst – aber schlafen kann man hier auch.

On dirait un musée de design ou d'art moderne – mais vous pouvez aussi y dormir.

Si bien tiene el aspecto de un museo de diseño o de arte moderno, también está concebida para conciliar el sueño.

Sembra quasi un museo di design e arte moderna – ma qui si può anche dormire.

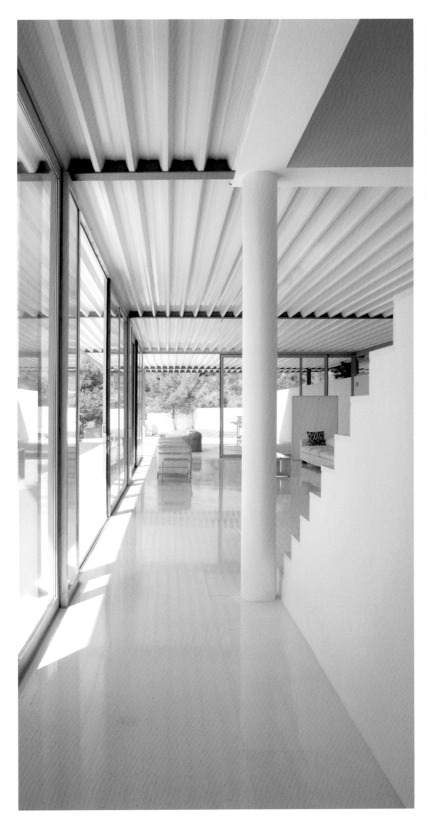

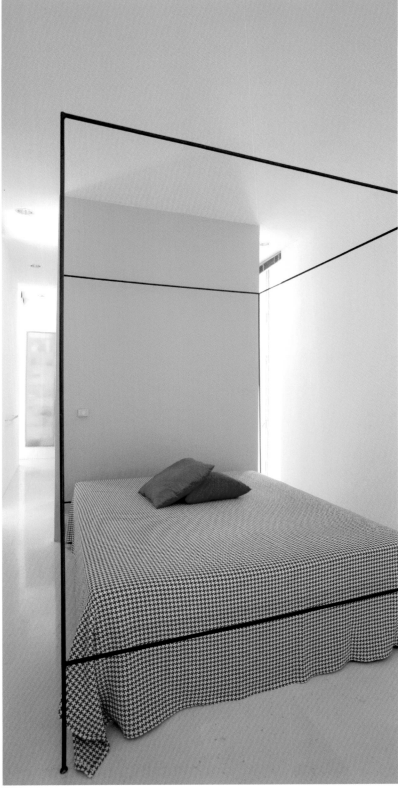

Beyond the large-size pool, the Mediterranean stretches out.

Jenseits des großzügigen Pools erstreckt sich das Mittelmeer.

La Méditerranée s'étend au-delà de l'immense piscine.

Más allá de la enorme piscina se extiende el Mediterráneo.

Al di là della grande piscina si estende il Mediterraneo.

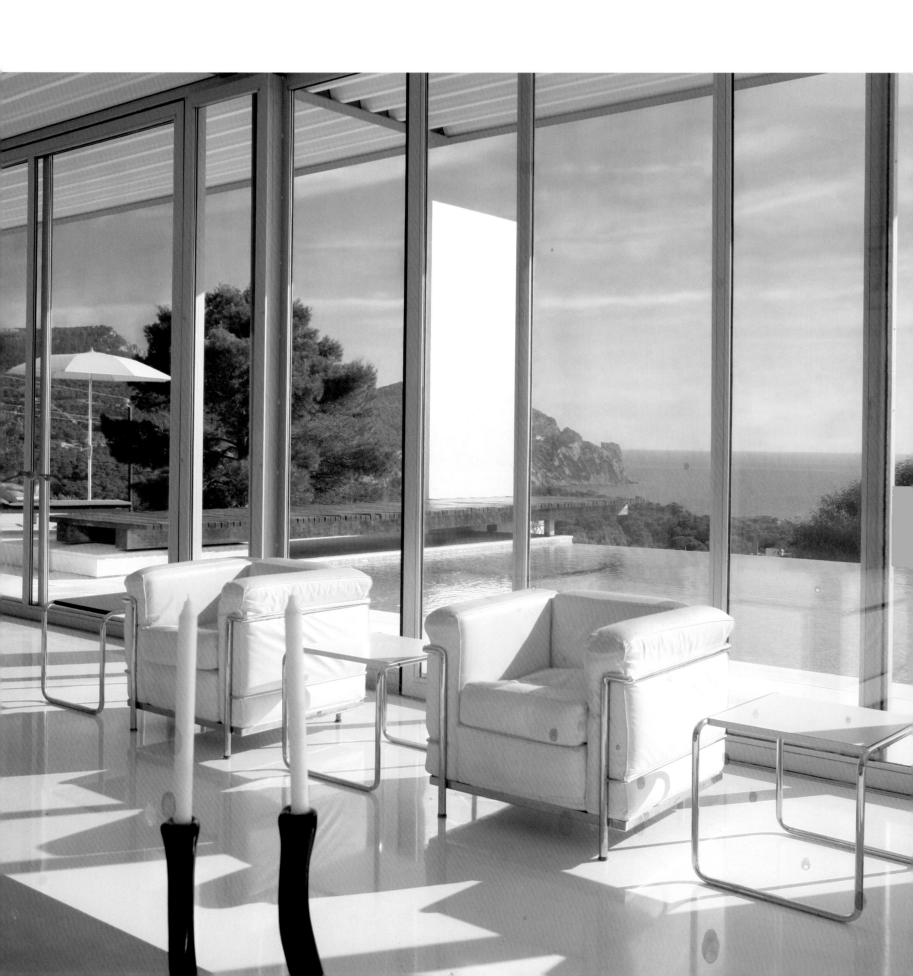

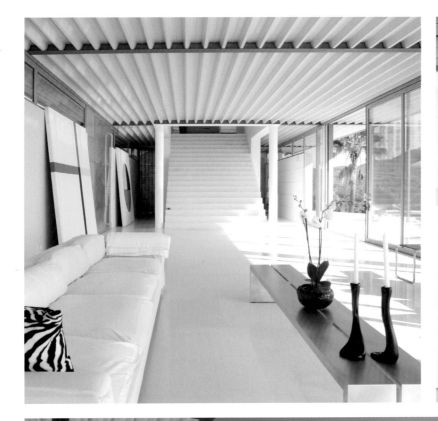

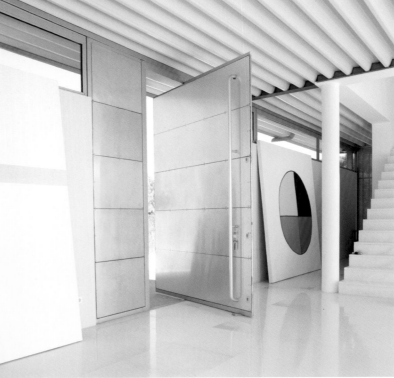

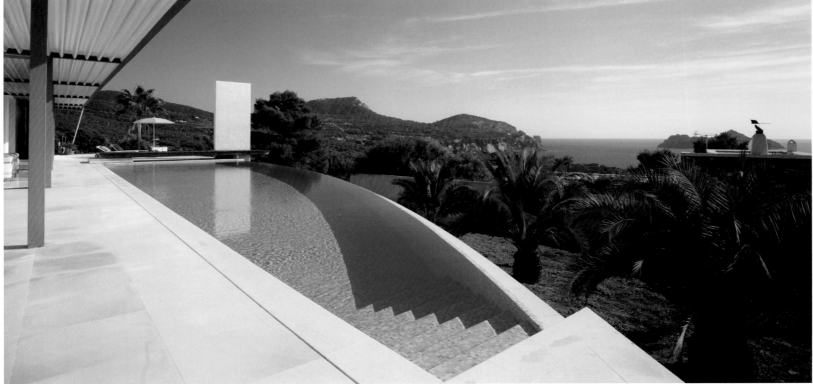

Luz de Ibiza

Ibiza, Spain

Oriental and Asian magic emanates from the Villa Luz de Ibiza in San José on Ibiza. Its 6,500 sq. ft. provide space for seven bedrooms including two outstanding suites with extravagant baths. Dark wood accentuates white walls and Moorish arches tower above colorful tiles and accessories. Stairs lead from the living room, lavishly furnished in an Asian and Oriental style, and fireplace down to a terrace with Mediterranean plants and the swimming pool. Here, you'll find a fantastic view of the ocean. And the sofas of the open-air lounge are wonderful for snoozing away long afternoons.

Orientalisch-Asiatischen Zauber verströmt die Villa Luz de Ibiza in San José auf Ibiza. Ihre 600 m² bieten Platz für sieben Schlafzimmer und zwei traumhaften Suiten mit extravaganten Bädern. Dunkles Holz akzentuiert weiße Wände, maurische Bögen wachen über farbenprächtigen Fliesen und Accessoires. Vom in einem orientalisch-asiatischen Mix üppig eingerichteten Wohnzimmer mit Kamin führen Stufen zu einer mediterran begrünten Terrasse mit Swimmingpool hinab. Von hier bietet sich ein fantastischer Blick aufs Meer. In den Sofas der unter freiem Himmel gelegenen Lounge lassen sich lange Nachmittage wunderbar verträumen.

La Villa Luz de Ibiza à San José sur l'île d'Ibiza dégage une atmosphère orientale-asiatique enchanteresse. Ses 600 m² abritent sept chambres et deux suites magnifiques aux salles de bains extravagantes. Le bois sombre accentue les murs blancs et les arches maures surplombent les tuiles et accessoires colorés. Depuis la salle de séjour orientale-asiatique luxueusement meublée avec cheminée, des marches mènent vers une terrasse avec plantes méditerranéennes et piscine. Elle offre une vue fantastique sur l'océan. L'après-midi, vous pouvez vous laisser aller à des rêves merveilleux, installé sur le canapé dans le salon à ciel ouvert.

Villa Luz de Ibiza de San José, en la isla de Ibiza, emana encanto oriental-asiático. En sus 600 m² tienen cabida siete dormitorios y dos suites maravillosas con extravagantes baños. La madera oscura acentúa la blancura de las paredes. Los arcos moriscos custodian azulejos multicolores y elementos decorativos. Atravesando unos peldaños desde el salón con chimenea y mobiliario de marcado carácter oriental se llega a la terraza ajardinada con piscina. Desde aquí, las vistas al mar son magníficas. En los sofás del lounge al aire libre se imaginan largas y agradables sobremesas.

La Villa Luz de Ibiza di San José, a Ibiza, emana una magia orientale. I suoi 600 m² offrono posto per sette camere da letto, tra le quali due meravigliose suite, con bagni di gusto fuori del comune. Il legno scuro accentua il bianco delle pareti, archi moreschi sovrastano piastrelle e accessori dai colori accesi. Dal salone con camino, arredato in modo orientale e sfarzoso, alcuni gradini portano giù verso un terrazzo con piscina ricco di piante mediterranee. Da qui si ha una vista fantastica sul mare. Durante i lunghi pomeriggi, nei sofà della lounge a cielo aperto, si può sognare meravigliosamente ad occhi aperti.

Architecture and accessories exude Oriental magic straight out of 1001 Nights.

Architektur und Accessoires verströmen orientalischen Zauber wie aus 1001 Nacht.

L'architecture et les accessoires dégagent un charme oriental semblant sortir tout droit des 1001 Nuits.

La arquitectura y los detalles emanan encantos de las mil y una noches.

L'architettura e gli accessori emanano una magia orientale da Mille e una notte.

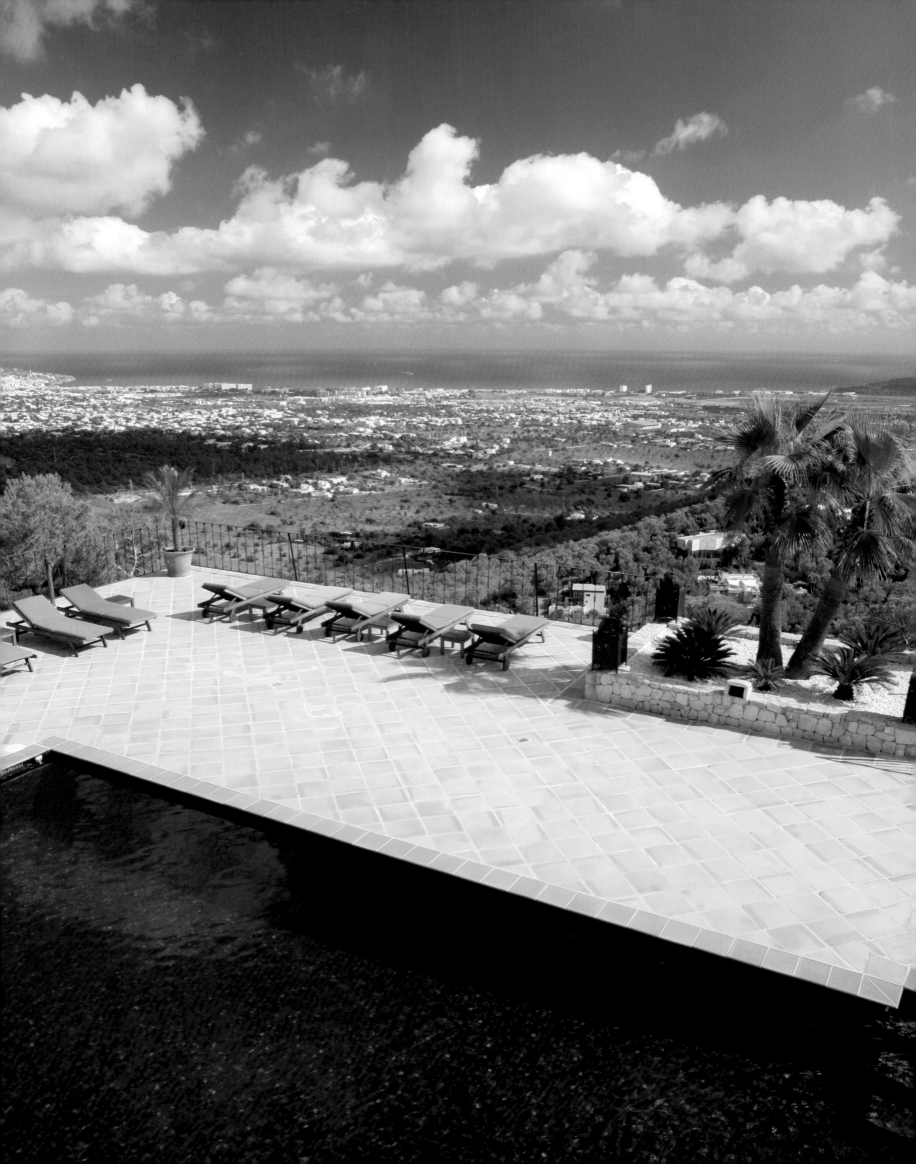

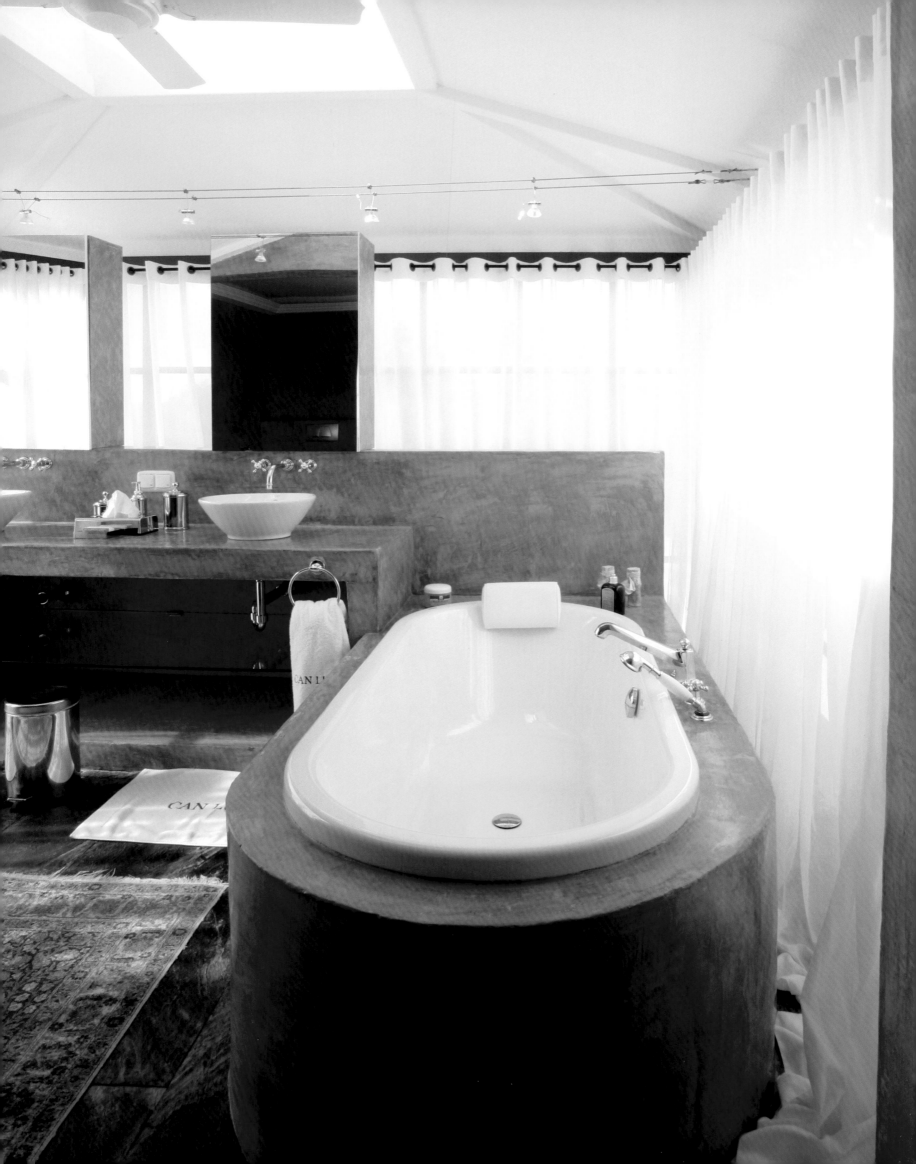

Valuable rugs also adorn the baths of the seven bedrooms. The Oriental-themed seating style with its thick pillows is beckoning. You won't have to be on floor level when it's time to eat, though.

Kostbare Teppiche schmücken auch die Bäder der sieben Schlafzimmer. Einladend ist die orientalisch anmutende Sitzgruppe mit dicken Kissen. Zum Essen muss man indes nicht ganz auf den Boden sinken.

Des tapis précieux ornent également les salles de bains des sept chambres. Le salon en style oriental avec ses épais coussins est très accueillant. Cependant, pas besoin de vous enfoncer jusqu'au sol pour y manger.

Exquisitas alfombras ornamentan los baños de los siete dormitorios. El grupo de asientos de corte oriental con mullidos cojines resulta especialmente atrayente. Para comer no hay por qué hundirse.

Tappeti pregiati adornano anche i bagni delle sette camere da letto. Il salottino orientale con i suoi grandi cuscini è molto invitante. Per mangiare, tuttavia, non è necessario abbassarsi completamente fino al pavimento.

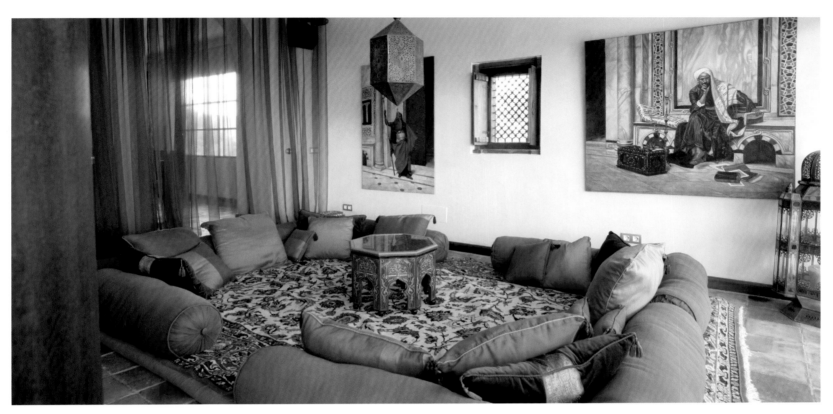

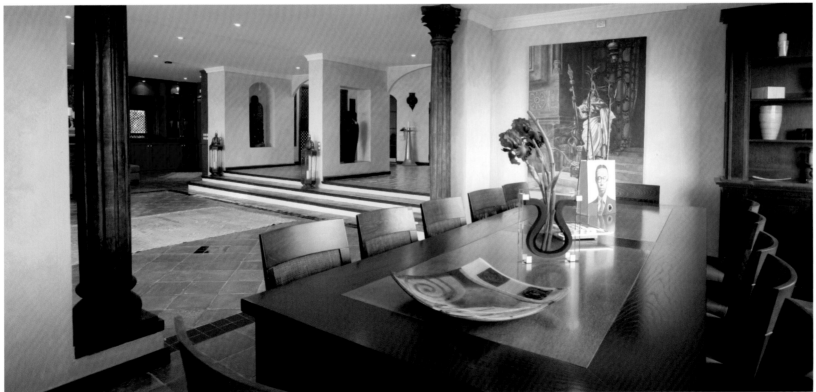

The terrace and open-air lounge are in a Mediterranean garden.

Terrasse und Open-Air-Lounge liegen in einem mediterranen Garten.

La terrasse et le salon à ciel ouvert ont pour cadre un jardin méditerranéen.

La terraza y el lounge al aire libre están emplazados en un jardín mediterráneo.

Il terrazzo e la lounge all'aperto sono situati nel giardino mediterraneo.

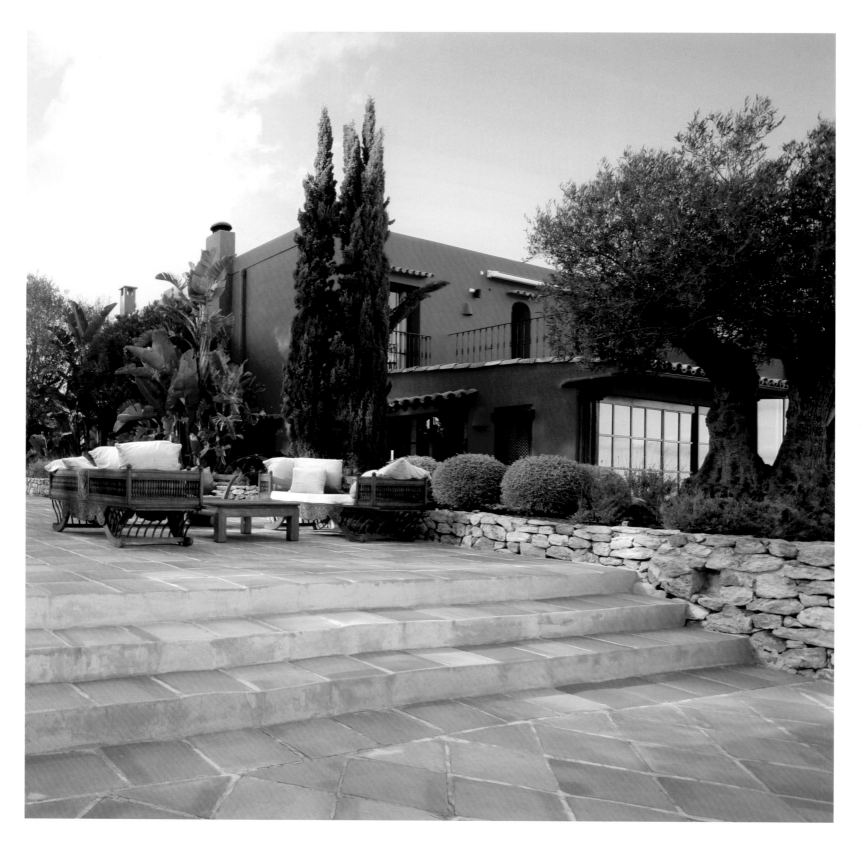

*The **living areas*** and bedrooms with their various décors are furnished opulently. Even art objects from Asia have found a home here and blend in harmoniously.

Opulent sind die *Wohnbereiche und unterschiedlich gestalteten Schlafzimmer ausgestattet. Auch Kunstobjekte aus Asien haben hier ihren Platz gefunden und fügen sich harmonisch ein.*

Les salles de séjour *et les chambres aux décorations variées sont richement meublées. Des objets d'art asiatiques y ont même trouvé leur place et s'y fondent harmonieusement.*

Fastuosas son las salas *de estar y los dormitorios, cada uno de diferente decoración. Las obras de arte procedentes de Asia han encontrado aquí acomodo y se integran de forma armoniosa.*

Le zone soggiorno *e le camere da letto, tutte diverse l'una dall'altra, sono riccamente arredate. Anche oggetti d'arte provenienti dall'Asia hanno trovato posto e si inseriscono armonicamente in questo ambiente.*

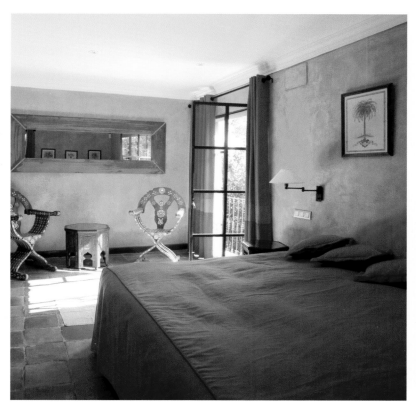

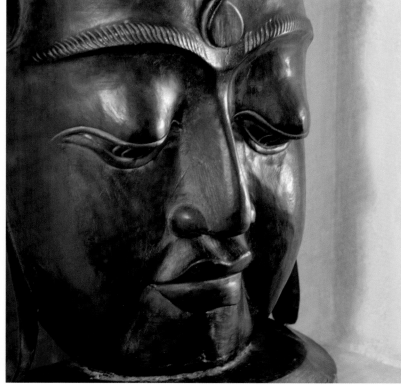

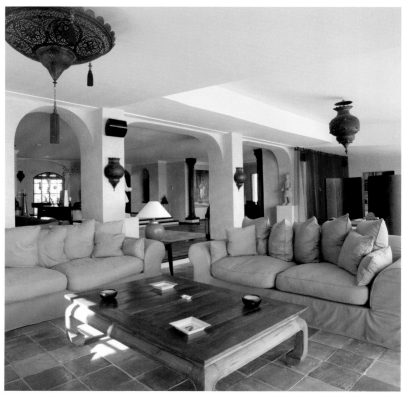

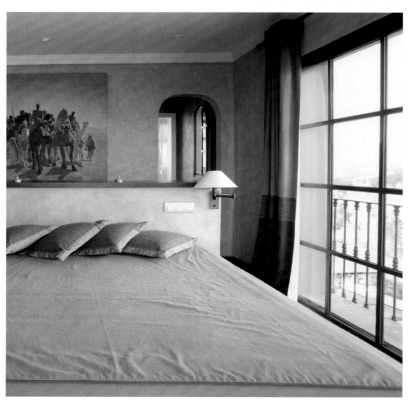

Villa Fonzita

Ibiza, Spain

A hint of Morocco drifts through this villa high above Es Cubells on Ibiza. One of its towers houses three bedrooms. A second tower, at a height of 23 ft., accommodates the living room with fireplace as well as a designer kitchen with adjoining dining room. In the gallery, a lounge with colorful rugs, low seating furniture, and white canvas evokes the feeling of a Berber tent in an Arabian fairytale world. Concrete, timber from Bali and Birma, and high-grade steel create a strong contrast to the vividly colored Arabian elements.

Ein Hauch von Marokko weht durch diese Villa über Es Cubells auf Ibiza. In einem seiner Türme sind drei Schlafzimmer, in einem zweiten das 7 m hohe Wohnzimmer mit Kamin und eine Designerküche mit anschließendem Speisezimmer untergebracht. Auf der Empore evoziert eine Lounge mit bunten Teppichen, niedrigen Sitzmöbeln und weißer Leinwand wie in einem Berberzelt eine arabische Märchenwelt. Beton, Hölzer aus Bali und aus Birma sowie Edelstahl schaffen einen starken Kontrast zu den farbenfrohen arabischen Elementen.

Il se dégage une atmosphère marocaine de cette villa dominant Es Cubells à Ibiza. Une de ses tours contient trois chambres. La seconde abrite la salle de séjour avec une cheminée d'une hauteur de 7 m sous plafond, ainsi que la cuisine moderne avec salle à manger adjacente. Dans la galerie, un salon avec des tapis colorés, des fauteuils bas et une toile blanche tendue rappelle les tentes berbères des contes orientaux. Le ciment, les bois importés de Bali et de Birma et l'inox créent un contraste fort avec les éléments arabes multicolores.

Un halo de Marruecos envuelve a la villa situado en Es Cubells, en la isla de Ibiza. En una de sus torres alberga tres dormitorios, mientras, en la segunda se ubican el salón de 7 m de altura con chimenea y una cocina de diseño con comedor contiguo. Evocando un mundo árabe de fábula la galería integra la sala de estar con multicolores alfombras, asientos de baja altura y una lona blanca a modo de tienda bereber. El hormigón, la madera de Bali y Birma y el acero inoxidable generan un marcado contraste con los coloristas elementos árabes.

In questa villa sopra Es Cubells a Ibiza si respira aria di Marocco. In una delle sue torri si trovano tre camere da letto, in un'altra si trova un salone alto 7 m con camino e una cucina di design con sala da pranzo annessa. Sul matroneo, una lounge con tappeti colorati, sgabelli bassi e una tela bianca evocano, come in una tenda berbera, un mondo arabo da favola. Il cemento, il legno proveniente da Bali e dalla Birmania, oltre all'acciaio inossidabile, creano un forte contrasto con gli elementi arabi pieni di colore.

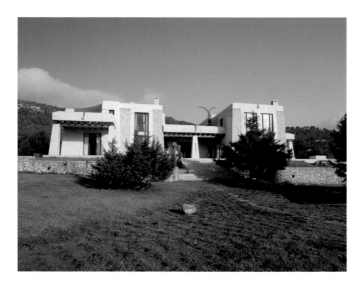

Villa Fonzita is located like a fortress high on its hill above Es Cubells.

Wie eine Festung sitzt die Villa Fonzita auf ihrem Hügel über Es Cubells.

La Villa Fonzita se dresse, telle une forteresse, sur une colline au-dessus d'Es Cubells.

Villa Fonzita se levanta como una fortaleza sobre una colina que domina Es Cubells.

Villa Fonzita si erge come una fortezza sulla collina che domina Es Cubells.

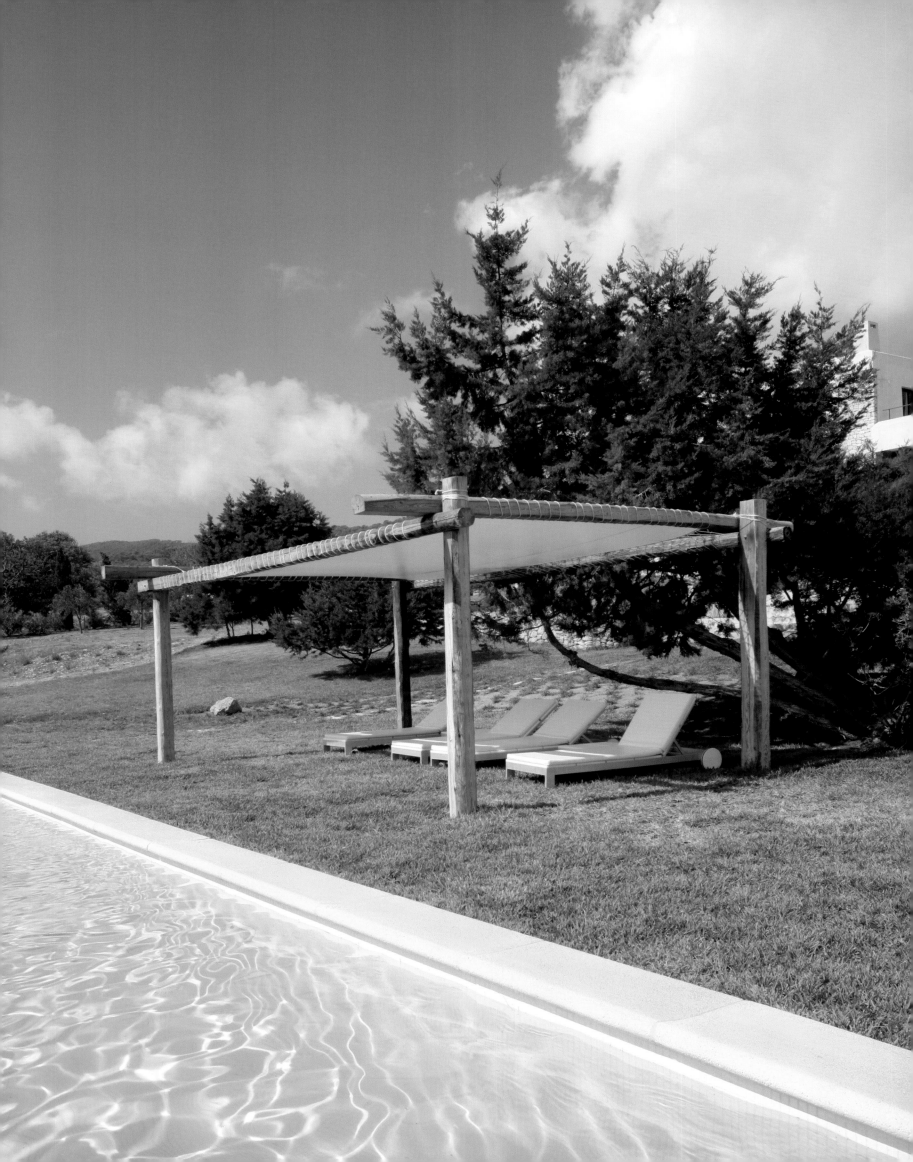

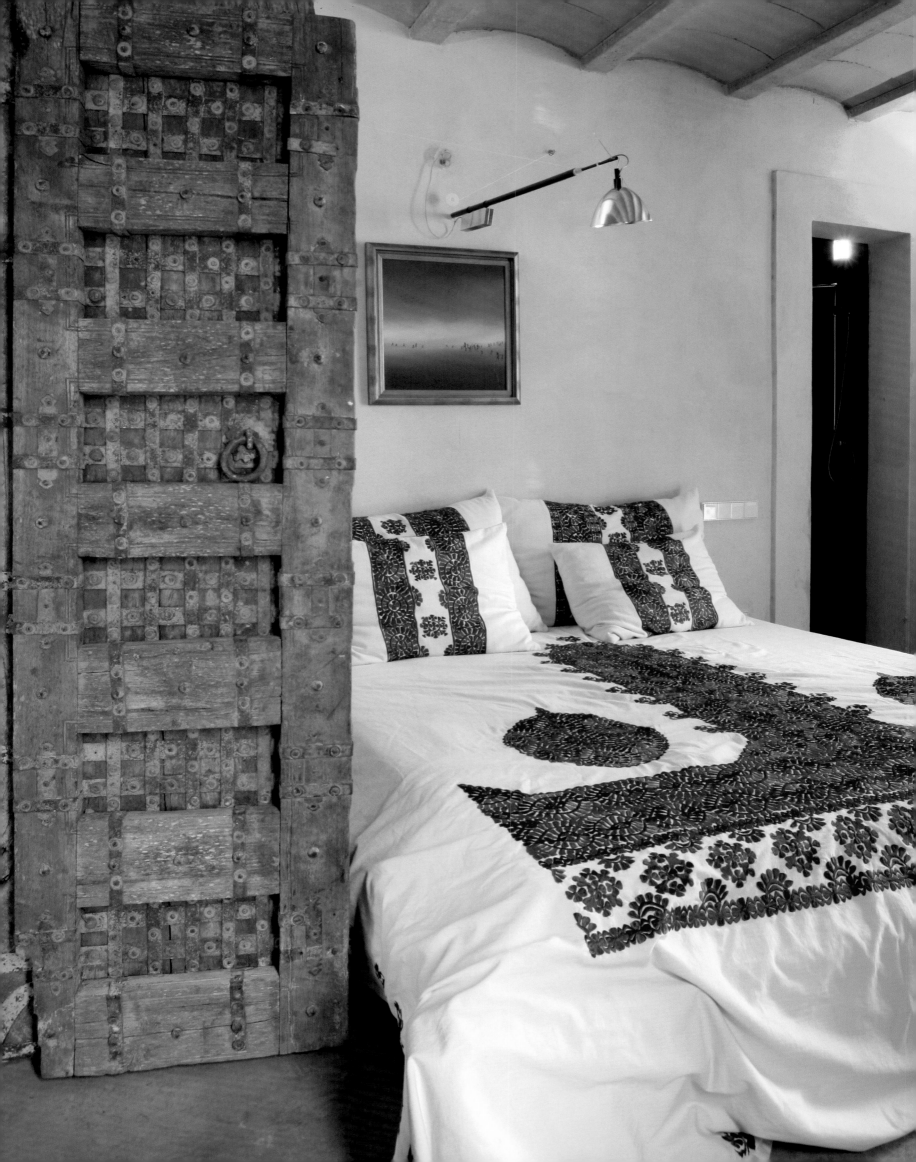

Strong contrasts: *Archaic materials, radiant colors, and contemporary comfort create an atmosphere to feel good in. The lounge that is designed like a Berber tent and the high, light-filled living room make an extraordinary and inviting impression.*

Starke Kontraste: *Archaische Materialien, leuchtende Farben und zeitgemäßer Komfort schaffen eine Atmosphäre zum Wohlfühlen. Originell und einladend zugleich wirken die einem Berberzelt nachempfundene Lounge und das hohe, lichtdurchflutete Wohnzimmer.*

Des contrastes marqués : *matériaux archaïques, couleurs vives et confort contemporain dégagent une sensation de bien-être. Le salon conçu comme une tente berbère et la salle de séjour inondée de lumière créent une atmosphère accueillante et exceptionnelle.*

Contrastes muy marcados: *materiales arcaicos, colores luminosos y confort contemporáneo crean un ambiente acogedor. La zona lounge, semejante a una tienda bereber, y la sala de estar de gran altura inundada de luz, resultan originales y confortables a la vez.*

Contrasti intensi: *materiali arcaici, colori vivi e comfort contemporaneo creano un ambiente accogliente. La lounge concepita come una tenda berbera ed il soggiorno alto e inondato di luce creano un'atmosfera al tempo stesso originale e invitante.*

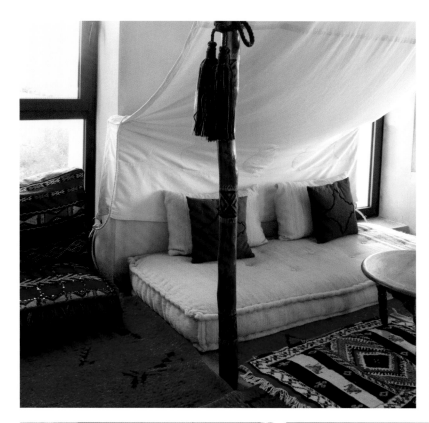 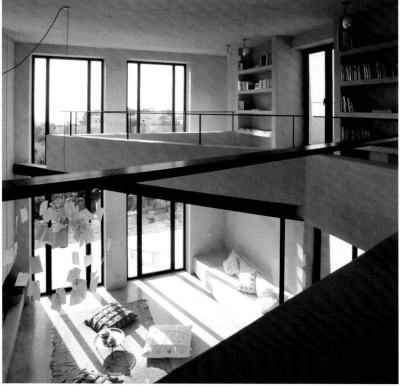

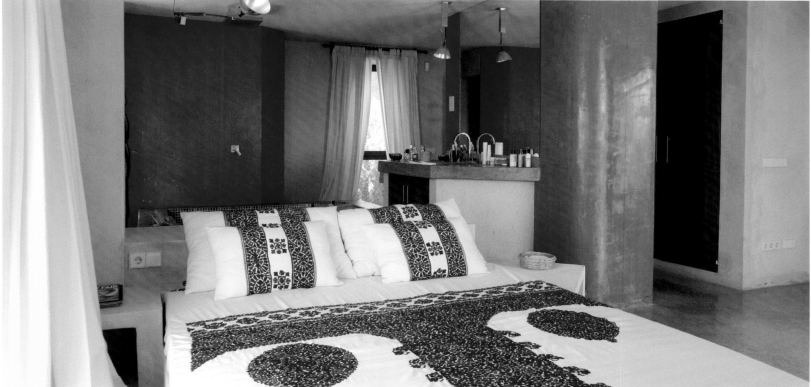

Casa Roja

Majorca, Spain

This splendid estate to the northeast of Majorca is fashioned after a Mexican hacienda, offering a marvelous panorama view of the town of Artà and the surrounding mountain range. The rural-bucolic facade of the villa reveals an interior of contemporary design. All of its rooms lead to the heart of the house, the patio. Since the patio is partially covered, it can serve as a meeting place year-round. A pergola with a barbecue place connects the house to its lavish outside premises. The villa's garden with its Mediterranean plants has an infinity pool.

Einer mexikanischen Hazienda ist dieses fürstliche Anwesen im Nordosten Mallorcas nachempfunden, das einen herrlichen Panoramablick auf Artà und die umliegende Bergkette bietet. Hinter der ländlich-rustikalen Fassade der Villa verbirgt sich ein Interieur in zeitgemäßem Design. Alle Zimmer führen zum Herz des Hauses, dem Patio. Weil er teilweise überdacht ist, kann er das ganze Jahr über als Treffpunkt dienen. Eine Pergola mit Grillplatz verbindet das Haus mit den großzügigen Außenanlagen. Im mediterran bepflanzten Garten liegt ein Infinity-Pool.

Cette splendide propriété au nord-est de Majorque prend modèle sur une hacienda mexicaine et offre une vue panoramique magnifique sur Artà et la chaîne de montagnes environnante. La façade rurale rustique de la villa cache un intérieur au design contemporain. Toutes les pièces mènent au cœur de la villa, le patio. Comme ce dernier est partiellement couvert, il peut servir de lieu de rencontre toute l'année. Une treille avec un barbecue relie la maison au terrain. Le jardin aux plantes méditerranéennes dispose d'une piscine à débordement.

Esta majestuosa edificación en el noreste mallorquín asemeja a una hacienda mexicana, desde la que se abren impresionantes vistas a Artà y a la cadena montañosa circundante. Tras la fachada de esta rústica casa de campo, se esconde un interior de diseño contemporáneo. Todos los cuartos llevan al corazón de la vivienda: el patio. Al estar parcialmente cubierto, sirve de punto de encuentro durante todo el año. Una pérgola con barbacoa enlaza la casa con el amplio jardín exterior de vegetación mediterránea y la piscina de desborde infinito.

Questa tenuta principesca situata nella parte nordorientale di Maiorca si rifà a una hazienda messicana, e offre una magnifica vista panoramica su Artà e la catena montuosa circostante. Dietro la facciata rustica della villa si nasconde un interno dal design contemporaneo. Tutte le stanze conducono al cuore della casa, il patio. Grazie al fatto che è parzialmente coperto, può essere sfruttato come punto di ritrovo per tutto l'anno. Una pergola con un angolo per le grigliate collega la casa con gli spaziosi impianti esterni. Nel giardino adornato con piante mediterranee si trova un infinity pool.

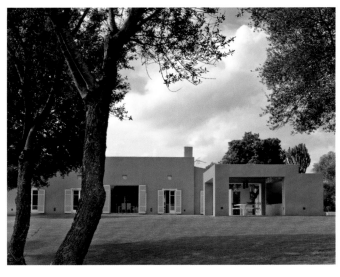

Strong colors, flat roofs and airy patios add a touch of Mexico to Majorca.

Kräftige Farben, flache Dächer und luftige Patios bringen einen Hauch von Mexiko nach Mallorca.

Des couleurs fortes, des toits plats et des patios aérés apportent une touche mexicaine à Majorque.

Colores vivos, tejados planos y patios espaciosos trasladan a Mallorca un aire mexicano.

I colori forti, i tetti piani e i patii ventilati portano un soffio di Messico a Maiorca.

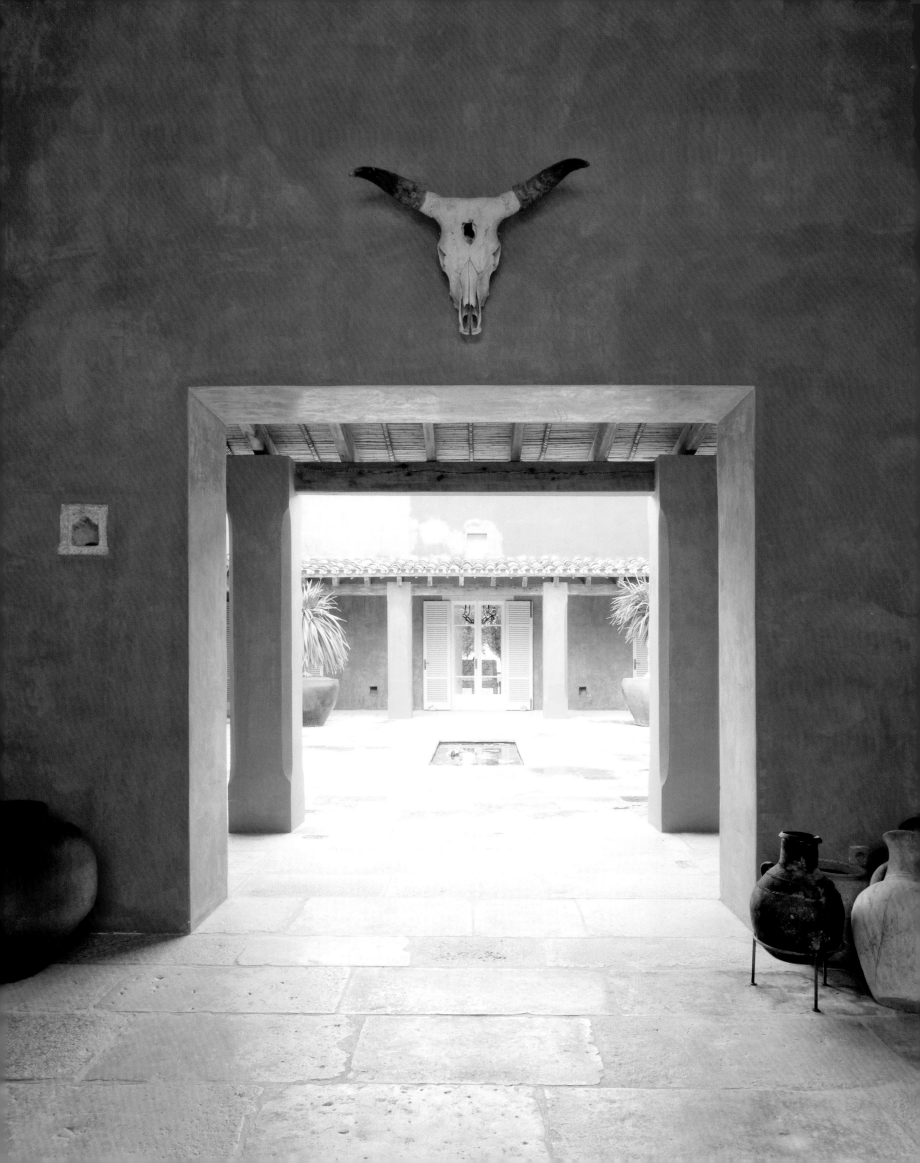

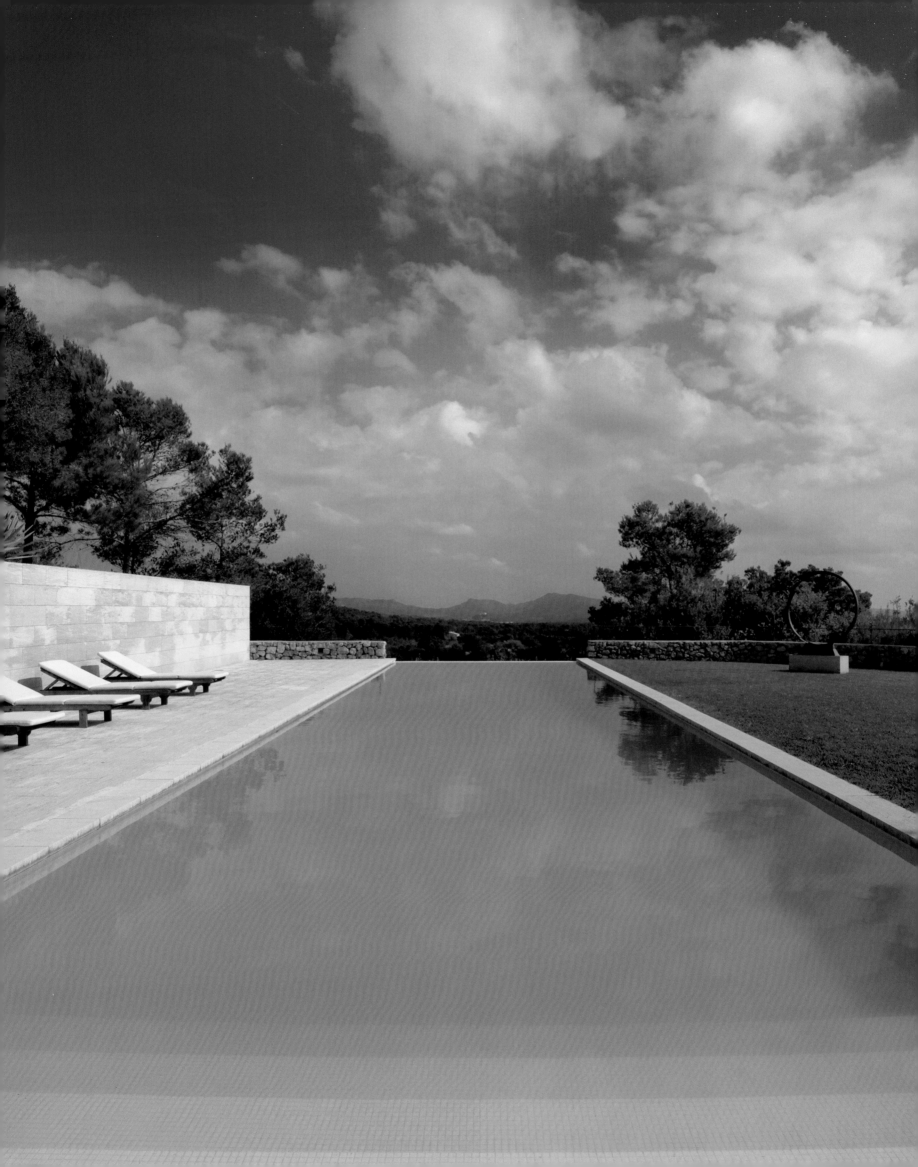

Dark accents like wooden beams and doors help balance the brightness of the white, purist interior. Inside, you'll find prominent displays of African and Asian craftsmanship.

Dunkle Akzente wie Holzbalken und -türen brechen die Helligkeit des weißen, puristischen Interieurs auf. Handwerkskunst aus Afrika und Asien kommt darin wirkungsvoll zur Geltung.

Des accents foncés comme les poutres et les portes en bois contrastent avec la clarté de l'intérieur blanc puriste. Les objets artisanaux africains et asiatiques y sont parfaitement mis en valeur.

Detalles en tonos oscuros como vigas y puertas de madera rompen con la luminosidad del interior blanco desnudo, en el que se realzan la artesanía africana y asiática.

Elementi scuri come le travi e le porte di legno spezzano la luminosità degli interni bianchi e puristici. Opere di artigianato africano e orientale vengono così valorizzate con grande effetto.

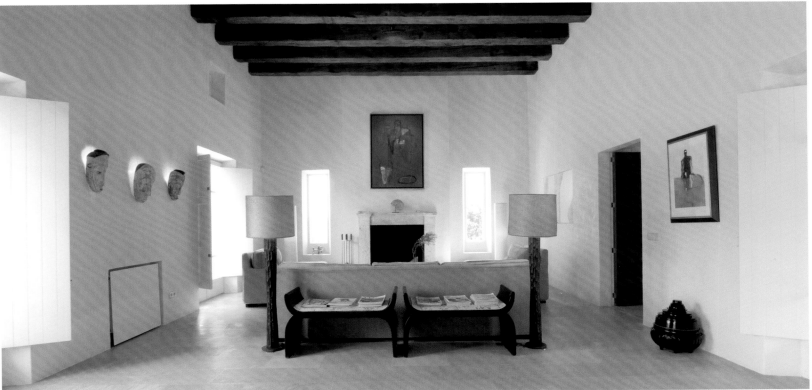

Villa Casa Nova

Faro, Portugal

The architecture of this villa near Faro is designed to express peace, strength and inspiration, so its décor dispenses with any superfluous details. Clean design, clear lines and colors and lots of space and light characterize the interior. The interlocking elements of the postmodern bungalow, which is kept in warm earth tones, form a fascinating contrast to the lush garden with its ancient olive trees. The terrace with its dining area and pool offers views of the ocean in the distance and the mountains.

Ruhe, Kraft und Inspiration soll die Architektur dieser Villa bei Faro vermitteln, und so verzichtet auch die Einrichtung auf jedes überflüssige Detail. Schnörkelloses Design, klare Linien und Farben, viel Platz und Licht kennzeichnen das Interieur. Die ineinander verschachtelten Elemente des postmodernen, in warmen Erdtönen gehaltenen Bungalows bilden einen reizvollen Kontrast zu dem üppigen Garten mit seinen uralten Olivenbäumen. Von der Terrasse mit Essbereich und dem Pool aus eröffnen sich Blicke auf das Meer in der Ferne und die Berge.

L'architecture de cette villa près de Faro a été conçue pour dégager paix, force et inspiration. Aussi le mobilier est-il également débarrassé de tout détail superflu. L'intérieur est caractérisé par un design simple, des lignes et couleurs nettes et beaucoup d'espace et de lumière. Le bungalow intègre des éléments postmodernes dans des teintes chaudes de terre qui forment un contraste fascinant avec le jardin luxuriant et ses vieux oliviers. La terrasse avec salle à manger et la piscine offrent une vue sur les montagnes et l'océan au loin.

Esta mansión de Faro está concebida para transmitir paz, fuerza e inspiración; de ahí que en su decoración se haya prescindido de todo detalle superfluo. El interior se caracteriza por un diseño austero, líneas y colores claros, mucho espacio y luz. Los elementos intercalados de este postmoderno bungalow de tonos cálidos forman un atractivo contraste con el exuberante jardín y sus longevos olivos. Desde la terraza con zona de comedor y la piscina se disfruta de las vistas de las montañas y el mar a lo lejos.

Tranquillità, forza e ispirazione sono i concetti che deve trasmettere l'architettura di questa villa presso Faro, e così anche l'arredamento rinuncia a ogni dettaglio superfluo. Un design senza fronzoli, linee e colori definiti, molto spazio e molta luce caratterizzano l'interno. Gli elementi, inseriti l'uno nell'altro, di questo bungalow post-moderno tinteggiato con i caldi colori della terra, formano un attraente contrasto con il giardino rigoglioso e i suoi ulivi secolari. Dal terrazzo con zona pranzo e dalla piscina si apre la vista sul mare in lontananza e sulle montagne.

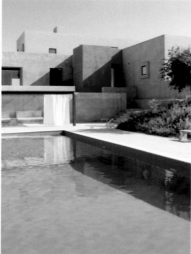

Every accessory of the cleverly designed bungalow is positioned in an effective way. The hanging daybed in the lounge offers a wonderful place to read and dream.

Jedes Accessoire des raffiniert geschnittenen Bungalows ist wirkungsvoll platziert. Einen herrlichen Platz zum Lesen und Träumen bietet das hängende Ruhebett in der Lounge.

Chaque accessoire du bungalow élégamment conçu est positionné de manière efficace. La méridienne suspendue dans le salon est un endroit merveilleux pour lire et rêver.

Cada uno de los accesorios de este refinado bungalow se ha emplazado de forma eficaz. La cama colgante de la sala de estar ofrece un lugar magnífico donde leer y soñar.

Ogni accessorio di questo bungalow suddiviso in modo molto razionale, è collocato ad effetto. Il divano sospeso che si trova nella lounge è un magnifico posto per leggere e sognare.

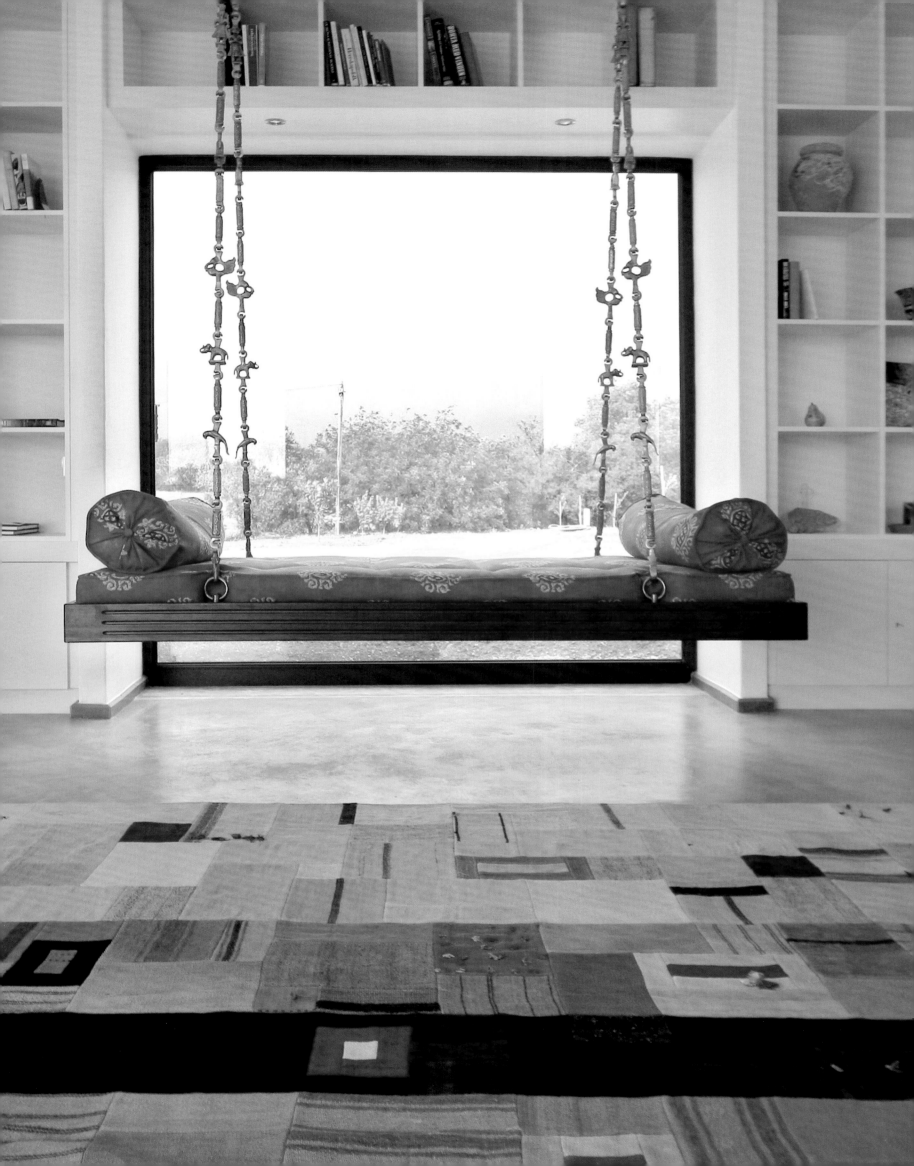

Earth tones and clear lines characterize the warm, elegant style of the building.

Erdtöne und klare Linien bestimmen den warmen, eleganten Stil des Gebäudes.

Le style chaleureux et élégant du bâtiment est characterisé par des couleurs de terre et des lignes pures.

El estilo cálido y elegante del edificio está marcado por tonos de tierra y lineas claras.

Colori della terra e linee pulite caratterizzano lo stile caldo ed elegante del edificio.

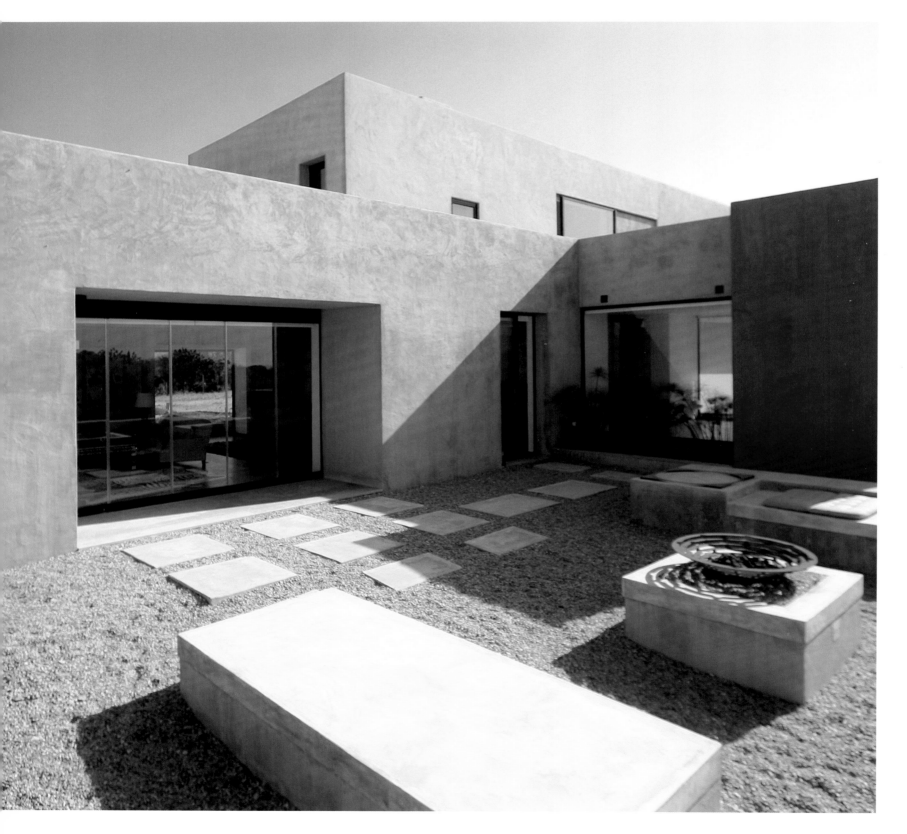

A living room with a fireplace, the kitchen with its own chef in charge, six tasteful bedrooms and stylish accessories make Casa Nova the perfect sanctuary.

Ein Wohnzimmer mit Kamin, die Küche, in der der hauseigene Koch Regie führt, sechs geschmackvolle Schlafzimmer und stilsicher gewählte Accessoires machen die Casa Nova zu einem perfekten Refugium.

Une salle de séjour avec cheminée, une cuisine avec son propre chef cuisinier aux fourneaux, six chambres pleines de goût et des accessoires élégants font de Casa Nova le sanctuaire parfait.

El salón con chimenea, la cocina con su propio cocinero o los seis elegantes dormitorios con elementos decorativos de gusto exquisito convierten a Casa Nova en el refugio perfecto.

Il soggiorno con camino, la cucina, in cui lavora il cuoco della casa, sei camere da letto di grande gusto e gli accessori selezionati rendono Casa Nova un rifugio perfetto.

Villa Pinhal

Comporta, Portugal

Villa Pinhal, consisting of two connected cubic blocks, is located in the middle of the natural wilderness of the Portuguese coast near Comporta. Its extensive glass fronts give it the appearance of a museum for modern art. High ceilings and freestanding staircases also reinforce the impression of space. White tables with chairs are scattered across the large living room like islands. The teak veranda surrounding the villa and the pool deck offers a view of green stone-pine. The living room with the open kitchen and dining area opens the view to a wooded plane.

Mitten in der wilden Natur der portugiesischen Küste bei Comporta liegt die aus zwei miteinander verbundenen Quadern bestehende Villa Pinhal. Mit ihren großflächigen Glasfronten sieht sie aus wie ein Museum für moderne Kunst. Hohe Decken und freie Treppen verstärken den Eindruck von Weite zusätzlich. Wie Inseln sind weiße Sitzgruppen in den großen Wohnraum gestreut. Von der Veranda aus Teakholz, die die Villa umschließt, und vom Pooldeck aus blickt man in einen grünen Pinienwald, vom Wohnzimmer mit dem offenen Küchen- und Essbereich auf eine bewaldete Ebene.

La Villa Pinhal, qui consiste en deux parallélépipèdes reliés, est située en pleine nature sur la côte portugaise, non loin de Comporta. Avec ses façades de verre, elle ressemble à un musée d'art moderne. Les hauts plafonds et les escaliers libres renforcent également l'impression d'espace. Des sièges blancs sont dispersés comme des îlots dans l'immense salle de séjour. Vous pouvez voir la pinède, de la terrasse en teck qui entoure la villa ou de la piscine. La salle de séjour avec cuisine ouverte et espace repas offre une belle vue sur une plaine boisée.

En plena naturaleza de la costa portuguesa, cerca de Comporta, se encuentra la Villa Pinhal formada por dos volúmenes cúbicos conexos. Sus grandes frontales de cristal se asemejan a un museo de arte moderno. Techos altos y escaleras exentas intensifican la sensación de amplitud. En el gran salón los conjuntos de sofás blancos se agrupan a modo de islas. Desde la tarima de teka que rodea la casa y la cubierta de la piscina se divisa el verde bosque de pinos; y desde el salón con cocina y comedor abiertos, el llano boscoso.

In mezzo alla natura selvaggia della costa portoghese, presso Comporta, si trova Villa Pinhal, composta da due quadrati collegati tra loro. Con le sue ampie vetrate ha l'aspetto di un museo d'arte moderna. Alti soffitti e scalinate libere rafforzano ulteriormente l'impressione di ampiezza. Le poltrone e i divani bianchi sono sparsi come isole nello spazio abitativo. Dalla veranda in teak, che racchiude la villa, e dal bordo piscina si può ammirare la pineta verde, dal salone con la zona cucina e la zona pranzo, si ammira la pianura boscosa.

Glass fronts open to the view of pristine nature, which you can enjoy undisturbed on a teak deck that runs around the entire house.

Glasfronten öffnen den Blick in unberührte Natur, die man von einem Deck aus Teakholz, das das ganze Haus umläuft, ungestört genießen kann.

Les façades de verre s'ouvrent sur une nature intacte, dont vous pouvez profiter en toute quiétude sur la terrasse de teck qui entoure toute la maison.

Los frontales de cristal despejan las vistas a la naturaleza virgen, que se disfruta sin obstáculos desde la tarima de teka alrededor de la casa.

Le vetrate aprono la vista sulla natura incontaminata, che si può ammirare indisturbati da una terrazza in legno teak che corre tutto intorno alla casa.

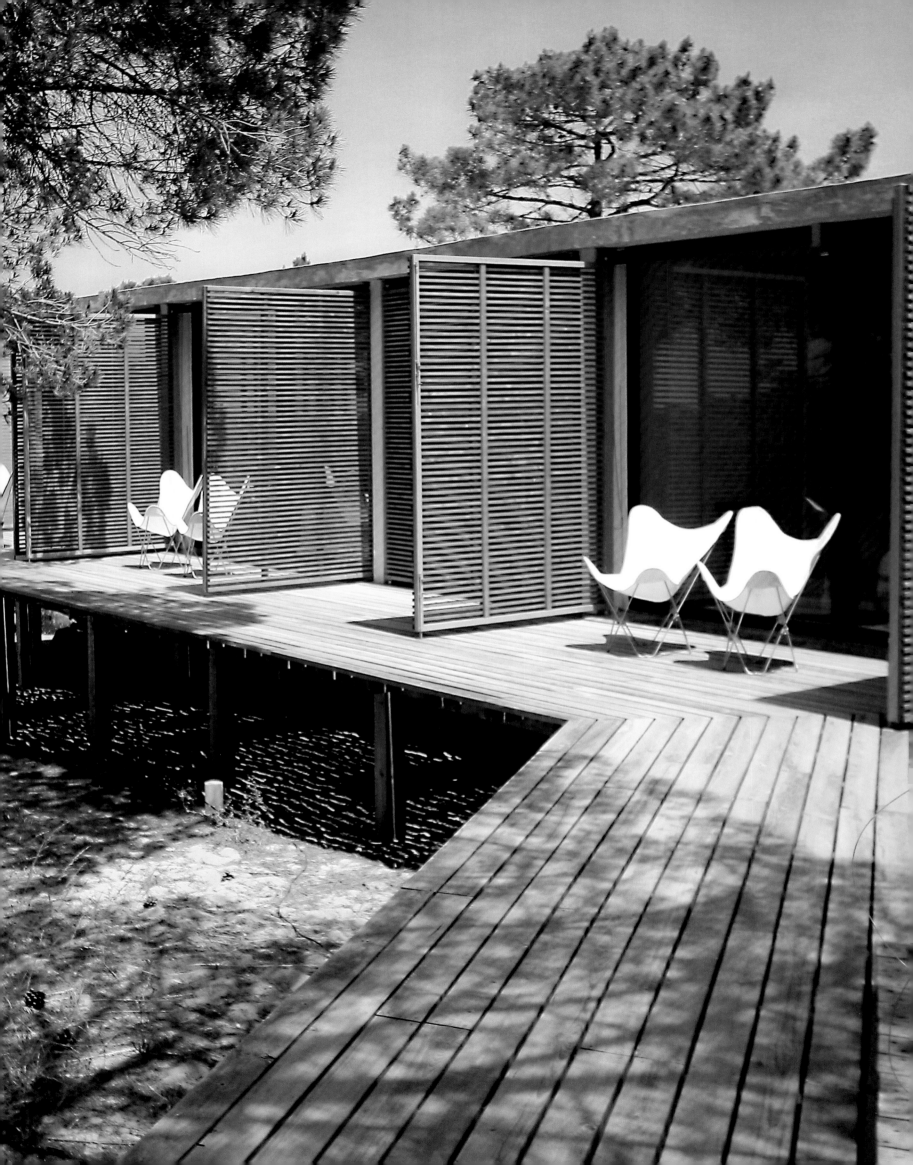

The décor is modern and totally minimalist. This makes the landscape outside of the glass fronts stand out even more prominently.

Modern und ganz zurückgenommen ist die Einrichtung. Umso stärker wirkt die Landschaft jenseits der Glasfronten.

Le mobilier est moderne et réduit au minimum. Le paysage de l'autre côté des baies vitrées paraît ainsi encore plus sensationnel.

La decoración es moderna y discreta, lo que intensifica el impacto del paisaje al otro lado de los ventanales.

L'arredamento, moderno e assai sobrio, dà risalto al paesaggio oltre le vetrate.

Lemonitra

Mykonos, Greece

The traditional Greek facade of this estate, extending across three levels above Panormos Bay on Mykonos, conceals a minimalist interior. The walls, ceilings and floors are kept in bright white, the bathrooms are functionally equipped and the furniture is positioned in a frugal but effective manner. Modern art adorns the living area on the top level and the kitchen opens to a veranda with a dining area. Each of the three bedrooms leads to the pool. If you prefer the ocean instead, the beach of Ftelia is less than a mile away.

Die traditionelle griechische Fassade dieses Anwesens, das sich auf drei Ebenen über der Panormos-Bucht auf Mykonos erstreckt, verbirgt ein minimalistisches Interieur. Die Wände, Decken und Böden sind in leuchtendem Weiß gehalten, die Bäder funktional ausgestattet und die Möbel sparsam, aber wirkungsvoll platziert. Den Wohnbereich in der obersten Ebene schmückt moderne Kunst, die Küche öffnet sich auf eine Veranda mit Essplatz. Jedes der drei Schlafzimmer führt zum Pool. Wer lieber im Meer planscht, fährt einen Kilometer zum Strand von Ftelia.

La façade grecque traditionnelle de cette propriété s'étendant sur trois niveaux au-dessus de la baie de Panormos à Myconos recèle un intérieur minimaliste. Les murs, plafonds et sols sont d'un blanc resplendissant, les salles de bains sont équipées de manière fonctionnelle et le mobilier est disposé avec parcimonie mais efficacité. L'espace-vie au dernier étage est orné d'art moderne, et la cuisine s'ouvre sur une véranda avec salle à manger. Chacune des trois chambres mène à la piscine. Si vous préférez plonger dans la mer, la plage de Ftelia est à seulement un kilomètre.

La tradicional fachada griega de esta construcción que se extiende a tres niveles a lo largo del golfo de Panormos esconde un interior minimalista. Paredes, techos y suelos se han mantenido en un blanco resplandeciente; los aseos se han equipado de forma funcional y los muebles aunque escasos, se han ubicado eficazmente. La sala de estar de la planta superior está decorada con arte moderno. La cocina se abre a un porche con comedor. Los tres dormitorios dan directamente a la piscina. Si se prefiere el mar, a un kilómetro queda la playa de Ftelia.

La facciata tradizionale greca di questa tenuta, che si estende su tre livelli sopra la baia di Panormos a Mykonos, nasconde un interno minimalistico. Le pareti, i soffitti e i pavimenti sono di un bianco luminoso, i bagni sono arredati in modo funzionale e i mobili, non eccessivi, sono collocati ad effetto. L'area abitativa nel livello più alto è arredata con oggetti d'arte moderna, la cucina si apre verso una veranda con una zona pranzo. Ognuna delle tre camere da letto porta alla piscina. Chi preferisce nuotare in mare, ha la spiaggia di Ftelia ad un chilometro di distanza.

The design and decor of this estate are extraordinary without corrupting the traditional style of the Cyclades.

Außergewöhnlich sind Design und Einrichtung dieses Hauses, ohne den traditionellen Stil der Kykladen zu beeinträchtigen.

L'architecture et le mobilier de cette maison sont extraordinaires, sans altérer le style traditionnel des Cyclades.

Tanto el diseño como la decoración de esta casa son extraordinarios y permanecen fieles al estilo de las Cícladas.

Il design e l'arredamento di questa casa sono fuori dal comune, senza corrompere lo stile tradizionale delle Cicladi.

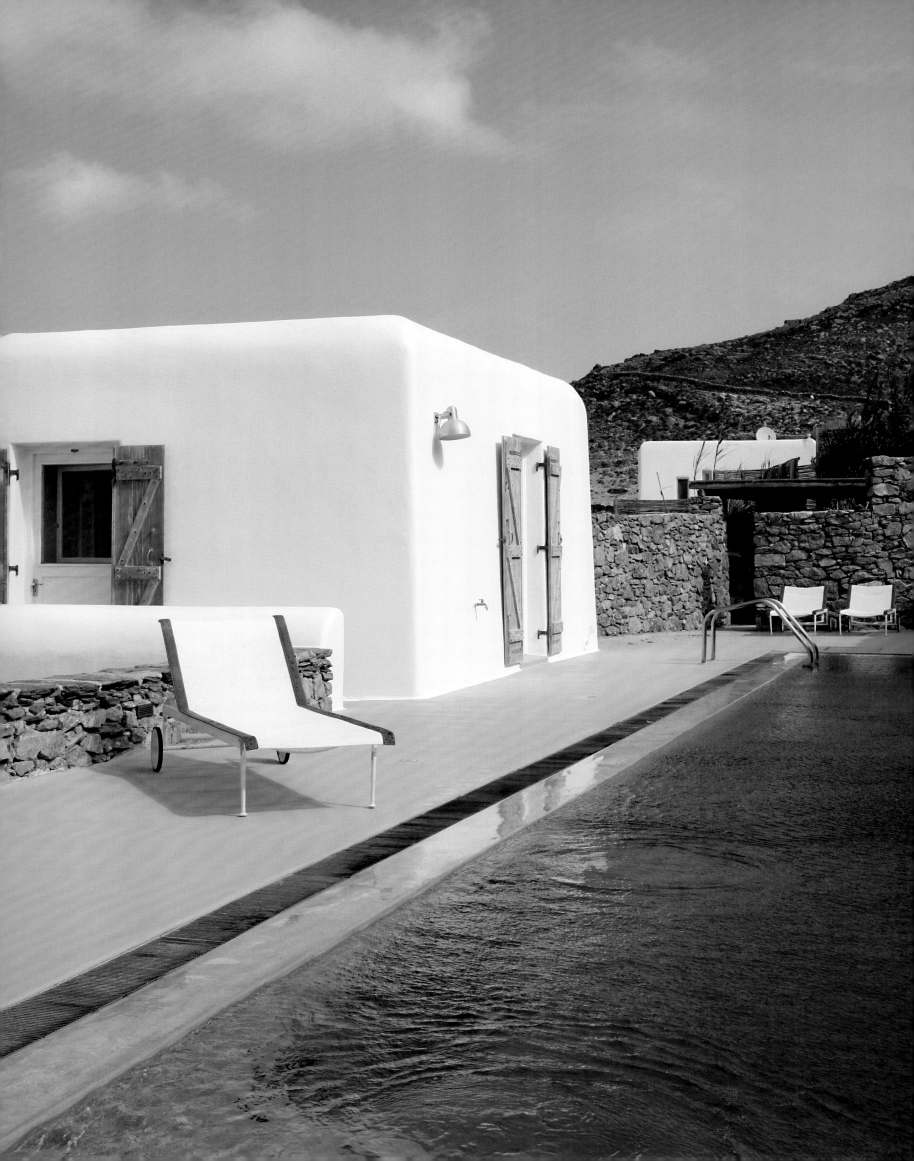

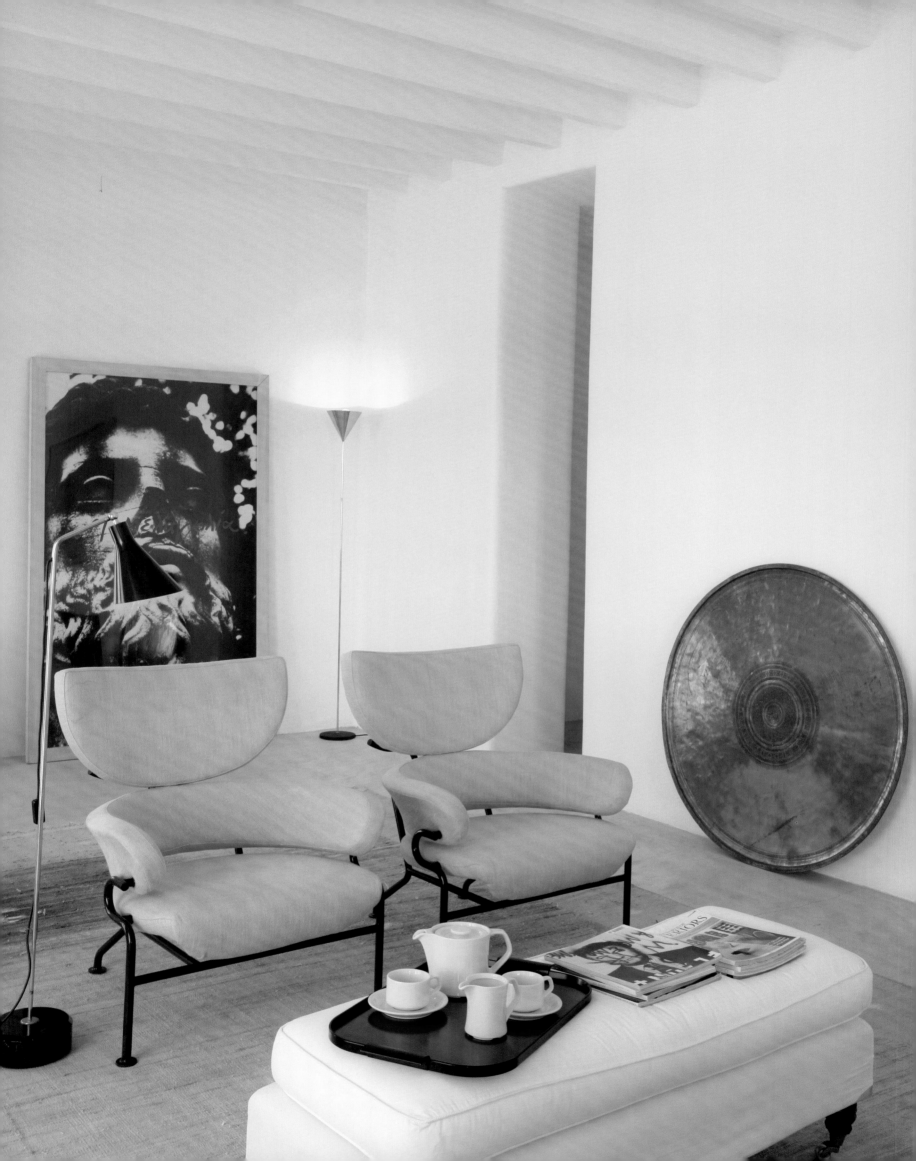

The living space is decorated with contemporary art, while the furnishings of the bedrooms show conscious restraint. All three levels of the house have a view of the ocean off the coast of Mykonos.

Den Wohnraum schmückt zeitgenössische Kunst, die Schlafzimmer sind bewusst zurückhaltend eingerichtet. Von allen drei Ebenen des Hauses blickt man auf das Meer vor Mykonos.

Le salle de séjour est décoré avec des œuvres d'art contemporain, tandis que le mobilier des chambres affiche une sobriété délibérée. Les trois niveaux de la maison ont tous vue sur la mer depuis la côte de Myconos.

La sala de estar está decorada con arte moderno; los dormitorios se han concebido austeramente de forma consciente. Desde los tres niveles de la casa se goza de vistas al mar.

La zona soggiorno è abbellita da oggetti d'arte contemporanea, le camere da letto sono arredate in modo consapevolmente sobrio. Da tutti e tre i livelli della casa si gode la vista sul mare di Mykonos.

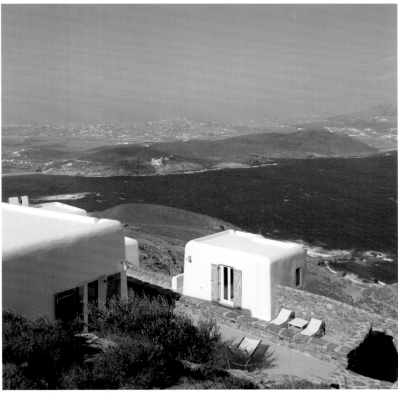
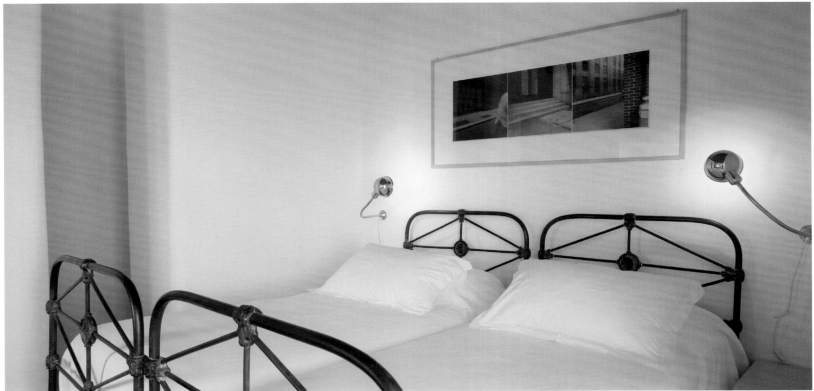

Ioannis Retreat

Mykonos, Greece

Against the backdrop of a white chapel, the terrace with its pool is spread out above the bay of Agios Ioannis, offering an enchanting view of the islands of Delos and Rinia. It's the perfect place to immerse oneself in watching the sun set. With its six bedrooms, the villa offers space aplenty—not to mention the Great Hall, dining room and comfortable lounges with various fireplaces. White textiles highlight the beautiful old furniture of the rooms. The beach of Kapari is just 1,300 ft. away.

Vor der Kulisse einer weißen Privatkapelle breitet sich die Terrasse mit dem Pool über der Bucht von Agios Ioannis aus und bietet einen zauberhaften Blick auf die Inseln Delos und Rinia. Sie ist ein perfekter Ort, um sich in den Anblick des Sonnenuntergangs zu versenken. Die Villa besitzt mit sechs Schlafzimmern viel Platz – von der Großen Halle, dem Esszimmer und den gemütlichen Lounges mit verschiedenen Kaminen gar nicht zu reden. In den Zimmern betonen weiße Textilien die schönen alten Möbel. Der Strand von Kapari liegt nur 400 m entfernt.

Avec une chapelle blanche pour toile de fond, la terrasse avec piscine s'étend au-dessus de la baie d'Agios Ioannis et offre une vue enchanteresse sur les îles de Delos et Rinia. C'est le lieu parfait pour s'immerger dans la contemplation du soleil couchant. Avec ses six chambres, la villa dispose d'un vaste espace – sans oublier la grande salle, la salle à manger et les salons accueillants autour des cheminées. Des tissus blancs mettent en valeur le beau mobilier ancien dans les pièces. La plage de Kapari n'est qu'à 400 m.

Con una capilla privada blanca como telón de fondo, la terraza con piscina se extiende sobre la bahía de Agios Ioannis ofreciendo unas vistas cautivadoras a las islas de Delos y Rinia. El lugar perfecto para dejarse llevar por el panorama del atardecer. La residencia dispone de un amplio espacio gracias a sus seis dormitorios, sin ya mencionar el gran vestíbulo, el comedor y los acogedores lounges con chimeneas. Los tejidos blancos de las estancias acentúan los bonitos muebles antiguos. La playa de Kapiri está a tan sólo 400 m.

Sullo sfondo di una cappella privata bianca, il terrazzo con piscina si apre sulla baia di Agios Ioannis, offrendo una vista fantastica sulle isole di Delo e Rinia. È un luogo perfetto per perdersi nello spettacolo del tramonto. La villa possiede sei camere da letto che le conferiscono molto spazio, senza considerare il grande salone, la sala da pranzo e le accoglienti lounge intorno a diversi camini. Nelle stanze, i tessuti bianchi danno risalto ai bei mobili antichi. La spiaggia di Kapari è a soli 400 m di distanza.

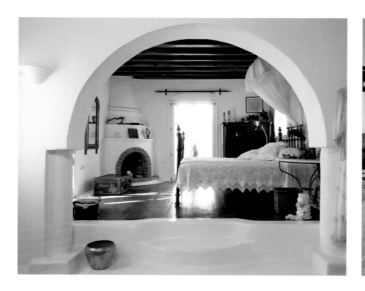

The simple architecture, somewhat bucolic in places and kept in white, follows Greek tradition, which also sets the tone for the interior.

Die schlichte, teilweise etwas rustikale und in Weiß gehaltene Architektur ist an die griechische Tradition angelehnt. Diese bestimmt auch das Interieur.

L'architecture simple quelque peu rustique, toute blanche, suit la tradition grecque. Elle définit aussi le ton à l'intérieur.

La arquitectura sobria y algo rústica dominada por el blanco se inspira en la tradición griega y define a la vez el interior.

L'architettura semplice, in parte rustica, in cui predomina il bianco, si ispira alla tradizione greca che definisce anche gli interni.

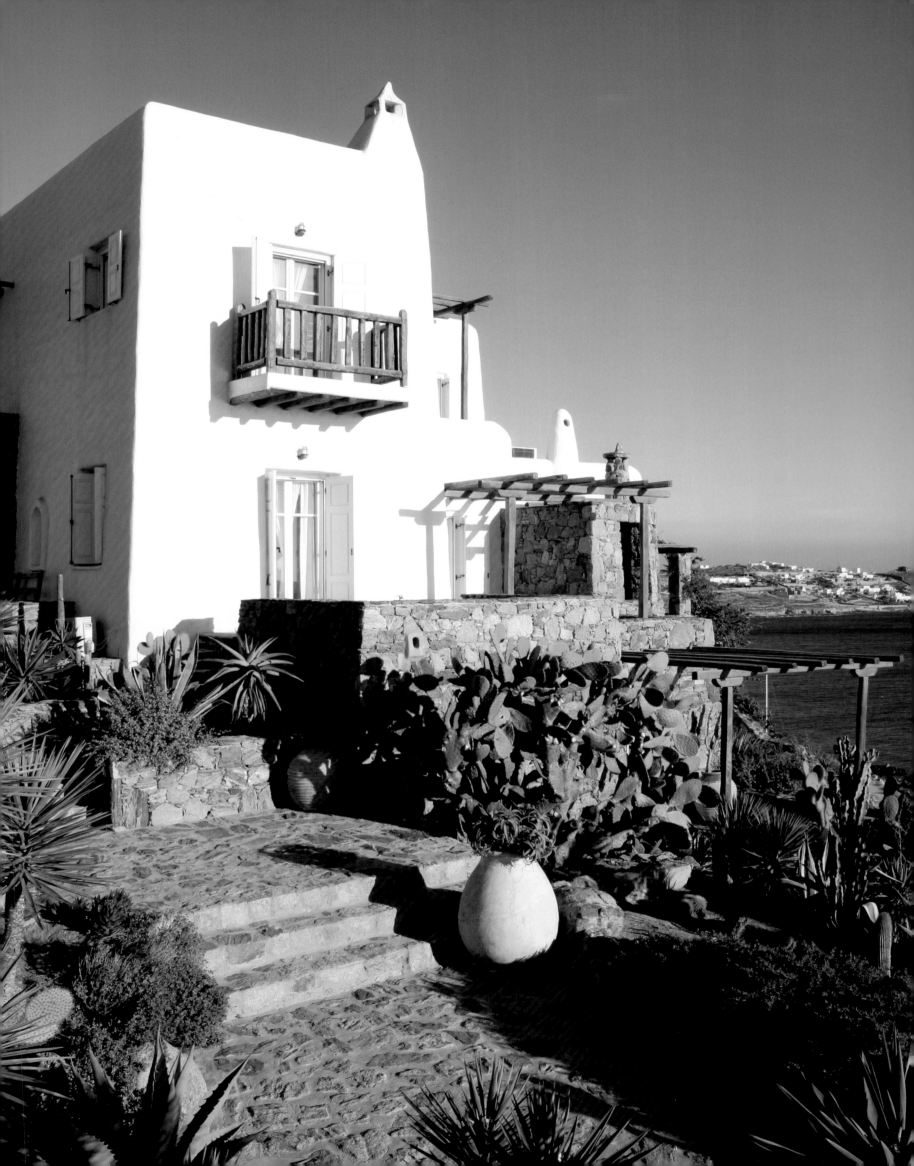

The rooms and terraces *have a spacious design and the rock walls integrated into the architecture lend a touch of eternity to the ambience.*

Die Räume und Terrassen *sind großzügig geschnitten und die in die Architektur integrierten Felswände verleihen dem Ambiente einen Hauch von Ewigkeit.*

Les pièces et les terrasses *sont spacieuses, et les parois rocheuses intégrées à l'architecture donnent une touche d'éternité à l'ensemble.*

Las estancias y la terraza *son muy espaciosas. Las paredes de roca integradas en la estructura arquitectónica infunden en el ambiente un halo de eternidad.*

I locali e i terrazzi *sono suddivisi spaziosamente e le pareti rocciose integrate nell'architettura donano all'ambiente un velo di eternità.*

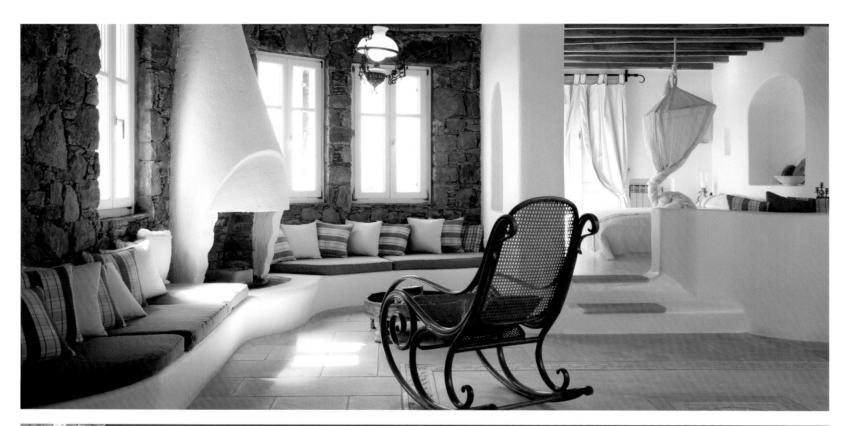

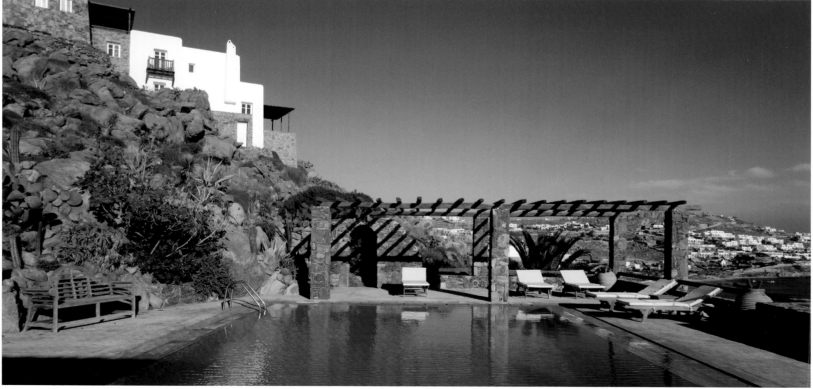

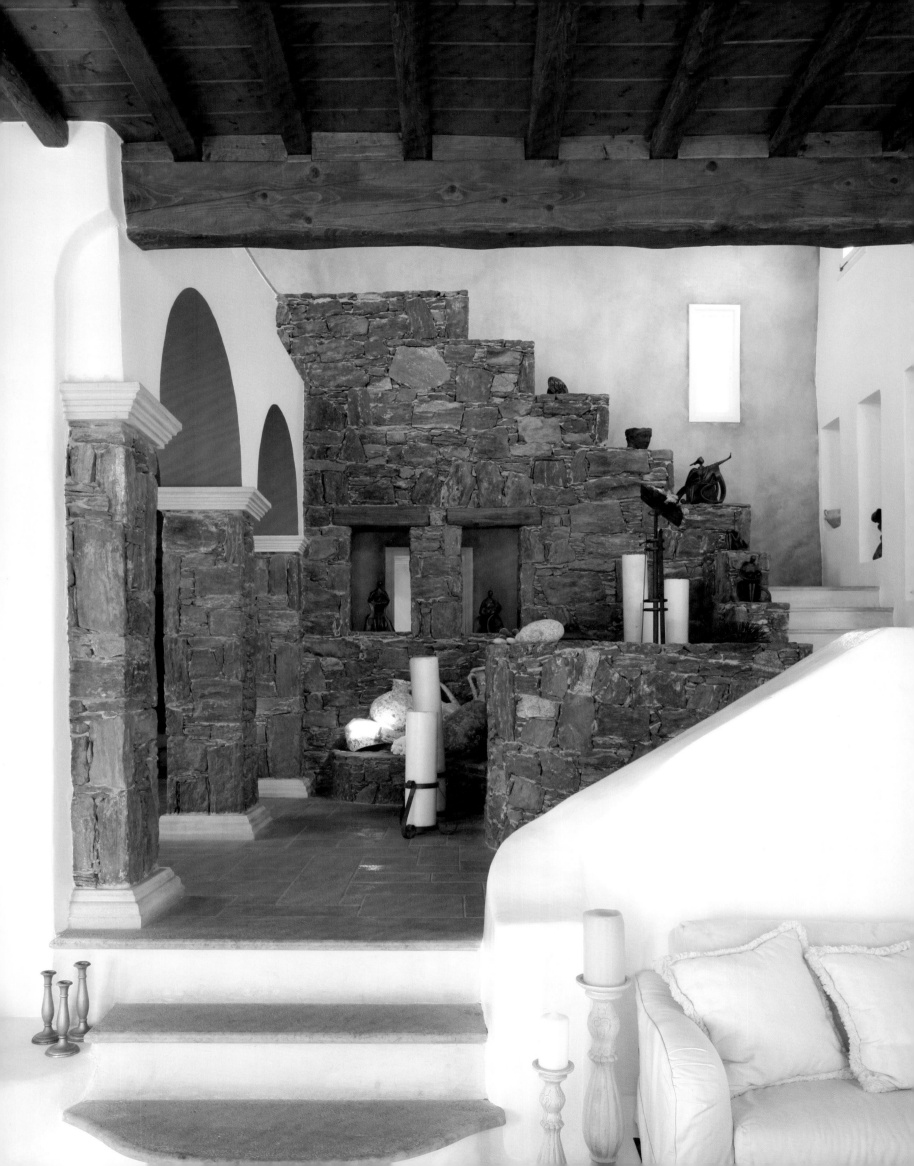

Villa Danae

Antiparos, Greece

Its distinct Greek style of white with blue accents and its modern design combine to form a purist, very effective ambience in this one-story villa on the island of Antiparos. Its furniture and accessories of fine materials are arranged to create an atmosphere of space and light. The infinity pool appears to blend directly into the ocean. The view from the terrace with its open-air lounge of the sand beach of Soros and the larger sister island of Paros in the distance is simply magical.

Der klare griechische Stil aus Weiß mit blauen Akzenten und ein modernes Design verbinden sich in dieser einstöckigen Villa auf der Insel Antiparos zu einem puristischen, überaus effektvollen Ambiente. Möbel und Accessoires aus edlen Materialien sind so platziert, dass eine Atmosphäre von Weite und Licht entsteht. Der Infinity-Pool scheint unmittelbar ins Meer überzugehen. Geradezu traumhaft ist der Blick von der Terrasse mit Freiluft-Lounge auf den Sandstrand von Soros und die größere Schwesterninsel Paros in der Ferne.

Dans cette villa de plain-pied sur l'île d'Antiparos, le style résolument grec, blanc avec des touches de bleu, associé à un design moderne, débouche sur une ambiance puriste, qui fait beaucoup d'effet. Les meubles et accessoires en matériaux précieux ont été disposés pour créer une impression d'espace et de clarté. La piscine à débordement semble se fondre directement dans l'océan. De la terrasse avec salon en plein air, la vue sur la plage de sable de Soros et l'île sœur de Paros, plus grande, au loin, est vraiment incroyable.

En esta vivienda de una sola planta en la isla de Antiparos el claro estilo griego, blanco con toques azules, y un diseño moderno se fusionan consiguiendo un ambiente puro y efectista. Mobiliario y elementos decorativos de materiales nobles se han distribuido con el fin de crear la sensación de amplitud y luminosidad. La piscina de desborde infinito parece prolongarse en el mar. Y fascinante es también la panorámica que se divisa desde la terraza con lounge abierto a la playa de Soros y la isla gemela de Paros.

In questa villa ad un piano situata sull'isola di Antiparos, lo stile greco ben definito, fatto di bianco con tocchi di blu, si unisce a un moderno design per sfociare in un ambiente puristico di grande effetto. I mobili e gli accessori fatti di materiali pregiati sono stati collocati in modo da creare un'atmosfera di ampiezza e luce. L'infinity pool sembra riversarsi senza discontinuità nel mare. La vista dalla terrazza con lounge all'aperto sulla spiaggia di sabbia di Soros e sulla più grande isola gemella di Paros, in lontananza, è semplicemente fantastica.

Nice perspective: *Seeing the ocean even before you get up—while you smell the fragrance of fresh coffee coming from the open kitchen.*

Schöne Aussichten: *Meerblick schon vor dem Aufstehen — aus der offenen Küche dringt derweil der Duft von frischem Kaffee.*

Panorama splendide : *la vue sur la mer, de votre lit, pendant que l'odeur du café frais arrive de la cuisine ouverte.*

Fantásticas perspectivas: *el mar se divisa desde el momento de levantarse, mientras de la cocina abierta va llegando el aroma del café recién hecho.*

Magnifica combinazione: *la vista sul mare già prima di alzarsi e il profumo del caffè appena fatto che giunge dalla cucina aperta.*

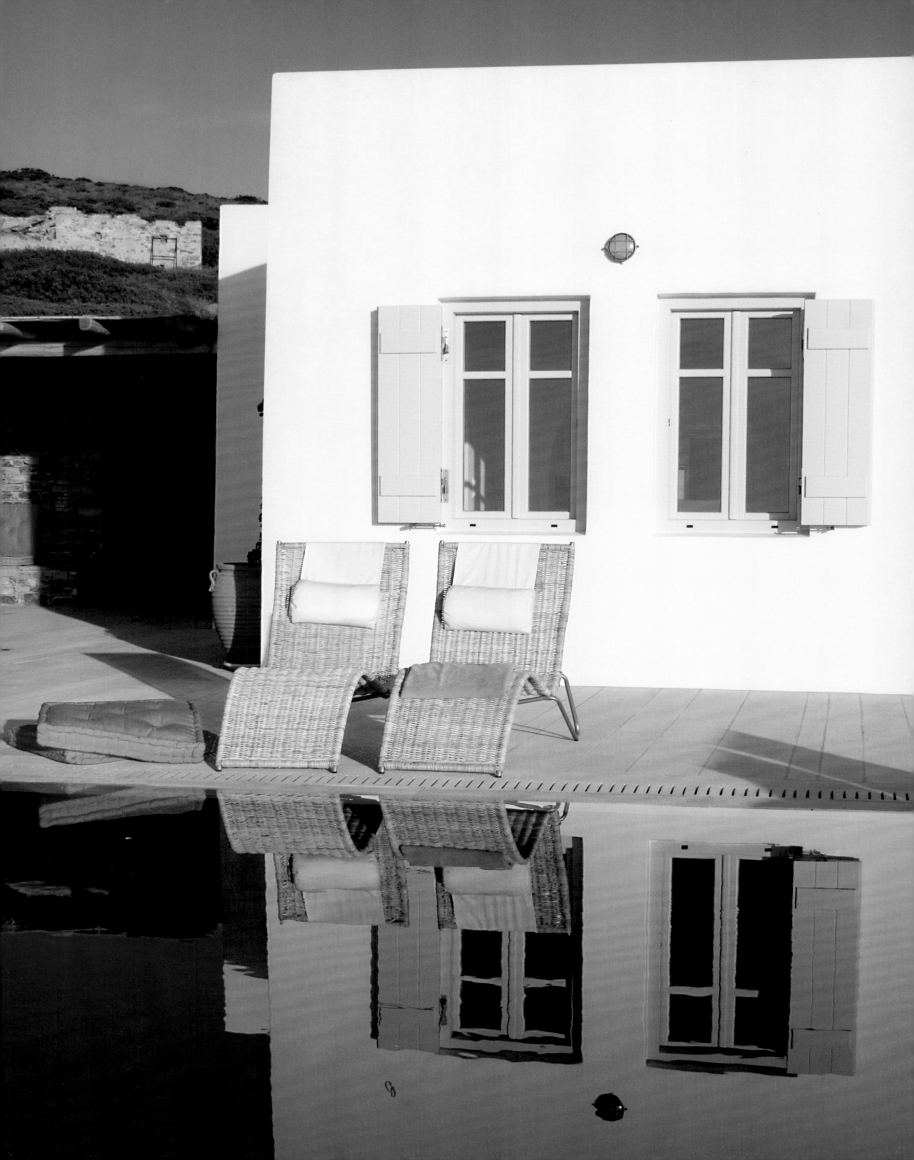

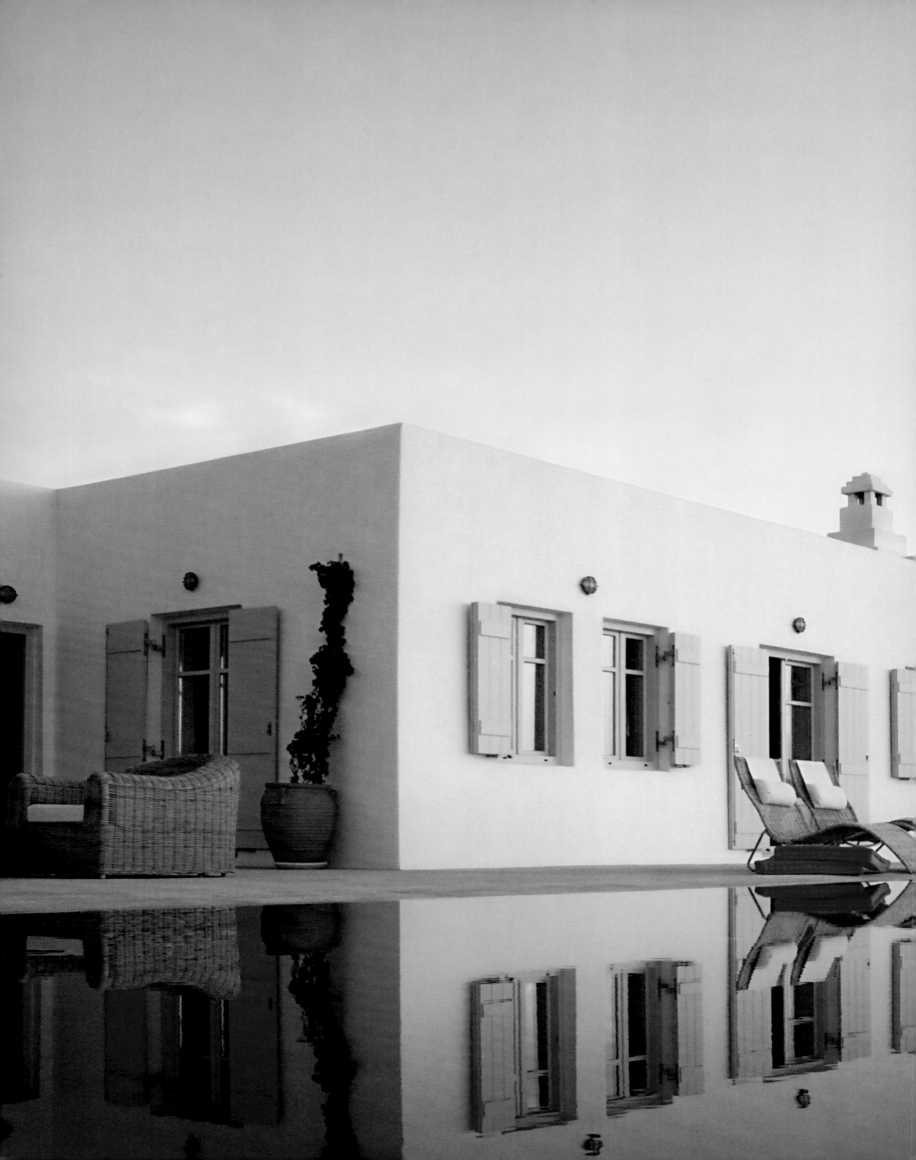

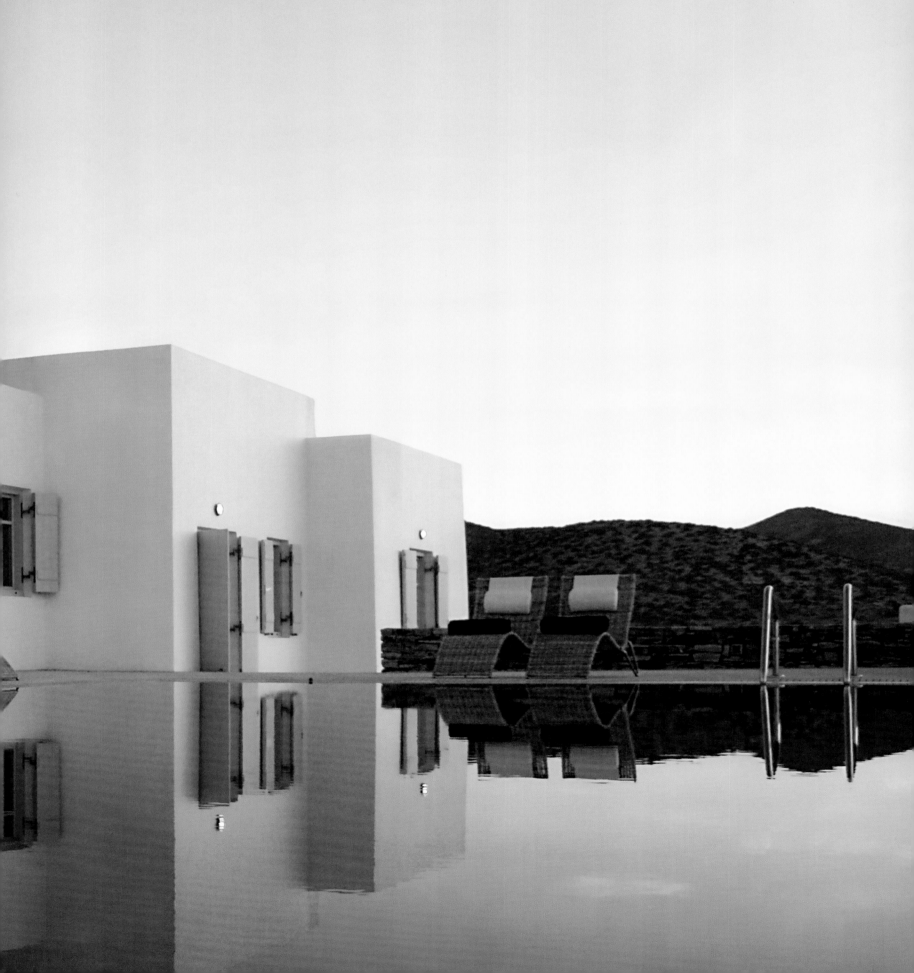

Ryad 9

Fès, Morocco

This carefully and authentically restored place is an oasis of peace at the center of the lively Medina (listed as a World Heritage Site by UNESCO) in Morocco's secret capital of Fès. Exquisite antiques from Asia, France and England harmonize with the Arabian architecture of arches, patios, radiantly colorful mosaics and tiles. Dining takes place in the stillness of the central patio. The terrace reveals a view of the city with its domes, minarets and city wall from the Middle Ages.

Eine Oase der Ruhe ist dieses liebevoll und authentisch restaurierte Haus inmitten der lebhaften, von der UNESCO zum Weltkulturerbe gezählten Medina von Marokkos heimlicher Hauptstadt Fès. Erlesene Antiquitäten aus Asien, Frankreich und England fügen sich harmonisch in die arabische Architektur aus Bögen, Patios, strahlend bunten Mosaiken und Fliesen. Gespeist wird in der Stille des zentralen Patios. Von der Terrasse öffnet sich der Blick auf die Stadt mit ihren Kuppeln, Minaretten und der Stadtmauer aus dem Mittelalter.

Au cœur de Fès animée, considérée en secret comme la capitale du Maroc, cette maison restaurée avec amour et authenticité au centre de la Médina, site classé au patrimoine mondial de l'Unesco, est une oasis de paix. D'exquises antiquités asiatiques, françaises et anglaises s'accordent harmonieusement avec l'architecture arabe et ses arches, patios, mosaïques et tuiles de couleurs vives. Vous pouvez dîner dans le silence du patio central. La terrasse dévoile une vue sur la ville avec ses dômes, ses minarets et son rempart médiéval.

En Fès, capital secreta de Marruecos, se esconde un oasis de paz cuidadosamente restaurado y manteniendo fielmente su autenticidad. La vivienda se encuentra en el centro de su populosa medina, declarada patrimonio cultural de la humanidad por la UNESCO. Antigüedades selectas de Asia, Francia e Inglaterra se funden armónicamente con la arquitectura árabe de arcos, patios, coloridos mosaicos y azulejos. La comida se sirve en el plácido patio central. Desde la terraza se goza de una panorámica de la ciudad, con sus cúpulas, minaretes y la muralla medieval.

Questa casa restaurata con amore e cura per i particolari è un'oasi di pace in mezzo alla vivace Medina di Fès, la capitale segreta del Marocco, dichiarata dall'UNESCO patrimonio dell'umanità. Le preziose antichità provenienti dall'Asia, dalla Francia e dall'Inghilterra si inseriscono armonicamente nell'architettura araba fatta di archi, patii, piastrelle e splendidi mosaici colorati. Si mangia nel silenzio del patio centrale. Dal terrazzo si apre la vista sulla città con le sue cupole, i suoi minareti e la cinta muraria medievale.

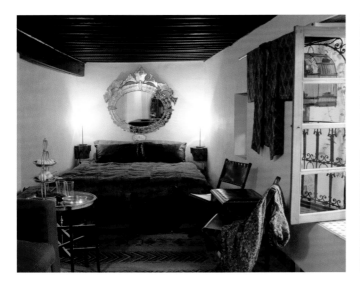

Classic Moroccan architecture blends in perfect harmony with Western and Asian antiques.

Klassische marokkanische Architektur verbindet sich mit westlichen und asiatischen Antiquitäten in perfekter Harmonie.

L'architecture marocaine classique se mêle aux antiquités occidentales et asiatiques en parfaite harmonie.

La arquitectura marroquí clásica se entrelaza en perfecta armonía con antigüedades occidentales y asiáticas.

La classica architettura marocchina si unisce in modo armonicamente perfetto alle antichità occidentali e asiatiche.

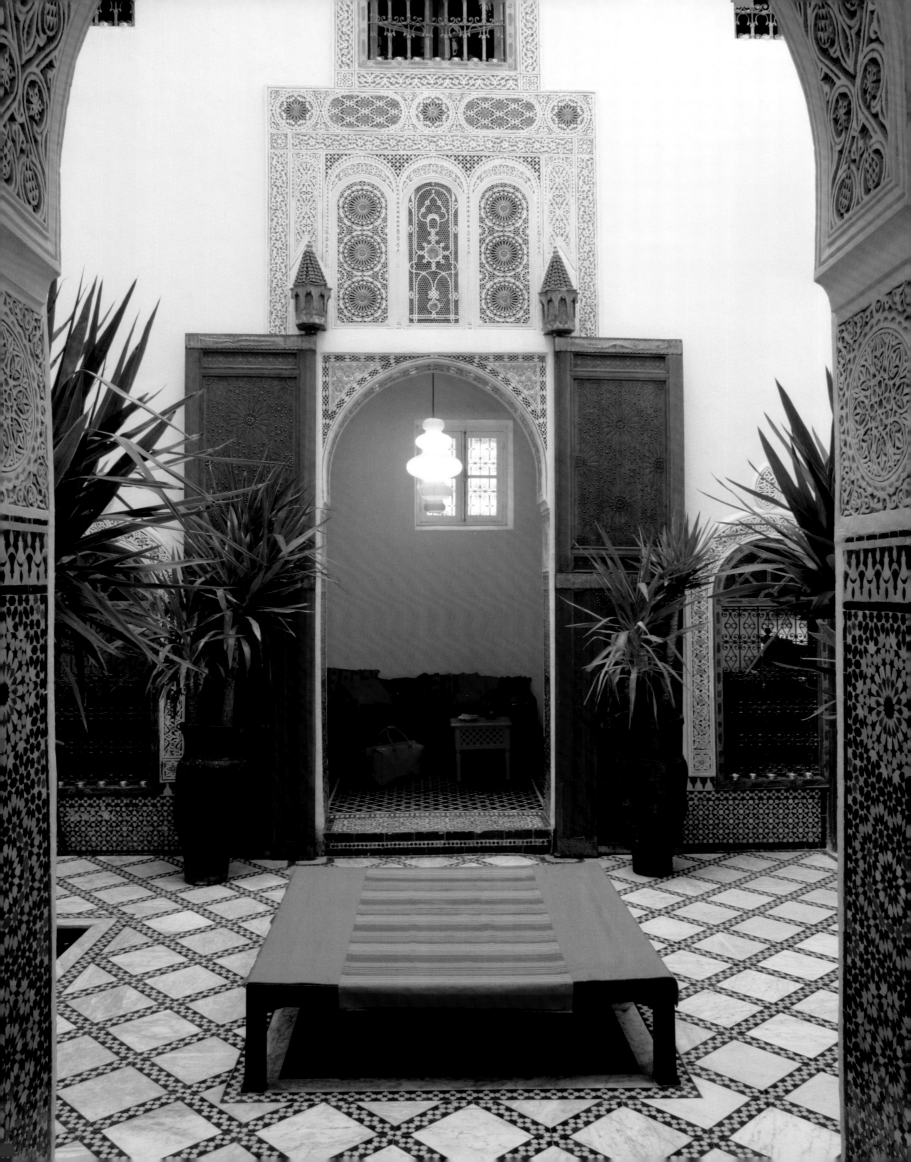

Ryad 9 was built as the private guesthouse of a wealthy merchant. Today, the hand-painted ceilings, furniture from various epochs and the spectacular roof terrace present a fairytale setting to any traveler.

Erbaut wurde Ryad 9 als privates Gästehaus eines reichen Kaufmanns; heute bilden die handgemalten Decken, Möbelstücke aus verschiedenen Epochen und die spektakuläre Dachterrasse eine märchenhafte Kulisse für jeden Reisenden.

Le Ryad 9 a été construit comme une dépendance privée pour un riche marchand. Les plafonds peints à la main, les meubles datant d'époques variées et la spectaculaire terrasse sur le toit forment un cadre féérique pour tous les voyageurs.

Ryad 9 se construyó originariamente como la vivienda para invitados de un acaudalado empresario. Los techos pintados a mano, el mobiliario de diversas épocas y la espectacular azotea conforman hoy un marco de fábula para todo viajero.

Ryad 9 fu costruita come casa privata per gli ospiti di un ricco mercante; oggi i soffitti dipinti a mano, i mobili di diverse epoche e lo spettacolare attico rappresentano uno scenario da favola per ogni viaggiatore.

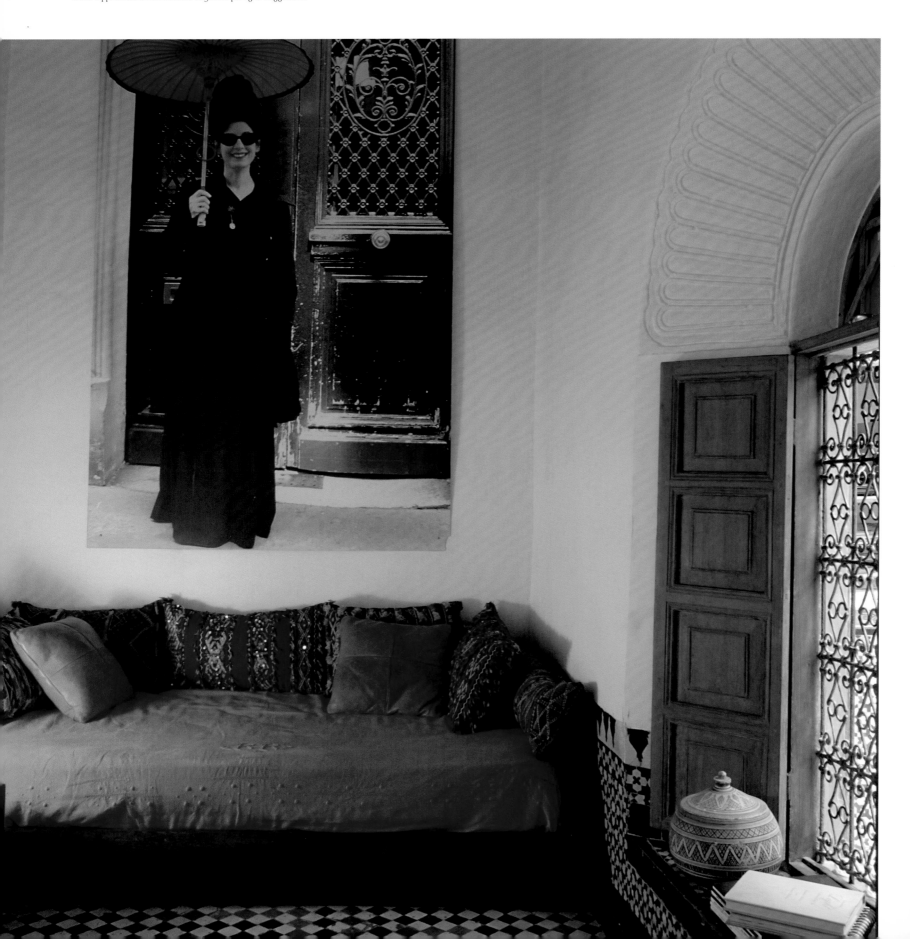

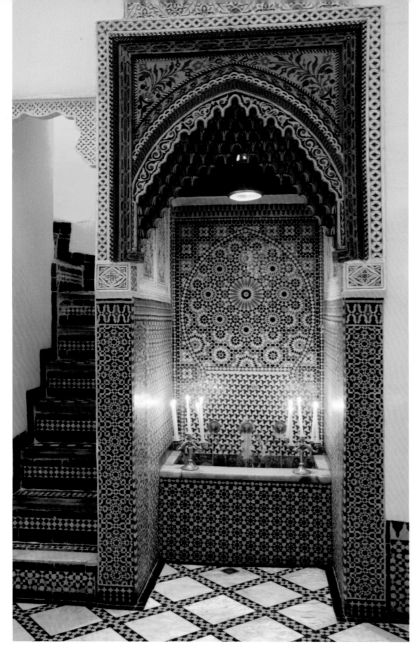

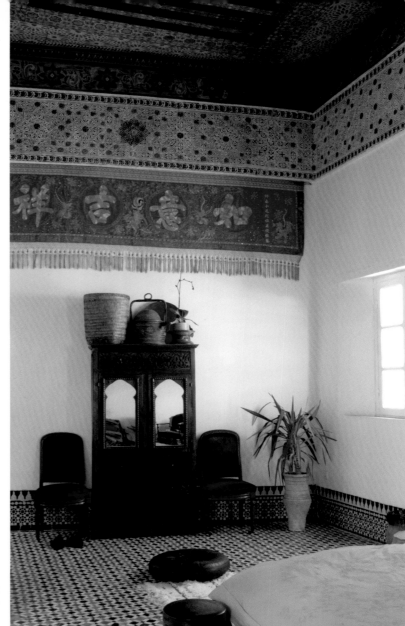

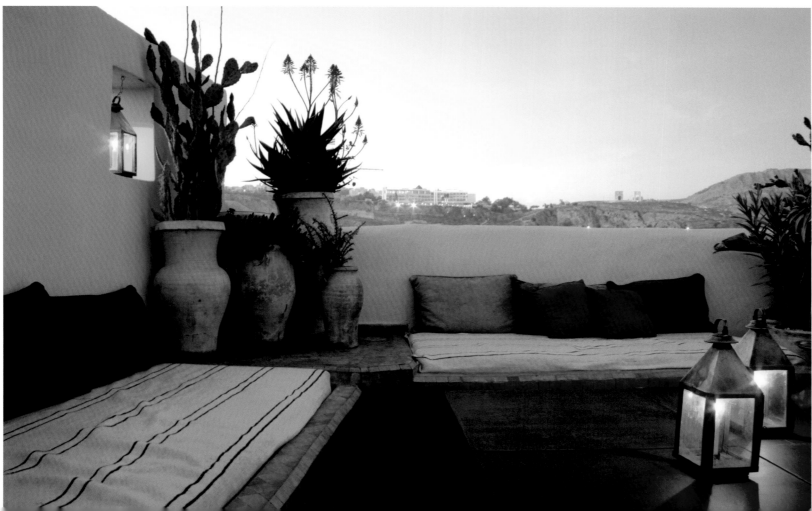

Dar al Sultan

Marrakech, Morocco

White walls, Moorish arches and ornaments, minimalist furnishings and exquisite materials characterize the "House of the Sultan" in Marrakech. Arabian architecture and accessories alongside the Italian design of the interior create a delightful contrast, giving the small guesthouse its special charm. A patio has been designed as an open-air living room with a pool while an additional inner courtyard serves as an oasis of tranquility. Once the heat of the day has subsided, enjoy some mocha on the roof of Dar al Sultan and watch the hustle and bustle of the Medina.

Weiße Mauern, maurische Bögen und Ornamente, minimalistisches Mobiliar und erlesene Materialien zeichnen das „Haus des Sultans" in Marrakech aus. Arabische Architektur und Accessoires und das italienische Design des Interieurs bilden einen reizvollen Kontrast und verleihen dem kleinen Gästehaus besonderen Charme. Ein Patio ist als Freiluftwohnzimmer mit Pool gestaltet, ein zweiter Innenhof bildet eine Oase der Ruhe. Wenn die Hitze des Tages weicht, kann man auf dem Dach beim Mokka sitzend das Treiben in der Medina beobachten.

Murs blancs, arches et ornements maures, mobilier minimaliste et matériaux précieux caractérisent la « Maison du Sultan » à Marrakech. L'architecture et les accessoires arabes créent un fascinant contraste avec le design italien de l'intérieur et confèrent à cette petite maison d'hôtes un cachet particulier. Un patio a été conçu comme une salle de séjour à ciel ouvert avec piscine. Une deuxième cour intérieure offre une oasis de paix et de tranquillité. Quand la chaleur de la journée s'apaise, vous pouvez observer du toit la vie animée de la médina en buvant un moka.

La "Casa del sultán" en Marrakech se caracteriza por muros blancos, arcos y ornamentos moriscos, mobiliario minimalista y materiales escogidos. La arquitectura y la decoración árabe y el diseño italiano del interior constituyen un sugestivo contraste y le otorgan un encanto especial a la pequeña casa de invitados. El patio con piscina se ha concebido como un salón al aire libre. Un segundo patio interior se encarga de ofrecer un oasis de paz. Cuando remite el calor diurno, se puede disfrutar de una taza de moca en la azotea y contemplar el trasiego de la medina.

Sono le pareti bianche, gli archi e gli ornamenti moreschi, il mobilio minimalistico e i materiali scelti a definire la "Casa del Sultano", a Marrakech. L'architettura e gli accessori arabi e il design italiano degli interni creano un allettante contrasto e donano alla piccola foresteria un fascino particolare. Il patio è stato allestito come salone all'aria aperta con piscina, un secondo cortile interno è una vera un'oasi di pace. Quando il calore del giorno si placa, si può osservare il viavai nella Medina, bevendo comodamente seduti una tazza di moka.

Humble design with an unwavering sense of style defines the charm of the house, which has an exotic terrace on its roof.

Zurückhaltendes, stilsicheres Design bestimmen den Charme des Hauses, das auf dem Dach eine exotische Terrasse besitzt.

Un design volontairement sobre et un grand sens du style font tout le charme de la maison, qui dispose d'une terrasse exotique sur le toit.

Su diseño discreto y fiel a su estilo caracteriza el encanto de la casa, en cuya azotea se ubica una exótica terraza.

Un design discreto e stilisticamente perfetto definiscono il fascino di questa casa che possiede una terrazza esotica sul tetto.

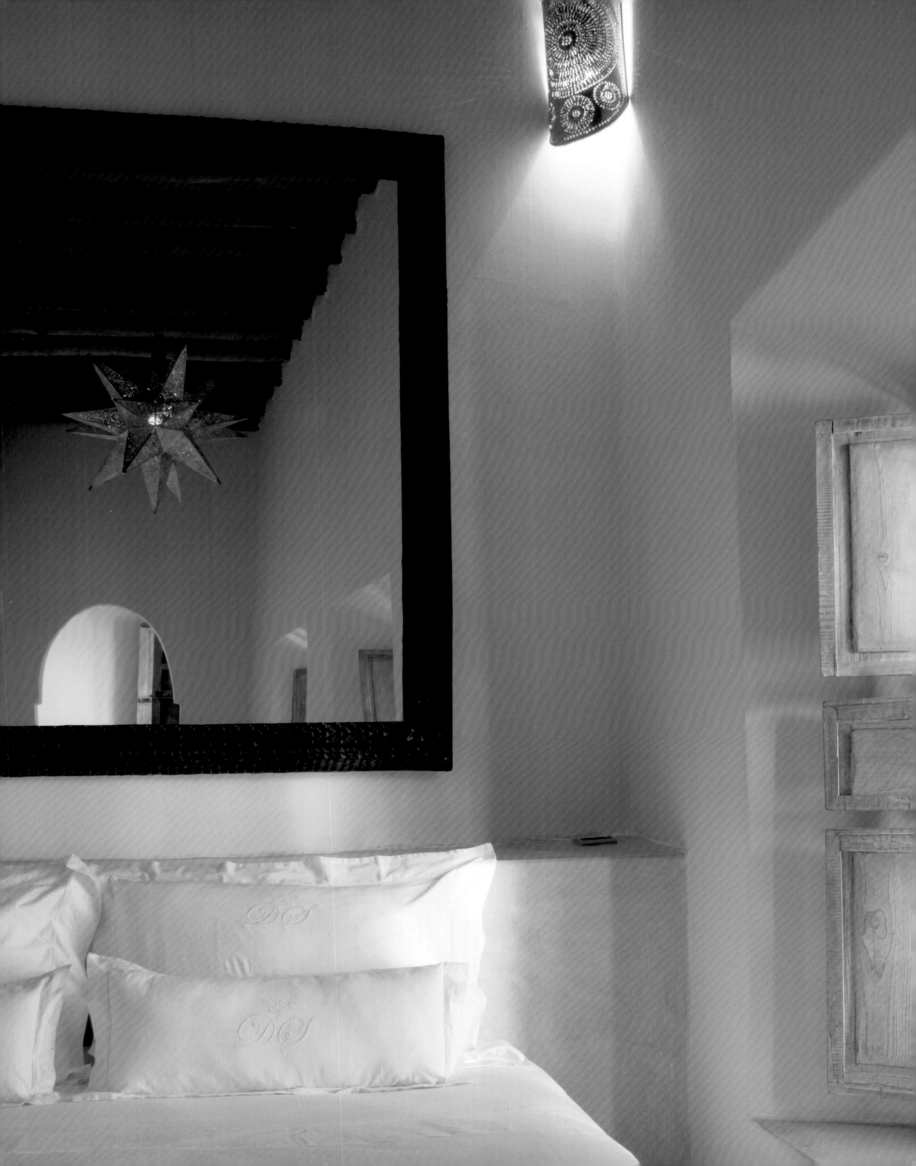

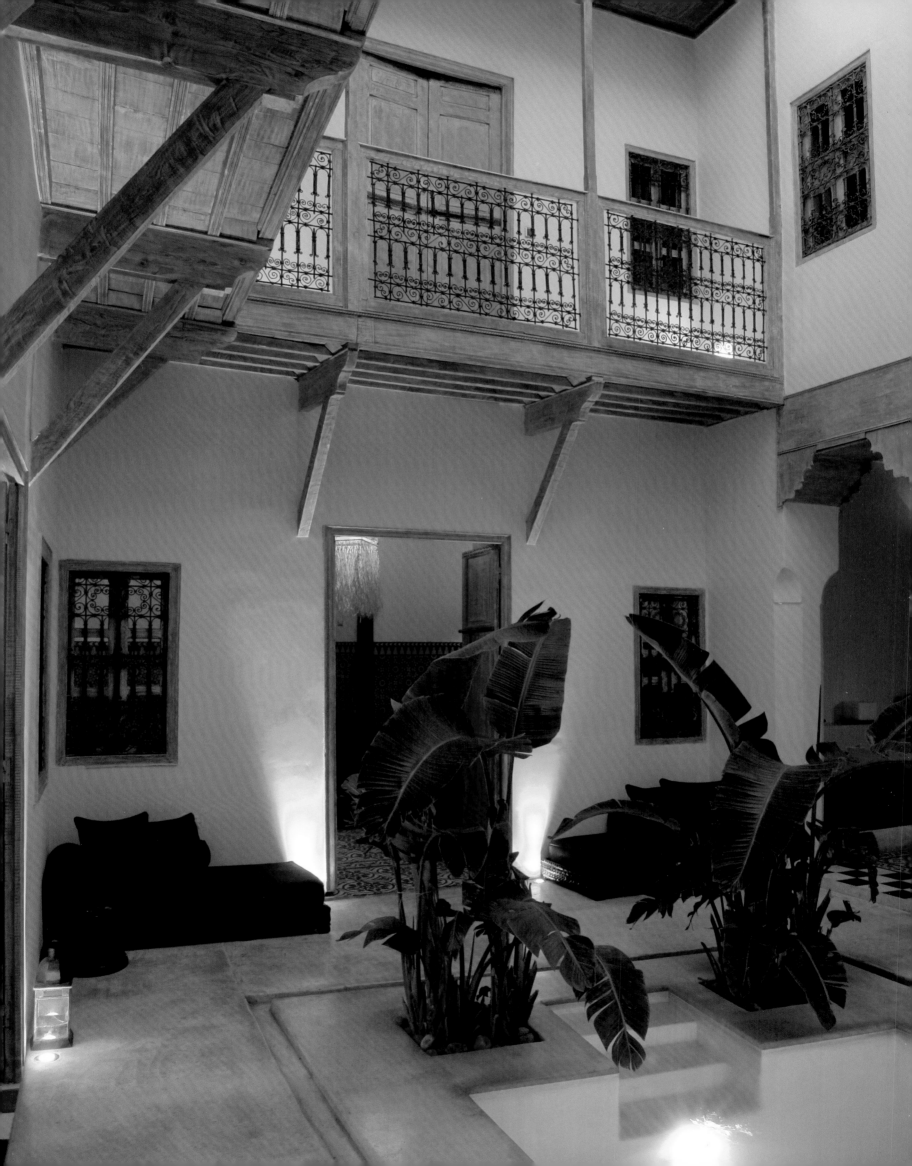

Less is more: *Handpicked items define the interior. Every detail of the house exhibits a flair for esthetics. Both patios bristle with atmosphere.*

Weniger ist mehr: *Handverlesene Stücke bilden das Interieur und jedes Detail des Hauses zeugt von ästhetischem Fingerspitzengefühl. Voller Atmosphäre sind die beiden Patios.*

Le moins devient un plus : *des objets triés sur le volet donnent forme à l'intérieur. Chaque détail de la maison témoigne du sens de l'esthétique. Les deux patios dégagent une atmosphère merveilleuse.*

Cuanto menos, mejor: *los interiores están conformados por objetos escogidos. Todos los detalles son una muestra del refinado gusto estético. Los patios envuelven en una atmósfera embriagadora.*

Quando il meno rende di più: *pezzi scelti con cura compongono gli interni, ogni dettaglio della casa dimostra un senso per l'estetica. I due patii sono pieni di atmosfera.*

 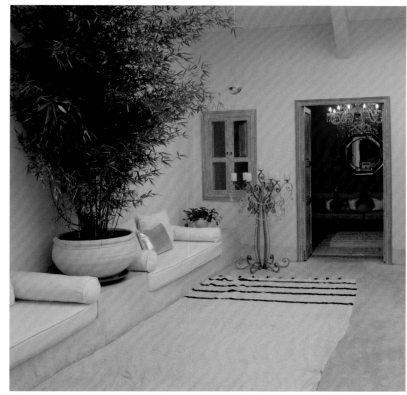

Villa Sama

Marrakech, Morocco

The architecture of Villa Sama is flat, distinct, spacious and extravagant. Just 20 minutes from the noise and bustle of downtown Marrakech, it extends across a 54,000 sq. ft. property in the upscale residential area of Palmeraie with the panorama of the Atlas Mountains as its backdrop. Oriental materials, patterns and furniture are highlighted by the purist ambience of the house. The glass fronts of the living room open up on three sides, as a lounge-terrace provides additional space.

Flach, klar, weitläufig und extravagant ist die Architektur der Villa Sama. 20 Minuten vom Lärm und Trubel der Innenstadt Marrakeschs entfernt, erstreckt sie sich in der schicken Wohngegend Palmeraie vor dem Panorama des Atlas-Gebirges auf einem 5.000 m² großen Grundstück. Orientalische Materialien, Muster und Möbel kommen in dem puristischen Ambiente des Hauses besonders wirkungsvoll zur Geltung. Die Glasfronten des Wohnzimmers lassen sich an drei Seiten öffnen. Eine Lounge-Terrasse schafft zusätzlichen Raum.

L'architecture de la Villa Sama est plate, claire, spacieuse et extravagante. A seulement 20 minutes du bruit et du tumulte du centre ville de Marrakech, elle s'étend sur une propriété de 5.000 m² dans le quartier résidentiel chic de la Palmeraie, avec vue sur la chaîne de l'Atlas en toile de fond. Les matériaux, les motifs et le mobilier orientaux sont parfaitement à leur place dans l'atmosphère puriste de la maison. Les baies vitrées de la salle de séjour peuvent être ouvertes sur trois côtés, et donnent sur un salon terrasse offrant un espace supplémentaire.

La arquitectura de Villa Sama resulta plana, diáfana, amplia y extravagante. A 20 minutos del bullicio y el ajetreo del centro de Marrakech, se ubica esta propiedad de 5.000 m², en la elegante zona residencial Palmerie con vistas panorámicas a la cordillera del Atlas. En el ambiente purista de la vivienda los materiales, mobiliario y motivos orientales revelan todo su valor. Los frontales acristalados del salón se abren por tres de sus lados. La terraza estilo lounge crea un espacio adicional.

L'architettura di Villa Sama è piana, nitida, spaziosa e fuori del comune. A 20 minuti dal rumore e dal trambusto del centro di Marrakech, essa si estende nella zona residenziale chic di Palmerie, davanti al panorama della catena montuosa dell'Atlante, su un terreno di 5.000 m². I materiali, i motivi e i mobili orientali vengono particolarmente valorizzati dall'ambiente puristico della casa. Le vetrate del soggiorno si possono aprire in tre punti e un terrazzo lounge crea altro spazio.

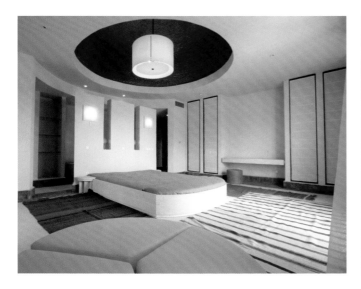

The frantic pace and heat of the city are far away: You'll feel cooler just by taking in the design of the Villa Sama.

Hektik und Hitze der Stadt sind weit entfernt: In der Villa Sama kühlt schon das Design.

Le rythme effréné et la chaleur de la ville sont bien loin : même le design de la Villa Sama a un effet rafraîchissant.

El alboroto y los calores de la ciudad quedan en la distancia. En Villa Sama, ya sólo el diseño consigue refrescar.

La frenesia e la calura della città sono molto lontane: a Villa Sama è già il design a rinfrescare.

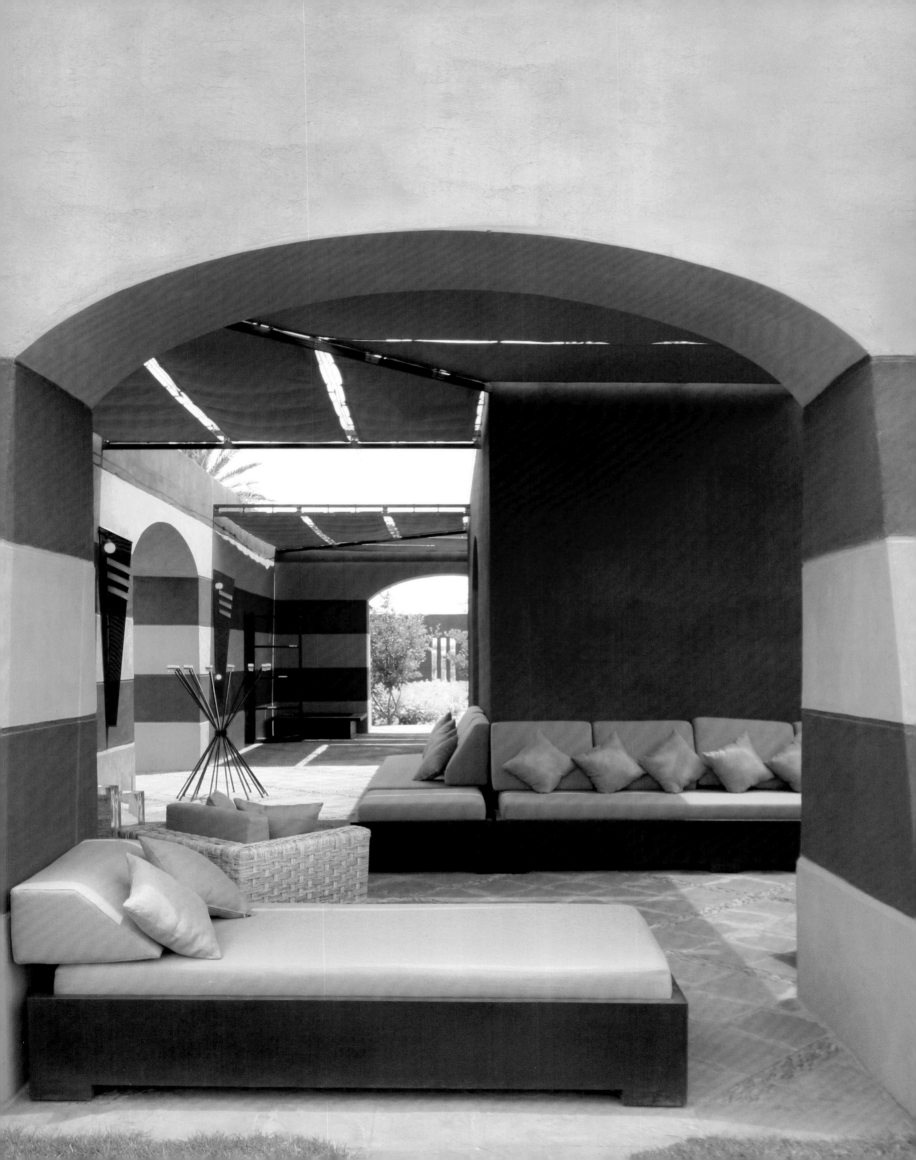

Its wide, open spaces, unique interior and architecture that's reminiscent of a fortress make this villa an experience in visual terms alone.

Weite Flächen, ein originelles Interieur und die an eine Festung erinnernde Architektur machen diese Villa schon optisch zu einem Erlebnis.

Cette villa est une vraie expérience visuelle avec son espace ouvert, son intérieur original et son architecture évoquant celle d'une forteresse.

Superficies amplias, un original interior y una arquitectura semejante a la de una fortaleza convierten a la villa en un placer para la vista.

Le superfici ampie, gli interni originali e l'architettura che ricorda una fortezza rendono questa villa particolare anche dal punto di vista visivo.

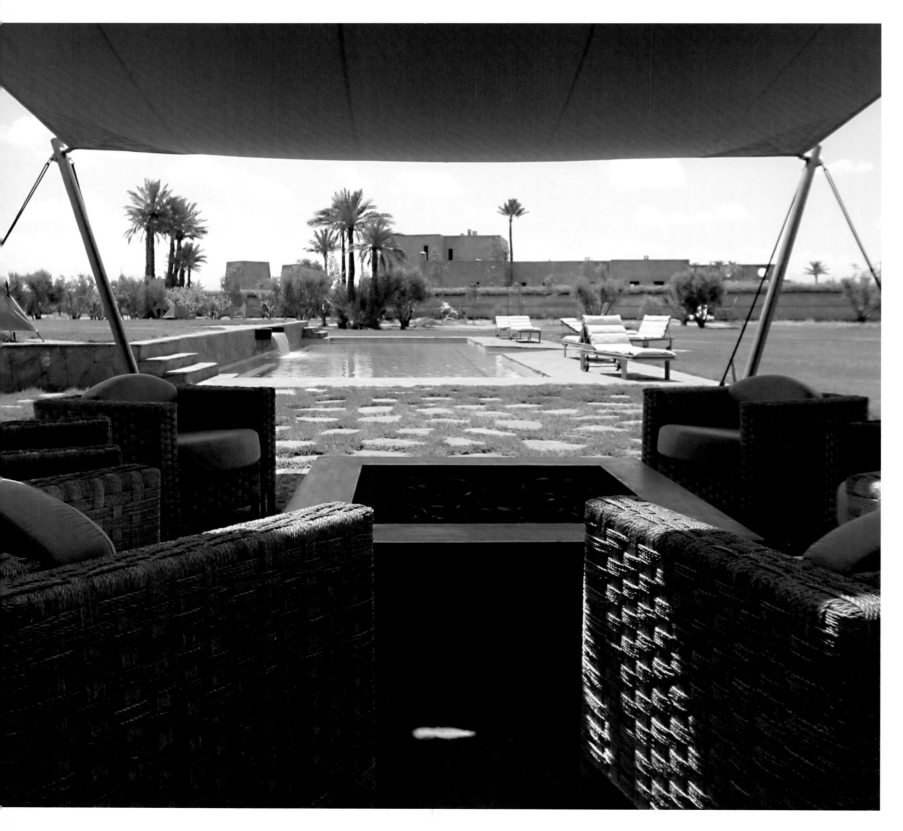

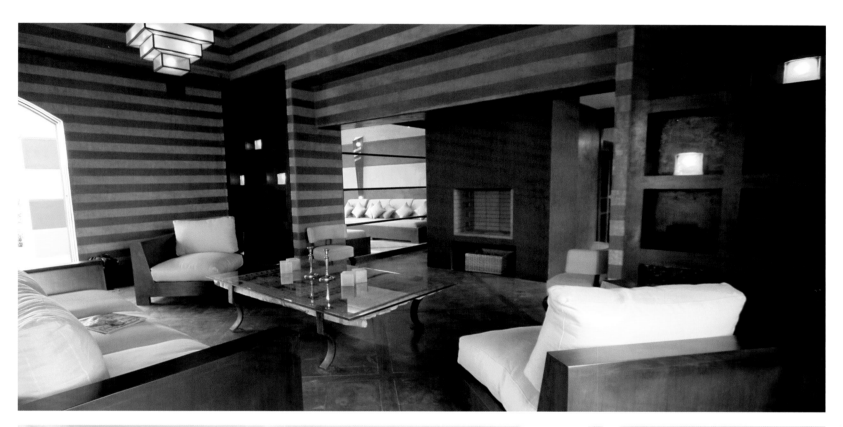

Villa Sama *Marrakech, Morocco* 167

Alfajiri Villas

Diani Beach, Kenya

At Diani Beach on the southern coast of Kenya, the three Alfajiri Villas share a splendid piece of land: Built on a cliff, in the appertaining garden and on the beach, each one offers fabulous views of the Indian Ocean. African and Asian works of art distinguish Cliff Villa and Garden Villa, while Beach Villa is distinguished by Caribbean colors. Their terraces with hand-carved sofas and thick pillows make you want to stay forever. Luckily, the golf course is just two minutes away and the coral reef off the coast is a magnificent snorkeling site.

Am Diani Beach an der Südküste Kenias teilen sich die drei Alfajiri-Villen ein prachtvolles Grundstück: Auf einer Klippe, im Garten und am Strand errichtet, bietet jede traumhafte Aussichten auf den Indischen Ozean. Afrikanische und asiatische Kunstobjekte prägen Cliff Villa und Garden Villa, karibische Farben die Beach Villa. Die Terrassen mit handgeschnitzten Sofas und dicken Kissen mag man kaum verlassen. Dabei liegt der Golfplatz nur zwei Minuten entfernt, und das Korallenriff vor der Küste ist ein grandioses Schnorchelrevier.

Les trois villas Alfajiri occupent un magnifique terrain sur la plage de Diani, sur la côte méridionale du Kenya : construites sur une falaise, dans un jardin ou encore sur la plage, chacune d'entre elles offre une vue fabuleuse sur l'Océan Indien. Cliff Villa et Garden Villa sont caractérisées par des objets d'art africains et asiatiques, alors que Beach Villa affiche des couleurs caribéennes. Vous aurez du mal à quitter les terrasses avec leurs canapés sculptés à la main et leurs coussins moelleux. Heureusement, le parcours de golf n'est qu'à deux minutes, et le récif de corail sur la côte offre un magnifique site de plongée.

Las tres villas ubicadas en Playa Diani, en la costa meridional keniata, comparten un terreno espectacular. Sobre el risco, en el jardín o junto a la playa, las vistas al océano Índico son todas de ensueño. Cliff Villa y Garden Villa están decoradas con obras de arte africanas y asiáticas, mientras, para Beach Villa se ha optado por tonos caribeños. Se podría pasar todo el día en las agradables terrazas con sofás estampados a mano y mullidos cojines. El campo de golf queda a dos minutos y el arrecife de coral es una fabulosa zona de buceo con esnórquel.

Sulla Diani Beach, sulla costa meridionale del Kenia, le tre ville Alfajiri si dividono un terreno magnifico: edificate su uno scoglio, in un giardino e su una spiaggia, ognuna di esse offre una vista da sogno sull'Oceano Indiano. Oggetti d'arte africani e asiatici caratterizzano la Cliff Villa e la Garden Villa, i colori caraibici la Beach Villa. Terrazze con sofà intagliati a mano e grandi cuscini invitano a non andarsene mai. Il campo da golf si trova a soli due minuti, e la barriera corallina davanti alla costa è il posto ideale per fare snorkeling.

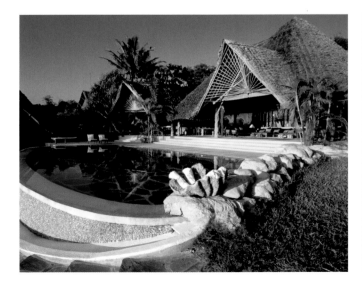

Garden Villa (l.) is all African, a sea breeze flows through Cliff Villa (r.).

Ganz afrikanisch wirkt die Garden Villa (l.), Luft durchströmt die Cliff Villa (r.).

Garden Villa (à gauche) a un design très africain, Cliff Villa (à droite) est très aérée.

El carácter de Garden Villa es marcadamente africano (i.). La brisa envuelve Cliff Villa (d.).

La Garden Villa (a sinistra) in stile africano, l'ariosa Cliff Villa (a destra).

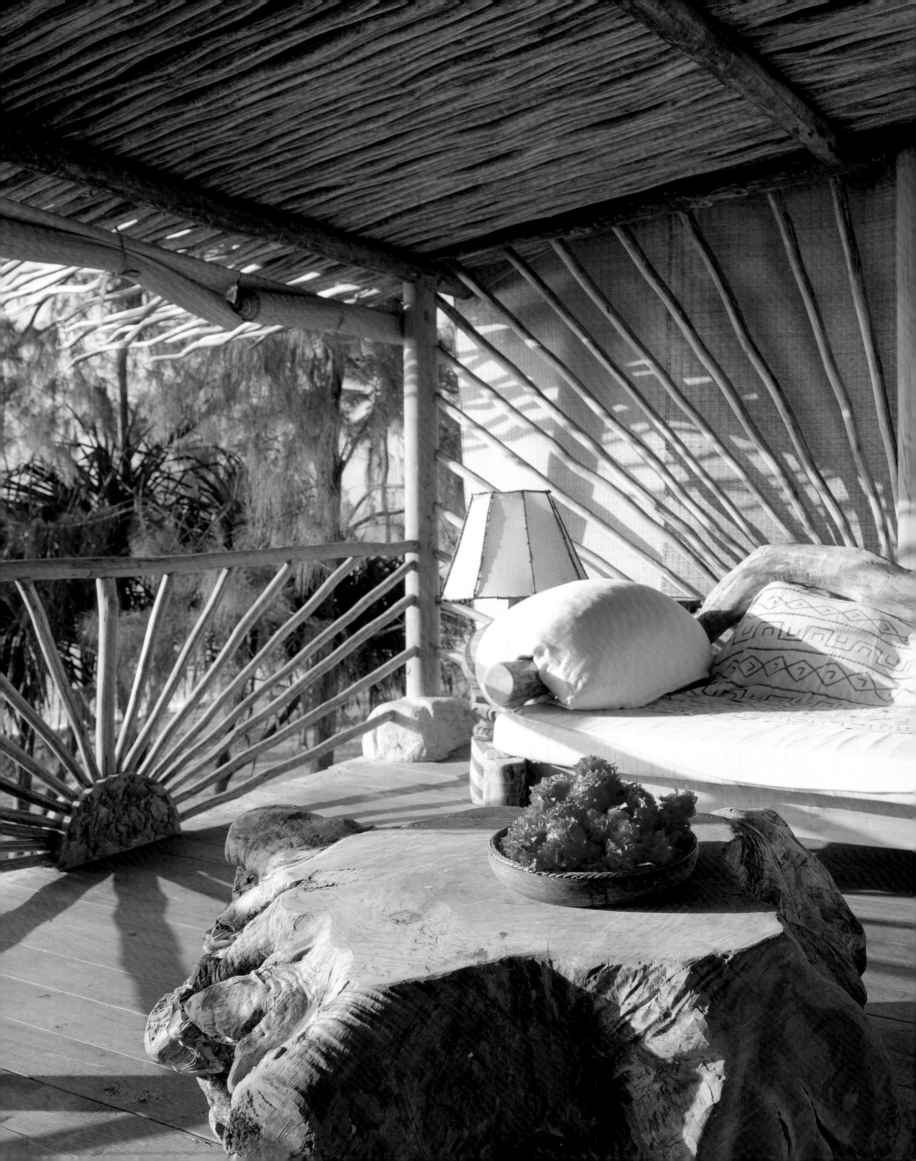

Garden Villa: Modern elegance beyond conventional African romanticism.

Garden Villa: Moderne Eleganz jenseits konventioneller Afrika-Romantik.

Garden Villa : une élégance moderne au-delà du romantisme africain traditionnel.

Garden Villa: moderna elegancia más allá del convencional romanticismo africano.

Garden Villa: eleganza moderna al di là del romanticismo convenzionale africano.

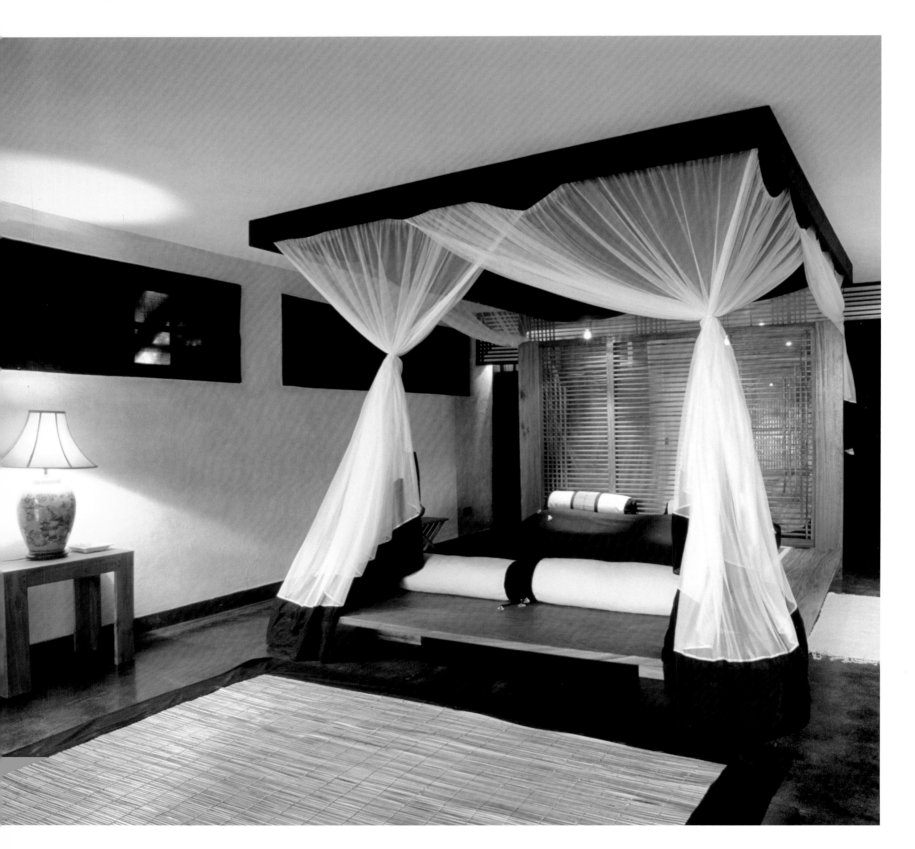

Spacious rooms with natural colors and materials distinguish the Alfajiri Villas.

Großzügige Räume und natürliche Farben und Materialien prägen die Alfajiri Villen.

Des pièces spacieuses aux couleurs et matériaux naturels caractérisent les Alfajiri Villas.

Las Villas Alfajira se caracterizan por sus grandes estancias y colores y materiales naturales.

Locali spaziosi e colori e materiali naturali caratterizzano le ville Alfajira.

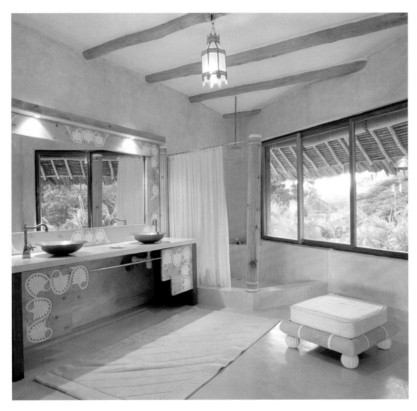

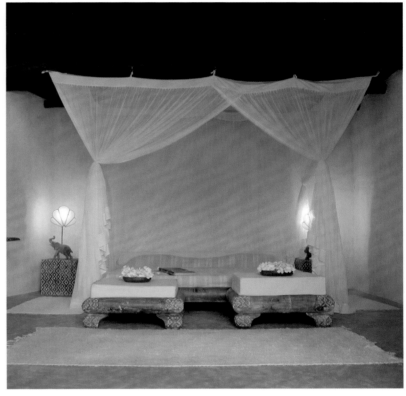

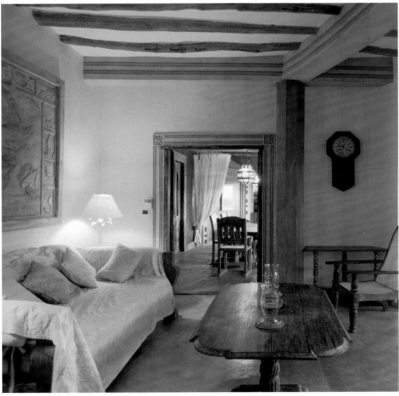

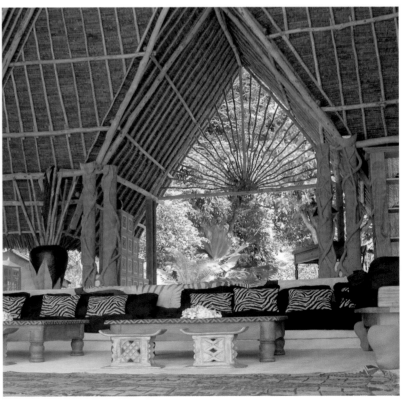

Villa Symphony
Cape Town, South Africa

In Camps Bay, a lovely seaside resort in Cape Town against the backdrop of the Twelve Apostles mountain range, Villa Symphony is listed among the area's largest estates. Made of glass, steel and African rosewood, this villa boasts nine balconies and a patio. It is located right next to a mountain river rushing down to the valley and two bridges take you to the far side of the property. The gallery of the living room offers a view of the pool and of the bay. The home cinema, gym, poolroom and wine cellar provide pleasant distractions.

In Camps Bay, Kapstadts schönem Badeort vor der Bergkulisse der Twelve Apostles, zählt die aus Glas, Stahl und afrikanischem Rosenholz erbaute und mit neun Balkonen und einem Patio versehene Villa Symphony zu den größten Anwesen. Sie liegt unmittelbar neben einem zu Tal rauschenden Bergfluss, und über zwei Brücken erreicht man den jenseitigen Teil des Grundstücks. Von der Galerie des Wohnzimmers schaut man auf den Pool und die Bucht. Heimkino, Sportraum, Billard und Weinkeller bieten eine angenehme Zerstreuung.

La Villa Symphony est une des plus grandes propriétés de Camps Bay, la coquette station balnéaire du Cap avec les montagnes des Douze Apôtres en toile de fond. Faite de verre, d'acier et de palissandre africain, la maison compte neuf balcons et un patio. Le site est directement à proximité d'un torrent qui descend vers la vallée. Ses deux ponts vous mènent à l'autre bout de la propriété. La galerie au-dessus de la salle de séjour donne sur la piscine et sur la baie. Le home-cinéma, la salle de sports, le billard et la cave à vins offrent des distractions agréables.

En Camps Bay, la preciosa playa de Ciudad del Cabo con las montañas de los Doce Apóstoles como telón de fondo, se levanta una de las mayores propiedades del lugar, una mansión construida con cristal, acero y palisandro africano, dotada de nueve balcones y un patio. La parcela está situada junto al río que desciende por el valle, y cruzando dos puentes se accede a su otro extremo. Desde la galería del salón se divisan la piscina y la bahía. El salón de cine, el gimnasio, la sala de billar y la bodega proponen una buena diversión.

A Camps Bay, la bella località balneare di Città del Capo davanti allo scenario delle montagne dei Twelve Apostles, Villa Symphony, costruita in vetro, acciaio e legno di rosa africano, corredata di nove balconi e di un patio, è una delle più grandi tenute. Si trova nelle immediate vicinanze di un torrente di montagna, scrosciante verso valle, e attraversando due ponti si raggiunge l'altra parte del terreno. Dalla galleria del soggiorno si guarda sulla piscina e sulla baia. Il cinema privato, la palestra, il biliardo e la cantina dei vini offrono una piacevole distrazione.

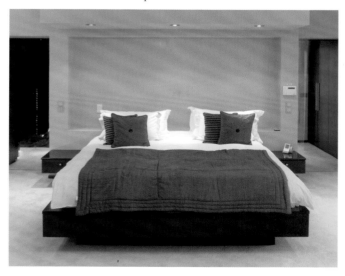

Cool, distinct and equipped with all the technical amenities, each room creates a counterpoint to the untamed nature outside the windows.

Kühl, klar und mit allen technischen Finessen ausgestattet, bildet jeder Raum einen Kontrapunkt zur ungezähmten Natur vor den Fenstern.

Fraîche, claire et disposant de tous les accessoires techniques, chaque pièce forme un contrepoint à la nature sauvage derrière les fenêtres.

Las estancias sobrias, de líneas claras y equipadas con toda tecnología, crean el contrapunto a la indómita naturaleza exterior.

Ogni locale, fresco, chiaro e arredato con tutte le raffinatezze tecniche, forma un contrappunto con la natura selvaggia oltre le finestre.

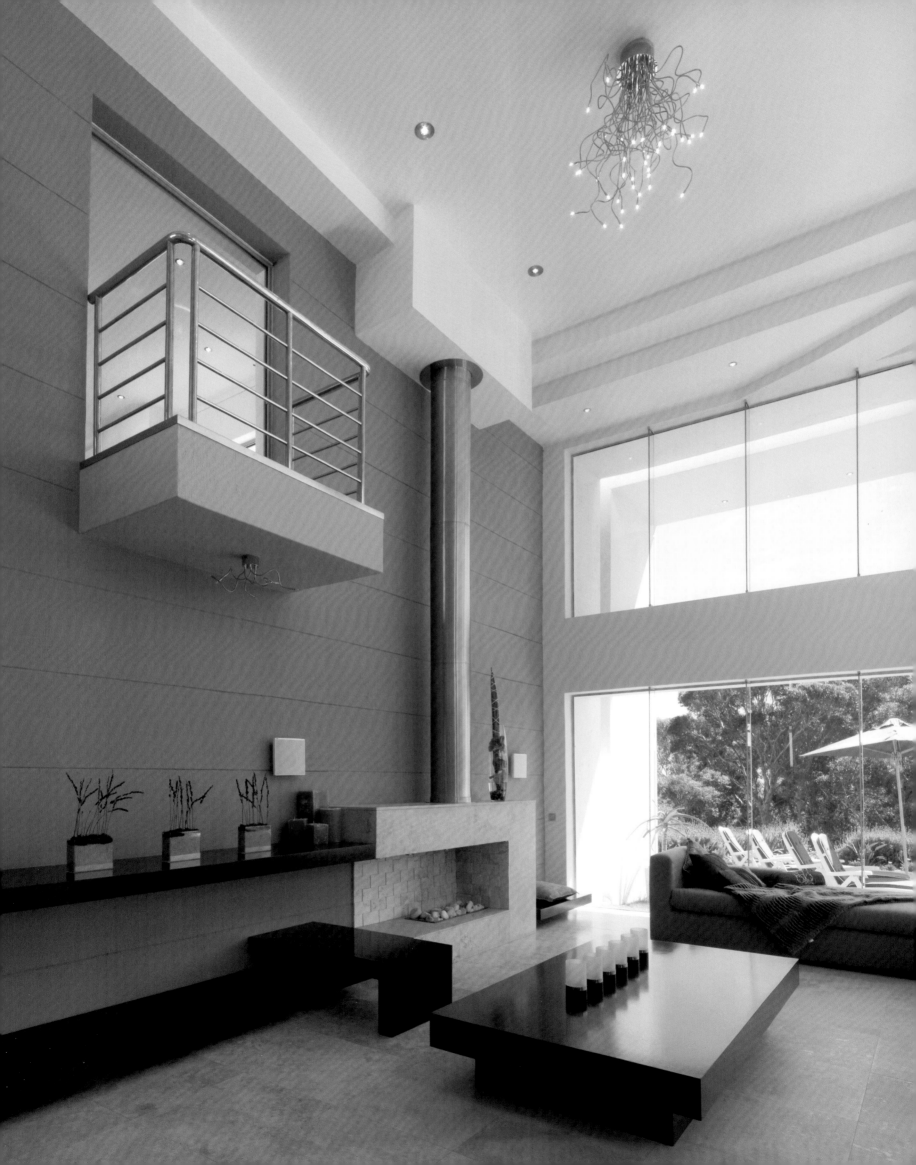

The kitchen of rosewood and stainless steel is state-of-the-art in terms of esthetics and technology.

Die Küche aus Rosenholz und rostfreiem Stahl ist ästhetisch und technisch auf dem neuesten Stand.

La cuisine de palissandre et d'inox est à la pointe en termes d'esthétique et de technologie.

La cocina de palisandro y acero inoxidable es claro ejemplo de los últimos avances estéticos y tecnológicos.

La cucina in legno di rosa e acciaio inossidabile è esteticamente e tecnicamente all'ultima moda.

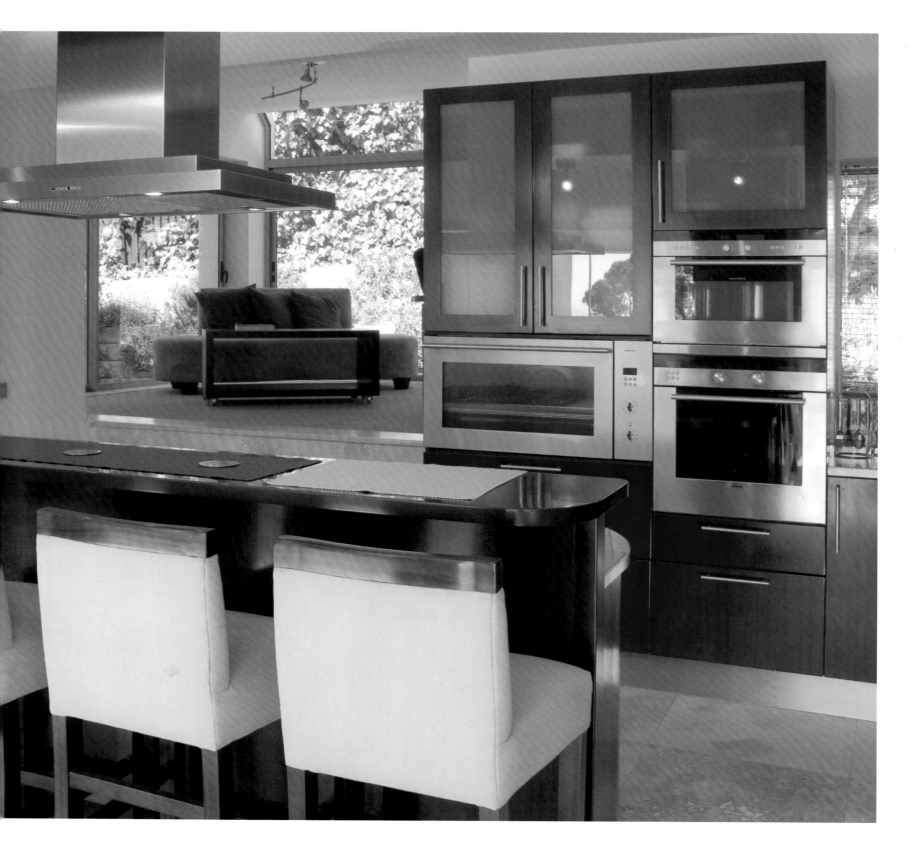

Classic structures and room divisions are broken up and reveal new perspectives.

Klassische Strukturen und Raumaufteilungen sind aufgebrochen und eröffnen neue Blickwinkel.

Les structures classiques et la répartition des pièces sont réinterprétées, ouvrant de nouvelles perspectives.

Se han transgredido las clásicas estructuras y divisiones espaciales para abrirse a nuevas perspectivas.

Le strutture classiche e le suddivisioni degli spazi si aprono a nuove prospettive.

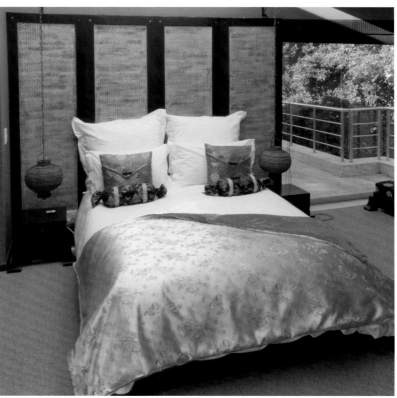

Birkenhead House

Hermanus, South Africa

Birkenhead House, a spaciously designed private house with eleven bedrooms and three pools, dominates a steep cliff above Walker Bay. The location is 75 miles southeast of Cape Town. An eclectic mix of tasteful accessories give it an atmosphere both elegant and cozy. You can enjoy unobstructed views of the bay and its beaches while having an aperitif under the sparkling chandelier in the lounge. Between May and December, Southern Right whales frequent the bay every year to calve. You can have a box seat on the terrace to behold of this spectacle.

120 km südöstlich von Kapstadt dominiert Birkenhead House, ein großzügig angelegtes Haus mit elf Schlafzimmern und drei Pools, eine schroffe Klippe über der Walker Bay. Eine außergewöhnliche Auswahl von geschmackvollen Accessoires verleihen ihm eine ebenso elegante wie behagliche Atmosphäre. Unter den funkelnden Kronleuchtern der Lounge genießt man zum Aperitif die ungehinderte Sicht auf die Bucht und ihre Strände. Zwischen Mai und Dezember ziehen Southern-Right-Wale jedes Jahr zum Kalben in die Bucht. Für dieses Schauspiel bietet die Terrasse einen Logenplatz.

A 120 km au sud-ouest du Cap, Birkenhead House, un bâtiment à l'architecture spacieuse comptant onze chambres et trois piscines, domine une falaise abrupte au-dessus de la Walker Bay. Une sélection exceptionelle des accessoires choisis avec soin créent une atmosphère à la fois élégante et confortable. Profitez de la vue panoramique sur la baie et ses plages en prenant l'apéritif sous le lustre étincelant du salon. Les baleines franches du sud viennent mettre leurs petits au monde dans la baie chaque année entre mai et décembre. De la terrasse vous êtes aux premières loges pour admirer ce spectacle.

A 120 km al sureste de Ciudad del Cabo, Birkenhead House, una colosal residencia con once dormitorios y tres piscinas, domina la Walker Bay desde un escarpado acantilado. Una selección extraordinaria de accesorios con gusto le confieren un ambiente elegante y acogedor. Bajo las brillantes lámparas del área lounge se disfruta del aperitivo con vistas a la bahía y las playas. Cada año, de mayo a diciembre, las ballenas francas australes vienen hasta aquí a parir. La terraza sirve de palco durante el espectáculo.

A 120 km a sud-est di Città del Capo domina Birkenhead House, una casa dal design arioso, con undici camere da letto e tre piscine domina una scogliera scoscesa sopra la Walker Bay. Un mix eclettico di accessori di gusto le donano un'atmosfera elegante e confortevole. Sotto i lampadari scintillanti della lounge, mentre si sorseggia l'aperitivo, si gode la vista panoramica sulla baia e sulle sue spiagge. Ogni anno, tra maggio e dicembre le balene di Southern Right vengono a figliare nell'insenatura. Per questo spettacolo, la terrazza offre i posti sul palco d'onore.

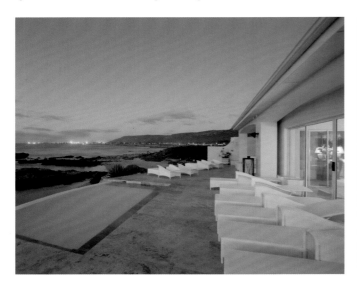 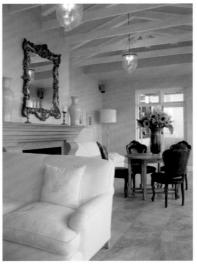

Stylish elegance sets the mood in this estate. The terrace offers a view of Walker Bay and the ocean surf.

Gediegene Eleganz bestimmt das Haus. Von der Terrasse aus blickt man auf die Walker Bay und den heranrollenden Ozean.

Une élégance pleine de goût définit l'ambiance de la maison. La terrasse offre une vue sur la Walker Bay et les vagues de l'océan.

La casa está caracterizada por una sobria elegancia. Desde su terraza se divisa la Walker Bay y la bravura del océano.

Un'eleganza accurata caratterizza la casa. Dal terrazzo si gode la vista sulla Walker Bay e sull'oceano increspato.

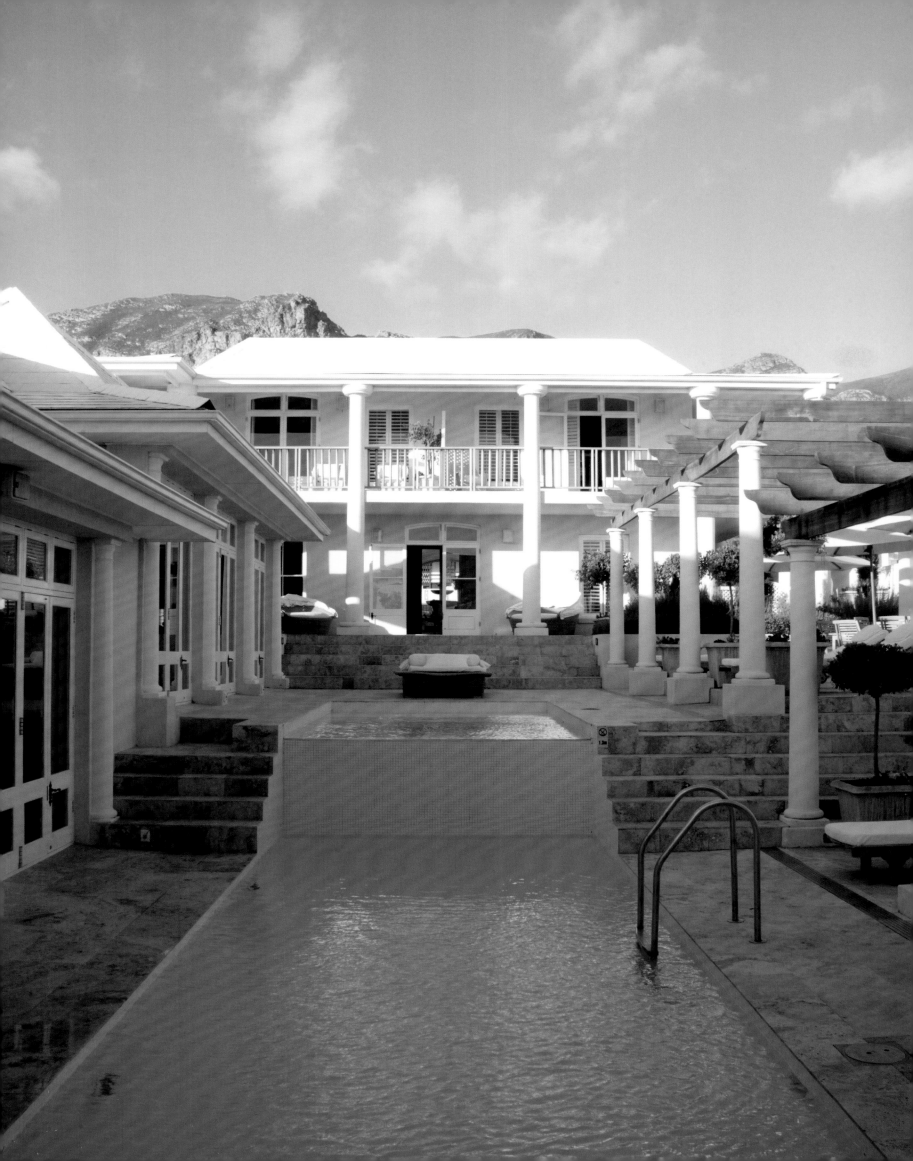

The décor and solarium reflect the colors of the beach and surf with white and a palette of crème hues.

Einrichtung und Sonnenterrasse nehmen mit Weiß und einer Palette von Cremetönen die Farben von Strand und Brandung auf.

Le mobilier et la terrasse reflètent les couleurs de la plage et du ressac avec une palette de tons blancs et crème.

La decoración interior y la azotea adoptan los tonos blancos y pastel de la playa y el oleaje.

L'arredamento e il terrazzo richiamano, con il bianco e una gamma di tonalità crema, i colori della spiaggia e della risacca.

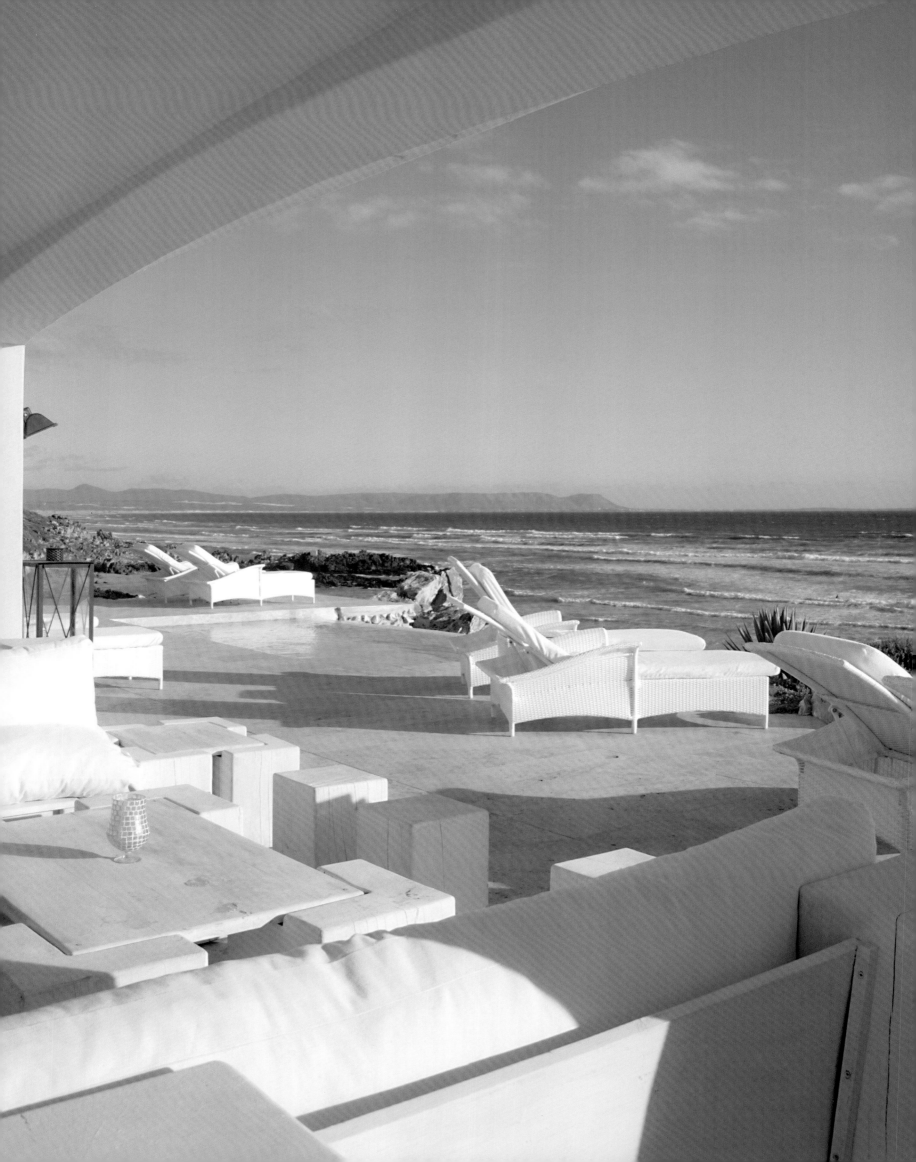

Apa Villa Thalpe

Galle Fort, Sri Lanka

This peaceful sanctuary is located 5 miles from the historic old town of Galles in the southwest of Sri Lanka, directly on the beach. Its seven suites with their modern décor are separated among three villas called Cinnamon, Cardamon and Safron, awakening anticipation of the country's richly spiced cuisine. The architecture of this refuge, with its terraces and open patios, fits harmoniously into the tropical landscape. Tall palm trees provide shade for its pool and, from its wooden deck facing the beach, you can catch a glimpse of the waves of the Indian Ocean.

Dieses friedliche Refugium liegt 8 km von der historischen Altstadt Galles im Südwesten Sri Lankas entfernt unmittelbar am Strand. Die sieben modern eingerichteten Suiten verteilen sich auf drei Villen, deren Namen Cinnamon, Cardamon und Safron Vorfreude auf die an Gewürzen reiche Landesküche wecken. Ihre Architektur fügt sich mit Terrassen und offenen Patios harmonisch in den tropischen Garten ein. Den Pool beschatten hohe Palmen und von seinem zum Strand weisenden Holzdeck schaut man auf die Wellen des Indischen Ozeans.

Ce sanctuaire paisible est situé à 8 km de la vieille cité historique de Galles, au sud-ouest du Sri Lanka, et donne directement sur la plage. Les sept suites au mobilier moderne sont réparties dans trois villas qui portent les doux noms de Cinnamon, Cardamon et Safron, donnant un avant-goût de la cuisine merveilleusement épicée du pays. Avec ses terrasses et ses patios ouverts, leur achitecture s'accorde harmonieusement avec le jardin tropical. La piscine profite de l'ombre des grands palmiers. Vous pouvez admirer les vagues de l'Océan Indien de la terrasse de bois qui fait face à la plage.

Este remanso de paz se encuentra a 8 km del casco histórico de Galles, al suroeste de Sri Lanka y a unos pocos pasos de la playa. Las siete suites decoradas con corte moderno, están distribuidas en las residencias Cinnamon, Cardamon y Safron, evocando la cocina local rica en especias. Su arquitectura se integra armónicamente en los jardines tropicales a través de terrazas y patios. Desde la piscina a la sombra de las palmeras y su cubierta de madera orientada a la playa, se contempla el oleaje del océano Índico.

Questo tranquillo rifugio si trova a 8 km dal centro storico di Galle, nel sud-ovest dello Sri Lanka, vicino alla spiaggia. Le sette suite, arredate in modo moderno, sono distribuite in tre ville, che con i loro nomi Cinnamon, Cardamon e Safron trasmettono la gioiosa attesa della cucina locale, ricca di spezie. La loro architettura, con terrazze e patii aperti, si inserisce armonicamente nel giardino tropicale. La piscina è situata all'ombra di grandi palme, e dalla sua terrazza di legno che guarda verso la spiaggia si gode la vista delle onde dell'Oceano Indiano.

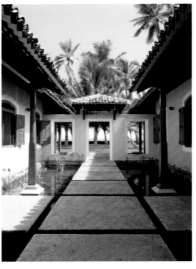

Pool and ocean meet on the horizon. Shady verandas and airy patios define the architecture of the villas.

Am Horizont treffen sich Pool und Ozean. Schattige Veranden und luftige Patios prägen die Architektur der Villen.

La piscine et l'océan se rencontrent à l'horizon. Les vérandas ombragées et les patios aérés caractérisent l'architecture des villas.

En el horizonte se funden piscina y océano. Las balconadas cubiertas de sombra y los patios inundados de brisas caracterizan la arquitectura de las villas.

All'orizzonte si incontrano la piscina e l'oceano. Le verande ombreggiate e i patii ventilati caratterizzano l'architettura delle ville.

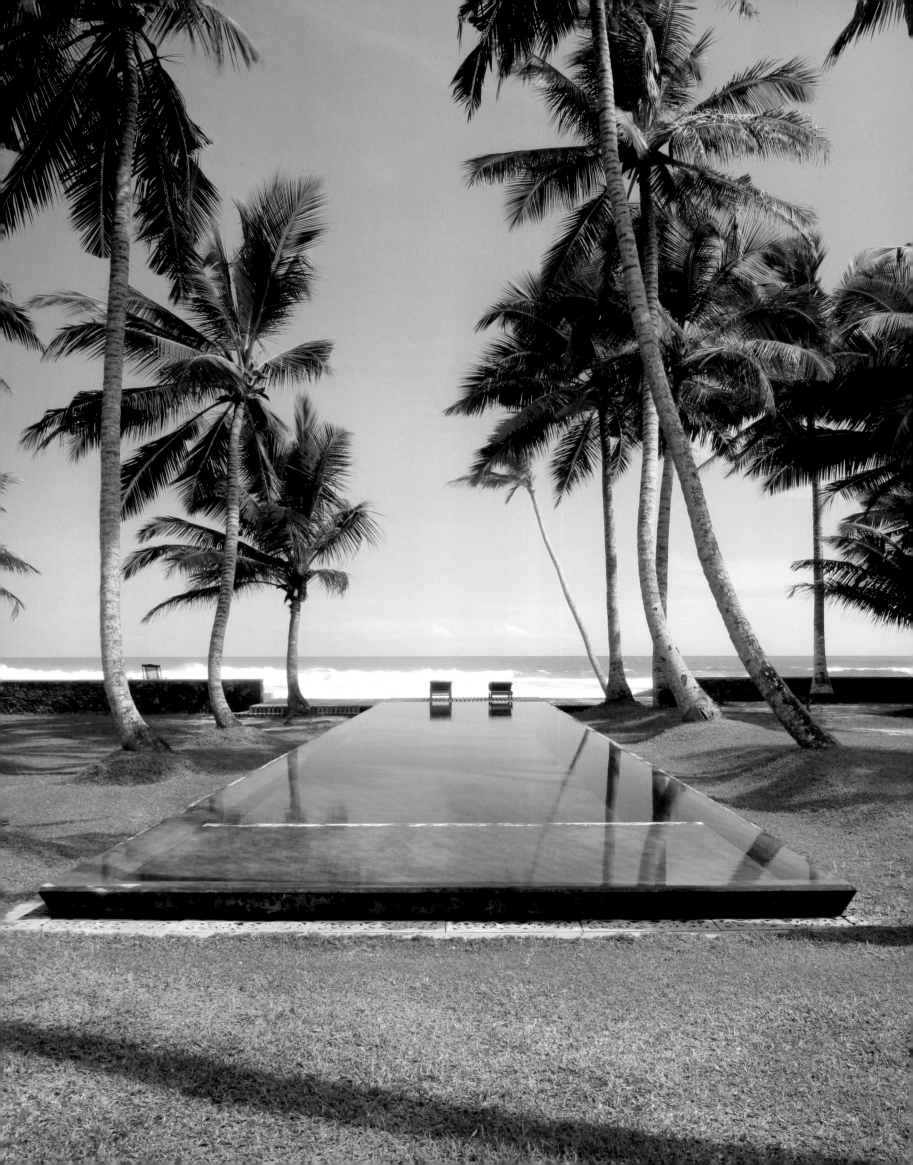

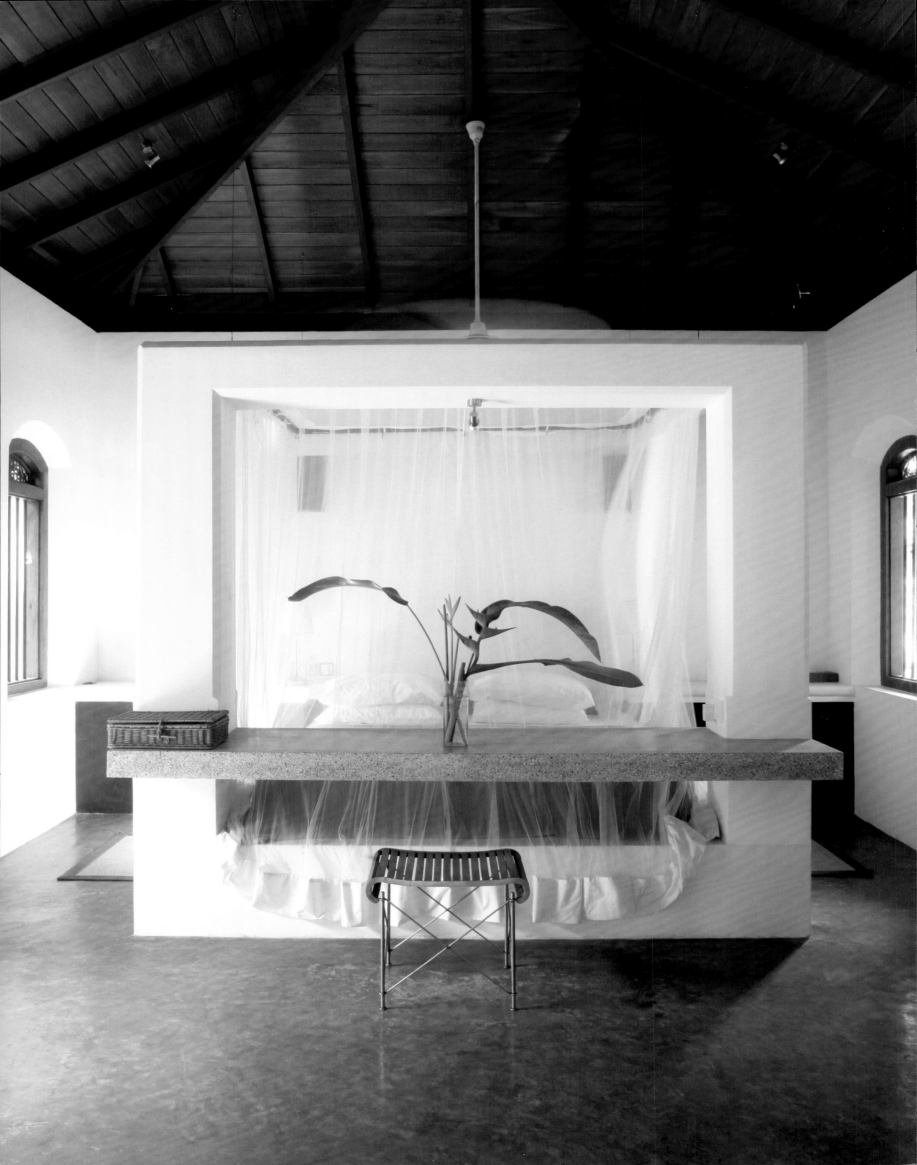

A mosquito net in a suite of Safron Villa ensures undisturbed dreams. Ceiling fans and shady terraces cool the tropical air.

Ein Moskitonetz in einer Suite der Safron Villa sorgt für ungestörte Träume. Ventilatoren und schattige Terrassen kühlen die tropische Luft.

Une moustiquaire dans une suite de la Safron Villa assure des rêves paisibles. Les ventilateurs au plafond et les terrasses ombragées rafraîchissent l'air tropical.

El mosquitero de una suite en Safron Villa vela por un sueño plácido. Ventiladores y terrazas a la sombra refrescan el aire tropical.

La zanzariera in una suite della Safron Villa garantisce sogni tranquilli. I ventilatori e le terrazze ombreggiate rinfrescano l'aria tropicale.

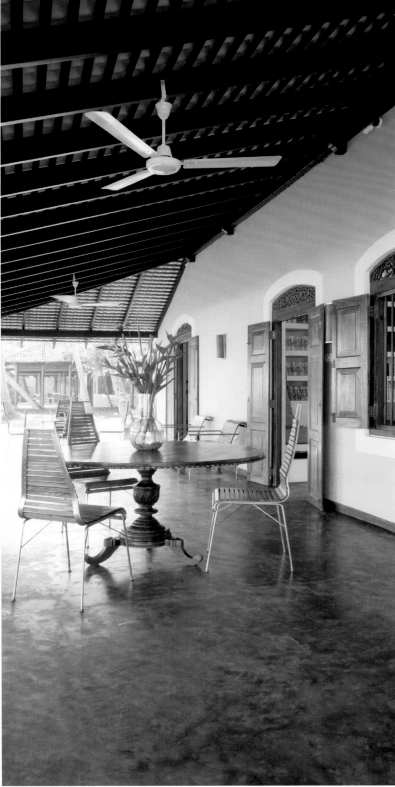

Taru Villas Taprobana

Bentota, Sri Lanka

Hidden next to a dream beach in Bentota, southwestern Sri Lanka, is Villa Taprobana with its nine guestrooms. Antiques suggest colonial charm as the blades of a fan hum from the ceiling. Discreet service makes it easy to forget everyday life there. Also, each new day reveals a new rhythm. Mornings begin with the song of the birds, the afternoon is marked by teatime and evenings bring the croaking of the frogs. The terrace offers a view of the frangipani trees and coconut palms with the ocean roaring beyond.

In Bentota im Südwesten Sri Lankas versteckt sich die Villa Taprobana mit ihren neun Gästezimmern an einem Traumstrand. Antiquitäten verströmen kolonialen Charme, unter der Decke summen die Blätter eines Ventilators. Dezenter Service macht es leicht, hier den Alltag zu vergessen. Und auch der Tag findet einen neuen Rhythmus. Der Morgen beginnt mit dem Gesang der Vögel, den Nachmittag markiert die Teestunde, den Abend das Quaken der Frösche. Von den Terrassen blickt man auf Frangipani-Bäume und Kokospalmen. Dahinter rauscht der Ozean.

La Villa Taprobana et ses neuf chambres d'hôtes se cachent sur une plage paradisiaque de Bentota, au sud-ouest du Sri Lanka. Quand les pales du ventilateur bourdonnent au plafond, les antiquités exaltent un charme colonial. Grâce au service, discret, il est facile d'y oublier la vie quotidienne. Et la journée prend ainsi un nouveau rythme. La matinée débute avec les chants des oiseaux, l'après-midi est marquée par l'heure du thé, et le soir amène les coassements des grenouilles. La terrasse a vue sur les frangipaniers et les cocotiers. L'océan murmure derrière eux.

En Betonta, al suroeste de Sri Lanka, ubicada en una playa de ensueño, se esconde Villa Taprobana con sus nueve habitaciones, antigüedades que despiden encanto colonial y el zumbido de las aspas de un ventilador de techo. El atento servicio hace olvidar la rutina diaria. Aquí el día adquiere un ritmo nuevo. La mañana comienza con el cantar de los pájaros, la tarde viene marcada por la hora del té y la noche por el croar de las ranas. Desde la terraza se divisan árboles Frangipani y cocoteros. De fondo, el susurro del océano.

A Bentota, nel sud-ovest dello Sri Lanka, si nasconde, presso una spiaggia da sogno, Villa Taprobana, con le sue nove camere per gli ospiti. I pezzi d'antiquariato trasmettono uno charme coloniale, sotto il soffitto ronzano le pale di un ventilatore. Un servizio discreto aiuta a dimenticare la vita di tutti i giorni. E anche il giorno trova un nuovo ritmo: la mattinata inizia con il canto degli uccelli, il pomeriggio è segnato dall'ora del tè, la sera dal gracchiare delle rane. Dalle terrazze si gode la vista degli alberi frangipane e delle palme da cocco. Sullo sfondo si sente il mormorio dell'oceano.

Time to take off your watch: This mix of Sinhalese and colonial elements of style aided by modern comfort helps you put aside time and everyday life.

Uhren ablegen: In diesem durch modernen Komfort ergänzten Mix aus singhalesischen und kolonialen Stilelementen lassen sich Zeit und Welt vergessen.

Enlevez votre montre : oubliez le temps et le reste du monde dans ce mélange d'éléments cingalais et coloniaux, que le confort moderne vient compléter.

Que se detenga el reloj: La mezcla de elementos estilísticos cingaleses y coloniales, enriquecida con el confort de hoy, consigue hacer olvidar el tiempo y el mundo.

Togliersi gli orologi: in questo connubio di elementi stilistici singalesi e coloniali integrati da comfort moderno, svaniscono il tempo e il resto del mondo.

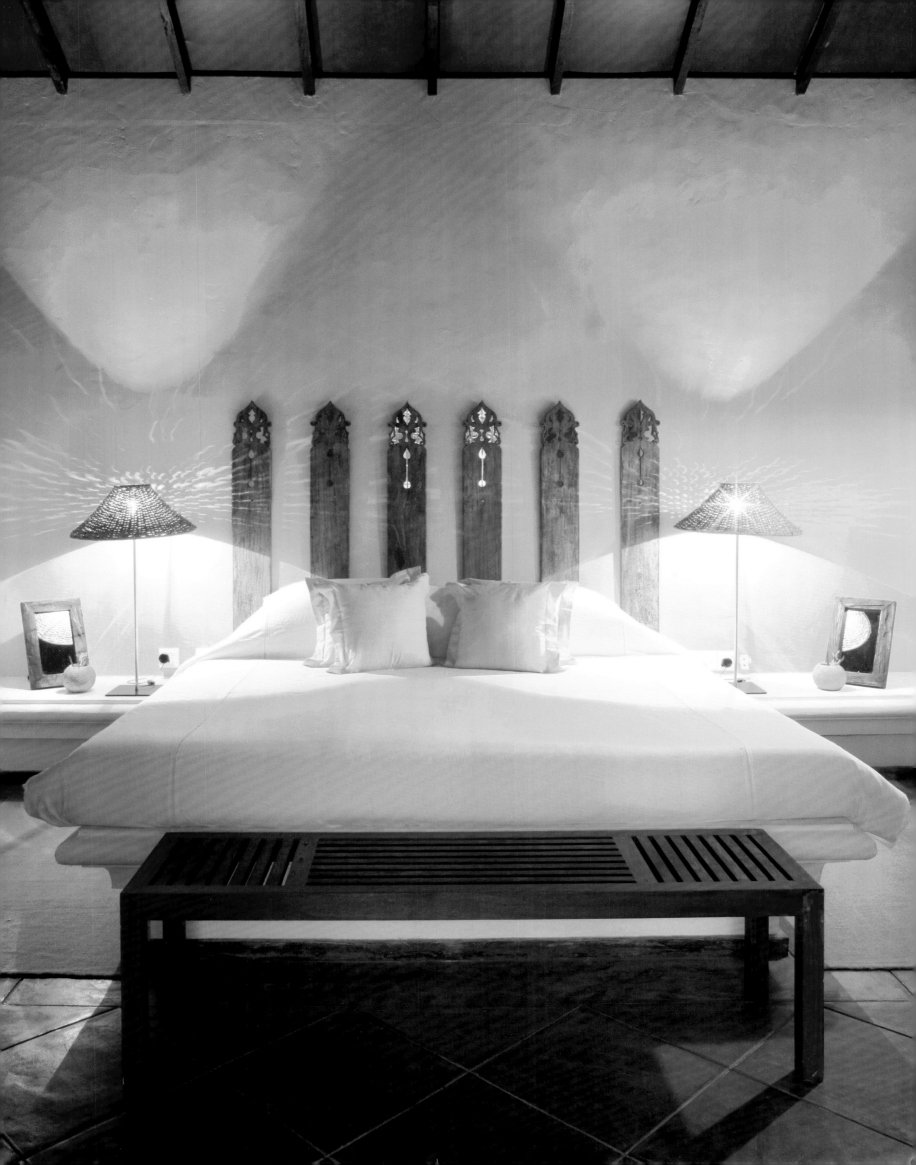

Feel right at home in the intimate atmosphere of this estate with its nine rooms. The terrace provides a perfect dinner-for-two setting.

Wie zu Hause fühlt man sich in der intimen Atmosphäre dieses Anwesens mit neun Zimmern. Die Terrasse ist eine perfekte Kulisse für ein Dinner zu zweit.

Vous vous sentirez chez vous dans l'atmosphère intime de cette propriété de neuf pièces. La terrasse est le cadre parfait pour un dîner à deux.

El ambiente intimista de este complejo con nueve dormitorios incita a sentirse como en casa. La terraza es el marco perfecto para una cena en pareja.

Ci si sente come a casa nell'atmosfera intima di questa tenuta con nove stanze. Il terrazzo è lo scenario perfetto per una cena a due.

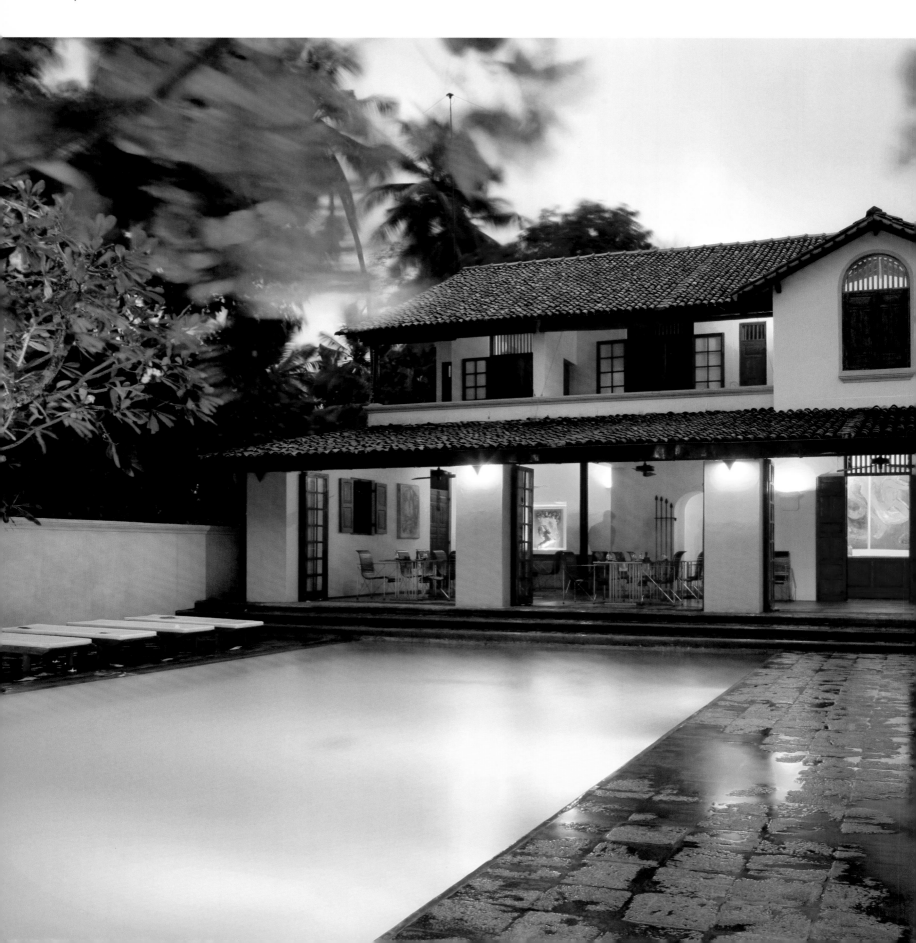

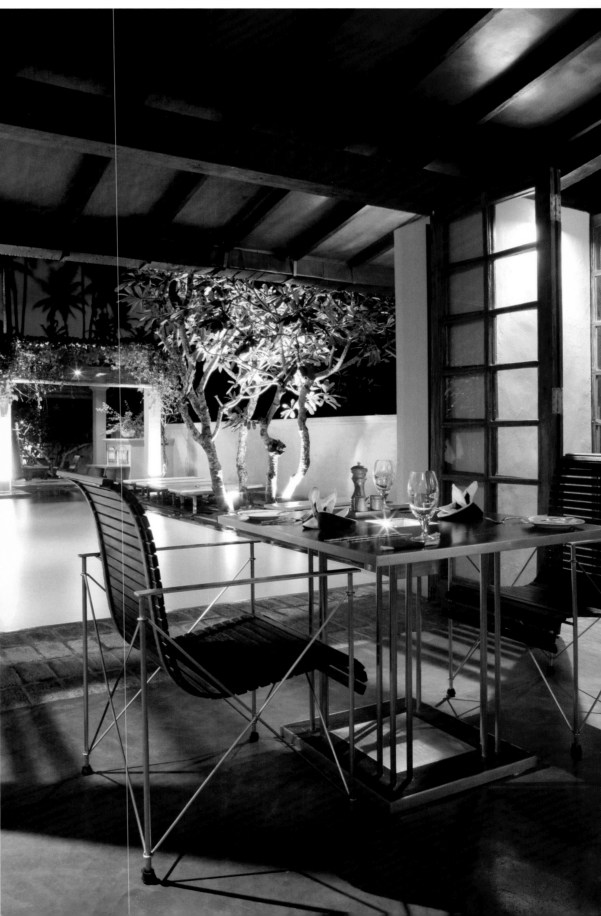

Villa Pantulan

Bali, Indonesia

In the middle of the green heart of Bali, near Ubud, a city known for its artists, you'll discover the grass-covered pavilions of the Villa Pantulan. The glass-fronted bedrooms offer an unobstructed view of the emerald hues of the surrounding bamboo forest and palm trees. The open two-story lounge with a library completely eliminates the boundary between inside and outside. From comfortable sofas, one can look out on water-lily ponds and rice fields. Water, bamboo and stone characterize the architecture of the estate. Its name means "reflection" and once you experience the tranquility of its garden, you'll understand why.

Mitten im grünen Herzen Balis, nahe der Künstlerstadt Ubud, liegen die grasgedeckten Pavillons der Villa Pantulan. Die Glasfronten der Schlafzimmer erlauben einen freien Blick auf die Smaragdtöne des umliegenden Bambuswaldes und der Palmen, die offene zweistöckige Lounge mit Bibliothek hebt die Grenze zwischen innen und außen vollends auf. Aus bequemen Sofas blickt man auf Seerosenteiche und Reisfelder. Wasser, Bambus und Stein prägen die Architektur des Anwesens, dessen Name „Reflexion" bedeutet. In der Ruhe des Gartens versteht man warum.

Les pavillons recouverts de pelouse de la Villa Pantulan sont au centre du cœur vert de Bali, près d'Ubud, la ville des artistes. Les chambres avec leurs baies vitrées offrent une vue dégagée sur la forêt de bambous environnante et les palmiers couleur émeraude. S'étendant sur deux niveaux, le salon ouvert avec bibliothèque abolit totalement la frontière entre intérieur et extérieur. Des confortables canapés, on peut voir les bassins de nénuphars et les rizières. L'eau, le bambou et la pierre caractérisent l'architecture de la propriété. Son nom signifie « réflexion », ce que vous comprendrez devant la sérénité du jardin.

En el pleno corazón verde de Bali, cerca de Ubud, la ciudad de los artistas, se ubican los pabellones de Villa Pantulan. Las cristaleras frontales de los dormitorios ofrecen vistas al bosque de bambú de color esmeralda y a las palmeras que rodean la propiedad. La sala de estar abierta de dos plantas, con biblioteca incluida, rompe las barreras entre interior y exterior. Desde los cómodos sofás se observan estanques rosados y campos de arroz. La arquitectura está definida por el agua, el bambú y la piedra. La vivienda lleva el nombre "reflexión"; sin duda el plácido jardín explica el por qué.

Nel cuore verde di Bali, vicino alla città d'arte Ubud, si trovano i padiglioni coperti d'erba di Villa Pantulan. Le vetrate delle camere da letto concedono la vista sulle tonalità smeraldo del bosco di bambù e delle palme circostanti, mentre la lounge aperta a due piani con biblioteca elimina completamente la barriera tra interno ed esterno. Da comodi sofà si guarda sui laghetti di ninfee e sulle risaie. L'acqua, il bambù e la pietra formano l'architettura della tenuta, il cui nome significa "riflessione". Nella tranquillità del giardino si capisce perché.

The green of the rice fields outside is soothing on the soul, while comfortable beds inside provide perfect rest.

Draußen wirkt das Grün der Reisfelder beruhigend auf die Seele, innen sorgen komfortable Betten für beste Erholung.

Le vert des rizières à l'extérieur a un effet calmant sur les âmes, tandis qu'à l'intérieur, les lits confortables vous permettent de récupérer au mieux.

El verde de los campos de arroz apacigua el espíritu. En el interior, las confortables camas proporcionan el mejor de los descansos.

All'esterno il verde delle risaie ha un effetto rilassante sull'anima, all'interno i letti confortevoli garantiscono il miglior ristoro.

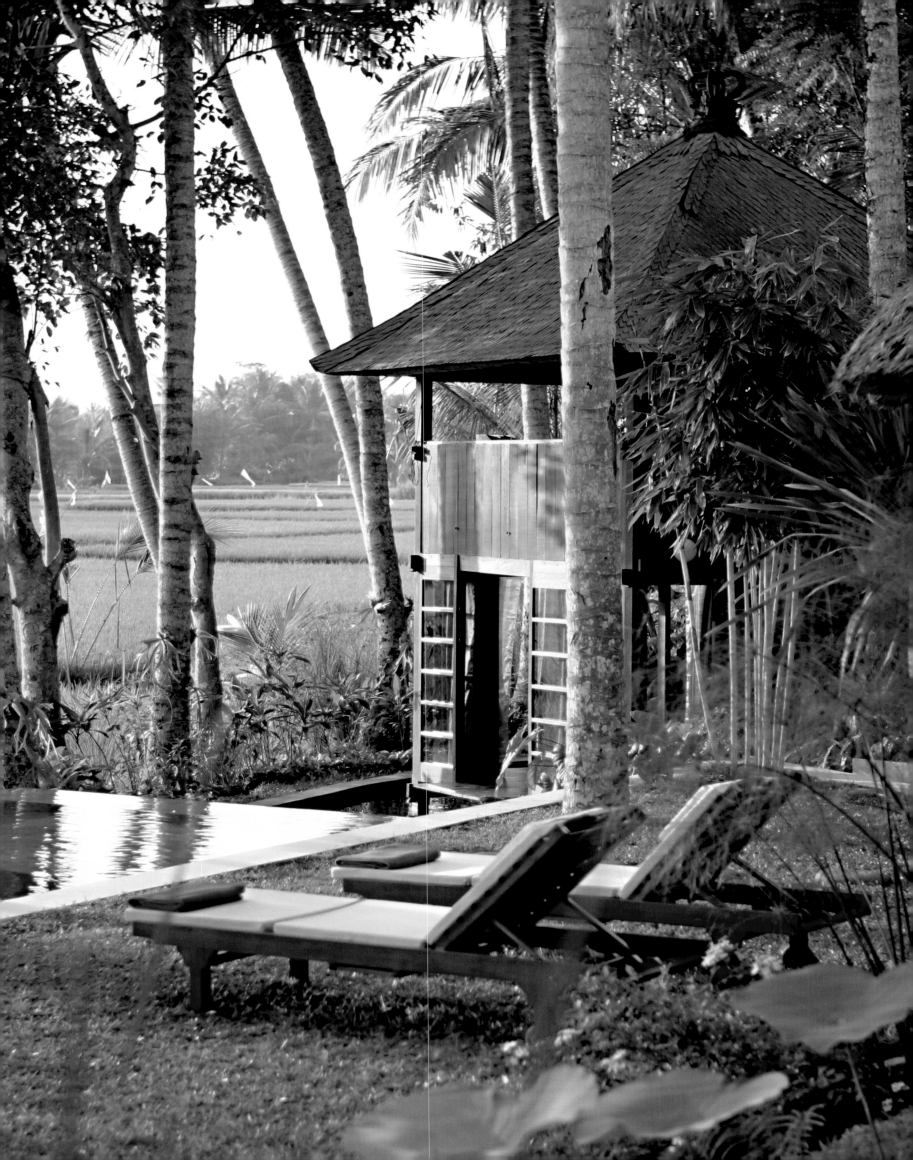

The open living room offers a beautiful view of the water-lily pond and the surrounding rice fields.

Das offene Wohnzimmer bietet einen schönen Blick auf Seerosenteich und die umliegenden Reisfelder.

La salle de séjour ouverte offre une magnifique vue sur les bassins de nénuphars et les rizières des alentours.

El salón abierto propone unas hermosas vistas al estanque de nenúfares y a los campos de arroz circundantes.

Il soggiorno aperto offre una vista bellissima sul laghetto di ninfee e le risaie circostanti.

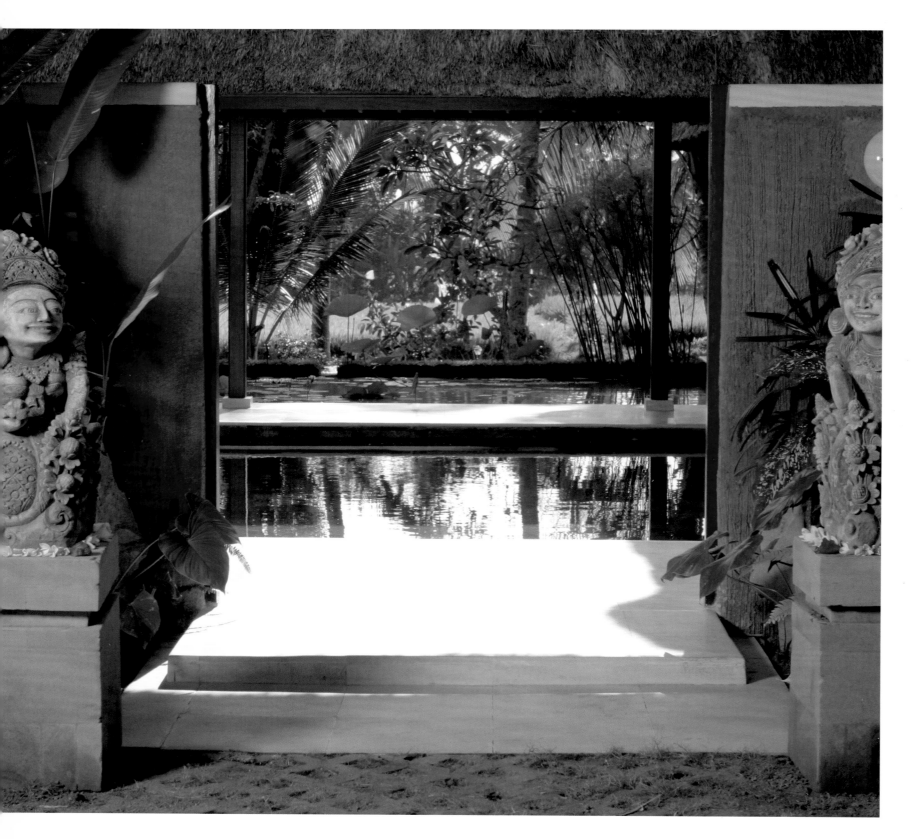

The open design of the bedrooms and baths makes you feel like you're outside.

Die offene Gestaltung von Schlafzimmern und Bädern vermittelt den Eindruck, man befände sich im Freien.

Le design ouvert des chambres et des salles de bains vous donne l'impression d'être à l'extérieur.

La disposición abierta de dormitorios y baños transmite la sensación de encontrarse al aire libre.

L'architettura delle camere da letto e dei bagni dà l'impressione di trovarsi all'aria aperta.

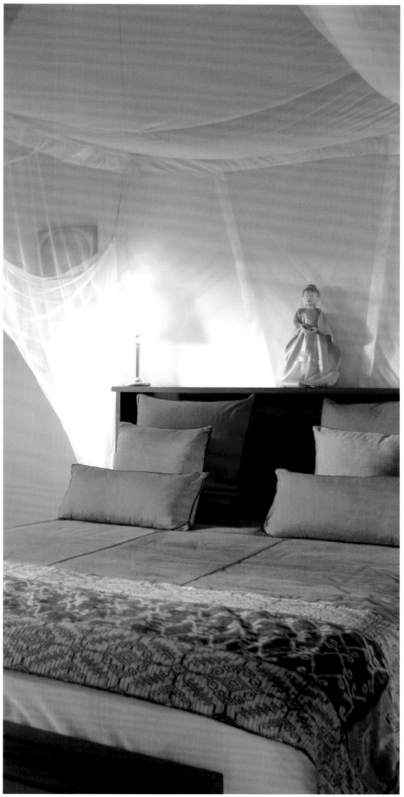

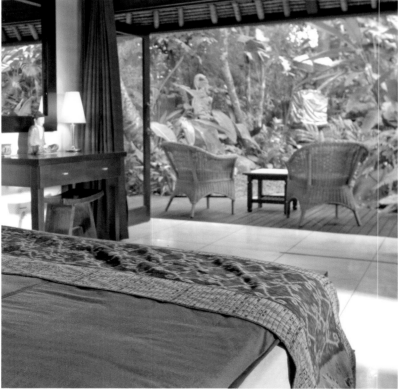

Villa Sungai

Bali, Indonesia

Not far from the coastal towns of Seminyak and Legian in southern Bali, these neighboring villas offer every conceivable luxury as they blend harmoniously into the surrounding landscape. A path over a pond leads from the charmingly elegant Villa Sungai to the smaller Villa Sungai Gold, similarly decorated in white and teak, but only designed for parties of two. The two houses offer a total of four bedrooms, six bathrooms, two pools and four dining areas. Tall glass fronts open the view of the surrounding pavilions, massage bales and palm garden.

Unweit der Küstenorte Seminyak und Legian im Süden Balis gelegenen, bieten diese Tür an Tür harmonisch in die Landschaft eingefügten Villen allen erdenklichen Luxus. Über einen Teich führt ein Fußpfad von der dezent eleganten Villa Sungai in die kleinere, ebenfalls in Weiß und Teakholz gehaltene Villa Sungai Gold, die nur für ein Paar konzipiert ist. Zusammen verfügen die Häuser über vier Schlafzimmer, sechs Bäder, zwei Pools und vier Essplätze. Hohe Glasfronten öffnen den Blick auf die umliegende Pavillons, Massage-Bale und den Palmengarten.

Situées près des villes côtières de Seminyak et Legian au sud de Bali, ces villas adjacentes intégrées harmonieusement au paysage offrent tout le luxe imaginable. Au-dessus un étang un sentier mène de l'élégante Villa Sungai à la Villa Sungai Gold, plus petite. Cette dernière est aussi décorée de blanc et de teck, mais conçue pour un couple seulement. Les deux maisons comptent un total de quatre chambres, six salles de bains, deux piscines et quatre espaces repas. De hautes façades de verre ouvrent la vue sur les pavillons voisins, les tables de massage et la palmeraie.

Ubicadas cerca de los enclaves costeros de Seminyak y Legian al sur de Bali, estas mansiones integradas de forma armónica en el paisaje ofrecen todos los lujos imaginables. Un paso por encima de un estanque enlaza la elegante Villa Sungai con Villa Sungai Gold, algo menor y concebida para una pareja, también decorada en blanco y madera de teka. Las dos casas suman un total de cuatro dormitorios, seis baños, dos piscinas y cuatro comedores. Unas grandes cristaleras frontales despejan las vistas al pabellón contiguo, la zona de masaje y el jardín con palmeras.

Situate poco lontane dalle località costiere di Seminyak e Legian, nel Sud di Bali, queste ville, inserite armonicamente porta a porta nel paesaggio, offrono tutto il lusso pensabile. Un percorso attraverso lo stagno porta dall'elegante e discreta Villa Sungai alla più piccola Villa Sungai Gold, tinteggiata anch'essa di bianco e costruita in teak, concepita solo per una coppia. Nel loro insieme le case dispongono di quattro camere da letto, sei bagni, due piscine e quattro zone da pranzo. Ampie vetrate aprono la vista ai padiglioni sottostanti, alle oasi per il massaggio e ai giardini di palme.

Bright, neutral shades define the decor to avoid distraction from the awe-inspiring nature of Bali.

Helle, neutrale Töne prägen die Einrichtung, damit nichts von der überwältigenden Natur Balis ablenkt.

Des teintes brillantes et neutres caractérisent les meubles, pour que rien ne distraie la vue de la nature grandiose de Bali.

Tonos claros y neutros dominan la decoración con el fin de que nada distraiga la atención de la indómita naturaleza balinesa.

Tonalità chiare e neutre caratterizzano l'arredamento, in modo che nulla possa distrarre dalla prorompente natura di Bali.

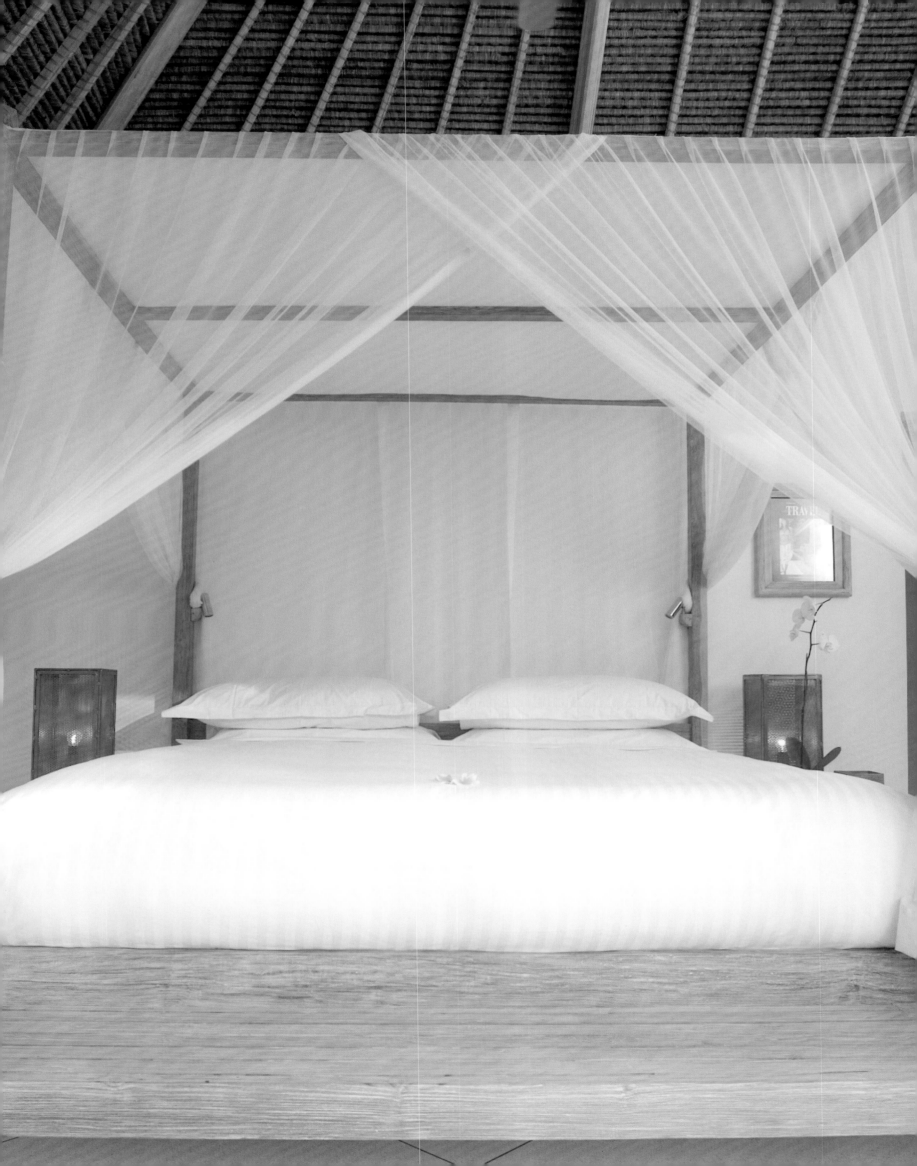

Natural colors and materials like Egyptian-cotton bed sheets all but guarantee restful sleep.

In natürlichen Farben und Materialien wie den Laken aus ägyptischer Baumwolle lässt es sich erholsam schlafen.

Dormez profondément dans des couleurs et des matériaux naturels, comme par exemple les draps en coton égyptien.

Los colores y materiales naturales, como el de las sábanas de algodón egipcio, inducen al descanso.

Colori e materiali naturali come le lenzuola di cotone egiziano rendono il sonno rigenerante.

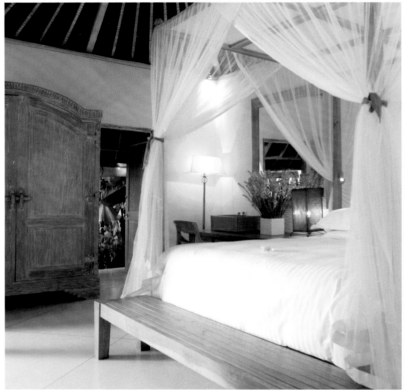

As many as fourteen people can dine in the open pavilion by the pool.

Im offenen Pavillon am Pool können bis zu vierzehn Personen speisen.

Jusqu'à quatorze personnes peuvent dîner dans le pavillon ouvert près de la piscine.

En el pabellón abierto junto a la piscina pueden comer hasta catorce comensales.

Nel padiglione aperto sulla piscina possono pranzare fino a quattordici persone.

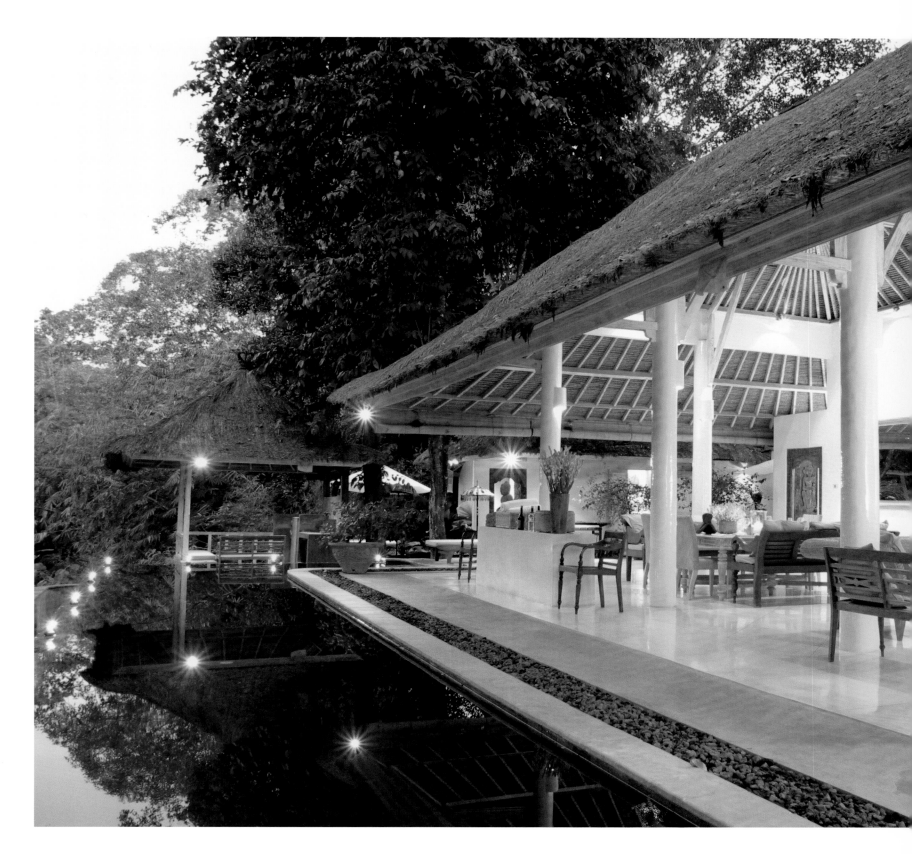

Villa Dewata

Bali, Indonesia

This elegant villa with five bedrooms and bathrooms is hidden on a quiet side street of Basangkasa, located near Seminyak and Legian to the southwest of Bali. Comfortable recliners and tables with chairs by the pool, an open-air lounge, and the open dining room suspend the boundaries between the inside and outside areas. Art objects typical of Bali and a purist interior offer repose for the eye. A butler coordinates the meals, serves tea in the afternoon and makes sure that the guests don't have to lift a finger.

In einer ruhigen Seitenstraße des in der Nähe von Seminyak und Legian im Südwesten Balis gelegenen Basangkasa versteckt sich diese elegante Villa mit fünf Schlafzimmern und Bädern. Komfortable Liegeplätze und Sitzgruppen am Pool, eine offene Lounge und der offene Speiseraum heben die Grenzen zwischen Innen- und Außenbereich auf. Landestypische Kunstobjekte und ein puristisches Interieur bieten Erholung fürs Auge. Ein Butler koordiniert die Mahlzeiten, serviert nachmittags den Tee und sorgt dafür, dass die Gäste keinen Finger rühren müssen.

Cette villa élégante avec cinq chambres et salles de bains se cache dans une paisible rue de Basangkasa, près de Seminyak et de Legian, au sud-ouest de Bali. Des endroits confortables pour se détendre et des fauteuils près de la piscine, un salon en plein air et une salle à manger ouverte abolissent les limites entre l'intérieur et l'espace extérieur. Des objets d'art typiques du pays et un intérieur puriste offrent un repos pour les yeux. Un majordome supervise les repas, sert le thé l'après-midi et s'assure que personne n'ait à lever le petit doigt.

En una tranquila calle secundaria de Basangkasa, población del suroeste balinés cercana a Seminyak y Legian, se esconde esta elegante residencia de cinco dormitorios y baños. Los cómodos divanes y conjuntos de sofás junto a la piscina, unidos al lounge y el comedor abiertos difuminan los límites entre el interior y el exterior. Objetos de arte autóctonos y un interior de líneas puras dan placer a la vista. Un mayordomo coordina las comidas: por la tarde sirve el té y se encarga de que los invitados no tengan que mover un dedo.

In una tranquilla strada laterale di Basangkasa, situata nelle vicinanze di Seminyak e Legian, nella zona sudoccidentale di Bali, si nasconde questa elegante villa con cinque camere da letto e bagni. Le sdraio e i salottini confortevoli presso la piscina, la lounge e la sala da pranzo aperte eliminano le linee di confine tra l'area interna e quella esterna. Gli oggetti d'arte locali e gli interni puristici fanno riposare gli occhi. Un maggiordomo coordina i pasti, serve il tè al pomeriggio e fa in modo che gli ospiti non debbano muovere un dito.

Balinese art objects stand out prominently in the sparsely furnished rooms.

In den sparsam eingerichteten Räumen kommen balinesische Kunstobjekte wirkungsvoll zur Geltung.

Les objets d'art balinais font beaucoup d'effet dans les pièces sobrement meublées.

La espartana decoración de las estancias hace resaltar sobremanera las obras de arte balinesas.

Nei locali arredati in modo spartano, risaltano efficacemente gli oggetti d'arte di Bali.

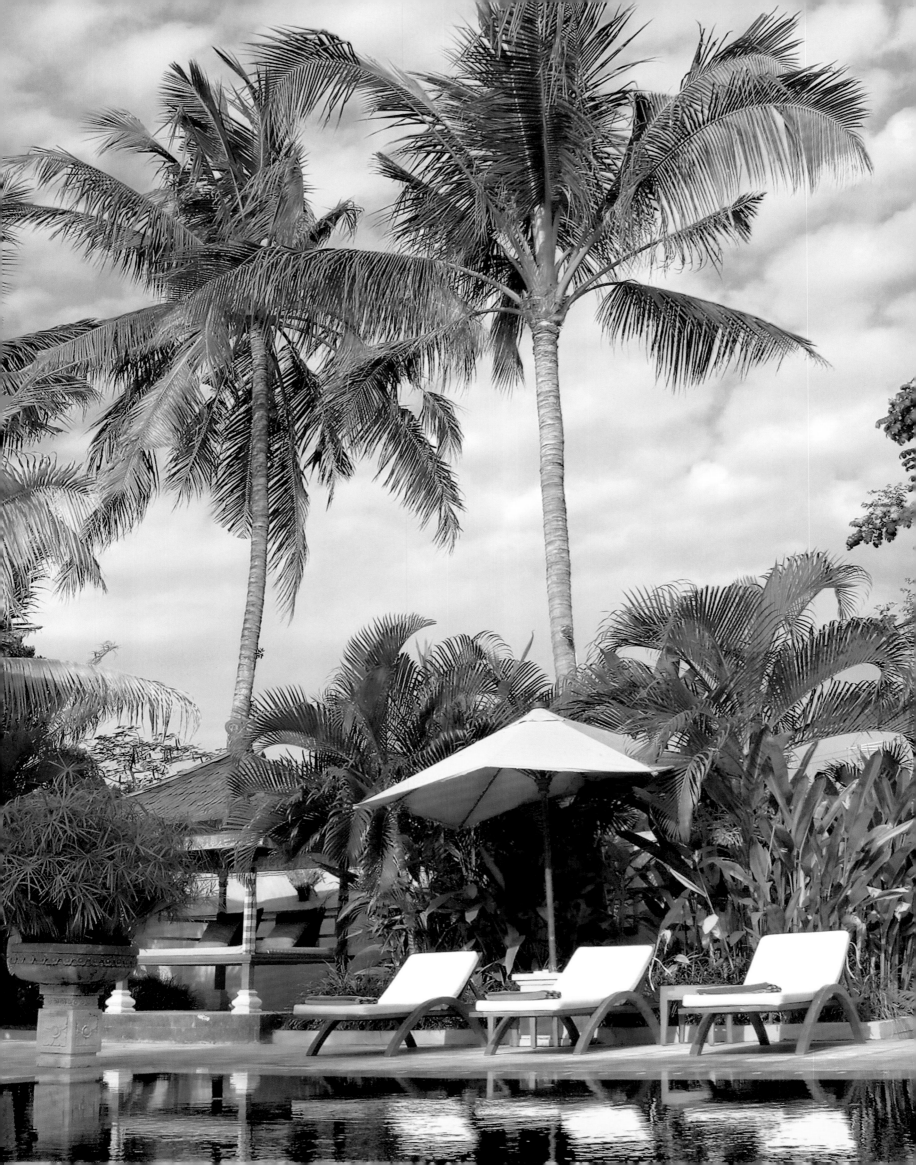

In the stillness of these temple-like grounds, it's hard to imagine that the main street is just 300 ft. away.

In der Ruhe dieser an einen Tempel erinnernden Anlage ist kaum vorstellbar, dass die Hauptstraße nur 100 m entfernt liegt.

Dans le calme de ces jardins sanctuaires, il est difficile d'imaginer que la rue principale n'est qu'à 100 m.

En la quietud de esta residencia semejante a un templo, cuesta creer que la calle principal quede a 100 m.

Nella tranquillità di questa tenuta che ricorda un tempio, non si riesce quasi ad immaginare che la strada principale disti solo poche 100 m.

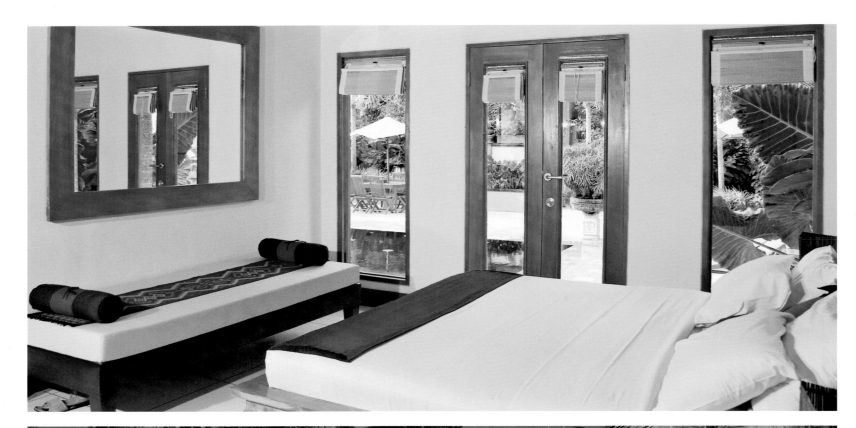

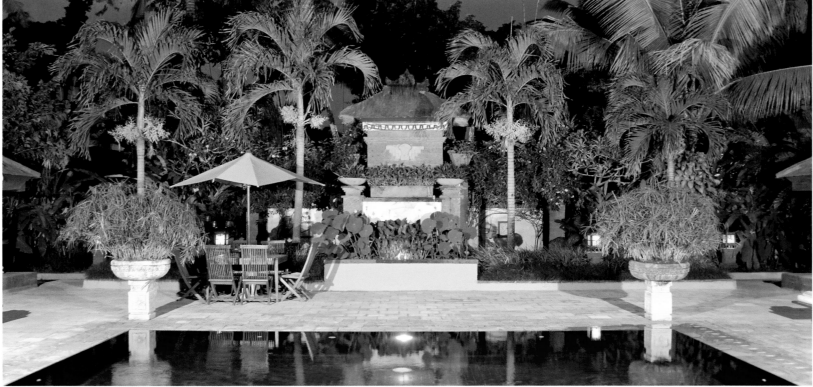

Dining with a view—*with enough room for visitors too.*

Speisen mit Aussicht — *und genug Platz für Besucher gibt es auch.*

Dîner avec vue — *et il y a assez de place pour les visiteurs.*

Comer con vistas *panorámicas y disponer además de espacio suficiente para las visitas.*

Pranzo con vista — *e vi è anche abbastanza posto per i visitatori.*

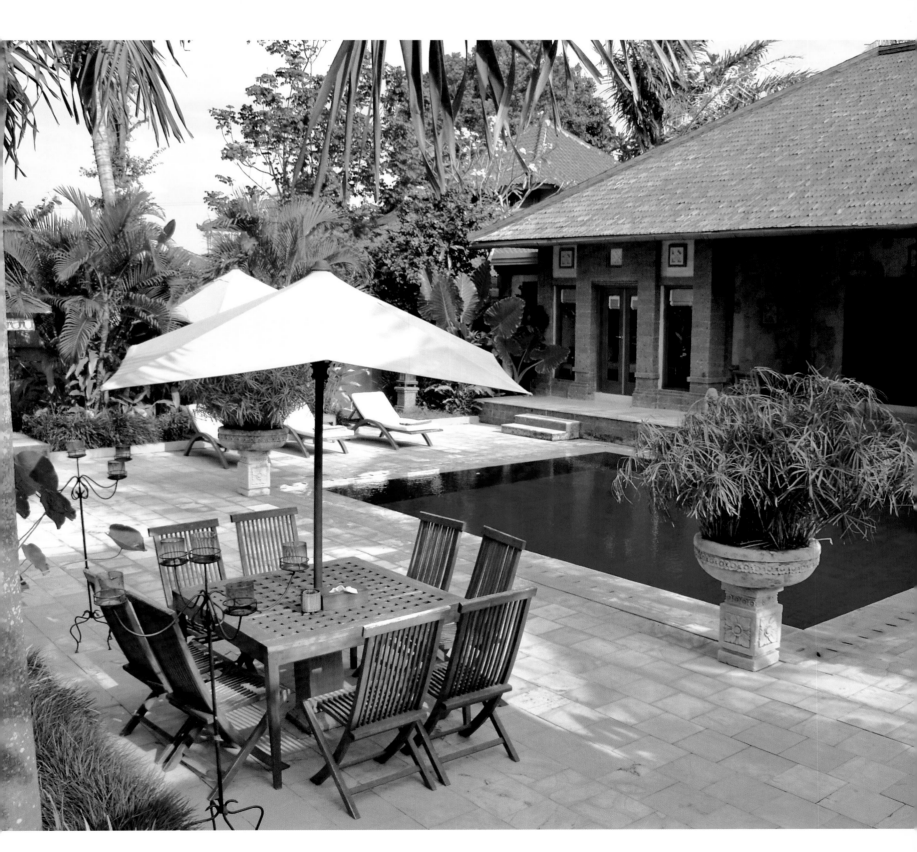

Commune by the Great Wall Kempinski

Beijing, China

Twelve architects from all over Asia designed the villas of the Commune by the Great Wall—an award-winning ensemble of contemporary architecture. As a Kempinski Hotel with an Anantara Spa, this chain of villas in the Shuiguan Mountains, one hour by car from the Beijing City, offers every creature comfort imaginable. With four to six bedrooms each, the houses naturally blend into the mountain chain despite their modern architecture in cubic forms and distinct lines—made possible by using wood with warm accents and tall windows that open the rooms to the outside and offer generous views.

Zwölf Architekten aus ganz Asien haben die Villen der Commune by the Great Wall entworfen – ein preisgekröntes Ensemble zeitgenössischer Architektur. Als Kempinski-Hotel mit einem Anantara-Spa bieten die Villen in den Shuiguan-Bergen, eine Autostunde von der Pekinger City entfernt, allen erdenklichen Komfort. Die Häuser mit je vier bis sechs Schlafzimmern fügen sich trotz ihrer modernen Architektur in kubischen Formen und klaren Linien wie selbstverständlich in die Natur des Höhenzugs ein – dafür sorgen Holz in warmen Tönen und die hohen Fenstern, die die Räume nach außen öffnen und weite Blicke bieten.

Douze architectes venant de toute l'Asie ont conçu les villas de la Commune by the Great Wall – un ensemble d'architecture contemporaine primé. Les villas des Monts Shuiguan, à une heure de voiture de Pékin, offrent tout le confort imaginable comme un hôtel Kempinski avec un spa Anantara. Chacune comptant de quatre à six chambres, les maisons s'harmonisent facilement avec l'environnement naturel des montagnes, malgré leur achitecture moderne aux formes cubiques et aux lignes claires – principalement grâce au bois aux teintes chaudes et aux hautes fenêtres qui ouvrent les pièces sur l'extérieur et offrent une vue panoramique.

Doce arquitectos venidos de toda Asia diseñaron las residencias de la Commune by the Great Wall, un compendio de arquitectura contemporánea que ha cosechado varios premios. Estas villas pertenecientes al hotel Kempinski con un spa Anantara están ubicadas a una hora por carretera del centro de Pekín, en las faldas de los montes Shuiguan y cuentan con cuatro a seis dormitorios dotados de todo el confort imaginable. A pesar de sus líneas modernas y claras y de sus formas cúbicas, se funden a la perfección en el entorno de colinas, gracias a los tonos cálidos de la madera y los grandes ventanales que se abren al exterior ofreciendo vastas panorámicas.

Dodici architetti da tutta l'Asia hanno progettato le ville della Commune by the Great Wall, un premiato gruppo di architettura contemporanea. In qualità di albergo Kempinski con una spa Anantara, le ville situate nelle montagne di Shuiguan, a un'ora di macchina dal centro di Pechino, offrono tutto il comfort immaginabile. Le case dispongono dalle quattro alle sei camere da letto e si inseriscono armoniosamente nel paesaggio montano, malgrado la loro architettura moderna dalle forme cubiche e dalle linee ben definite, grazie alle tonalità calde del legno e alle ampie finestre che aprono gli spazi verso l'esterno e offrono un vasto panorama.

 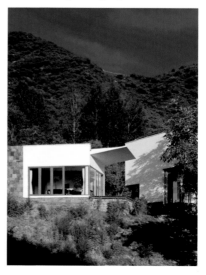

All the facets of Asia: The tea room of the Bamboo Wall House designed by Japanese architect Kengo Kuma is lined with bamboo on four sides. You can see a tower of the Great Wall of China from here.

Alle Facetten Asiens: Das Teezimmer des vom japanischen Architekten Kengo Kuma entworfenen Hauses Bamboo Wall wird an vier Seiten von Bambus begrenzt. Von hier sieht man einen Turm der Chinesischen Mauer.

Toutes les facettes de l'Asie : la salle de thé de la maison Bamboo Wall dessinée par l'architecte japonais Kengo Kuma, est couverte de bambous sur quatre côtés. De là, vous pouvez voir une tourelle de la Grande Muraille de Chine.

Todas las facetas de Asia: el salón de té del arquitecto nipón Kengo Kuma en la casa Bamboo Wall está cercado en sus cuatro costados con bambú. Desde aquí se divisa una de las torres de la Gran Muralla china.

Tutte le sfaccettature dell'Asia: la stanza per il tè nella casa Bamboo Wall, progettata dall'architetto giapponese Kengo Kuma, viene delimitata su quattro lati dal bambù. Da qui si vede una delle torri della Muraglia Cinese.

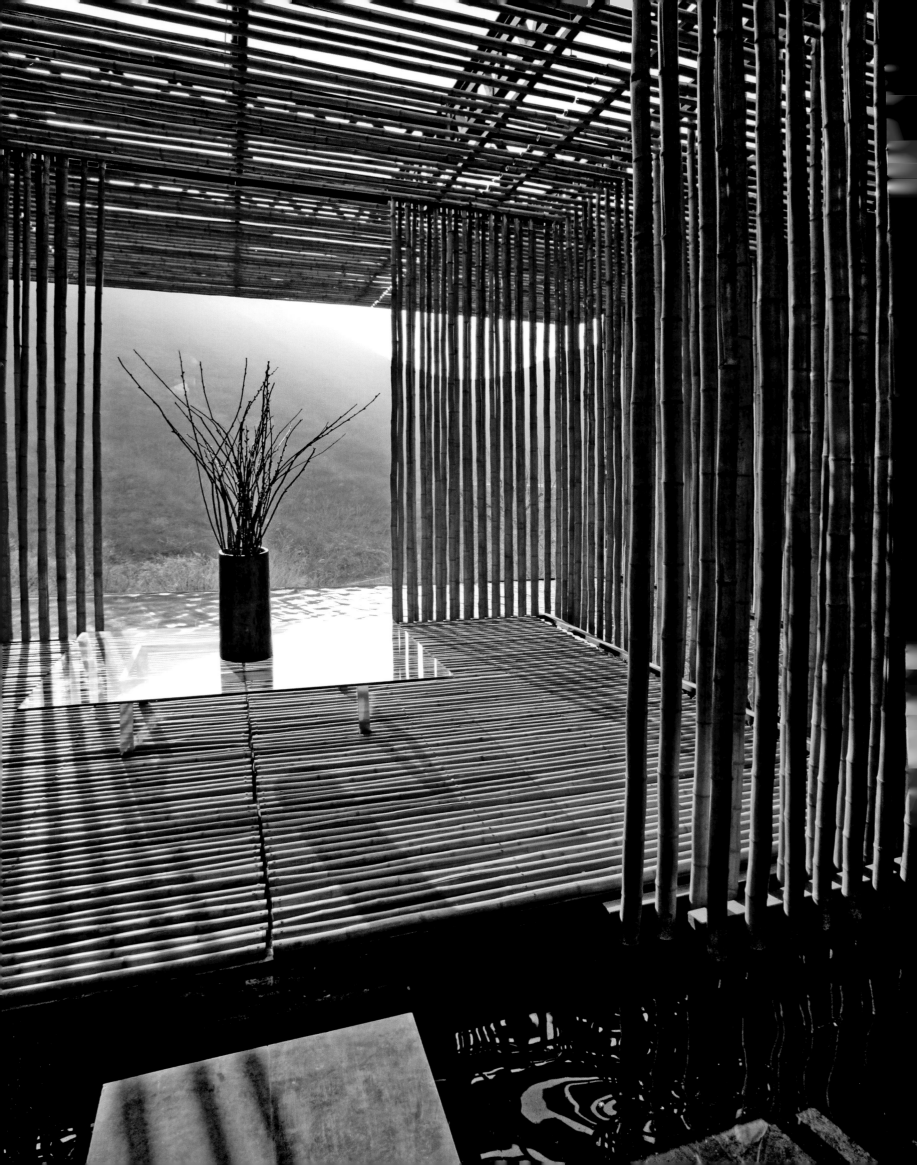

The Cantilever House was designed by Antonio Ochoa. The light wooden floors of the four bedrooms are designed to capture and reflect the sunlight.

Das Cantilever House entwarf Antonio Ochoa. Die hellen Holzböden der vier Schlafzimmer sollen das Sonnenlicht aufnehmen und widerspiegeln.

La Cantilever House a été conçue par Antonio Ochoa. Le plancher en bois clair des quatre chambres sert à absorber et à refléter la lumière.

La Cantilever House es un diseño de Antonio Ochoa. El parqué en tonos claros de los cuatro dormitorios capta y refleja la luz del sol.

La Cantilever House è stata progettata da Antonio Ochoa. I pavimenti in legno chiaro delle quattro camere da letto raccolgono la luce del sole e la rispecchiano.

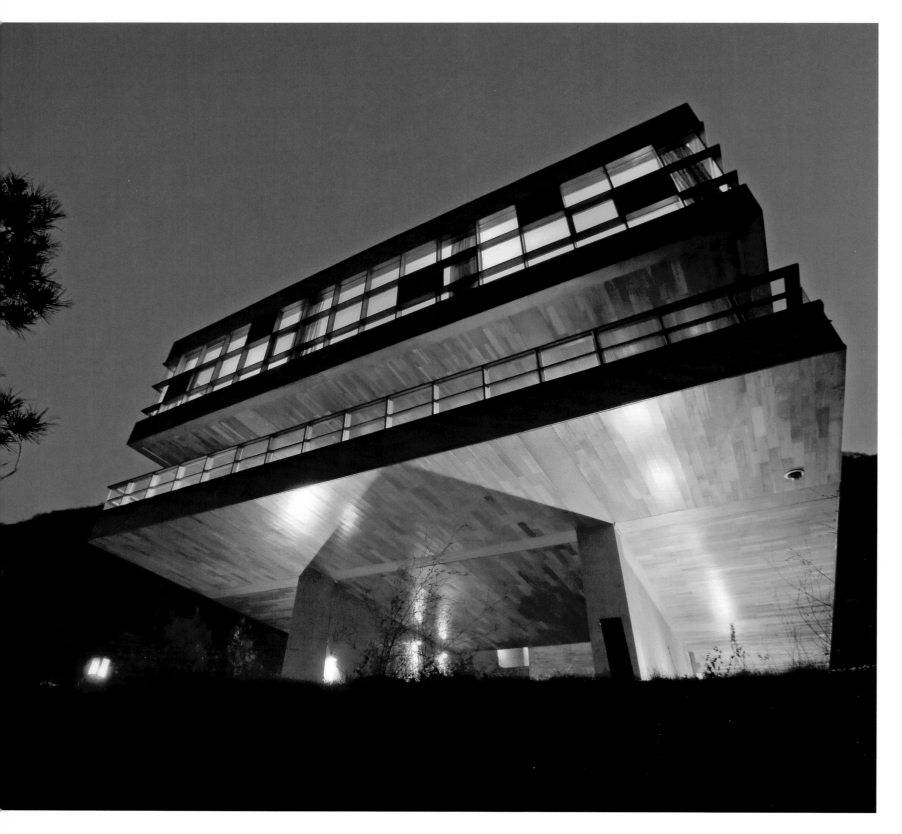

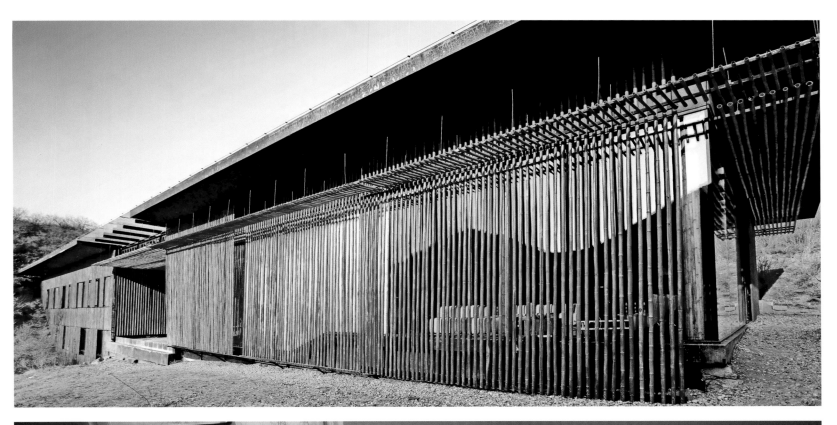

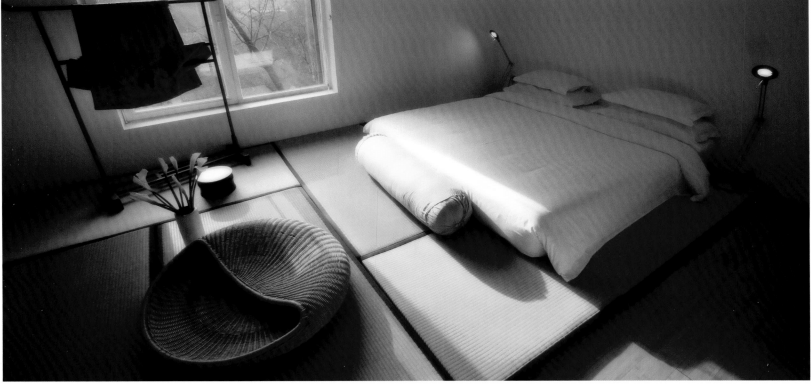

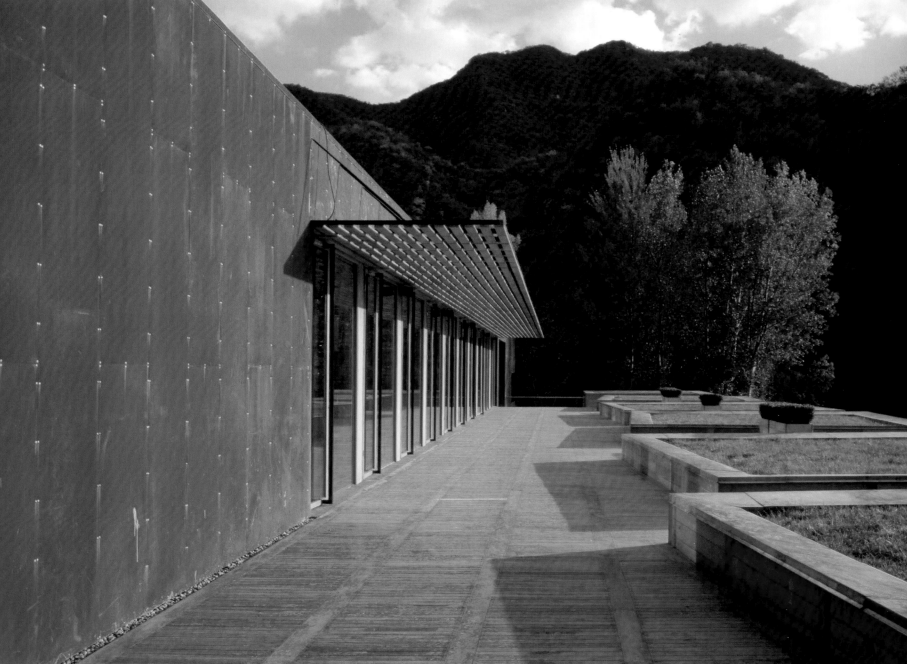

The bedrooms either offer a view of the mountains or of the Great Wall, which is just ten minutes away.

Die Schlafzimmer blicken entweder in die Berge oder auf die Chinesische Mauer, die man in nur zehn Minuten erreichen kann.

Les chambres ont vue soit sur la montagne, soit sur la Grande Muraille, qu'on peut rejoindre en moins de dix minutes.

Los dormitorios gozan de vistas a las montañas o a la Gran Muralla china, a la que se llega en diez minutos.

Le camere da letto hanno la vista sulle montagne oppure sulla Muraglia Cinese, che può essere raggiunta in soli dieci minuti.

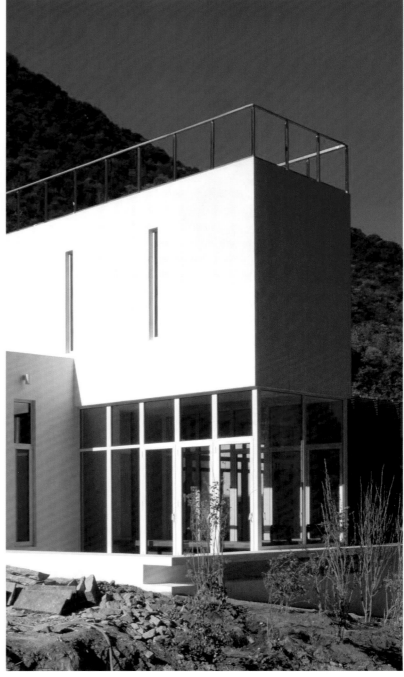

Olive Grove Retreat

Heathcote, Victoria, Australia

Behind the simple facade of this cottage in the green hills of Heathcote in the Australian state of Victoria, sparkling chandeliers, a fireplace and beige-and-white furniture that's equally elegant and comfortable form an exciting contrast to the wilderness outside the large windows. The secluded location of the cottage allows the luxury of having a four-poster bed on the veranda. Other oases of peace include the bedroom with its intentionally frugal furniture and the bathroom with its freestanding tub. This is the perfect hideaway for couples.

Hinter der schlichten Fassade dieses Cottages in den grünen Hügeln von Heathcote im australischen Bundesstaat Victoria bilden funkelnde Kronleuchter, ein Kamin und die ebenso eleganten wie bequemen, in Beige und Weiß gehaltenen Möbel einen spannungsreichen Kontrast zur Wildnis vor den großen Fenstern. Die abgeschiedene Lage erlaubt den Luxus eines Himmelbetts auf der Veranda. Weitere Oasen der Ruhe sind das bewusst sparsam möblierte Schlafzimmer und das Bad mit freistehender Wanne. Es ist der perfekte Fluchtort für ein Paar.

Derrière la simple façade de ce cottage sur les collines vertes d'Heathcote, dans l'état australien de Victoria, un lustre étincelant, une cheminée et un mobilier beige et blanc à la fois élégant et confortable forment un agréable contraste avec la nature sauvage visible par les larges fenêtres. Ce lieu isolé permet le luxe d'un lit à colonnes sur la véranda. La chambre, meublée avec soin et parcimonie, et la salle de bains avec sa baignoire libre constituent d'autres oasis de paix. C'est le parfait refuge pour un couple.

Tras la sencilla fachada de esta casa de campo en las verdes colinas de Heathcote, en el estado australiano de Victoria, las luminosas arañas, la chimenea y los elegantes y cómodos muebles en beige y blanco, dan lugar a un interesantísimo contraste frente al agreste panorama que se divisa a través de los grandes ventanales. Su ubicación recóndita, permite gozar del lujo de una cama al aire libre en el porche. Otro oasis de paz es el dormitorio, deliberadamente parco en mobiliario y su baño con bañera exenta. El lugar de escapada perfecto para una pareja.

Dietro la facciata sobria di questo cottage immerso nelle verdi colline di Heathcote, nello stato australiano di Victoria, il lampadario luccicante, il camino e i mobili beige e bianchi, tanto eleganti quanto comodi, creano un forte contrasto con il paesaggio selvaggio che si vede dalle grandi finestre. Il luogo appartato concede il lusso di un letto a baldacchino sulla veranda. Altre oasi della pace sono costituite dalla camera da letto arredata in modo consapevolmente spartano e il bagno con la vasca staccata dalle pareti. E' il luogo perfetto per una fuga a due.

It only looks like a simple cottage: The exquisite interior in white and beige is light years away from the wilderness outside.

Nur scheinbar ein einfaches Cottage: Das erlesene Interieur in Weiß und Beige ist von der Wildnis draußen Lichtjahre entfernt.

On dirait un simple cottage, mais l'intérieur raffiné, blanc et beige, est à des années lumières de la nature sauvage de l'extérieur.

En apariencia, una simple casa de campo. El selecto interior en tonos blancos y beiges está a años luz del exterior salvaje.

Un cottage semplice solo all'apparenza: gli interni pregiati in bianco e beige sono lontani anni luce dal paesaggio selvaggio circostante.

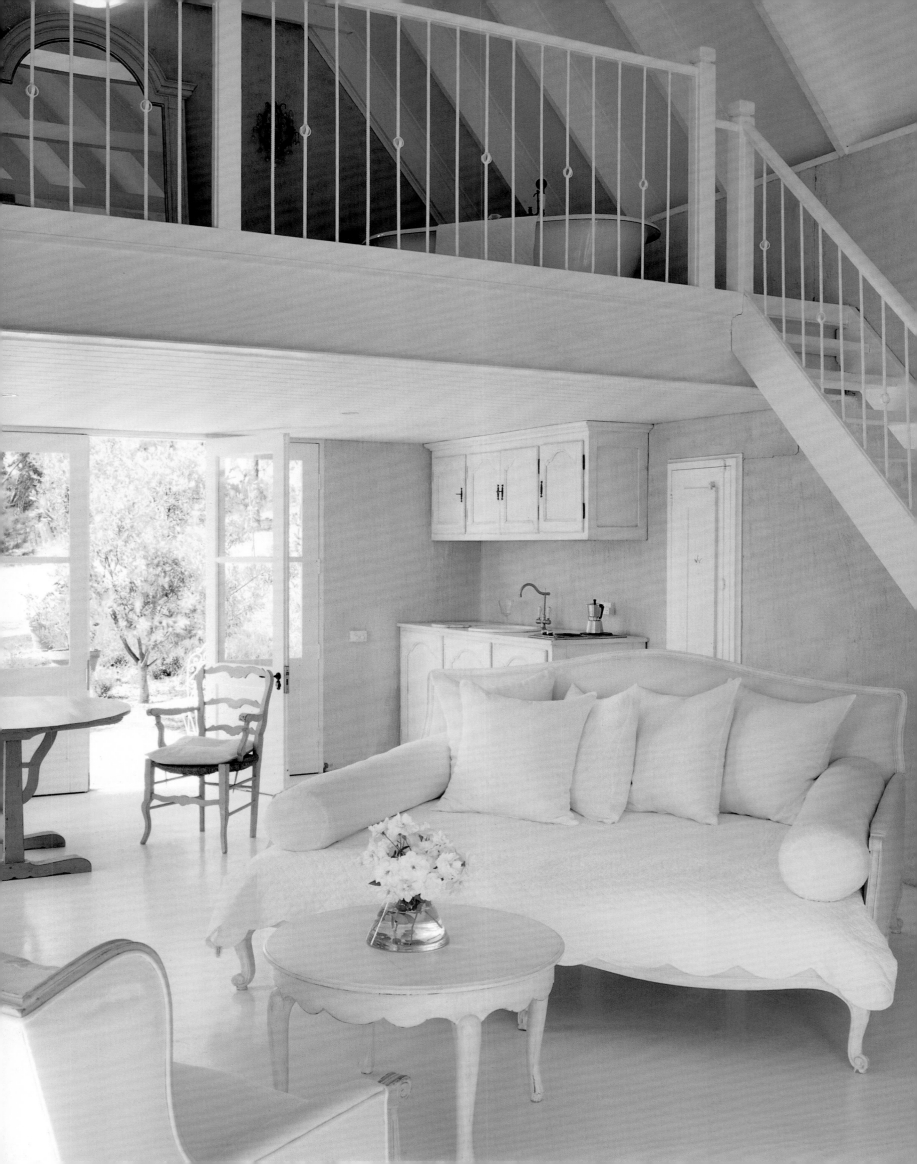

The fondly selected and arranged furniture exudes a touch of nostalgia. The secluded location ensures undisturbed peace and quiet, even in the garden.

Einen Hauch von Nostalgie verströmen die liebevoll ausgewählten und arrangierten Möbel. Die abgeschiedene Lage garantiert ungestörte Ruhe auch im Garten.

Les meubles choisis et disposés avec soin dégagent une touche de nostalgie. Le lieu isolé garantit également une paix et une sérénité totales dans le jardin.

El mobiliario, escogido y colocado con dedicación, transmite cierta sensación de nostalgia. Su apartada ubicación garantiza tranquilidad imperturbable también en el jardín.

I mobili scelti e disposti con cura emanano un soffio di nostalgia. La posizione appartata garantisce tranquillità indisturbata anche in giardino.

Moonlight Head Private Lodge

Yuulong, Victoria, Australia

This lodge lies between the ocean and wild bush on a cliff on Great Ocean Road in Victoria. Its futuristic glass roof creates an atmosphere of space flooded with sunshine. Local materials used in the construction of the lodge and an ingenious energy concept emphasize responsibility for the land and the lodge's connection to it. Its interior combines European designer furniture with antique Oriental rugs. As the day draws to a close, guests can enjoy some well-chilled Australian wine as they watch kangaroos hop across the grounds of the lodge.

Auf einer Klippe an der Great Ocean Road in Victoria liegt diese Lodge zwischen dem Meer und wildem Buschland. Das futuristische Glasdach schafft eine Atmosphäre sonnendurchfluteter Weite. Die beim Bau verwendeten lokalen Materialien und ein ausgeklügeltes Energiekonzept betonen die Verantwortung für das Land und die Verbundenheit mit ihm. Das Interieur kombiniert europäische Designermöbel mit antiken orientalischen Teppichen. Wenn der Tag sich neigt, können die Gäste bei einem gut gekühlten australischen Wein Kängurus beobachten, die über das Gelände der Lodge hüpfen.

Ce pavillon entre océan et bush sauvage se dresse sur une falaise, sur la Great Ocean Road, dans l'état de Victoria. Le toit de verre futuriste crée une impression d'espace inondé de soleil. Les matériaux locaux utilisés pour la construction et le concept énergétique ingénieux traduisent l'attitude responsable par rapport à la terre et son lien avec elle. L'intérieur marie meubles de designers européens et tapis orientaux antiques. A la tombée du jour, les invités peuvent boire du vin australien bien frais en regardant les kangourous bondir sur tout le terrain du pavillon.

El lodge se levanta sobre un acantilado de la Great Ocean Road de Victoria, entre el mar y la zona de monte salvaje. El futurista tejado de cristal crea un ambiente de amplitud bañado por el sol. El uso de materiales autóctonos y un ingenioso concepto energético enfatizan su responsabilidad y vínculo con el terreno. El interior combina mobiliario europeo de diseño con antiguas alfombras orientales. Al atardecer, los huéspedes tienen la posibilidad de degustar una copa de vino australiano fresco contemplando los canguros dando saltos por el recinto.

Su uno scoglio presso la Great Ocean Road, a Victoria, si trova questo lodge tra mare e boscaglia selvaggia. Il futuristico tetto di vetro crea un'atmosfera di ampiezza piena di sole. I materiali locali utilizzati per la costruzione e un raffinato piano energetico sottolineano la responsabilità per la terra e il legame con essa. L'interno combina mobili di design europeo con tappeti orientali antichi. Quando il giorno giunge al termine, gli ospiti possono bere del vino australiano fresco osservando i canguri che saltano sul terreno intorno al lodge.

Futuristic architecture in the wilds of nature. The view ends only at the horizon.

Futuristische Architektur in wilder Natur. Die Aussicht endet erst am Horizont.

Une architecture futuriste en pleine nature sauvage. La vue s'arrête seulement à l'horizon.

Arquitectura futurista en plena naturaleza salvaje. La panorámica acaba en el horizonte.

Architettura futuristica nella natura selvaggia. La vista finisce solo all'orizzonte.

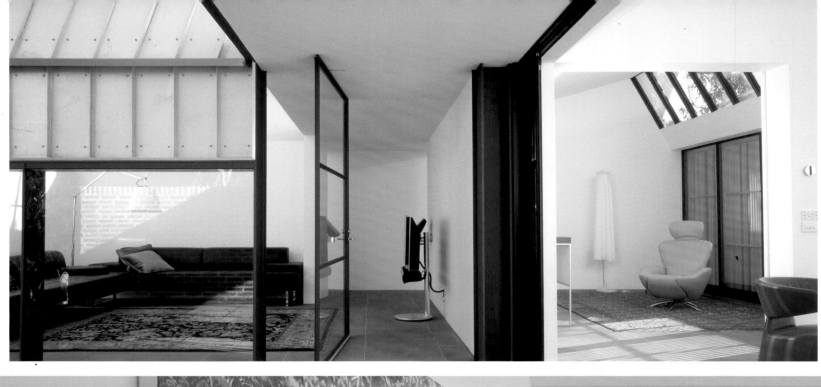

The living space of 2,800 sq. ft. abounds with surprising details. Both the furniture and materials were examined for their esthetics and recycling qualities—like the bright-red fireplace beneath the glass roof.

Die 260 m² Wohnfläche stecken voller überraschender Details. Möbel und Materialen wurden auf Ästhetik und Recyclefähigkeit hin geprüft – zum Beispiel der knallrote Kamin unter dem Glasdach.

L'espace de vie de 260 m² est plein de détails surprenants. Le mobilier tout comme les matériaux utilisés ont été choisis pour leur esthétique et leur capacité de recyclage – comme par exemple, la cheminée rouge vif sous le toit de verre.

Sus 260 m² esconden detalles sorprendentes. Se analizó el nivel estético y de reciclado de muebles y materiales, como es el caso de la chimenea en rojo vivo bajo el techo de cristal.

La superficie abitabile di 260 m² è piena di dettagli sorprendenti. I mobili e i materiali sono stati controllati dal punto di vista estetico e di capacità riciclabile: per esempio il camino rosso fuoco sotto il tetto di vetro.

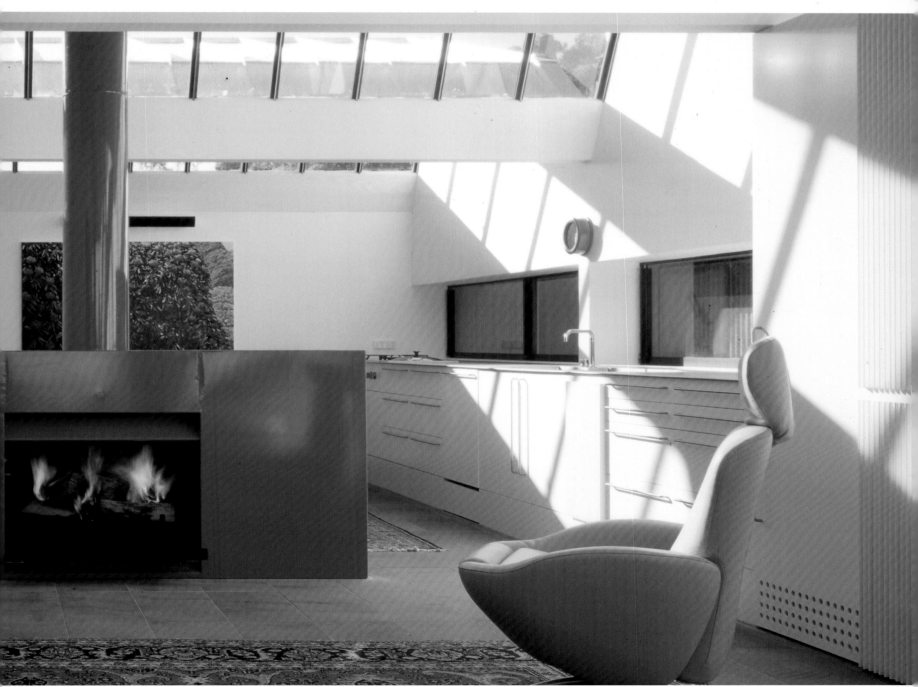

Rahimoana

Bay of Islands, New Zealand

Villa Rahimoana is an island of luxury amid pristine nature in New Zealand's subtropical north. It is spread out near the historic town of Russell above the Bay of Islands. Its four bedrooms are decorated with modern works of art while its window fronts offer wide views of the Pacific and the surrounding archipelago on three sides. Its exquisite amenities include a private movie theatre, a heated infinity pool and Jacuzzi, a private beach and use of the villa's own Porsche.

Die Villa Rahimoana ist eine Insel des Luxus inmitten der ursprünglichen Natur des subtropischen Nordens von Neuseeland. Sie erstreckt nahe des historischen Städtchens Russell oberhalb der Bay of Islands. Ihre vier Schlafzimmer sind mit modernen Kunstwerken dekoriert, die Fensterfronten bieten auf drei Seiten des Hauses weite Blicke auf den Pazifik und die umliegende Inselwelt. Zu den exquisiten Annehmlichkeiten zählen ein Privatkino, ein beheizter Infinity-Pool und ein Jacuzzi, ein Privatstrand sowie die Benutzung des hauseigenen Porsche.

La Villa Rahimoana est un îlot de luxe au milieu d'une nature vierge dans le nord subtropical de la Nouvelle-Zélande. Elle est située à l'extérieur de la ville historique de Russel, au-dessus de la Bay of Islands. Ses quatre chambres sont décorées d'œuvres d'art modernes. Les baies vitrées offrent une large vue sur le Pacifique et les îles environnantes, sur trois côtés de la maison. Elle compte, entre autres précieux équipements, un cinéma privé, une piscine à débordement chauffée et un jacuzzi, une plage privée et l'usage de la Porsche de la villa.

Villa Rahimoana, ubicada cerca de la histórica localidad de Russell, sobre la Bay of Islands, constituye un reducto del lujo en medio de la naturaleza virgen subtropical del norte de Nueva Zelanda. Sus cuatro dormitorios están decorados con obras de arte modernas. Los ventanales frontales ofrecen vistas al Pacífico y a los archipiélagos cercanos desde tres de los lados de la casa. Entre las comodidades más exclusivas destacan el cine, la piscina de desborde infinito climatizada, jacuzzi, playa privada y el uso del Porsche propiedad de la casa.

Villa Rahimona è un'isola di lusso in mezzo alla natura incontaminata del Nord subtropicale della Nuova Zelanda. Si estende vicino alla cittadina storica di Russell sopra alla Bay of Islands. Le sue quattro camere da letto sono decorate con opere d'arte moderne, le vetrate offrono su tre lati della casa un'ampia vista sul Pacifico e sull'arcipelago circostante. Tra le piacevoli comodità ci sono un cinema privato, un infinity pool riscaldato e una Jacuzzi, una spiaggia privata e l'utilizzo di una Porsche propria della casa.

This glass palace is absolutely glamorous. Luxury is an unwritten law on the inside while the wilderness of New Zealand reigns on the outside.

Absolut glamourös ist dieser gläserne Palast. Innen ist Luxus ein ungeschriebenes Gesetz, außen regiert die ursprüngliche Natur Neuseelands.

Ce palais de verre est d'un glamour absolu. Le luxe est une loi tacite à l'intérieur alors que la vie sauvage de Nouvelle-Zélande règne à l'extérieur.

Un palacio de cristal cargado de glamour. En su interior rige la ley del lujo. En el exterior reina la naturaleza virgen neozelandesa.

Questo palazzo di vetro è pieno di fascino assoluto. All'interno il lusso è una legge non scritta, mentre all'esterno domina la natura intatta della Nuova Zelanda.

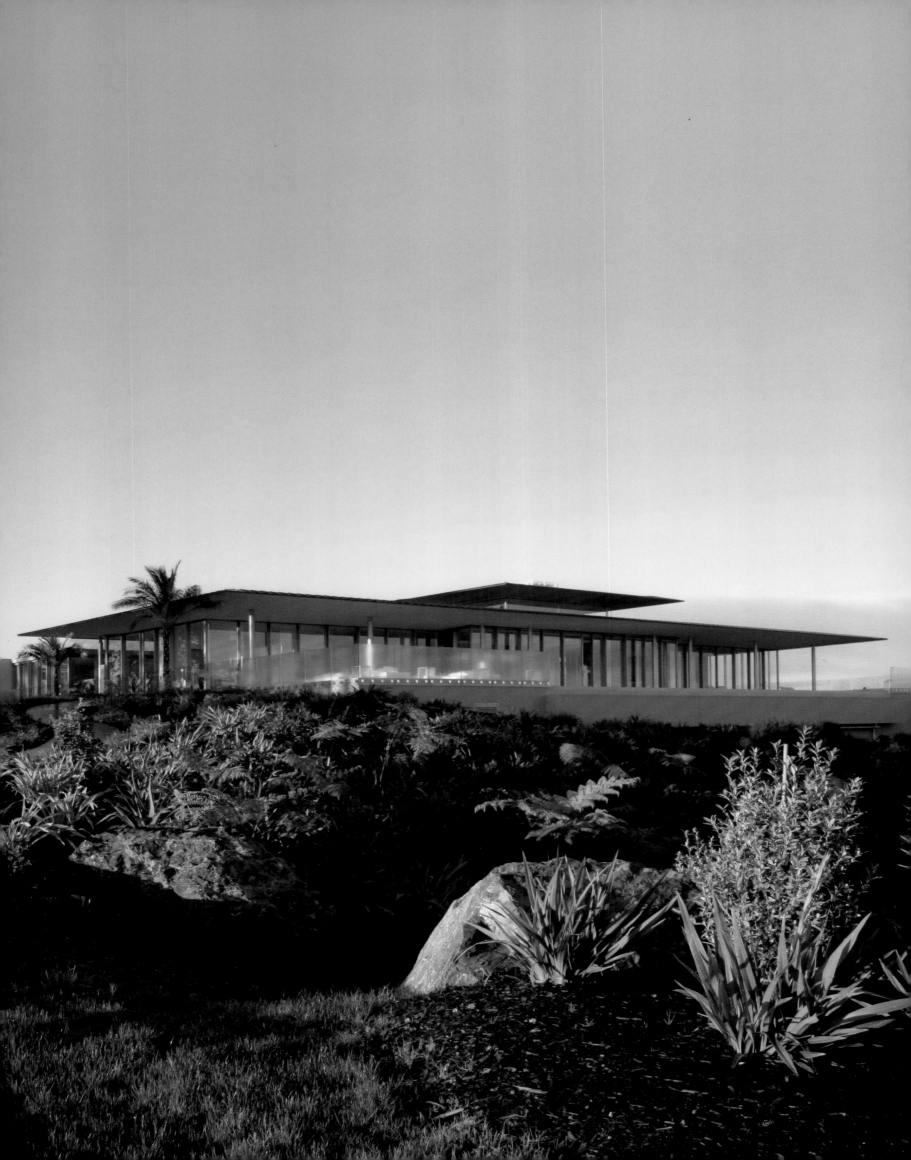

Divine sleep *above the ocean: Light and warmth bathe every room of the villa, which was named in the Maori language after the Sun God standing above the ocean.*

Göttlich schlafen *über dem Ozean: Licht und Wärme durchfluten alle Räume des Hauses, das in der Sprache der Maori nach dem über dem Meer stehenden Sonnengott benannt ist.*

Un sommeil divin *au-dessus de l'océan : la lumière et la chaleur inondent chaque pièce de la maison. Son nom signifie en maori « Dieu du soleil au-dessus de l'océan ».*

Descansar como *una divinidad junto al océano. El calor y la luz inundan las estancias de esta casa, cuyo nombre viene del maorí y hace referencia al dios sol que brilla sobre el mar.*

Dormire divinamente *al di sopra dell'Oceano: la luce e il calore inondano tutti i locali della casa, il cui nome, nella lingua dei Maori, corrisponde a quello del dio del sole che sovrasta il mare.*

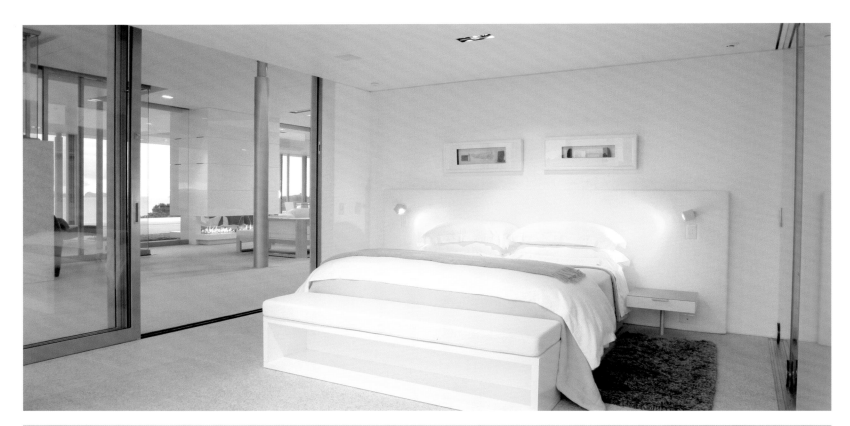

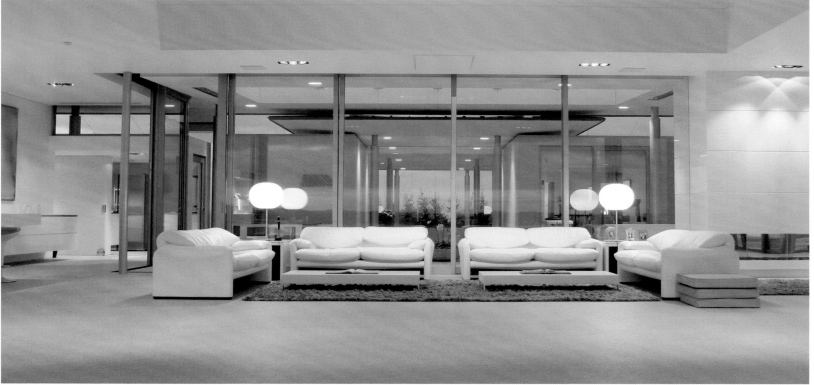

Index

USA

Aspen

Villa Bear's Creek
www.villazzo.com

4 bedrooms incl. 1 king-size master suite with bathroom, 1 bedroom with 2 full-size beds with bathroom, 2 queen-size bedrooms with bathrooms. Living room, dining room, office. Total interior space: 4,000 sq.ft. / 370 m². Outdoor Jacuzzi. Barbecue. 2 min. drive to Aspen Main Street, 10 min. from Aspen Airport, 3 min. to gondola, 10 min. to next golf course, 5 min. to tennis court.

Miami Beach

Villa Athena
www.villazzo.com

Situated on Hibiscus Island overlooking Biscayne Bay. Main house with 4 bedrooms incl. master suite, lounge, dining room, kitchen and numerous dining alcoves, bar areas and terraces. Guest house with 3 bedrooms, office, gym and movie theater. Boat house. All buildings connected by walkways. Interior space: 9,500 sq.ft. / 880 m², total area 19,690 sq.ft. / 1,830 m². Automatic entrance gate. Large swimming pool. 5 min. to South Beach, 15 min. from Miami International Airport, 1 min. to tennis court, 10 min. to golf course.

Miami Beach

Villa Grandioso
www.villazzo.com

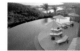

The property comprises 5 bedrooms incl. 1 king-size master suite and 4 king-size bedrooms with bathrooms. Living room, dining room, home theater, billiard room, media room with a large projection screen and full surround sound equipment. 1,200 sq.ft. / 110 m² dining kitchen. Indoor Jacuzzi. Barbecue and bar. Total area 14,000 sq.ft. / 1,300 m², interior space: 16,146 sq.ft. / 1,500 m². Automatic entrance gate. Staff. 5 min. from South Beach and a 15 min. drive from Miami International Airport.

Caribbean

Providenciales

Bajacu
www.bajacu.com

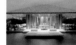

Property for up to 10 guests. 5 bedrooms (3 with king beds, 2 with 2 double beds). 7 baths, 2 living rooms, interior and exterior dining area. Gourmet kitchen. Office with Internet access, fax, printer and scanner. Sunset terrace. 2 heated pools 9,500 sq.ft. / 880 m² under roof and 3,500 sq.ft. / 350 m² terrace. Total estate 11 acres / 4.5 ha. Staff of two living on site in a separate staff house. Non-smoking villa. Private and direct access to the sea. Gated estate, alarm system and safe in each room. 15 min. drive from the airport.

Providenciales

Amanyara
www.amanresorts.com

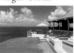

Resort comprising 40 contemporary guest pavilions and 33 secluded 3- and 4-bedroom-villas for rent incl. a spacious living room and dining room pavilion, a fully outfitted kitchen, and an infinity pool. Guests can leave their private villa and make use of the resort facilities such as restaurant with in- and outdoor area, bar with terrace and daybeds, swimming pool, cinema, fitness center, beach club and sports facilities. 25 min. drive from Providenciales International Airport.

Virgin Gorda

Katitche Point Greathouse
www.katitchepoint.com

Small holiday village for up to 10 guests on a hill of the west side of Virgin Gorda. Main house on 3 levels incl. 1 master bedroom and 4 suites, living and dining area for up to 14 people. BOSE stereo system and CD collection. Wine cellar. Dining verandahs and outside pool. Comprehensive guest services. Chef on request. 5 min. walk to private beach, 10 min. to Mahoe Bay Beach. Located in Virgin Gorda, 2 ½ miles / 4 km from Virgin Gorda Airport.

Anguilla

Villa Indigo
www.littleharbourestates.com

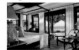

Villa on the beach surrounded by private tropical gardens for up to 12 guests. 7 bedrooms with en suite bathrooms each comprising 3 master bedrooms, 1 of them with pool and patio area, 2 king size rooms, 1 double room and 1 single room. 3 Kitchens. Dining Pavilion and outside dining areas. Barbeque. Main lounge and reception, TV lounge. 2 swimming pools, private beach with floating platform. Full time maid service. Situated at Little Harbour 15 min. from Anguilla Airport.

Anguilla

Bird of Paradise
www.anguillabird.com

Property on the beach incl. 4 bedroom suites each with its own balcony, panoramic views, own refrigerator and coffee service. The master bedroom features his own plunge pool. An office can serve as a 5th bedroom. Large interior living room with flat screen TV, DVD and CD player. 3 dining experiences. 2 swimming pools. Several exterior living areas, one with a fireplace. Office, Internet. Security system. Located a short walk from Sandy Hill Bay, 10 min. drive from airport.

Antigua

Antigua Wild Dog Villa
www.antigua-villa-rentals.com

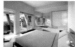

Property for up to 6 guests comprising 3 buildings. 3 bedrooms each with en suite bathroom and air-condition. Living room featuring dining area, gourmet kitchen, TV, surround stereo, DVD and CD equipment. Internet. Office. Pool with Badujet Swim Jet System. Located on a hill of the North-East coast of Antigua, 2 min. drive to white sand Jabberwocky Beach, 2 miles / 3 km from the airport.

Saint Martin

Mes Amis
www.pierrescaraibes.com

Cliffside property for up to 22 guests comprising 2 villas on 7 acres / 3 ha. 11 bedrooms with en suite bathrooms. The master suite has a private terrace and glass walled spa overlooking the ocean. Living room with glass sliding doors, dining room and state-of-the art kitchen. Media room. Gym, Jacuzzi and 2 heated pools. Pool bar and outside dining areas. Gourmet chef. Located at Terres Basses, 4 miles / 6 km from the airport. ¼ mile / ½ km to the beach.

Saint Martin

No Limit
www.pierrescaraibes.com

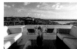

Hillside villa housing three 3 equal sized, king-size bedrooms with en suite bathrooms. Large open-plan living area, gourmet kitchen and terrace with gazebo. Infinity pool and spa, air-conditioned gym. Located on the hillside of Terres Basses, ⅔ mile / 1 km to the beach, 4 miles / 7 km from the airport.

Mustique

Wyler House
www.mustique-island.com

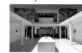

Beach villa for up to 6 guests comprising 3 bedroom suites with en suite bathroom each. Kitchen, living room and dining room. Gym and media room each with underwater views of the swimming pool. 100 ft. / 30 m swimming pool. 6 terraces. Internet. Three people staff. Situated at the North coast of Mustique, 10 min. from the airport.

Mexico

Careyes

Cuixmala
www.cuixmala.com

24.000 acres / 100 km² biosphere reserve with private beaches at the Costalegre housing 9 casitas with 1 to 3 bedrooms, 3 villas with 3 to 4 bedrooms and the main house Casa La Loma with 4 bedrooms and 6 bungalows, 11 bedrooms totally. The casitas area features 1 pool, villas and Casa La Loma offer private pools and stuff. Private beach club, water sports. Security officers. Private airstrip for aircrafts up to King Air B200. Located in Jalisco, 1 h from Manzanillo Airport, 2 ½ hrs from Puerto Vallarta International Airport.

Careyes

Casas de Careyes
www.careyes.com.mx

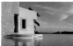

The property comprises 6 individual fully staffed villas featuring different sizes and a resort with further villas called Casitas de las Flores. Beach restaurant, polo club. Located in Jalisco, 2 hrs South of Puerto Vallarta, 1 h from Manzanillo.

Brazil

Trancoso

Villa Trancoso
www.brazilianbeachhouse.com

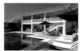

4 bedroom villa for up to 8 guests. Dining room. Kitchen. Open plan sitting room and shaded terrace on the first floor. Sun deck and pool. Tennis court and 18-hole golf course on the door step. Private path to the beach. Private gravel runway less than ⅔ mile / 1 km from the property. Located on the Terravista estate, 5 min. from the beach, 15 min. drive to Trancoso and 1 h from Porto Seguro Airport.

Switzerland

Klosters

Chalet Eugenia
www.descent.co.uk

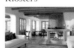

Secluded chalet with private drive sleeping 12–15 guests. 7 bedrooms with en suite bathrooms, some with terrace. Study with telephone and fax, computer with internet. Videos, DVD, CD, flat screen TV. Private south-facing garden. Games room. Wine cellar. Sauna. 3 min. drive to the center of Klosters and 2 hrs from Zurich Airport.

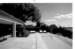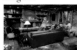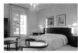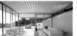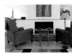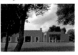

Kenya

Diani Beach

Alfajiri Villas

www.alfajirivillas.com

Beach property comprising 3 individual villas, 12 rooms in total. Private dining area and swimming pool in Cliff Villa. Garden & Beach Villa share the same pool. Sea view gazebos. Meals and drinks, massage and golf incl. in the rates. Located on the south coast in Diani, 1 h from Mombasa Airport.

South Africa

Capetown

Villa Symphony

www.landmark-gmbh.de

Property for up to 10 guests with natural river flowing through. 5 rooms with en suite bathroom. 9 balconies, 4 lounges, 2 fireplaces. Over 10.225 sq.ft. / 950 m² living space, whole property 20.450 sq.ft. / 1.900 m². Surround sound on all floors and outdoor. Kitchen. Mini business center with ADSL Internet, fax and printer. Patio with barbeque. Sparkling swimming pool, gym. 360° security beams, CCTV cameras exterior. 4 lock up garages. Butler and maid service. 25 min. drive from Cape Town International Airport.

Hermanus

Birkenhead House

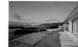

www.birkenheadhouse.com

Property for up to 22 guests comprising 11 suites, most of them with sea views. Dining room. 3 pools, 1 on dual levels. Spa, gym and treatment room. Located in Hermanus a few steps from Voëlklip Beach, 90 min. drive from Cape Town.

Sri Lanka

Galle Fort

Apa Villa Thalpe

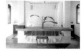

www.villa-srilanka.com/apathalpe

Property located on the beach comprising 3 villas: Villa Saffron and Villa Cardamom incl. 2 suites each, Villa Cinnamon incl. 3 suites. 1 pool shared by all 3 villas. English speaking staff. Situated 5 miles /8 km south of Galle, 3–4 hrs drive from Colombo International Airport.

Bentota

Taru Villas Taprobana

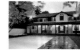

www.taruvillas.com

9 room beachside villa on a 1 ¼ / 2 km unspoiled beach outside of Bentota. All rooms have en suite bathrooms with guest amenities and balconies or terraces. Swimming pool and pavilion. Beach service. Treatments. Water sports facilities nearby. Staff. 2 ¼ hrs drive from the airport (approx 60 miles / 100 km).

Indonesia

Bali

Villa Pantulan

www.balistylevillas.ch

Property for up to 10 persons consisting in 4 pavilions, one of them with 2 bedrooms. 5 bedrooms in total with en suite bathrooms. Gourmet kitchen. Open living- and dining room. Library, media room with TV. Bale for massages and meditation. Artist atelier. Orchid garden. Staff incl. chef and driver. Located in the South of Ubud, 1 h drive from the airport.

Bali

Villa Sungai

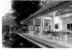

www.bali-villasungai.com;
www.baliluxuryhoneymoons.com

Property comprising 2 villas. Villa Sungai and Villa Sungai Gold that can be booked individually or in conjunction. Villa Sungai comprises 3 bedrooms and 4 bathrooms. Dining for up to 14 guests. Double spa room. Bar Bale. Infinity pool. Villa Sungai Gold features 1 bedroom and 2 bathrooms. Dining area for 8 guests. Pool. Spa Bale. Both villas are fully staffed incl. drivers and chefs. 10 min. drive from Canggu, 15 min. to markets and a golf course, 20 min. from Legian and 40 min. from the airport.

Bali

Villa Dewata

www.balivillas.com/villas/dewata2

Property comprising of 3 individual villas. Villa Dewata II is the most luxurious one featuring 5 bedrooms with en suite bathrooms for up to 10 adults. Spacious living and dining areas, air-conditioned TV lounge. Tropical garden with 65 ft. / 20 m swimming pool. Can be combined with the adjacent Villa Dewata I & III to accommodate larger groups. Personal butler, private chef and cooks, maids, houseboys, gardeners. Quiet but central location in Seminyak, a few min. to shops and restaurants, 20 min. drive from Ngurah Rai International Airport.

China

Beijing

Commune by the Great Wall Kempinski

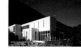

www.communebythegreatwall.com

Property with view over the Chinese Wall comprising 11 individual villas which can be rented completely only and 31 further resort villas. "Kids club" housing a kids club and accommodation. 3 restaurants, Anantara Spa. Located in the Shuigan Mountains, 1 h drive from Beijing International Airport and 15 min. from Badaling private airport.

Australia

Heathcote

Olive Grove Retreat

www. olivegroveretreat.com

1 room country villa in a 40 acres / 16 ha secluded setting of the Australian bush. Bedroom suite with en suite bathroom on the first floor. Living room. No TV, no phone. Massage and a maid available. Infinity pool. Private opera. Private chef for dining and breakfast available on request. 1 ½ hrs drive from Melbourne, 1 h from Melbourne Airport.

Yuulong

Moonlight Head Private Lodge

www.moonlighthead.com

Exclusive remote lodge featuring 2.800 sq.ft. / 260 m² of living space for up to 8 guests. 4 bedrooms with en suite bathroom each. Living area. Kitchen. Staff. Located 140 miles / 225 km from Melbourne, a 3 hrs drive.

New Zealand

Bay of Islands

Rahimoana

www.eaglesnest.co.nz

The villa belongs to the Eagles Nest Resort. 4 private en suite bedrooms featuring original artwork. 82 ft. / 25 m heated infinity lap pool, heated Jacuzzi, gym, far infra red sauna. High technology office. Sound systems in all rooms. Home theater. Private beach. Security throughout. Personal staff, trainer and chef. Porsche Cayenne Turbo. 2 min. drive from Russell, 45 min. from Kerikeri, the closest airport, which is a 40 min. flight from Auckland. 60 min. helicopter flight from Auckland Airport.

Photo Credits

Produced by fusion publishing gmbh, stuttgart . los angeles

Editorial team:

Patricia Massó, Martin Nicholas Kunz (Editors & Authors)

Katharina Feuer (Layout)

Jan Hausberg (Imaging)

Stefanie Bisping (Text)

Alphagriese Fachübersetzungen, Düsseldorf (Translations)

Dr. Suzanne Kirkbright, Artes Translations, UK (Copy Editing)

Published by teNeues Publishing Group

teNeues Verlag GmbH + Co. KG
Am Selder 37, 47906 Kempen, Germany
Tel.: 0049-(0)2152-916-0, Fax: 0049-(0)2152-916-111
Press department: arehn@teneues.de

teNeues Publishing Company
16 West 22nd Street, New York, NY 10010, USA
Tel.: 001-212-627-9090, Fax: 001-212-627-9511

teNeues Publishing UK Ltd.
P.O. Box 402, West Byfleet, KT14 7ZF, Great Britain
Tel.: 0044-1932-403509, Fax: 0044-1932-403514

teNeues France S.A.R.L.
93, rue Bannier, 45000 Orléans, France
Tel.: 0033-2-38541071, Fax: 0033-2-38625340

www.teneues.com